DIGITAL STORYTELLING, MEDIATIZED STORIES

Steve Jones
General Editor

Vol. 52

PETER LANG
New York • Washington, D.C./Baltimore • Bern
Frankfurt am Main • Berlin • Brussels • Vienna • Oxford

DIGITAL STORYTELLING, MEDIATIZED STORIES

Self-representations in New Media

Knut Lundby, Editor

PETER LANG
New York • Washington, D.C./Baltimore • Bern
Frankfurt am Main • Berlin • Brussels • Vienna • Oxford

Library of Congress Cataloging-in-Publication Data

Digital storytelling, mediatized stories: self-representations
in new media / edited by Knut Lundby.
p. cm. — (Digital formations; v. 52)
Includes bibliographical references and index.
1. Interactive multimedia. 2. Digital storytelling.
I. Lundby, Knut.
QA76.76.I59D57 006.7—dc22 2008014443
ISBN 978-1-4331-0274-5 (hardcover)
ISBN 978-1-4331-0273-8 (paperback)
ISSN 1526-3169

Bibliographic information published by **Die Deutsche Bibliothek**.
Die Deutsche Bibliothek lists this publication in the "Deutsche
Nationalbibliografie"; detailed bibliographic data is available
on the Internet at http://dnb.ddb.de/.

FSC
Mixed Sources
Product group from well-managed
forests, controlled sources and
recycled wood or fiber

Cert no. SCS-COC-002464
www.fsc.org
©1996 Forest Stewardship Council

Author photo by Gunnar Grøndahl
Cover design by Joni Holst

The paper in this book meets the guidelines for permanence and durability
of the Committee on Production Guidelines for Book Longevity
of the Council of Library Resources.

© 2008 Peter Lang Publishing, Inc., New York
29 Broadway, 18th floor, New York, NY 10006
www.peterlang.com

Printed in the United States of America

Contents

PART V ON THE EDGE

Introduction: Digital storytelling, mediatized stories

KNUT LUNDBY

This book aims to understand transformations in the age-old practices of storytelling that have become possible with the new, digital media. The resulting digital stories could be called 'mediatized stories'.

Digital Storytelling is proliferating. Amateur personal stories, focusing on 'me', flourish on social networking sites on the web and in digital storytelling workshops. This book deals with such self-representational stories in new media.

The approach is interdisciplinary. How can the mediation or mediatization processes of Digital Storytelling be grasped? The book offers an encounter between a sociological perspective of media studies and a socio-cultural take of the educational sciences. Aesthetic and literary perspectives on narration as well as a questioning from an informatics perspective are also included in the book.

Small-scale stories

There is a variety of digital storytelling forms, for example, those related to the narrative power of visual effects in film (cf. McClean, 2007) or the creative

opportunities in interactive entertainment (Miller, 2004). This book, in contrast, focuses on small-scale Digital Storytelling, or what Kelly McWilliam in her chapter calls 'specific digital storytelling,' denoted in this introduction with the capital D and capital S. They are small-scale as a media form. The stories focused on here are usually short, just a few minutes long. Second, they are small-scale in the sense that they are made with off-the-shelf equipment and techniques. The productions are not expensive—there may, for example, be zooming of still pictures rather than moving images. Third, the stories are small-scale, centring the narrator's own, personal life and experiences and usually told in his or her own voice.

This is the case with the now classic model of Digital Storytelling developed by the Center for Digital Storytelling in California from the first half of the 1990s. 'There are all kinds of stories in our lives that we can develop into multimedia pieces', founder of the Center, Joe Lambert (2006, p. 27), explains. In his book on Digital Storytelling, subtitled 'Capturing Lives, Creating Community', he points out a range of personal stories that could be made about important relationships to a significant other, honouring and remembering people who have passed, stories on adventures or accomplishments in one's life, on a place that is important to the storyteller, on one's work, on recovery, love or discovery (Lambert, 2006, pp. 27–31).

A new media practice emerged. In 2001, the BBC in Wales took up such Digital Storytelling under the rubric 'Capture Wales' (Meadows, 2003). Later, this small-scale media movement spread to England, Scandinavia, Australia and other—mostly rich and digitally saturated—parts of the world (Lundby, forthcoming).

Some of the contributors to this book offer more detailed accounts and criticisms of these stories of Digital Storytelling. Kelly McWilliam and John Hartley introduce the Center for Digital Storytelling in California and Capture Wales as background to their own domestic experiences in Australia. The two expand the map in their book *Story Circle. Digital Storytelling Around the World* (Hartley & McWilliam, forthcoming). Nancy Thumim examines critically the Capture Wales initiative. She also examines another case of storytelling using digital means, namely the 'London Voices' project at the Museum of London; an oral history project. This is an example of Digital Storytelling defined more broadly. Both are mediating self-representations, involving the digitisation of 'ordinary people's' stories, displayed on publicly available websites, made through cultural institutions in society (Thumim, 2007, forthcoming).

The stories made in such projects may be counted in tens of thousands. The Center for Digital Storytelling alone has helped produce some 12,000 stories through a fifteen-year-long history.[1] Hundreds of stories are displayed on the

BBC Wales website, and there are many, many other outlets around the globe. Still, this remains a small-scale media practice compared to dominant practices of television production and consumption, or other big media.

One reason why 'classic' Digital Storytelling will stay relatively small is the time-demanding production process that is required. This is not primarily about getting familiar with the technology. Rather, it is the art of making a good story. The Center for Digital Storytelling, as well as the Capture Wales and similar projects, requests their storytellers to attend workshops over several days, even weeklong. Before actually producing their multimedia tales, the participants spend time with supervisors in a 'Story Circle' where the plot and text of their digital stories are developed (Lambert, 2006, pp. 93–101; Hartley & McWilliam, forthcoming).

'Storytelling' implies the shaping of the story as well as the sharing of it with others afterwards. It was the Internet that expanded the space of Digital Storytelling—it offered new options to share the 'classic' small-scale stories created in story circles at various corners of the globe. The World Wide Web also gave rise to new forms: Blogging, in text only or with video, as well as the social networking sites on the web offer new opportunities to share short personal stories. These new media practices are taught and learned from person to person. No workshop is required to put up a self-representational short video on YouTube or your personal profile on Facebook and MySpace. Not all of these 'profiles' are stories in a proper sense, as David Brake discusses in Chapter 16 of this book, but much of the blogging and social networking on the web are 'personal media practices' (Lüders, 2007). The appearance of storytelling on mobile phones (Klastrup, 2007) adds to the expansion. Much of this activity should be regarded and studied as Digital Storytelling. The same may apply to digital stories produced in designated workshops for museums or other institutions. All such self-representational forms are here included in the term, and the phenomenon of, Digital Storytelling.

Nick Couldry in Chapter 3 defines the space of Digital Storytelling to encompass 'the whole range of personal stories now being told in potentially public form using digital media resources'. This is a suitable definition for this book. It does not aim at a comprehensive overview of all forms of personal Digital Storytelling; rather, some political and theoretical issues across forms are brought to the fore.

Giving a voice?

Does Digital Storytelling have democratic potential? The problems of scalability concern Hartley, in Chapter 11. Can enough stories be made and enjoyed by

enough people to sustain this media practice as compelling, connected and democratic, he asks. Couldry is sceptical, as well; although he acknowledges the 'deficit of recognition' in our society that Digital Storytelling may meet. He fears that Digital Storytelling is, and will remain, a largely isolated phenomenon, cut off from the wider distribution of social and cultural authority and respect. Couldry discusses critically the claim that Digital Storytelling has democratic potential. He listens deeply to the story told by Joe Lambert and other pioneers. Particularly in the US setting, the initiators of Digital Storytelling, for reasons of social justice, wanted to give marginalised groups a voice (Lambert, 2006, pp. 1–4).

This media practice may well remain small-scale. Nevertheless, for those who employ Digital Storytelling in their own lives, this practice may actually give them a voice, or be significant in other ways. The democratic potential in Digital Storytelling may be released within institutional settings, as Ola Erstad and Kenneth Silseth argue in their chapter on agency in Digital Storytelling in schools (Chapter 12). Whether this actually becomes a democratic move depends on how many turn to such practices, as well as on the edge it may have in civil society and political life.

There is potential: Digital Storytelling is a bottom-up activity. It is a 'user-generated' media practice. Digital Storytelling is performed by amateurs and not by media professionals. So-called 'ordinary people' develop the necessary competences to tell their own stories with new digital tools. However, one may make a distinction to the user-generated perspective, as Brake does in his chapter. He characterises 'lay' productions on sites like YouTube or MySpace as bottom-up compared to the institutionally led projects that are produced by 'amateurs' but under professional guidance.

The new media that are applied for Digital Storytelling are easily at hand and simple to use. They could turn users into producers: Hartley, in his chapter (Chapter 11), even terms them 'self-made media'. Mostly, Digital Storytelling takes place with standard software on standard laptops or PCs. In addition, a digital camera and a scanner to digitise paper photos are useful and a video camera may add footage. Especially in societies with a widespread digital (prod)user competence, the road is not a long one to a digital story that could be shared with others. While the Digital Storytelling workshops spend some energy on the application of the multimedia software, most of the time is devoted to the development of the story itself. The narratives that come out of the story circles are usually highly personal. They are self-representations. So are many postings on the web, in blogs as well as on social networking sites.

Self-representations

The focus of this book is on *self-representational* digital stories. These are personal stories, told with the storyteller's own voice. They are representations in the first person. The 'self' is social, shaped in relationships, and through the stories we tell about who we are. This applies in 'classic' Digital Storytelling as in new forms of social networking. Although

> it indeed appears that, for many young people, social networking is 'all about me, me, me', this need not imply a narcissistic self-absorption. Rather, following Mead's (1934) fundamental distinction between the 'I' and the 'me' as twin aspects of the self, social networking is about 'me' in the sense that it reveals the self embedded in the peer group, as known to and represented by others, rather than the private 'I' known best by oneself. (Livingstone, 2008)

Current communication technologies may alter the role of the self in the social world, Waite (2003) claims. The representations of selves in various forms of Digital Storytelling are part of collective patterns of 'Modernity and Self-Identity' (Giddens, 1991), although Giddens' 'armchair introspection' may easily slide into a 'disregard of the more mundane examples of reflexivity involved in digital practices', as Kirsten Drotner writes in her chapter (Chapter 4). They make individual stories on shaping of identity. Digital Storytelling is about 'crafting an agentive self' (Hull & Katz, 2006).

David Gauntlett, in this book as well as in *Creative Explorations* (Gauntlett, 2007), demonstrates how people may represent their identities—not in Digital Storytelling but by building metaphors with Lego bricks and figures. A similar construction process takes place with the digitised raw elements of text, images and sound that are built into a short, personal digital story. If the story is self-representational, it displays aspects of identity.

Self-representational stories may appear authentic. This, however, is an assumed authenticity, as pointed out by Birgit Hertzberg Kaare and Knut Lundby in their chapter (Chapter 6). Because of the close links to the autobiography of the narrator, Digital Storytelling is often regarded as a genuine or authentic activity. The slogan from the Center for Digital Storytelling that 'Everybody has a story to tell' is, in a way, misleading. A person could have many stories to tell. The authenticity of the digital story is not a given. To play with narrative is to play with identity.

The outcome of digital narration takes many forms, dependent on the users' individual resources and the affordances of the software they apply, Lotte Nyboe and Kirsten Drotner maintain in their chapter (Chapter 9) on identity

aspects of Digital Storytelling. Based on a study of young people's production of digital animations, the authors in particular look at identity formation in relation to digital forms of co-production (cf. de Leeuw & Rydin, 2007). Nyboe and Drotner see the aesthetic dimension of cultural identity as a key to the processes of digital narration. They argue that there is a need to reframe existing theories of cultural identity and cultural production in light of the digital mode.

Digital narratives

It does matter that it's digital, as Tone Bratteteig states in her chapter (Chapter 15). Technology is an important part of how people express themselves and communicate with others. Characteristics of digital media influence digital stories and storytelling practices. Therefore, she argues, it is important to address technical issues as a part of Digital Storytelling.

Digital media facilitate, for one, the possibilities of narrative co-production and participation. Classic Digital Storytelling may appear as an individual exercise—telling 'my' story—but is actually deeply rooted in the collaborative processes of the story circle of the production workshop, and maybe in template narratives in the overall culture, as Ola Erstad and James V. Wertsch point out in their chapter. Similarly, storytellers on social networking sites mostly act in their own names, usually upon wide and deep processes of collaboration and informal learning from peers.

Such collaboration relates to questions of authorship and authority. Larry Friedlander, in Chapter 10, writes about narrative strategies in a digital age under the changing relationship between authorship and authority. With the appearance of the digital, interactive experience, Friedlander holds, we get stories that may multiply the authors, distribute their energy across a wide field of participants, redefine their powers and limits and rewrite all the rules. This is a more general argument, relevant to various forms of digital narratives, particularly those in interactive computer games. 'Digital narratives aspire to the variety and plentitude of a "world" rather than to the fixed structure of a text', Friedlander argues. Even with a short, personal digital story the author may be able to share glimpses of a world with the reader/user.

If not a 'world' in the immersive sense of digital narration in interactive games, small-scale Digital Storytelling may take shape in 'discursively ordered domains', as McWilliam argues in her account of Australian projects. This comprises a 'constant negotiation over what, precisely, digital storytelling is, how it is best applied, what it is for, and where it should be located', she writes.

The developments of Digital Storytelling within 'discursively ordered domains' point to the context in which such digital media practices operate and their larger social, cultural and economic significance, McWilliam reminds.

Challenging institutions

Digital stories are personal, small-scale stories. However, the wider meaning or significance of Digital Storytelling has to be sought in the large-scale contexts of its production and uses. Digital Storytelling almost without exception takes place within institutional frameworks.

This book explains how the user-generated bottom-up practices of Digital Storytelling challenge not only big media but also traditional schools. While Digital Storytelling has mostly been applied outside the educational setting, self-representational Digital Storytelling can be used as a tool for the fostering of agency (that is 'the capacity to make a difference') among young people in school, Erstad and Silseth argue in their chapter (see also McWilliam's chapter). Digital Storytelling puts emphasis on important issues that face the educational system, concerning the way students are engaged in their own learning processes by using new technologies. Digital Storytelling challenges the school by affecting the relationship between student and teacher roles, by exploring the understanding of what knowledge is, by engaging the students in a collective way, by the multimodality of its stories or texts, and by making explicit the relationships between formal and informal contexts of learning.

Hartley, in Chapter 11, notes that Digital Storytelling challenges the media industries by providing a myriad of stories. Broadcasting, cinema and publishing houses have for decades been busy scaling up audiences, focusing on distribution rather than production. Story-*telling* has been taken care of by highly trained professionals. User-generated Digital Storytelling to some extent may change this.

Differences in media structure between Britain and the US underline the importance of institutional aspects: despite all the big broadcasting networks, it may be more difficult to get a marginalised voice heard in the US media market than with the public service-based media system in Britain.[2] The Center for Digital Storytelling in California was set up as an alternative to the main media system; in contrast, Capture Wales was established within the main public service broadcasting company. In a public service institution a broad range of interests and voices could expect to be represented, although this may not in fact happen, but in Capture Wales, participants from Story Circle workshops were invited to shape and share their digital story within the institution.

Among the institutional activities transformed by digital media use is family life. Elisabeth Staksrud writes about how parents are being challenged by their children's online life. Her chapter (Chapter 13) explores, with material from Norway, contextual factors that influence children's self-representations online.

The questions on 'mediatized stories' are about various transformations that might take place with digital storytelling, as discussed in several chapters in this book (e.g., Erstad & Wertsch, Couldry, Drotner, Friedlander).

Multimodality—semiotic transformations

The new media capacity of prime significance in the production of Digital Storytelling is the multimodality offered by digitalisation. Composition across modes is nothing new. Even oral storytelling may apply a range of modes in a complex whole, as a composition of tale, ballad, melody and text (Ortutay, 1964, p. 186). Multimodality need not be digital at all, but through digital technologies multimodality is made 'easy, usual, "natural"' (Kress, 2003, p. 5). A single binary code could be used for representations in a variety of multimodal compositions to appear in combinations of speech, music, text, graphics, still or moving images. The binary representation is an abstraction from the fact that current is continuous, as Tone Bratteteig reminds in her chapter in this book.

What 'ordinary' people do with the multimodal variety of semiotic resources becomes interesting. With digitalisation 'the different modes have technically become the same at some level of representation, and they can be operated by one multi-skilled person, using one interface, one mode of physical manipulation, so that he or she can ask, at every point: "Shall I express this with sound or music?", "Shall I say it visually or verbally?" and so on' (Kress & van Leeuwen, 2001, p. 2).

In Digital Storytelling, amateurs could make such semiotic decisions with standard software on regular PCs or laptops. Glynda Hull and Mark Evan Nelson (2005) set out to locate 'the semiotic power of multimodality' during which they analyse a digital story, 'Lyfe-N-Rhyme', created by a young man in West Oakland, California. Multimodal capacity is a key to understanding Digital Storytelling, as compared to oral or written storytelling, and Hull and Nelson's empirical studies strongly confirm that multimodal composing depends on computer technologies. They locate the semiotic power of multimodality in Digital Storytelling in the blending of new and old textual forms. In this book Nelson and Hull expand their research into studies of multimodal selves, applying perspectives from Bakhtin (Chapter 7).

Multimodality or digital remix (Lankshear & Knobel, 2006, p. 107) is the key to understanding the types of narrative that are created in Digital Storytelling (Meadows, 2003; Hull & Nelson, 2005). Multimodal composing is not an additive art; 'a multimodal text can create a different system of signification, one that transcends the collective contribution of its constitutive parts' (Hull & Nelson, 2005, p. 225). Digital Storytelling should not be understood as a phenomenon equivalent to either oral storytelling or to written narratives (Scheidt, 2006). Digital Storytelling creates a new composition.

Gunther Kress draws attention to such semiotic transformations that take place in multimodal practices. The multimodal resources made available with digital media 'provide users of the resource with the ability to reshape the (form of the) resources at all times in relation to the needs of the interests of the sign-maker'. These transformations operate on the forms and structures within a mode and have to be complemented by the concept of transduction, that accounts for the shift of semiotic material across modes (Kress, 2003, p. 36). For matters of convenience, transduction is here included in the concept of semiotic transformations.

Narrative transformations

Larry Friedlander illuminates, in his chapter, what I will term the narrative transformations of Digital Storytelling. Friedlander refers to another key characteristic of digital media alongside multimodality, namely, the interactive capacity. He considers 'the havoc being wrought by contemporary digital narratives' part of the 'cultural transformations' of our time.

Protean transformations, that is the ever-changing and versatile, characterise the digital options, Friedlander reminds us:

> Great modern artists, such as Joyce or Beckett, have tried to convey their vision of this fragmented world by subverting the formal order of earlier novels. . . . This is an art of *protean transformations*, disrupted and unresolved plots, and characters who have a weak and wavering sense of a self. Such highly unstable fiction mirrors the shifting, phantasmagoric quality of modern experience. And, yes, all this formal instability can sound quite like a foreshadowing of the digital world. (My emphasis)

Although Friedlander treats digital narrative, in a more general sense the 'laws of transformation' apply to small-scale personal digital stories as well:

> Each of its elements—space, time, objects, beings, and actions—can be selected, arranged, and transformed for the needs of an aesthetic experience. Thoughts can be-

come visible, objects can metamorphose according to emotional and aesthetic rules, and background elements (such as floors or skies) can suddenly communicate symbolic meanings. Within the world, all obeys the *law of transformation*, all is choice and interaction. (My emphasis)

Narrative transformations relate to semiotic transformations, on different levels of analysis of Digital Storytelling. If semiotic transformations are micro processes, narrative transformations appear on a meso level. However, Digital Storytelling takes place within macro contexts.

Institutional transformations

Challenging institutions, Digital Storytelling may imply transformations of or within the context in which it operates. Social institutions may be conceptualised as concrete: schools, for example. Institutions may also be understood in a generalised sense, in this case, as education or even wider as socialisation.

Stig Hjarvard (2004, 2007, forthcoming 2008), on such a general level, has worked out a theory of institutional transformations related to the work of media. By 'media' he understands a 'technology that allows transfer of or interaction with a symbolic content across time or space' (2004, p. 48). The transformations that Hjarvard observes are termed 'mediatization'. They may cut across different social institutions but could influence institutions in various ways and degrees. The media are integrated into other institutions at the same time as the media become an institution in its own right. 'Thus, social interaction within institutions (e.g., the family), between institutions (e.g., science and politics) and in society as a whole is performed by and through the media' (Hjarvard, 2007, p. 3).

Mediatization is defined as a 'process through which core elements of a social or cultural activity (like work, leisure, play, etc.) assume media form' (Hjarvard, 2004, p. 48; 2007). Mediatization could take place in a strong form, where the institution (the social or cultural activity) itself assumes media form so that the activity has to be performed through interaction with a medium. Mediatization could also take in a weaker form, where the symbolic content and the institutional activity are 'influenced by media environments that they gradually become more dependent upon and interconnected with'. Combinations of weak and strong forms may, of course, also occur (Hjarvard, 2004, p. 49).

Digital Storytelling may be a limited media phenomenon in the major processes of mediatization but the transforming logic is the same. The old art of storytelling is one of those social and cultural activities that, given the digital

opportunities, may assume media form. Such transformations pave their way into storytelling institutions such as schools and even media organisations.

Mediatization or mediation?

The concepts of mediation and mediatization were introduced in media studies well before digital media became applied in storytelling. However, the processes are intensified by digital media with their capacity for semiotic, narrative and institutional transformations. In his chapter, mapping out conceptual choices to grasp the emerging space of Digital Storytelling, Couldry counters Hjarvard's proposal on 'mediatization'. Couldry prefers the concept of mediation to grasp the social and cultural transformations due to the role of media.

The discussion between Couldry and Hjarvard highlights the clear positions of theoretical work of British (e.g., Schlesinger, 1993; Silverstone, 1999) and Scandinavian (e.g., Hernes, 1977; Asp, 1986) media scholars, respectively.[3] There is a common reference to the concept of 'media logic' as coined by the American scholars David Altheide and Robert Snow (1979). This reference is either used affirmatively, as by Hjarvard in the mediatization camp, or critically as is usual among the mediation theorists (like Couldry in this book).

To Hjarvard, mediatization generally, 'denotes the process through which society increasingly is becoming dependent on the logic of the media' (Hjarvard, 2007, p. 2; Schulz, 2004). Couldry finds this to be linear thinking, based on a tendency to claim broad social and cultural transformations from one single type of media-based logic.

Couldry's claim may itself be a bit one-eyed. Hjarvard has a multifaceted understanding of 'media logic' as the *organizational, technological, and aesthetic* functioning, including the ways in which media *allocate material and symbolic resources* and work through *formal and informal rules*' (Hjarvard, 2007, p. 3, italics in original). Digital technologies in Digital Storytelling definitely do not obey just a single logic. The multimodality of digital media operates according to mixed logics (Kress, 2003, pp. 1–6).

Hjarvard minimises the meaning of mediation. 'Mediation' for him refers to communication and interaction through a medium in a particular setting, where the message and the relation between sender and receiver may be affected. Analyses of mediation focus on how the media influence both message and relation between sender and receiver, he holds (Hjarvard, 2007, pp. 3–4). This comes close to regarding 'mediation' as representation. I will term this a *narrow* or focused conceptualisation of 'mediation'.

When Couldry performs his friendly attack on the Scandinavian under-

standing, Hjarvard's conceptualisation of 'mediatization' is characterised in a similarly narrow way. Couldry links Hjarvard's understanding of 'mediatization' to media *form*. This is to focus on 'a particular transformative logic or mechanism that is understood to do something distinctive to (that is, to 'mediatize') particular processes, objects and fields', he writes in his chapter. Mediatization in the narrow or focused sense points to the transformation of processes into forms or formats suitable for media re-presentation. So, for Hjarvard as well as for Couldry, the narrow definition of the other's main concept is focused on representations.

The British colleagues apply the concept of mediation to the larger transformative processes. Actually, the British do not have the word 'mediatization' in their vocabulary. Roger Silverstone (2005, p. 189) influenced by Jesús Martín-Barbero (1993) did make a *broad,* all-encompassing definition of 'mediation': The whole range of transformative processes, institutionally and technologically driven, end up embedded, where the social works in turn as a mediator; institutions, and technologies as well as the meanings that are delivered by them are mediated in the social processes of reception and consumption. Against this, Hjarvard's concept, especially in the strong but maybe also in the weak form, can be termed *broad* 'mediatization': a long-term process through which core elements of a social or cultural activity assume media. Roughly, one could say that 'broad mediation' covers about the same transformation processes as 'broad mediatization'.

Tension and mediation

Whether one accepts that transformations due to digital technologies and competences make digital stories into 'mediatized stories' or not, one has to admit that the shaping of digital stories is subject to mediation.

Thumim (2007), following the media studies path, points out tensions shaping self-representations in Digital Storytelling projects. She suggests that the mediation process is constituted through these tensions. She explores the notion of the 'ordinary person' as a construct, the notion of community as a construction, and how there are tensions about how to define and achieve quality. In her chapter in this book (Chapter 5) she explores how processes of cultural mediation are constituted through tensions in these areas.

Within the broader definition of Digital Storytelling as personal stories being told in public form with digital tools, Thumim looks at one project following the California model and another project that has nothing to do with

that model. She distinguishes textual, institutional and cultural aspects of me-diation. This is not to deny other aspects of the mediation processes.

With textual mediation, Thumim (forthcoming) explores tensions that arise in self-representational texts. The tensions of institutional mediation relate to the context for the production of self-representational stories. With the notion of 'cultural mediation', Thumim, in this book, points to the symbolic resources or the points of view that the storytellers or participants bring from outside and into the institutions where the production of the digital stories takes place. These are the cultural elements and expectations they bring to the creation of their own self-representations. She underlines that wider cultural formations affect and shape the institutions and the texts that the storytellers have to adapt to.

Although individuals working on their own self-related texts without the guidance or encouragement of an institution may, thereby, escape some of the mediating influences of Digital Storytelling organisations, Brake suggests in his chapter on MySpace users that their work is nonetheless mediated by the variety of tacit rules, social relations and the subtle framing of the software used to publish it.

This connects to the understanding of 'mediation' with 'cultural tools' that Erstad and Wertsch bring into this book. In their 'Tales of mediation', in Chapter 2, they apply a socio-cultural theory to Digital Storytelling. In constructive tension to the concepts of mediation and mediatization from media studies presented so far, they draw upon theories of mediation from the school of Lev Vygotsky and other Russian social psychologists prominent in the educational sciences.

This book invites this encounter between media scholars and educational researchers, between a media sociological view and socio-cultural psychological perspective. Couldry represents the media studies conceptualisations. Drotner in her chapter builds bridges between the learning studies and media studies camps. On her way to reconstruction she challenges Couldry's concept of mediation as well as Hjarvard's understanding of mediatization. In order to create dialogue between the discourses on media and on learning, Drotner advocates that the semiotic as well as the social aspects of the meaning-making practices in digital storytelling are taken into account. Media, then, are considered selected cultural resources.

'Cultural tools' are prominent in a socio-cultural theory of mediation. Er-stad and Wertsch discuss narrative as well as digital media as cultural tools and how they merge in Digital Storytelling. Their main question is how new digital media might transform the role narratives play in our lives. Hence, they pose the question of how 'mediatized' stories are being shaped.

The Mediatized Stories project

This book is born out of the international research project 'Mediatized Stories: Mediation perspectives on digital storytelling among youth' www.intermedia. uio.no/mediatized/. Most of the authors are part of this research project, of which the editor is project manager. Scholars in six countries cover cases from California through Europe to Georgia, Iran and Japan.

Colleagues studying Digital Storytelling in Australia add importantly to this book. John Hartley and Kelly McWilliam, from their base at the Australian Research Council Centre of Excellence for Creative Industries and Innovation, at Queensland University of Technology, also edit the forthcoming volume, *Story Circle. Digital Storytelling Around the World*.

The two groups of researchers met to discuss 'Digital Storytelling: Critical Accounts of a Californian Export' at UC Berkeley, California, in a pre-conference to the annual meeting of the International Communication Association, May 2007. Some of the contributions in this book build on presentations there.

Book outline

The following fifteen contributions are arranged in five sections. First, the section on *Concepts and Approaches* raises the theoretical discussion on 'mediation' versus 'mediatization' as seen from media studies versus educational studies.

The second section, on *Representing Oneself*, maps out some key dimensions of self-representations in Digital Storytelling, namely, their multivocality and multimodality, tensions that arise in the cultural mediation of the stories, and the assumed authenticity of these autobiographical narratives.

Third, different *Strategies of Digital Narration* are discussed, related to institutions, participants and texts, with special emphasis on the importance of the aesthetic dimension and the consequences of digital narration for authorship and authority.

Fourth, consequences for key institutions of the new forms of agency with the 'self-made media' of Digital Storytelling are explored. This is discussed in the section on *Challenging Authorities*—of parents, schools and the media industry.

The section *On the Edge* raises new questions. They are about a social scientist's methodology of using metaphors in storytelling—with Lego bricks, countered by a computer scientist who somewhat provocatively asks 'Does it

matter that it is digital?' Finally, a media scholar explores the opportunities in shaping the 'me' in MySpace.

Notes

The construction of this book would not have been possible without the scholarly co-operation within the 'Mediatized Stories' project, initially inspired by the DUSTY project in Oakland, California (Hull & James, 2007). The project was brought to its base in Norway through contact with Eli Lea and her colleagues at FlimmerFilm in Bergen. The Mediatized Stories project was later happily extended to link with colleagues researching Digital Storytelling at Queensland University of Technology in Australia. Further, there would have been no book without the invitation and encouragement from Steve Jones, the editor of the Digital Formations series; as well as the enthusiastic support from Mary Savigar and her team at Peter Lang. Heather Owen helped in a gentle way those of us who are not native users of English. Thanks to all who supported this book project, including the Research Council of Norway and the institutions of the participating researchers who funded these explorations into *Digital Storytelling, Mediatized Stories*.

1. According to the director, Joe Lambert, in an e-mail 12 December 2007 upon request.
2. I owe this observation to Tone Bratteteig.
3. Of course, the pattern is not always this clear-cut. For example, the Swedish media and cultural theorist Johan Fornäs had been applying both concepts in his writings (Fornäs, 1995, pp. 1, 210; 2000).

References

Altheide, D. L., & Snow, R. P. (1979). *Media logic*. Beverly Hills: Sage.

Asp, K. (1986). *Mäktiga massmedier. Studier i politisk opinionsbildning*. Stockholm: Akademilitteratur.

de Leeuw, S., & Rydin, I. (2007). Migrant children's digital stories. Identity formation and self-representation through media production. *European Journal of Cultural Studies, 10*(4), 447–464.

Fornäs, J. (1995). *Cultural theory and late modernity*. London: Sage.

———. (2000). The crucial in between. The centrality of mediation in cultural studies. *European Journal of Cultural Studies, 3*(1), 45–65.

Gauntlett, D. (2007). *Creative explorations. New approaches to identities and audiences*. London: Routledge.

Giddens, A. (1991). *Modernity and self-identity. Self and society in late Modern Age*. Cambridge: Polity Press.

Hartley, J., & McWilliam, K. (Eds.). (forthcoming). *Story circle. Digital storytelling around the world*. Oxford: Blackwell.

Hernes, G. (1977). Det media-vridde samfunn. *Samtiden, 86*(1), 1–14.

Hjarvard, S. (2004). From bricks to bytes: The mediatization of a global toy industry. In I. Bondebjerg & P. Golding (Eds.), *European culture and the media* (pp. 43–63). Bristol: Intel-

lect.

————. (2007). *Changing media—Changing language. The mediatization of society and the spread of English and Medialects.* Paper presented at the International Communication Association 57th Annual Conference. San Francisco, May 24–28.

————. (forthcoming 2008). Mediatization—An institutional approach. *Nordicom Review 29*(2).

Hull, G. A., & James, M. A. (2007). Geographies of hope. A study of urban landscapes, digital media, and children's representations of place. In P. O'Neill (Ed.) *Blurring boundaries. Developing writers, researchers, and teachers. A tribute to William L. Smith.* Cresskill, NJ: Hampton Press.

Hull, G. A., & Katz, M.-L. (2006). Crafting an agentive self: Case studies of digital storytelling. *Research in the Teaching of English, 41*(1), 43–81.

Hull, G. A., & Nelson, M. E. (2005). Locating the semiotic power of multimodality. *Written Communication, 22*(2), 224–261.

Klastrup, L. (2007). *Telling & sharing? Understanding mobile stories & the future of narratives.* Paper presented at the 7th International Digital Arts and Culture Conference 2007. Perth, September 15–18.

Kress, G. (2003). *Literacy in the new media age.* London: Routledge.

Kress, G., & van Leeuwen, T. (2001). *Multimodal discourse: The modes and media of contemporary communication.* London, New York: Arnold.

Lambert, J. (2006). *Digital storytelling. Capturing lives, creating community* (2nd ed.). Berkeley, CA: Digital Diner Press.

Lankshear, C., & Knobel, M. (2006). *New literacies. Everyday practices and classroom learning* (2nd ed.). Maidenhead: Open University Press.

Livingstone, S. (2008). Taking risky opportunities in youthful content creation: Teenagers' use of social networking sites for intimacy, privacy and self-expression. *New Media & Society, 10*(3), 459–477.

Lundby, K. (forthcoming). The matrices of digital storytelling: Examples from Scandinavia. In J. Hartley & K. McWilliam (Eds.), *Story circle. Digital storytelling around the world.* Oxford: Blackwell.

Lüders, M. (2007). *Being in mediated spaces. An enquiry into personal media practices.* Oslo: University of Oslo.

Martín-Barbero, J. (1993). *Communication, culture and hegemony: From the media to mediations.* London: Sage.

McClean, S. T. (2007). *Digital storytelling. The narrative power of visual effects in film.* Cambridge, MA: The MIT Press.

Meadows, D. (2003). Digital storytelling: Research-based practice in new media. *Visual Communication, 2*(2), 189–193.

Miller, C. H. (2004). *Digital storytelling: A creator's guide to interactive entertainment.* Oxford: Focal Press/Elsevier.

Ortutay, G. (1964). Principles of oral transmission in folk culture (Variations, Affinity). *Acta Ethnographica, VIII*(3–4), 175–221.

Scheidt, L. A. (2006). Adolescent diary weblogs and the unseen audience. In D. Buckingham & R. Wilett (Eds.), *Digital generations. Children, young people and new media* (pp. 193–210). London: Lawrence Erlbaum.

Schlesinger, P. (1993). Introduction. In J. Martín-Barbero (Ed.), *Communication, culture and hegemony. From the media to mediations* (pp.viii-xv). London: Sage.

Schulz, W. (2004). Reconstructing mediatization as an analytical concept. *European Journal of Communication, 19*(1), 87–101.

Silverstone, R. (1999). *Why study the media?* London: Sage.

———. (2005). The sociology of mediation and communication. In In C. Calhoun, C. Rojek & B. Turner (Eds.), *The Sage handbook of sociology* (pp. 188–207). London: Sage.

Thumim, N. (2007). *Mediating self-representations: Tensions surrounding 'ordinary' participation in public sector projects.* London: London School of Economics and Political Science, University of London.

———. (forthcoming). Tensions in the text: Exploring self-representations in Capture Wales and London's Voices. In J. Hartley & K. McWilliam (Eds.), *Story circle. Digital storytelling around the world.* Oxford: Blackwell.

Waite, C. K. (2003). *Mediation and the communication matrix.* New York: Peter Lang.

PART I

CONCEPTS
AND APPROACHES

Tales of mediation: Narrative and digital media as cultural tools

OLA ERSTAD AND JAMES V. WERTSCH

The power of expression is a basic element of human development. The way we express ourselves, through whatever medium available, is one of the key elements in how human beings have evolved since our ancestors started their quest for survival. Humans are now able not only to reinterpret the perception of their world but also to find out more about the tools they used and the impact these tools have (Wertsch, 1998; Säljö, 2005). Starting from paintings made on cave walls, humans represented 'their world', and in order to do that they had to 'invent' tools for painting and systems of meaning making for how things should be represented and the symbolic nature of such representations.

Building on the ideas of the French cultural psychologist Ignace Meyerson, Jerome Bruner discusses what he calls 'the externalization tenet' (1996, p. 22). This refers to the notion that the main function of collective cultural activity is to produce 'works'—or *oeuvres* in French. This can be larger systems like the arts and sciences of a culture, or smaller 'works' like a presentation of a project by a group of students in front of the rest of the class. Bruner shows how important such collective 'works' are for producing and sustaining group solidarity and how they can help *make* a community. At the same time they are

important in promoting a sense of the division of labour that goes into making a product (Bruner, 1996, p. 23).

This sets out our main arguments in this chapter, framed within what is termed as 'sociocultural studies of mind' (Wertsch, del Rio & Alvarez, 1995). We will not discuss digital storytelling or 'mediatized stories' per se but rather present an approach towards the concept of mediation and the use of cultural tools. Narratives are seen as cultural tools that we all relate to and use in our meaning-making activities (Bruner, 1996; Wertsch, 1998). As such, they change over time due to cultural and technological developments. Our approach is motivated by the genetic analysis made by Lev Vygotsky (1896–1934), with the assumption that it is possible to understand many aspects of mental functioning only if one understands their origin and the transitions they have undergone at different levels. The main question in this chapter is then how new digital media might transform the role narratives play in our lives.

This is basically about 'telling lives', that is, how people use different mediational means in their everyday life to express personal narratives and share these with others. There are several examples of how digital media might play a role in such practices. 'Telling Lives' refers to the BBC initiative on digital storytelling where people taking part in different workshops can post their digital stories (www.bbc.co.uk/tellinglives). 'Telling lives' is also the name of a project of the EU initiative eTwinning, where a school in Norway and a school in Finland have collaborated to create digital stories among the students about certain personal aspects of their own lives. The same title can also be found as part of museum blogs (tellinglivesblog.com) where people at certain events can present their stories through the 'Telling Stories' story-capture booth and upload them to the Internet. 'Telling Lives' for us represents the expressive element of storytelling defined by the new information and communication technologies, where people tell stories about their personal lives and share these with others.

We will combine conceptual discussions with examples and reflections on the importance of mediation and narratives as cultural tools in our society. We start with some key aspects of a socio-cultural approach to the mind before we go on to the concept of mediation.

Culture, communication and cognition

What we call a socio-cultural approach is related to the ideas of many authors from a variety of disciplines. Figures such as Dewey (1938) and Kress (1985)

are relevant, for example. Even though these authors highlight the impact of the social on the personal we will differ in the way we relate our discussion to a specific approach on learning and human development originally outlined by the Russian psychologist Lev Vygotsky. Today a socio-cultural approach includes several different perspectives and 'schools of thought'. Our ambition here is not to present the different dimensions of this approach but rather to highlight certain key elements that we believe are important in our studies of 'mediatized stories'.

The main objective of such a socio-cultural approach to the mind is to explicate the relationships between human mental functioning, on the one hand, and the cultural, institutional, and historical situations in which this functioning occurs, on the other (Wertsch et al., 1995, p. 3). So the central task is to understand how individual functioning is shaped by and related to the socio-cultural setting within which it exists.

The renewed interest in such issues, and the reinterpretation of the texts of Vygotsky in the 1970s, especially in American discussions, can be seen as a strong movement away from methodological individualism. In our discussion it is therefore important to argue against an understanding that stories are unique to the individual and rather move towards the social origins of individual mental functioning and collective dimensions of storytelling, learning and meaning making. These arguments against a strong individual reductionist tendency are important for our approach towards mediation.

In summing up the main characteristics of what he calls 'a cultural psychology', Michael Cole (1996, p. 104) mentions the following points:

- It emphasises mediated action in a context.
- It insists on the importance of the 'genetic method' understood broadly to include historical, ontogenetic, and microgenetic levels of analysis.
- It seeks to ground its analysis in everyday life events.
- It assumes that the mind emerges in the joint mediated activity of people. Mind, then, is in an important sense, 'co-constructed' and distributed.
- It assumes that individuals are active agents in their own development but do not act in settings entirely of their own choosing.
- It rejects cause-effect, stimulus-response, explanatory science in favour of a science that emphasises the emergent nature of the mind in activity and that acknowledges a central role for interpretation in its explanatory framework.
- It draws upon methodologies from the humanities as well as from the social and biological sciences.

What these points show us is the complexity embedded in studying human psychological and communicative activities. Such a socio-cultural approach emphasises that human action is mediated through the semiotic means available in the culture (Mertz & Parmentier, 1985). In this perspective, cultural tools are situated, historically, culturally and institutionally. The focus is on human action and not on behaviour as 'mechanistic materialism' (Taylor, 1985).

Human action is closely linked to communication processes and the use of cultural tools, both material and abstract, for example, language, for meaning making by individuals and groups. It is not communication seen in a linear fashion as something transmitted from a sender through a channel to a receiver. As we shall see below it is more in line with a semiotic tradition of meaning making by using signs, situated within cultural settings and building on historical developments.

In Vygotsky's writings there is a recognition of a complex relationship between history as change and history as universal human progress (Wertsch et al., 1995). This is seen in his account of the particular aspect of history that was of most interest to him, that is, 'the symbolic-communicative spheres of activity in which humans collectively produce new means for regulating their behavior' (Scribner, 1985, p. 123).

As Wertsch (1998) has argued, the natural unit of analysis in this approach will be 'mediated action', or 'agent-acting-with-mediational-means', in order to highlight the focus on the agent–instrument relationship. In his book *Mind as Action* Wertsch outlines certain properties of mediated action (1998, p. 25):

1. mediated action is characterised by an irreducible tension between agent and mediational means,
2. mediational means are material,
3. mediated action typically has multiple simultaneous goals,
4. mediated action is situated on one or more developmental paths,
5. mediational means constrain as well as enable action,
6. new mediational means transform mediated action,
7. the relationship of agents towards mediational means can be characterised in terms of mastery,
8. the relationship of agents towards mediational means can be characterised in terms of appropriation,
9. mediational means are often produced for reasons other than to facilitate mediated action,
10. mediational means are associated with power and authority.

Mediated action as an analytic approach to the study of mind is thereby

seen both on the microgenetic level of agents and instruments, and on broader issues of socio-cultural history and issues of cultural struggle as in power relationships. Even though our main interest in this chapter is on the tension between agent and mediational means, other aspects of mediated action as part of mediatized stories will be discussed.

When studying digital storytelling we have to take these broader perspectives on culture, communication and cognition into consideration as a way of connecting inter- and intra-personal processes. The important point here is that storytelling is not something 'invented' by the individual, but renegotiated in a cultural process in which we all participate. People may believe that they have a totally unique story, one that nobody has ever had before. This can be seen as an autobiographical obsession in our western culture through a long tradition of written texts but also in cultural expressions in general, through art, science and so forth (Taylor, 1989). From our point of view this is not an individual endeavour but rather built into general cultural and historic processes where we reuse and further develop stories through mediational means, thereby ensuring layers of 'multivoicedness' of being (Bakhtin, 1981).

Semiotic mediation, cultural tools and transformation

In a general sense the term 'mediation' can be associated with the objectification of symbolic meaning in time and space as part of socio-historic development. However, one needs to specify this concept according to particular objects, social groups, historical periods, and so forth (Rasmussen, 2000). Since Hegel, the term has incorporated more specified meanings through the insertion of *Vermittlung* (the German term for mediation), and which is built into different perspectives on the role of media in our society. Raymond Williams (1976, p. 205) distinguishes three aspects of mediation: (a) finding a central point between two opposites, as in political negotiations; (b) describing the interaction between two opposed concepts or forces with the totality to which they are assumed to belong; and (c) describing such interaction as in itself substantial, with forms of its own, so that it is not the neutral process of the interaction of separate forms, but an active process in which the form of the mediation alters the things mediated, or by its nature indicates their nature. (See also Rasmussen, 2000.) The last aspect provides a point of departure in our exploration of mediation linked to mediatized stories.

In Vygotsky's writings the construct of mediation, especially semiotic me-

diation, played a central role, becoming increasingly important during the last years of his life and career (Wertsch, 1985, p. 50; Wertsch et al., 1995, p. 20). A year before his death he wrote that 'the central fact about our psychology is the fact of mediation' (Vygotsky, 1982, p. 166). He provided an outline of how mental functioning is situated in a cultural space. Vygotsky extended Engels's notion of instrumental mediation by applying it to 'psychological tools' as well as to the 'technical tools' of production (Wertsch, 1985, p. 77). He invoked the analogy between psychological tools, or what he termed 'signs', and technical tools, or simply 'tools', at several places in his writing. Language, which was Vygotsky's main interest, can then be seen as a cultural tool and speech as a form of mediated action.

Vygotsky was, however, not alone in pointing out the role of different cultural tools and mediation in human functioning. Similar ideas can be seen among contemporaries of his such as Bakhtin, Leontev, Lotman and also going back to Engels and Dewey. The common point is how new forms of mediation always transform human action. Central issues for all these thinkers are on the role of text in cultural settings, about action in the sense of interpersonal activities and human development. During the last twenty-five years there has been a renewed interest especially in the theoretical thinking of Vygotsky but also drawing on Leontev about activity theory and Bakhtin on the role of 'utterance' and 'voice'. Our approach builds on all three thinkers, even though we will mainly refer to Vygotsky since our main arguments are close to his theoretical propositions.

Vygotsky touched on two forms of mediation. The first is 'explicit mediation', which relates to the overt, intentional introduction of a 'stimulus means' into the flow of action. It relates to the materiality of mediational means. The second is 'implicit mediation', which provided the foundation of Vygotsky's account of egocentric and inner speech. This perspective focuses on how some signs are transparent and largely inaccessible to conscious reflection.

There are two important properties of psychological tools that need to be taken into consideration (Wertsch, 1985, pp. 79–80). The first is that by being included in the process of behaviour, a psychological tool alters the entire flow and structure of mental functions. There are different sets of tools and different forms of thinking that go with them. Vygotsky viewed the introduction of a psychological tool (for example, language) into a mental function (such as memory) as causing a qualitative transformation of that function. In his approach psychological tools are not viewed as auxiliary means that simply facilitate an existing mental function while leaving it qualitatively unaltered. Rather, the emphasis is on their capacity to transform mental functioning. Vygotsky

did not view development as a steady stream of quantitative increments but in terms of fundamental qualitative transformations associated with changes in the psychological tools.

The second major property of mediation in his account is that by their nature psychological tools are social, not organic or individual. The mediational means, or cultural tools, are inherently situated culturally, institutionally and historically. There are two aspects in which Vygotsky considered psychological tools to be social. First, he considered psychological tools such as language, various systems for counting, mnemonic techniques, algebraic symbol systems, and so forth to be social in the sense that they are the products of socio-cultural evolution. Individuals have access to psychological tools by virtue of being part of a socio-cultural milieu. The cultural knowledge of our society is in a developmental sense built into our tools. The second aspect concerns the more 'localized' social phenomena of face-to-face communication and social interaction. Instead of examining forces that operate on a general socio-cultural level, the focus here was on the dynamics that characterise individual communicative events. Vygotsky said of language, the most important psychological tool in his approach, that 'the primary function of speech, both for the adult and for the child, is the function of communication, social contact, influencing surrounding individuals' (Wertsch, 1985, p. 81).

Another point about mediation is that it involves constraints as well as empowerment (Wertsch et al., 1995, pp. 24–25). Any form of mediation involves some form of limitation. It frees us from some earlier limitations while at the same time introducing new ones of its own. Our emphasis, of course, is often on the new possibilities that new mediational means represent for empowerment and new actions. However, we need to keep a focus on the limitations at the same time, on how tools shape our action in an inherently limiting way.

The important point here, and again, a point that is often missed in sociological and psychological studies, is that when a new tool, a new medium, is introduced into the flow of action, it does not simply facilitate or make an existing form of action more efficient. The emphasis is on how it transforms the form of action, on the qualitative transformative, as opposed to facilitative, role of cultural tools.

So when we move from memorising long stretches of poetry to just saying it is good enough to read them out of a textbook with feeling or find them on the Internet, using such external symbolic storage, there is more than just a change in the efficiency in a mode of action and the mental processes that go with it. Such a change imposes search strategies, new storage strategies, new memory access routes, new options in both the control of and analysis of one's own thinking, all of which represents a qualitative transformation in mediated

action. We now turn to one such issue, the role of narratives and mediatized stories in our culture.

Narratives as 'equipment for living'

Narratives in our culture can be described as powerful cultural tools. They give us a structured way of accessing knowledge in a culture and a way of expressing intentions and how we relate to others. These properties reflect broader claims about artefacts outlined by Hutchins:

> What we learn and what we know, and what our culture knows for us in the form of the structure of artefacts and social organisations are these hunks of mediating structure. Thinking consists of bringing these structures into co-ordination with each other such that they can shape (and be shaped by) each other. The thinker in this world is a very special medium that can provide co-ordination among many structured media, some internal, some external, some embodied in artefacts, some in ideas, and some in social relationships. (1986, p. 57)

There are several traditions of examining the role of narratives in our culture (e.g., Mitchell, 1981). Our interest is related to how narratives function as cultural tools and influence human functioning. Both Wertsch (1998) and Bruner (1990, 1996) analyse narrative and historical texts as cultural tools. Bruner highlights the role of narratives in human functioning as part of his fundamental critique of the 'computational view', which is concerned with information processing. The 'computational view' is fundamental to our whole education system and the dominating perspective on learning on which it is based. In its place, or at least as complement, Bruner argues for what he calls 'culturalism'.

> For the evolution of the hominid mind is linked to the development of a way of life where 'reality' is represented by a symbolism shared by members of a cultural community in which a technical-social way of life is both organized and construed in terms of that symbolism. This symbolic mode is not only shared by a community, but conserved, elaborated, and passed on to succeeding generations who, by virtue of this transmission, continue to maintain the culture's identity and way of life. . . . On this view, knowing and communicating are in their nature highly interdependent, indeed virtually inseparable. (1996, p. 3)

In his elaborations on this, Bruner defines narrative as a central mode of human thought and as a vehicle of meaning making. Storytelling and narrative are viewed as the way people in general create a version of the world in which

they can envisage a place for themselves, a personal world. (1996, p. 39). Bruner distinguishes between logical-scientific thinking, which is more specialised for treating physical 'things', and narrative thinking, for treating people and their plights.

With reference to Kenneth Burke (1966) we might view narratives as 'equipment for living'. The way narratives are structured as plots with characters makes a transition from the fictional to the real world. Literature, for example, can be seen as equipment for interpreting and categorising human action. Burke (1966) claims that literature (discourse) equips individuals with attitudes for dealing with recurring situations. This can also be related to other mediated texts, as stated by Cole and Keyssar;

> For the richness of our lives depends not only on how much equipment we carry with us, but how we use that equipment and in what context it is relevant. The chisel in the hands of a sculptor is different than the chisel in the hands of a bricklayer, but it is not clear that one uses the tool better than the other. The first step, and one that continues to meet with resistance, is to recognize and work with films such as 'Romeo and Juliet' and 'Nashville', as well as printed books, as equipments for living. This is not to reduce meaning to usefulness, but to enlarge our concept of 'meaning' and 'usefulness'. (1985, p. 69)

Narratives, seen as a cultural tool, are part of our living, bridging past, present and future (Wertsch, 1998). They are tools in cultural settings that pre-exist any group or individual use. These tools, especially in the case of narrative forms, are not a product of independent invention, and they influence us in different ways and become part of the repertoire of means we use in our everyday lives, our 'telling lives'. When we talk about human action, narratives are used as a basis for 'seeing' events, a way of understanding characters in our environment. In this way they become very important equipment for the formation of the collective and individual identity. This can be seen in studies on such phenomena as national narratives and collective memory (Wertsch, 1998).

When discussing narratives as cultural tools, it is important to distinguish between two basic narrative levels. On the one hand, we have 'specific narratives', which deal with concrete places, characters, events. This is the usual sense of 'narrative'. They can be fictional or real, but they involve specific characters, places and events. On the other hand, we have 'schematic narrative templates' which are more transparent, having the capacity to shape thinking and speaking in ways that are hard to identify or reflect upon. A schematic narrative template is schematic in the sense that it is generalised, abstract, without specifics on actors, times and places. It is narrative because it has an emplotted form, one that is especially transparent in the sense that like a clear window it

is something through which one views the world without realising it is there. It appears as if you are looking onto reality directly. Part of its power to shape thinking and speaking comes from the fact that it is hard to see and appreciate the fact that we are using it as cultural tool. And a schematic narrative template is a template in that there is one story line that helps us make sense of many specific episodes, the same story over and over with different characters, making the basis for collective memory, collective narratives and national narratives. Schematic narrative templates tend to be extremely conservative and resistant to change, both because of their transparency and because they are tied to our identity.

As part and parcel of particular socio-cultural settings, schematic narrative templates in various contexts differ from one another. They are not universal. What it means to be Norwegian, American, French and so forth is shaped in part by the use of certain schematic narrative templates. How we conceive ourselves as either Norwegian or American depends to a large extent on certain narratives that shape national identity. As a Norwegian this is connected to narratives for example about 'winter and skiing', 'the importance of being in nature', 'upholding peace and democracy'. As an American it may be tied more to issues like 'equal possibilities', 'cultural melting pot' and 'superpower'. Such issues can be seen at play in Samuel Huntington's book *Who Are We? The Challenges to America's National Identity* (2004), where he argues for an agenda of conserving and preserving established notions of American national identity. In his view these notions are threatened by immigration in the United States today. Our point here is that mediatized stories can involve both specific narratives and schematic narrative templates, with the power of the latter often harder to detect and more resistant to change.

Our interest is in the transformative role of cultural tools and how for example the introduction of digital technologies can change the fundamental form of certain actions such as narratives about a national past. This can, for example, be seen in moving from a culture based on techniques of memorisation, to a culture developing new ways of storage and use of texts, and towards new symbolic systems and increasing availability of information as seen in the use of the Internet that might have a major impact on such processes.

An interesting question that arises in this connection is how such narratives are more likely to be contested today in the light of new information and communication technologies. What is ongoing and what is resistant to change versus what may be new and transformative? National identity for example might be more open to being influenced by other schematic narrative templates than before, as young people use a broader set of narratives in their identity work. New technological platforms for communication can also be

used to debate the construction of narratives to a greater degree than before the emergence of the newest forms of Information and Communication Technology (ICT).

One example can be taken from the former Soviet republic of Georgia, where online forums play an important role in dealing with issues of collective identity.[1] Chat rooms in Georgia are in many respects similar to chat rooms in other countries. They are occupied by young people, and rarely visited by adults. The topics covered are typically a function of interests, age and gender. However, online forums that have developed in Georgia (www.forum.ge), a country that has gone through major social transitions after having been part of the Soviet Union, often take the form of sites of serious discussion on cultural and political issues. In these forums there are participants of all ages, and different topics are covered. What is particularly interesting is how these forums are used to discuss transitions in national identity and highlight differences between different groups of the population and areas of the country.

In this context it is possible to see examples of Georgians who have been expelled from the breakaway region of Abkhazia talking about their past and future, recalling their childhood and sharing their views, and also finding old classmates and neighbours. Such forums can serve as a shared space where different narratives about national identity and past events become apparent, for example about whether it was Russians, Abkhazians or Georgians who started the armed conflict in Abkhazia in the early 1990s that resulted in ethnic Georgians being expelled. One example is the following posting in the forum that shows the strong narrative divisions made between us (Georgians who had formerly lived in Abkhazia) and them (Georgians from other regions of the country).

> To those of you posting on this topic: you all are from Tbilisi, and none of you is Sukhumian, and you know NOTHING about what happened there! I lived there! Already in Soviet times, every Abkhazian hated Georgians. 'When will we get rid of you?!,' they said. If you (a Georgian) entered a shop and found an Abkhaz vendor working in it, then you would be in trouble. They would make you stand at the end of the queue and wait until all the Abkhaz who were in the shop at the time had bought everything they wanted. Up to that point the vendor would not pay any attention to you, just because you were a Georgian. There were cases when they would even close the shop right in front of you as you tried to enter. YES! They HATED Georgians!

Such mediational means reflect certain narrative constraints. This writer saw a non-negotiable gulf between his own and others' accounts. There are several similar instances of how narratives 'grasp together' events and characters in qualitatively different ways. Such frozen narratives can be seen in many conflicts such as those between Armenians and Azeris, Israelis and Palestinians,

and Koreans and Japanese.

As cultural tools, narratives can be used to represent both the past and the present. And when we look at how people around the world use digital media to tell stories we see how this creates both support for schematic narrative templates and for counter-narratives. Some of the usual mechanisms of regulating and negotiating between narrative accounts are no longer readily available. Everybody can post their interpretation and reformulations of events without having to encounter and negotiate with others in ways that earlier had shaped such encounters. Everybody believes that he or she has a story to tell, and digital technologies create new possibilities for this, which brings us to the next section.

New performance spaces

The emergence of new media and technologies in our society has brought new conditions for mediated action and narratives as cultural tools. In recent years we might describe this as a transition from mass media towards more 'personal media'. All media are of course personal in the sense that they are mediational means for meaning making. However, the new possibilities of user generated content production represented by web 2.0 make the personal voice more apparent. Information and communication technologies can be used for producing and consuming narratives in a whole new way by people around the world, as seen on Internet sites like 'MySpace' and 'YouTube'. By using terms like my(space), you(tube) or face(book) we see combinations of the personal expression and the mediational means used in an integrated way.

There are indeed critical points to be made about the autobiographical obsession in the participation culture (Jenkins, 2006) of these new sites. The large number of videos and texts is formidable, and this raises concerns about who will be heard or read. Many postings on these sites are not viewed by others at all. However, our interest is not so much on these new social networking sites, but rather on some other mediated actions made possible by new digital media and the Internet.

With reference to Goffman (1959), we can talk about new 'performance spaces', especially for young people. They use these online sites to express personal opinions, views and comments either through videos taped at home, written text or other means that are uploaded to shared spaces on the Internet. This implies a space where we are part of the cultural flow of using different narratives and where we talk about ourselves. Performance is part of the expressive nature of human functioning mentioned at the beginning of this

chapter, and it takes place in different spaces of society, using a range of different tools, as, for example, seen in new virtual environments (Laurel, 1993; Turkle, 1995, 2007).

Mediatized stories are in this sense seen as global phenomena of shared narratives where our conception of mediation assumes a central perspective in understanding what these narratives represent. This can be linked to what Juri Lotman termed the semiosphere, as a continuing world of communication as a system like the ecological system or biosphere (Lotman, 1990).

One example is the blogging culture that started to develop at the end of the 1990s and which has now moved into new versions on different 'social networking sites'. However, we can still see examples of how these new performance spaces such as blogs play an important role as mediational means and narratives as cultural tools. In an online article by Masserat Amir-Ebrahimi (2004)[2], based on her research, she describes how blogs in Tehran represent an important performance space for certain groups in their redefinition of the self and consolidation of new identities. She discusses how, in Western democratic societies, cyberspace is often viewed as an 'alter' space of information, research and leisure that functions in a parallel or complementary fashion to existing public spaces and institutions. In countries where public spaces are controlled by traditional or restrictive cultural forces, however, the Internet can take on varied significance. In Iran, where the public sphere is closely monitored and regulated by traditional and state forces, the Internet has become a means to resist the restrictions imposed on these spaces. As she explains, for people living in these countries, especially marginalised groups such as youth and women, the Internet can be a space more 'real' than everyday life. From this perspective, an analysis of Internet use is an important tool by which to study socio-cultural forms hidden in everyday life but revealed in the virtual world.

She goes on to explain how, since the revolution in Iran in 1979, 'multiple personalities' have become second nature to their society. To maintain their security in social spaces, individuals must obey assorted codes that are particular to each space (private, public, official, etc.) or vis-à-vis their counterparts (women/men, youth/elders, children/parents, students/instructors, ordinary individuals/morality enforcers). The dissimulation and social invisibility in terms of appearances and behaviours are constantly shifting according to variables such as place, time and spectators, and they are defined according to the status, gender and age of social actors. For many women and youths, for example, particular urban districts and hours of the day demand concomitant performances.

The arrival of the Unicode system in the digital world has made the entry of young middle-class Iranians in cyberspace much easier. Specifically, the

introduction of the Persian font and the possibility of typing in Persian have made possible an indigenous approach to the Internet. Weblogs have since become an alternative space to discuss matters censored in ordinary public spaces, but in this alternative medium this is done more through text than talk. Weblogs, through their 'comments' section, allow an open and wide discussion between different social actors on an unprecedented scale. In this sense, weblogs have become realms and spaces where all kinds of discussion and interaction between readers and writers can take place. The continual availability of and access to past written records and archives give youth greater self-awareness and self-development. More than any other generation, they have the ability to review and consider their past and their relations with others. In addition, weblog archives provide others with the ability to judge and comment on their track records. The existence of such archives forces bloggers to think more about what they write and accept responsibility for it.

Weblogs, as Amir-Ebrahimi explains, have become a key site for Iranians to participate in the new virtual world and at the same time rediscover their own selves and desires while constructing new relations and communities often not possible in real spaces. Weblogs also reveal important trends, desires and transformations in the subjectivities of Iran's next generation as well as an ongoing struggle between youth and traditional and state authorities over the limits placed on public discourse.

For youth, this empowerment begins with a redefinition of the self and consolidation of new identities. Many of them believe that their 'real/true' identities have been 'lost/repressed/ hidden' in the real/physical public spaces of Iran. Amir-Ebrahimi argues that the act of weblog writing in the universal, yet also semi-private space of the Internet, can help youth discover, reconstruct and crystallise their 'true' selves in virtual public spaces. In the absence of the body, these new 'bodyless-selves' enter a new world and form new communities which are restricted and controlled in their real physical spaces. At the same time, Amir-Ebrahimi refers to studies which found that some of these new identities can encounter new sources of limitation, self-censorship and disempowerment in the virtual, as well as real, spaces.

The lack of freedom in real public spaces has rendered virtual spaces an important site for new encounters, the formation of communities, finding friends (especially of the opposite sex) and, finally, the possibility of redefining the self according to one's own narrative. Thus, virtual space in Iran is a space for shaping repressed identities in all their simple and complicated forms. Through the continuous practice of writing, individuals can assert layers of their personality that they were hitherto unable to assert in real life.

Through text and personal history, individuals can gradually create a narra-

tive of the self in virtual space that may be entirely new. Through this narrative, individuals undergo a process of identity-formation which the virtual world makes increasingly possible. In transient interactions such as chat rooms, these identities can be temporary and unstable. In weblogs, however, identities are gradually formed, crystallised and transformed into secondary identities for webloggers. To maintain this consistency and coherence of character, the blogger is obliged to abide by a more vigorous discipline of thought and articulation than is often required in real spaces. The individual acquires a new 'constructed' virtual identity that can be measured and judged by others.

Similar expressions can be seen when Sherry Turkle (1995) quotes a conversation with a woman who has made a date with a man she has been chatting with for several months. The woman is anxious because she feels a schism between her virtual and real identities:

> I didn't exactly lie to him about anything specific, but I feel very different online. I am a lot more outgoing, less inhibited. I would say I feel more like myself. But that's a contradiction. I feel more like who I wish I was. I'm just hoping that face to face I can find a way to spend some time being the online me. (1995, p. 179)

In spite of the increased feelings of freedom in cyberspace, Amir-Ebrahimi discusses how both female and male webloggers practice self-censorship. Yet, their censorship of the 'self' is different in cyberspace in the sense that the individual decides the limits. In this regard, the subjectivity of the 'self' among bloggers is one of the most important characteristics of this medium.

Other interesting examples of new performance spaces and mediatized stories stem from developments in online gaming communities and virtual environments (Renninger & Shumar, 2002; Gee, 2003). They are interesting because they show how these cultural tools create new conditions for storytelling and narratives. This can be seen in virtual communities like 'Second Life' (http://secondlife.com/) as an indication of recent developments in spaces online. This is sort of a 'parallel world' to our real and physical environment, where people buy land, build houses, make friends, get jobs, seek entertainment, and other things that people usually do in a physical environment. However, in this virtual space people create 'avatars' as representations of themselves through which they interact with other virtual characters.

The question is then how mediated action in such virtual environments influences people's conduct and interaction. From our perspective it is clear that such environments create new narrative structures and that digital storytelling becomes a central form of mediated communication in such worlds. New narratives might appear that build on familiar narratives, but ones that are transformed into something new due to the new environments and ways

of interacting with 'unknown' people. Such new cultural tools create different conditions for activities and people's conceptions.

Similar tendencies can be seen in multiplayer online games, where narrative structures are already provided, but where participants still create new storylines by collaborating, creating avatars and communicating through audio and written text. This can also be brought into simulations of real issues, like *Global conflicts: Palestine* (http://www.globalconflicts.eu/). In this online game, individuals enter an ongoing conflict in the real world as a journalist, where they meet and interact with different characters and hear their stories. Their task is to create a new digital story in the form of a newspaper article, where they can use available headlines, photos and quotes to build the article. In this way they both relate to different stories and create and express their own story.

These examples show the complex nature of how new technologies create new performance spaces where young people in particular take advantage of these new mediational means to engage themselves in digital storytelling.

Conclusion: Creating spaces for mediated action

The socio-cultural approach to mediation we have outlined is grounded in a few basic assumptions. The most important is the relationship between human mental functioning and the cultural, institutional and historical situations in which this functioning occurs. Our discussion of mediation is understood as 'agent-acting-with-mediational-means'. The important point made here is that the 'cultural tools' that we use for meaning making change over time. The main argument in this chapter concerns the nature of transformations embedded in the development of cultural tools and how they then fundamentally change mediated action. Something new appears as we start to use new tools. Another argument made in this chapter relates to the role of narratives in our culture. We have distinguished between two basic narrative levels. On one level we find 'specific narratives', which is how we usually understand narratives as consisting of a storyline, characters, events and so forth. On another level we can find 'schematic narrative templates', which are very much part of how we use narratives in our culture, but which are harder to identify and which are resistant to change. The latter kinds of narratives have the capacity to shape our thinking. We believe both narrative structures are important in analysing mediatized stories and digital storytelling.

The implications of these arguments are then related to the terminology of 'performance spaces'. We see this as an important way of grasping mediated action as the relationship between agent and tool in cultural and contextual settings. The interesting issue we have highlighted in the latter part of this chapter is the implications of new digital technologies for creating new performance spaces. We have just taken a few examples of much broader cultural processes of transformation due to technological developments. This is not interpreted in a technological deterministic or individual reductionist way but rather seen as a complex interrelationship between agent and tool. New digital technologies give us certain affordances (Gibson, 1979) that we might take advantage of in different ways.

In this way digital storytelling for us represents developments in the way humans relate to each other and their surroundings. They represent new performance spaces and possibilities for mediated action. Our challenge is then to grasp how these new cultural tools change the use of narratives and the act of storytelling in fundamental ways.

Notes

1. The information for this illustration was provided in a study conducted by Levan Karumidze in Tbilisi, Georgia. The interpretation, including any possible misinterpretation, however, is that of the co-authors of this article.
2. Masserat Amir-Ebrahimi is an urban sociologist and geographer who has worked extensively on Tehran, particularly on the southern parts of the city. Since 2001, she has been serving as the executive and scientific coordinator of the Atlas of Tehran Metropolis, a collaborative project between Le monde iranien of the CNRS (National Center for Scientific Research) and the Tehran Geographical Information Center (TGIC). Currently she is conducting research on new public spheres and the impact of cyberspace on the daily lives of women and youth in Tehran. The research project, 'Authority and Public Spaces in Iran', was assisted by an International Collaborative Research Grant from the Social Science Research Council's Program on the Middle East & North Africa. Data from this study were obtained through regular consultation of weblogs, different focus groups and personal interviews with webloggers.

References

Amir-Ebrahimi, M. (2004). *Performance in everyday life and the rediscovery of the 'self' in Iranian weblogs.* Bad Jens—Iranian Feminist Newsletter. Retrieved 3. September from www.badjens.com/rediscovery.html

Bakhtin, M. (1981). *The dialogic imagination: four essays by M.M. Bakhtin* (M. Holquist, Ed., C.

Emerson & M. Holquist, Trans.). Austin: University of Texas Press.

Bruner, J. (1990). *Acts of meaning*. Cambridge, MA: Harvard University Press.

———. (1996). *The culture of education*. Cambridge, MA: Harvard University Press.

Burke, K. (1966). *Language as symbolic action: Essays on life, literature, and method*. Berkeley: University of California Press.

Cole, M. (1996). *Cultural psychology. A once and future discipline*. Cambridge, MA: Harvard University Press.

Cole, M. & Keyssar, H. (1985). The concept of literacy in print and film. In D. R. Olson, N. Torrance, & A. Hildyard (Eds.). *Literacy, language and learning. The nature and consequences of reading and writing*, pp. 50–72. New York: Cambridge University Press.

Dewey, J. (1938). *Logic: The theory of inquiry*. New York: Holt, Rinehart & Winston.

Gee, J. P. (2003). *What video games have to teach us about learning and literacy*. New York: Palgrave Macmillan.

Gibson, J. (1979/1986). *The ecological approach to visual perception*. Hillsdale, NJ: Lawrence Erlbaum Associates.

Goffman, E. (1959). *The presentation of self in everyday life*. New York: Doubleday.

Huntington, S. (2004). *Who are we? The challenges to America's national identity*. New York: Simon & Schuster Paperbacks.

Hutchins, E. (1986). Mediation and automatization, *Quarterly Newsletter of the Laboratory of Comparative Human Cognition*, April, *8*(2), 47–58.

Jenkins, H. (2006). *Convergence culture. Where old and new media collide*. New York: New York University Press.

Kress, G. (1985). *Linguistic processes in sociocultural practice*. London: Oxford University Press.

Laurel, B. (1993). *Computers as theatre*. Reading, MA.: Addison-Wesley.

Lotman, J. (1990). *Universe of the mind: A semiotic theory of culture*. London: I. B. Tauris & Co Ltd.

Mertz, E. & Parmentier, R. J. (1985). *Semiotic mediation. Sociocultural and psychological perspectives*. Orlando: Academic Press.

Mitchell, W. J. T. (1981). *On narrative*. Chicago: The University of Chicago Press.

Rasmussen, T. (2000). *Social theory and communication technology*. Aldershot: Ashgate.

Renninger, K. A. & Shumar, W. (Eds.). (2002). *Building virtual communities. Learning and change in cyberspace*. Cambridge: Cambridge University Press.

Scribner, S. (1985). Vygotsky's uses of history. In J. V. Wertsch (Ed.), *Culture, communication, and cognition: Vygotskian perspectives*, pp. 119–145. Cambridge: Cambridge University Press

Säljö, R. (2005). *Lärande & kulturella redskap—Om lärprocesser och det kollektiva minnet* (Learning and cultural tools—On learning processes and collective memory). Stockholm: Norstedt Akademiska Förlag.

Taylor, C. (1985). *Human agency and language. Philosophical papers 1*. Cambridge: Cambridge University Press.

———. (1989). *Sources of the self. The making of the modern identity*. Cambridge: Cambridge University Press.

Turkle, S. (1995). *Life on the screen: Identity in the age of the Internet*. New York: Simon and Schuster.

Turkle, S. (Ed.) (2007). *Evocative objects: Things we think with*. Cambridge, MA: MIT Press.

Vygotsky, L. S. (1982). Sobranie sochinenii. Tom pervyi: Problemy teorii istorii psikhologii (Collected works: Vol. 1, Problems in the theory and history of general psychology). Moscow:

Izdatel'stvo Pedagogika.

Wertsch, J. (1985). *Vygotsky and the social formation of mind.* Cambridge, MA: Harvard University Press.

———. (1998). *Mind as action.* New York: Oxford University Press.

Wertsch, J., del Rio, P. & Alvarez, A. (1995). Sociocultural studies: history, action, and mediation. In J. Wertsch, P. del Rio & A. Alvarez (Eds.), *Sociocultural studies of mind.* pp. 1–34. Cambridge, MA: Harvard University Press.

Williams, R. (1976). *Keywords. A vocabulary of culture and society.* London: Fontana Press.

THREE

Digital storytelling, media research and democracy
Conceptual choices and alternative futures

NICK COULDRY

Introduction

Digital storytelling represents a novel distribution of a scarce resource—the ability to represent the world around us—using a shared infrastructure. As such, this distinct form of the digital media age suggests a new stage in the history of mass communication, or perhaps in the supersession of mass communication; it therefore has implications for the sustaining, or expansion, of democracy but only under complex conditions, yet to be fully identified. This chapter seeks to clarify what those conditions are or, if that is still premature, at least to clarify what questions need to be answered if digital storytelling's social consequences and democratic potential are to be understood, not merely hyped.[1]

Understanding digital storytelling as a broad social phenomenon involves moving beyond such storytelling's status merely as texts or processes of production/distribution to consider broader 'effects'. I will focus on just two ways of thinking about those effects: the concept of 'mediation' (Martín-Barbero,1993;

Silverstone,1999; Couldry, 2000) and the concept of 'mediatization' (Mazzoleni & Schulz, 1999; Hjarvard, 2004; Schulz, 2004). Digital storytelling, because of its complexity as narrative and social process, provides a good opportunity to clarify the respective advantages and disadvantages of these concepts in the course of developing our necessarily still speculative understanding of the social life of digital storytelling itself. By 'digital storytelling' I will mean the whole range of personal stories now being told in potentially public form using digital media resources.

My argument at its broadest is that theories of mediatization, because they look for an essentially linear transformation from 'pre-media' (before the intervention of specific media) to 'mediatized' social states, may be less useful for grasping the dynamics of digital storytelling than other approaches which I identify with the uses of the term 'mediation' mentioned earlier.[2] The latter approaches emphasise the *heterogeneity* of the transformations to which media give rise across a complex and divided social space rather than a single 'media logic' that is simultaneously transforming the whole of social space at once. At stake here is not so much the liberatory potential of digital storytelling (although I want to clarify that too), but the precision with which we understand media's complex social consequences. We should not expect a single unitary answer to the question of how media transform the social, since media themselves are always at least doubly articulated, as both transmission technology and representational content (Silverstone, 1994) in contexts of lived practice and situated struggle that themselves are open to multiple interpretations or indeed to being ignored. While its attentiveness to the nonlinear will be my main reason for choosing 'mediation' as a concept for grasping 'digital storytelling', I will not be claiming that mediation is always a more useful term than 'mediatization'. They are different concepts with different valences. At most I will be claiming that, in spite of its apparent vagueness, 'mediation' has a multivalence which usefully supplements accounts of the 'mediatization' of the social.

I will begin by clarifying the differences between the terms 'mediatization' and 'mediation' before contrasting how each would analyse digital storytelling's social consequences. Then I will seek to reinforce my argument for the continued importance of the term 'mediation' by reviewing the claims for the 'community' dimension of digital storytelling that cannot be assessed through the concept of mediatization alone. I will end with some reflections on how the likely obstacles to the social role of digital storytelling might be overcome.

Conceptual background

My argument proceeds by contrasting two wide-range concepts for grasping the social transformations actually and potentially linked to digital storytelling. Let me acknowledge immediately some arbitrariness here at the level of pure terminology, since some writers (Altheide, 1985; Gumpert & Cathcart, 1990) have used the term 'mediation' to characterise precisely the transformation of societies through a linear media logic that more recently has been termed 'mediatization'.[3] That does not, however, affect the conceptual contrast I am making.

Mediatization

Let me start from the term 'mediatization', whose profile in media theory has grown considerably in recent years.

Mediatization, as developed by Stig Hjarvard and others (Hjarvard, 2004), is a useful attempt to *concentrate* our focus on a particular transformative logic or mechanism that is understood to do something distinctive to (that is, to 'mediatize') particular processes, objects and fields: a distinctive and consistent transformation that it is suggested can only properly be understood if seen as part of a wider transformation of social and cultural life through media operating from a single source and in a common direction, a transformation of society by media, a 'media logic' (Altheide & Snow, 1979). This is an important general claim, and insofar as it involves the specific claim that many cultural and social processes are now constrained to take on a form suitable for media re-presentation, it is based on transformations that are undeniable: there is, for example, no question any more of politicians doing politics without appearing in or on media, and no social campaign can operate without some media presence.

It is clear the concept of mediatization starts out from the notion of replication, the spreading of media forms to spaces of contemporary life that are required to be re-presented through media forms:

> As a concept mediatization denotes the processes through which core elements of a cultural or social activity (e.g., politics, religion, language) assume media form. As a consequence, the activity is to a greater or lesser degree performed through interaction with a medium, and the symbolic content and the structure of the social and cultural activities are influenced by media environments which they gradually become more dependent upon. (Hjarvard, 2007, p. 3)

However, the theory of mediatization insists that from this regular dependence of zones of social or cultural activity on media exposure wider consequences follow, which taken together form part of a broader media logic: 'by the logic of the media we understand their *organizational, technological, and aesthetic* functioning, including the ways in which media *allocate material and symbolic resources* and work through *formal and informal rules*' (Hjarvard, 2007, p. 3, original emphasis). Winfried Schulz (2004) in his helpful discussion of 'mediatization' theory, including by German-speaking scholars, breaks the term 'mediatization' down into four 'processes' (extension, substitution, amalgamation and accommodation) but, in doing so, confirms indirectly the linear nature of the logic that underlies theories of mediatization. How else, for example, can we understand the notion of 'substitution' (Schulz, 2004, pp. 88–89) which implies that one state of affairs has become another because of the intervention of a new element (media)?

As I explain later, my reservations with the theory of 'mediatization' begin only when it is extended in this way to cover transformations that go far beyond the adoption of media forms or formats to the broader consequences of dependence upon media exposure. The latter will include transformations in the agents who can act in a particular field, how they can act, with what authority and capital, and so on. These latter types of transformation may require different theoretical frameworks, such as Bourdieu's field theory (1993), if they are to make detailed sense; if so, their causal workings will not be analysable under one single 'logic' of 'mediatization', since Bourdieu's account of social space is always multipolar. I will come later to some other limitations of the term 'mediatization'.

However, I would not want to deny the advantages of the term 'mediatization' for media theory. 'Mediatization' encourages us to look for common patterns across disparate areas. Mediatization describes the transformation of many disparate social and cultural processes into forms or formats suitable for media re-presentation. One example might be in the area of state/religious ritual: when we see weddings or other ceremonies taking on features that make them ready for re-mediation (via digital camera) or imitating features of television versions of such events, this is an important shift and is captured by the term mediatization. Another more complex example is the mediatization of politics (Meyer, 2003; Strömbäck, 2007). Here the argument is not just about the forms of political performance or message transmission, but about the incorporation of media-based logics and norms into political action. In the most extreme case, media, it has been argued, change the ontology of politics, changing what counts as political action, because of the requirement for all effective *policy* to be explainable and defensible within the constraints of media formats

(Meyer, 2003). Prima facie an example of this is the argument in a recent book by a retired British civil servant, Christopher Foster (Foster, 2006) that, under Britain's New Labour government, 'Cabinet' meetings have been profoundly changed by the media pressures that impinge on government: becoming much shorter, and changing from being open deliberations about what policy should be adopted to being brief reviews of the *media impact* of policies already decided elsewhere.

However, as this last example suggests, there is a blurring masked by the term 'mediatization'. Are such changes to the running of government in Britain *just* the result of media's influence in the political domain? Or are they linked also to *political* forces, to shifts in the power that national governments have in relation to external markets and other factors (compare Leys, 2001) which have narrowed the scope of national political action and deliberation? Surely 'media logic' and 'political logic' are not necessarily binary opposites that are simply substitutable for one another; instead they interpenetrate or cut across each other. Saskia Sassen's recent work (2006) offers an important entry-point into the spatial complexity of these interactions among media, state and economy within 'globalization'.

This reinforces the broader problem with mediatization theory already suggested: its tendency to claim that it has identified *one single type of media-based logic* that is superseding (completely replacing) older logics across the whole of social space. While this is useful when we are examining the media-based transformation of very specific social or institutional practices, it may in more complex cases obscure the variety of media-related pressures at work in society: for example, practical necessities which make media exposure useful, but not always essential, for particular actors; the role of media skills in the capital of particular agents as they seek in various ways to strengthen their position in a particular field; the role of media as networks whose influence does not depend on the logics embedded in media contents but on the reshaping of fields of action themselves (Benson & Neveu, 2005). These are influences too heterogeneous to be reduced to a single 'media logic', as if they all operated in one direction, at the same speed, through a parallel mechanism, and according to the same calculus of probability. Media, in other words, are *more than a language* (or 'logos') for transforming social or cultural contents in one particular way.

The problem is not that mediatization theorists do not recognise the breadth of these changes; they certainly do, and this is largely what grounds their claim for the broad implications of the term. The problem is that the concept of 'mediatization' itself may not be suitable *to contain* the heterogeneity of the transformations in question. There are two ways in which this argument might be made more fully. One would be by considering in detail how the basic

insights of mediatization theory can be developed within a version of Bour-
dieu's field theory (compare Couldry, 2003b). This line of argument would,
however, take me some way from the specific issues raised by digital storytell-
ing. The other way of arguing for the limits of the term 'mediatization' which
I will pursue here is by exploring the virtues of the complementary approach
to media's social consequences that following other writers I gather under the
term 'mediation'. Do media (and specifically digital storytelling, to which I
come in detail later) have social consequences which have not been—and could
not readily be—captured by the theory of mediatization, and which are better
encompassed by the concept of 'mediation'? This is what I will argue.

Mediation

Media processes involve a huge complexity of inputs (what are media?) and
outputs (what difference do media make, socially, culturally?), which require
us to find another term to differentiate the levels within and patterns across
this complexity. According to a number of scholars, that term is 'mediation'.[4]
'Mediation' as a term has a long history and multiple uses: it has for a very long
time been used in education and psychology to refer to the intervening role
that the process of communication plays in the making of meaning. In general
sociology, the term 'mediation' is used for any process of intermediation (such as
money or transport). My concern here is however with the term's specific uses
in media research. Within media research, the term 'mediation' can be used to
refer simply to the act of transmitting something through the media, but here
I have in mind a more substantive definition of the term which has received
more attention in media research since the early 1990s. One crude definition
of 'mediation'—in this substantive sense—is the overall effect of media insti-
tutions existing in contemporary societies, the overall difference media make
by being there in our social world. This only gestures in the right direction
without helping us differentiate any of mediation's components; indeed it gets
us no further definitionally than the catch-all use of the term 'mediatization' I
rejected a moment ago. A more useful approach is via John B. Thompson's term
'mediazation' (1995)—as it happens, he avoids the term 'mediation', because of
its broader usage in sociology (see above). Thompson notes that

> By virtue of a series of technical innovations associated with printing and, subse-
> quently, with the electrical codification of information, symbolic forms were produced,
> reproduced and circulated on a scale that was unprecedented. Patterns of commu-
> nication and interaction began to change in profound and irreversible ways. These
> changes, which comprise what can loosely be called the '*mediazation of culture*', had a

clear institutional basis: namely, the development of media organisations, which first
appeared in the second half of the fifteenth century and have expanded their activities
ever since. (1995, p. 46, added emphasis)

This is helpful because it turns the general question of media institutions' con-
sequences into a series of specific questions about media's role in the transfor-
mation of action in specific sites, on specific scales and in specific locales.

There is, it might seem, a risk that 'mediation' is used so broadly that it is
simply a substitute for the 'media saturation' about which many writers within
and outside media research have written, most notably Baudrillard (1983). But
while the idea of 'media saturation' does capture the media density of some
contemporary social environments, it does not capture the multi-directionality
of how media may be transforming society. This is where I turn to Roger Sil-
verstone's definition of 'mediation', the approach for which I want to reserve
my main use of that term. Here is Silverstone:

Mediation, in the sense in which I am using the term, describes the *fundamentally,
but unevenly, dialectical process* in which institutionalised media of communication (the
press, broadcast radio and television, and increasingly the world wide web), are in-
volved in the general circulation of symbols in social life. (Silverstone, 2002, p. 762,
added emphasis)

Silverstone explains the nature of this dialectic in a later essay: 'mediation re-
quires us to understand how processes of communication *change the social and
cultural environments that support them* as well as the relationships that par-
ticipants, both individual and institutional, have to that environment and to
each other' (Silverstone, 2005, added emphasis; see also Madianou, 2005). This
helpfully brings out how any process of mediation (or perhaps 'mediazation')
of an area of culture or social life is always at least two-way: 'media' work, and
must work, not merely by transmitting discrete textual units for discrete mo-
ments of reception, but through a process of environmental transformation
which in turn transforms the conditions under which any future media can be
produced and understood. 'Mediation' in other words is a nonlinear process.

Can we build on Silverstone's insight into the dialectics of mediation,
and so reinforce the contrast with the purely linear logic of 'mediatization'?
Arguably Silverstone's term 'dialectic' is too friendly to capture all aspects of
mediation's nonlinearity. It disarms us from noticing certain asymmetric inter-
relations between actors in the media process, and even the impossibility of
certain actors or outputs influencing other actors or outputs. Rather than see-
ing mediation as a dialectic or implied conversation, it may be more productive,
I suggest, to see mediation as capturing a variety of dynamics within media

flows. By 'media flows', I mean flows of production, flows of circulation, flows of interpretation or reception, and flows of recirculation as interpretations flow back into production or flow outwards into general social and cultural life. We need not assume any 'dialectic' between particular types of flow, still less does it assume any stable circuit of causality; we must allow not only for nonlinearity but for discontinuity and asymmetry. More specifically, this adjustment allows us to emphasise two possibilities only hinted at in Silverstone's definition of mediation: first, that what we might call 'the space of media' is structured in important ways, durably and partly *beyond* the intervention of particular agents; and second that, because of that structuring, certain interactions, or 'dialectics'—between particular sites or agents—are closed off, isolating some pockets of mediation from the wider flow. This point will be important later. The media sphere is extraordinarily concentrated in crucial respects; indeed the very term 'the media' is the result of a long historical construction that legitimates particular concentrations of symbolic resources in institutional centres (Couldry, 2000, 2003a). With this qualification to Silverstone's notion of dialectic, however, 'mediation' remains an important term for grasping how media shape the social world which, as we shall see, usefully supplements the theory of mediatization, in contributing to our understanding of 'digital storytelling'.

It is time now to consider how these different approaches to understanding the broader social consequences of media—mediation and mediatization—might contribute distinctively to grasping the potentials, and limits, of new media and specifically digital storytelling.

Digital storytelling as mediatization

Any account of digital storytelling's long-term consequences in terms of mediatization must start from the claim that there are certain consistent patterns and logics within narrative in a digital form. In principle this is difficult, since the main feature of a converged media environment is that narrative in *any* original format (from spoken story to elaborate hypertextual commentary to photographic essay) can be widely circulated through a single 'digital' site. But let me simplify the argument by limiting 'digital storytelling' to those online personal narrative formats that have recently become prevalent: whether multimedia formats such as MySpace and Facebook, textual forms such as blogs, the various story forms prevalent on more specialist digital storytelling sites, or the many sites where images and videos, including material captured on personal mobile devices, can be collected for wider circulation (such as YouTube). Is there a common logic to these formats, a distinctive 'media logic', that is

consistently channelling narrative in one particular direction?

Some important features of online narrative forms immediately spring to mind, important, that is, by contrast with oral storytelling. These features stem in various ways from the oversaturation of the online information environment: first, a pressure to mix text with other materials (sound, video, still image) and more generally to make a visual presentation out of narrative, over and above its textual content; second, a pressure to limit the length of narrative, whether to take account of the limits of people's attention when reading text online, or to limit the file size of videos or sound tracks; third, a pressure towards standardisation because of the sheer volume of material online and people's limited tolerance for formats, layouts or sequences whose intent they have difficulty interpreting; fourth, a pressure to take account of the possibility that any narrative when posted online may have unintended and undesired audiences. We are, I suggest, at too early a stage in the development of digital storytelling to be sure which of these pressures will prove most salient and stable, or whether other unexpected pressures will overtake them in importance. But *that* there will be some patterns is unquestionable; whatever patterns become standard will be consequential in so far as having an online narrative presence *itself* becomes expected of well-functioning citizens. That people are already making such an assumption emerges from recent press reports that employers are searching blogs and social networking sites for personal information that might be relevant to judging job applicants' suitability.

However this last case also brings out the complexity of the transformations under way. If digital storytellers assume their public narratives will be an archive that can be used against them in years to come, they may adjust what stories they tell online. Indeed the evidence of David Brake's recent study of MySpace users (Chapter 16 in this book) is that young people are already making similar adjustments *of content*, not merely style, for more immediate reasons, to avoid giving compromising information to people at school or in their local area who may be hostile or dangerous to them. This is an important finding, since it brings out precisely the complexity of causal influences at work here. It is not simply that young people already have in fixed form identifiable stories of themselves they want to tell and that the digital format imposes certain constraints on those particular stories, producing an adjustment we can register as an effect of 'mediatization'. Instead young people are *holding back* personal material that might in theory have gone into their MySpace or Facebook site. This problematises any idea that social networking sites represent *simply* the mediatization (and publicisation) of formerly private self-narratives although journalists have drawn precisely this conclusion. On the contrary we might argue young people, by holding back personal narratives

from such sites, are protecting an older private/public boundary rather than tolerating a shift in that boundary because of the significant social pressures to have an online presence.

We start to see here how the transformations under way around digital storytelling cannot be contained within a single logic of mediatization, since involved also are logics of use and social expectation that are evolving alongside digital narrative forms: we are closer here to the dialectic which Silverstone saw as at the heart of the mediation concept.

Digital storytelling as mediation

If, as I earlier suggested, we can understand mediation as the resultant of flows of production, circulation, interpretation and recirculation, then there would seem to be three main angles from which we might approach 'digital storytelling' as mediation:

1. by studying how digital storytelling's contexts and processes of production are becoming associated with certain practices and styles of interpretation (stabilities in the *immediate and direct context* of storytelling);
2. by studying how the outputs of digital storytelling practices are themselves circulated and recirculated between various sites, and exchanged between various practitioners, audience members and institutions (stabilities in the *wider flows* of digital stories and the resulting personal and institutional linkages, flows which the possibility of digital storytelling while on the move, using mobile phones and other mobile digital devices, complicate considerably);
3. by studying the *long-term consequences* of digital storytelling as a practice for particular types of people in particular types of location and its consequences for wider social and cultural formations, even for democracy itself.

Needless to say, these are areas where extended empirical work must be done. The third perspective in particular ('long-term consequences') involves considering the wider interactions, if any, between particular storytelling practices and general media culture. When a practice such as digital storytelling challenges media's normal concentration of symbolic resources so markedly, analysing the consequences for *wider* society and culture is, of course, difficult, but it cannot be ignored in case we miss the possibility that digital storytelling really does

contribute to a wider democratisation, a reshaping of the hierarchies of voice and agency. The resulting issues, while they encompass issues of media form (and therefore mediatization), go much wider and can therefore only be captured, I will argue, by the dialectical term 'mediation'.

We can learn a lot here from the work of the American sociologist Robert Wuthnow on the social and ideological consequences of the book (Wuthnow, 1989). Wuthnow in *Communities of Discourse* analyses the factors that contributed to major ideological shifts such as the Reformation and the birth of modern democratic politics. He sees the medium of the book and the new information networks it made possible as essential to these long-term changes. But what makes Wuthnow's account so interesting is that his argument does not stop there—if it did, it would be an old-style technological determinism. Wuthnow argues that we cannot understand the impact of the book, *over the longer term*, unless we look at a number of contingent factors, some environmental, some institutional and some at the level of what he calls 'action sequences' (1989, p. 7). Factors Wuthnow identifies include, first, the development of settings for communication other than the book (such as the church, the school, the political party), second, the many interlocking social and political processes that created new contexts for cultural production more generally, and, third, the ways in which new circuits for the distribution of ideas, such as the journal, emerged over time and then became gradually institutionalised in certain ways.

Wuthnow's rich historical account clearly invites us to think not only about the detailed processes necessary for the book to be stabilised in cultural life in a certain way, but also about the unevennesses (to use Silverstone's term again) of any such process. We might add another factor, implicit in Wuthnow's account: the emerging processes of *hierarchisation* that developed through the above changes. Think of the literary public sphere, for example, and the social exclusions on which it was famously based, the eighteenth-century coffeehouse *versus* the market-square (Stallybrass & White, 1986; Calhoun, 1992). Wuthnow asks us to think systematically about the types of space in which particular symbolic practices (in his case, the regular practices of reading and discussing printed materials in pamphlet, newspaper or book form; in ours, the practice of exchanging digital stories) become under particular historical circumstances embedded more widely in individual routines and the organisation of everyday life.

Wuthnow's emphasis on institutional spaces (such as the church or school) far beyond the immediate moments of media production, circulation or reception, is inspiring for research on digital storytelling; first, for drawing our research into the wider territory of *education and government*; and second, for

its emphasis on *space*, more precisely on the complex historical conditions under which new social spaces emerge that ground new routines. We could approach the same question from a different disciplinary angle by drawing on the geographer Henri Lefebvre's concept of 'social space'. As Lefebvre puts it provocatively

> The social relations of production have a social existence to the extent to which they have a spatial existence; they project themselves into a space, becoming inscribed there, and in the process producing that space itself. (Lefebvre, 1990, p. 129)

If Lefebvre is right and all social and cultural change involves transformations of 'social space' in this sense (think of the normalisation of television as a domestic medium through its embedding in the space of the home), then any successful embedding of digital storytelling in the everyday life of mediated democracies will involve a similar spatial transformation, with resulting spatial asymmetries too.

Translating Wuthnow's argument to the early twenty-first century context of digital storytelling, we can ask a series of questions about 'mediation' beyond those asked above:

4. what patterns, if any, are emerging in the institutional settings in which digital storytelling is now taking place? Who is included in them and who isn't?
5. What types of resources and agents are typically drawn upon in creating and then sustaining effective sites of digital storytelling, and how in detail are effective contexts for the production and reception of digital stories created? (Equally what factors typically undermine those sites and contexts?)
6. Are any new circuits for the distribution of digital stories and social knowledge developing through and in relation to digital storytelling sites? What wider profile and status do those circuits have?
7. What broader links, if any, are being made between the field of digital storytelling and other fields of practice—education, civic activism, mainstream media production, popular culture generally, and finally politics?

We can focus these questions a little more sharply. Wuthnow explains his larger argument as one about how ideas work: they do not work by floating freely, but instead they need to 'become embedded in concrete communities of discourse' (1989, p. 552). There is a striking intersection here with Etienne

Wenger's (1998) concept of 'communities of practice'. Wenger uses the term 'community', he says, as 'a way of talking about the social configurations in which our enterprises are defined as *worth pursuing* and our participation is recognisable as *competence*' (1998, p. 5, added emphasis). For Wenger, 'communities of practice are the prime context in which we can work out common sense through mutual engagement' (1998, p. 47): put another way, Wenger is concerned with the social production of value and authority, and these must be crucial to the broader processes of 'mediation' in which digital storytelling will come, if it does, to matter.

It is these points—the building of community through the construction of value and the giving of recognition (compare Honneth, 2007)—on which I want to focus in the next section, since they are crucial to digital storytelling's claims to reenergise community and possibly even democracy. This discussion will take us further into the territory of mediation and away from the territory, independently important though it is, of mediatization.

Digital storytelling and the conditions of democracy

Robert Dahl in his theory of polyarchy—a cautious account of the preconditions of a democracy that does not yet exist—prescribes that 'citizens should posses the political resources they would require to participate in political life pretty much as equals' (Dahl, 1989, p. 322). Among the resources which Dahl thinks it most important to distribute more fairly for this purpose are not only economic resources but also 'knowledge, information and cognitive skills' (1989, p. 324). It is in relation to the latter that digital storytelling is potentially relevant, but to see this, we need to supplement Dahl's account with Nancy Fraser's more recent demonstration of the interconnection between the distribution of resources and the distribution of recognition as dimensions of justice (Fraser, 2000, p.116). Correcting injustices of recognition means counteracting 'an institutionalised pattern of cultural value that [constitutes] some social actors as less than full members of society and prevents them from participating as peers' (2000, p. 113), but crucially as Fraser argues this involves a redistribution of resources too.

We can complete the link to digital storytelling by noting that the extreme concentration of symbolic resources in media institutions constitutes an important dimension of social power precisely because it institutes an inequality of social recognition in Fraser's sense: as a result, we can talk not only of

the hidden injuries of class (Sennett and Cobb, 1972) but also of the 'hidden injuries of media power' (Couldry, 2001). Digital storytelling in principle represents a correction of those latter hidden injuries since it provides the means to distribute more widely the capacity to tell important stories about oneself—to represent oneself as a social, and therefore potentially political, agent—in a way that is registered in the public domain. Digital storytelling is perhaps particularly important as a practice because it operates *outside* the boundaries of mainstream media institutions although it can also work on the margins of such institutions; for the latter, see Nancy Thumim's work on how power asymmetries are worked out in digital storytelling sponsored by media institutions such as the BBC (Thumim, 2006; Chapter 5 of this book). In that sense digital storytelling contributes to a democratisation of media resources and widening the conditions of democracy itself. Digital storytelling vastly extends the number of people who at least in principle can be registered as contributing to the public sphere, enabling, again in principle, quite a radical revision of both of Habermas' accounts (the earlier pessimistic and the later, more optimistic accounts) of the public sphere (Habermas, 1989, 1996).

We need to understand in more detail how, given the previous analysis, the practice of digital storytelling can be understood to work in this broader way. Here the words of the leading exponent of digital storytelling, Joe Lambert, founder of the Center for Digital Storytelling in Berkeley (www.storycenter. org) provide some inspiration.

Lambert's book *Digital Storytelling* (now in its second edition: Lambert, 2006) discusses the background to the practice of digital storytelling in a way that relates interestingly to the history of mass media: needed, he argues, is not just an expansion of digital literacy but a greater faculty for listening to others' stories (2006, pp. 16, 95) that contrasts explicitly with the normal context for consumers of broadcast media. The aim of digital storytelling is not to produce media for broadcast but to produce 'conversational media': 'much of what we help people create would not easily stand alone as broadcast media, but, in the context of conversation, it can be extraordinarily powerful' (2006, p. 17). Lambert has a sharp sense of the hidden injuries of media power; 'we can live better as celebrated contributors, we can easily die from our perceived lack of significance to others, to our community, to our society' (2006, p. 3). Digital storytelling is offered as a technique for increasing understanding across generations, ethnicities and other divides, and as a tool in activist organising, education, professional reflection and corporate communication (2006, pp. 111, 112, 114, 165).

Digital storytelling is a tool with such diverse uses that it almost certainly cannot be understood as having any one type of consequence or even form. I

want to concentrate however on the claims made by Lambert for digital storytelling's links to democracy, particularly the practice of 'storycatching' which through meetings of 'storycircles' in particular communities catches stories which otherwise would not be exchanged. The aim is, in part, political: 'to engage us in listening to each other's stories with respect and then perhaps we can sort out new solutions . . . by reframing our diverse connections to the big story' (2006, pp. xx-xxi); 'as we envision it, storycatching will become central to planning and decision making, the foundation upon which the best choices can be made' (2006, p. xxi). It would be a mistake to pass by this (for some, utopian) vision since it addresses the disarticulation between individual narratives and social or political narratives that Alain Touraine has expressed in almost apocalyptic form:

> we are witnessing the end of the close correspondence between all the registers of collective life—the economic, the social, the political and the cultural—that were once unified within the framework of the nation. (Touraine, 2001, p. 103)

Others (Bennett, 1998; Turner, 2001) have expressed similar concerns in less dramatic terms. Storycircles, seen from a sociological point of view, are a practical setting, easily replicable, for *mutual* exchange of stories that tests out the degree to which we find each other's lives incommensurable with our own and that, since each of us is differently inserted in the various 'registers of collective life', the degree to which the multi-level contradictions within our own lives are resolvable.

In so far as the digitalisation of storytelling is offered as a means by which to address a fundamental problem in contemporary democratic societies, how are we to understand Lambert's claim and the *sociological* conditions through which it might be realisable? More specifically, which concept—'mediatization' or 'mediation'?—is more useful for grasping the dynamics of such processes? Mediatization is concerned with the systematic consequences of the standardisation—of media formats and reliance on access to media outlets—for particular areas of contemporary life. It is clear that, *if* digital storytelling becomes standardised in particular ways, this might be significant, but there is no strong reason to believe in advance that such standardisation would be more consequential socially than other factors within storytelling: experiences of group formation, exchange and learning, and so on. More consequential, I suggest, are questions we might address through a concern with 'mediation': questions about how the availability of digital storytelling forms enable enduring habits of exchange, archiving, commentary and reinterpretation, and on wider spatial and social scales than otherwise possible; questions about the institutional embedding of the processes of producing, distributing and receiving digital

stories.

We need, in other words—if we are to take Lambert's vision of digital storytelling's potential contribution to democracy seriously, as I believe we should—to follow closely not just the forms and styles of digital storytelling and not just who is involved in what locations in digital storytelling, and where, but in what wider contexts and under what conditions digital stories are exchanged, referred to, treated as a resource, and given recognition and authority. The fear—articulated abstractly in my earlier adjustment to Silverstone's notion of the dialectic of mediation—is that digital storytelling is, and will remain, a largely isolated phenomenon, cut off from broader media and the broader range of everyday life, both private and public/political: remaining, to put it crudely, a phase that individuals and groups 'go through', not recognised more widely in the regular distribution of social and cultural authority or respect. The hope—strongly articulated as a vision by Joe Lambert—is that, from out of local practices of making, exchanging and collecting digital stories, wider networks and habits will stabilise, just as they did around the practice of reading, with consequences for the distribution of power in intensely mediated but also increasingly unequal societies.

Let me conclude this chapter by moving beyond conceptual survey to discuss, albeit speculatively, what approaches (practical, imaginative) might be relevant to avoiding this isolation of digital storytelling from its wider social potential.

Conclusion

At this point you might expect me to offer a series of practical proposals for channelling resources into digital storytelling practices and networks. While such resources may well, of course, be useful, and provide a valuable form of public subsidy at a time when even in the United Kingdom, one of its historical homes, the concept of 'public service broadcasting' is under challenge (Ofcom, 2007), I want to point to a different type of deficit that threatens to undermine the social potential of digital storytelling over the longer term. This is an imaginative deficit, a failure to see the interconnected nature of a contemporary crisis of voice affecting political, economic and cultural domains in neoliberal democracies and which underlies the risk that islands of good digital storytelling practice will remain isolated, disarticulated from each other and from wider social change.

I call that underlying crisis a 'crisis of voice' and I can only sketch it here (for a longer, but still preliminary account, see Couldry, 2008). What are the

elements that must be seen as interconnected, if we are to grasp that crisis of voice? First, an uncertainty about the meaning and feasibility of democratic politics. Beck (2000) in social theory, Fraser (2005) in political theory, and Sassen (2006) in social and political science have all questioned to what extent democratic politics must now be conducted in spaces beyond the nation-state. Within the nation-state, it is increasingly uncertain whether neoliberal democracies can continue to deliver opportunities for anything approaching democratic participation (electoral participation in countries such as the United Kingdom is at dangerously low levels), where the dynamics of policy influence in today's 'market-driven politics' (Leys, 2001) lies largely beyond national governments, generating problems with mechanisms of representation (as delegation) which spill over into broader problems of representation (as symbolisation).

A second uncertainty affects economics, where the absolute prioritisation of market logics has been challenged by critical economists who question whether neoliberal doctrine sufficiently recognises people as agents with an individual voice: this takes various forms, whether Amartya Sen's (2002) insistence on an ethical dimension in economics or the 'happiness' research of Richard Layard (2006) and Robert Lane (2000). Meanwhile, the marginalisation of workers' voices in market logics creates increasing tensions, expressed aphoristically in complaints about 'work/life balance' and practically in the silent sanction of redundancy and 'flexible' labour markets.

Third, a crisis of voice can also be discerned in mediated public culture. While interactive formats and online spaces have prima facie brought audience/user 'voice' into the heart of media production, much popular culture resolves itself into two modes where voice is illusory: celebrity culture (a discourse, however multi-directional, about centralised human reference-points, driven by market needs) and 'reality' programming, a pedagogic mode which generates and sustains social norms of performance and desire. The role of popular culture in promoting social norms is in itself not new of course; what is new is that such norms are played out, often mockingly, through the bodies and emotions of 'ordinary people', who are both objects of instruction and apparent subjects of empowerment.

These three crises within political, economic and cultural domains need to be seen as connected to the same underlying condition of neoliberal democracies, that is, the normative prioritisation of market over social values. That is why there is one larger crisis, not three unconnected ones. Resistance to these contradictions must start with the reaffirmation of voice (that of individuals and groups) within the management of the social. By recognising the multiple threats to voice, we are in position to see more clearly the problematic bases of

recognition (Honneth, 2007) in contemporary societies and so the difficulty of sustaining any broader notion of democratic culture (Dewey, 1946) in neoliberal regimes.

It is within this wider, indeed multidimensional, deficit of recognition (in Honneth's sense) that the social and technological possibility of digital storytelling emerges as both disruptive and potentially hopeful. Digital storytellers, after all, can be many types of people: media consumers, local media producers, vulnerable people with unmet needs, employees with concerns to express about their working conditions, citizens who feel they are not being heard. These 'types' of storyteller may, of course, intersect in one and the same person, since all of us at different times are vulnerable, employed or in need of employment, or citizens; that is Dewey's point about the necessary multidimensional and multilocal nature of genuine democracy. The idea of digital storytelling—the idea that each person has a voice and a story, and that there could be a place where that story is gathered with other stories for exchange and reflection—that principle is a major challenge to the conditions that I have described symptomatically as a crisis of voice. But this potential of digital storytelling can only become fully visible once we see that the lack of democracy in the workplace, political disenchantment and the false offers of interactivity in much popular culture are part of the same crisis and challenge.

For that, we must go beyond analysing digital storytelling as the linear replaying of a single 'media logic' and see it as part of a more complex nonlinear process of 'mediation'. But adjusting our conceptual tools is only the start. To see the longer-term potential of digital storytelling in its wider social context, we must imagine a new calibration between social and market forces, political form, and the distribution of narrative resources—a calibration that no doubt will require an extended political vocabulary—just as, in order to achieve the full social potential of the printed book, it was necessary to imagine the institutions of modern representative democracy. The point, of course, is not that by itself digital storytelling could be the catalyst of such major change, but rather that it is only in the context of change on that scale that the potential of digital storytelling as a social form can be fully grasped.

Notes

Parts of this chapter were published in a different version in *New Media & Society* in 2008, issue 10(3). Thanks to Sage Publishing and to the editors of *New Media & Society* for their kind permission to republish here.
1. These reflections have been developed in the context of, and supported by, the Mediatized

Stories network run by the University of Oslo since 2005 and funded by the Norwegian Research Council. Thanks to my collaborators in the network and particularly to Knut Lundby, its leader. Thanks also to the journal's anonymous reviewers for helpful comments on an earlier version.

2. As we will see, there is some definitional violence here, since some theories of 'mediation' are closer to 'mediatization' in their emphasis on a linear logic of transformation.
3. As noted by Schulz in his discussion of mediatization (Schulz, 2004, p. 92).
4. I want to acknowledge the influence in the following paragraphs of my conversations between 2001 and 2006 with the late Roger Silverstone whose breadth of insight will, for a long time, be greatly missed.

References

Altheide, D. (1985). *Media power.* Beverly Hills: Sage.
Altheide, D. and Snow, R. (1979) *Media logic.* Beverly Hills: Sage.
Baudrillard, J. (1983). *Simulations.* New York: Semiotext(e).
Beck, U. (2000). The cosmopolitan perspective: Sociology of the second Age of Modernity? *British Journal of Sociology, 51*(1), 79–105.
Bennett, L. (1998). The uncivic culture: Communication, identity, and the rise of lifestyle politics. *PS: Political Science and Politics, 31*(4), 740–761.
Benson, R., & Neveu, E. (Eds.) (2005). *Bourdieu and the journalistic field.* Cambridge: Polity.
Bourdieu, P. (1993) *The field of cultural production.* Cambridge: Polity.
Calhoun, C. (Ed.) (1992). *Habermas and the public sphere.* Cambridge, MA: MIT Press.
Couldry, N. (2000). *The place of media power.* London: Routledge.
———. (2001). The hidden injuries of media power. *Journal of Consumer Culture, 1*(2), 155–174.
———. (2003a). *Media rituals: A critical approach.* London: Routledge.
——— (2003b). Media meta-capital: Extending the range of Bourdieu's field theory. *Theory and Society, 32*(5/6), 653–677.
———. (2008). Media and the problem of voice. In N. Carpenter & B. de Cleen (Eds.), *Participation and media production. Critical reflections on content creation*, pp. 15–26. Bristol: Intellect Press.
Dahl, R. (1989). *Democracy and its critics.* New Haven, CT: Yale University Press.
Dewey, J. (1946). *The public and its problems.* New York: Henry Holt.
Foster, C. (2006). *British Government in crisis.* Oxford: Hart Publishing.
Fraser, N. (2000) 'Rethinking Recognition', *New Left Review* 3, 107–120.
———. 2005. Reframing global justice. *New Left Review (ns) 36*, 69–90.
Gumpert, G., & Cathcart, R. (1990). A theory of mediation. In B. Ruben & L. Lievrouw (Eds.), *Mediation, information and communication*, pp. 21–36. New Brunswick, NJ: Transaction.
Habermas, J. (1989). *The structural transformation of the public sphere.* Cambridge: Polity.
———. (1996). *Between facts and norms.* Cambridge: Polity.
Hjarvard, S. (2004) From bricks to bytes: The mediatization of a global toy industry. In I. Bondjeberg & P. Golding (Eds.), *European culture and the media*, pp. 43–63. Bristol: Intellect.
———. (2007). Changing media—Changing language: The mediatization of society and the

spread of English and Medialects. Paper presented to ICA annual conference, San Francisco, 24–28 May.

Honneth, A. (2007). *Disrespect*. Cambridge: Polity.

Lambert, J. (2006). *Digital storytelling: capturing lives, creating community* (2nd ed.). Berkeley, CA: Digital Diner Press.

Lane, R. (2000). *The loss of happiness in market democracies*. New Haven, CT: Yale University Press.

Layard, R. (2006). *Happiness*. Harmondsworth: Penguin.

Lefebvre, H. (1990). *The production of space*. Oxford: Blackwell.

Leys, C. (2001). *Market-driven politics*. London: Verso.

Madianou, M. (2005). *Mediating the nation*. London: UCL Press.

Martin-Barbero, J. (2003) *Communication, culture and hegemony*. London: Sage.

Mazzoleni, G., & Schultz, W. (1999). 'Mediatization' of politics: A challenge for democracy? *Political Communication, 16*, 247–261.

Meyer, T. (2003). *Media democracy*. Cambridge: Polity.

Ofcom (2007). *A new approach to public service content in the digital age*. Retrieved 10 December 2007 from http://www.ofcom.org.uk/consult/condocs/pspnewapproach/newapproach.pdf

Sassen, S. (2006). *Territory, authority, rights*. Princeton: Princeton University Press.

Schulz, W. (2004). Reconstructing mediatization as an analytical concept. *European Journal of Communication, 19*(1), 87–101.

Sen, A. (2002). *Rationality and freedom*. Cambridge, MA: Harvard University Press.

Sennett, R. and Cobb, J. (1972) *The hidden injuries of class*. New York: Cambridge University Press.

Silverstone, R. (1994). *Television and everyday life*. London: Routledge.

———. (1999). *Why study the media?* London: Sage.

———. (2002). Complicity and collusion in the mediation of everyday life. *New Literary History, 33*, 745–764.

———. (2005). Mediation and communication. In C. Calhoun, C. Rojek, & B. Turner (Eds.), *The international handbook of sociology*, pp. 188–207. London: Sage.

Stallybrass, P., & White, A. (1986). *The politics and poetics of transgression*. London: Methuen.

Strömbäck, J. (2007). Four phases of mediatization: An analysis of the mediatization of politics. Paper presented to ICA annual conference, San Francisco, 24–28 May.

Thumim, N. (2006). Mediated self-representations: 'Ordinary people' in 'communities'. In S. Herbrechter & M. Higgins (Eds.), *Returning (to) communities: Theory, culture and political practice of the communal*, pp. 255–274. Amsterdam and New York: Rodopi Press.

Thompson, J. (1995). *The media and modernity*. Cambridge: Polity.

Touraine, A. (2001). *Beyond neoliberalism*. Cambridge: Polity.

Turner, B. (2001). The erosion of citizenship. *British Journal of Sociology, 52*(2): 189-209.

Wenger, E. (1998). *Communities of practice: Learning meaning and identity*. Cambridge: Cambridge University Press.

Wuthnow, R. (1989). *Communities of discourse*. Cambridge, MA.: Harvard University Press.

Boundaries and bridges
Digital storytelling in education studies and media studies

KIRSTEN DROTNER

In both scholarly and popular discourse, we currently witness an abundance of accounts made about the ways that young people in particular are offered new forms of self-presentation and narrative identity spaces through their extensive engagements with the so-called web 2.0 services such as social networking sites, wikis and blogs. Much is made of the transformative nature of these digital forms of expression and interaction and of their implications in both personal and social terms. These implications tend to be described in normative tones of celebration or concern, the first often focusing on the perceived democratic potential to be found in new forms of civic visibility and voice while the other often stresses the potential risks involved in disclosing personal information and accessing unsolicited content online (Huffaker, 2004; Livingstone & Bober, 2006; Thurlow, 2006; boyd, 2007; overviews in Buckingham, 2000; Drotner, 2008).

While it is undoubtedly true that digitisation in general and web 2.0 services in particular offer new outlets for shaping, sharing and storing social narratives, the main argument to be explored in the following pages is that these practices operate as key drivers of future competence formation. If this is true,

scholars need to unravel the interlacing of learning theories and media theories in order to map out the socio-cultural enablers and constraints of these processes. One way in which to begin such an endeavour is to explore the ways in which the key terms 'mediation' and 'mediatization' are used in the respective traditions of learning studies and in media studies. Both these terms focus on intersubjective interaction, that is, they tackle the basic relation between self and other, or subject and society. But they do so from very different theoretical perspectives and with somewhat different implications.

This chapter, then, briefly maps out some key characteristics of web 2.0 storytelling and relates these characteristics to policy discourses on competence formation as a backdrop to a conceptual exploration of the uses of mediation and mediatization in learning theories and media theories, respectively. By way of conclusion, I offer some pointers for future interaction between the two theoretical traditions as a way of progressing what I take to be a necessary scholarly dialogue for action.

Web 2.0 storytelling

While narration is integral to virtually all known societies, indeed may be seen as a basic human faculty of meaning-making (Bruner, 1990), new media such as the personal computer, the Internet and mobile devices offer means of producing and participating in narratives that in some respects differ from what we know from other sign technologies such as the book, the letter, the audio tape, the analogue photograph and broadcast radio and television.[1] For example, a study of publicly available English-language blogs (weblogs) found that 70.4 per cent may be defined as diary blogs focusing on personal narratives, and more than a third of bloggers are adolescents (Herring, Scheidt, Bonus & Wright, 2004).

In the following, I will apply the term digital storytelling to cover these wider, ongoing processes of social narration through digital means. In a more empirical sense, it may be questioned whether it is feasible to study a diverse range of narrative practices under a single rubric, but, within the context of the main arguments set out in this chapter, the generic term will serve as a useful shorthand for important overall trends that scholars, practitioners and policy-makers arguably need to heed. However, it should be noted from the outset that my use of the term differs somewhat from the more specific application of the term which originates in the community-based programmes developed at the Center for Digital Storytelling in Berkeley, California. From here, the term and the idea of digital storytelling has gained international currency as a

shorthand for personal narratives created, communicated and shared through digital means and training for the requisite tools (see Lundby, Chapter 1 of this volume). In line with ideals found in, for example, oral history movements of the 1970s to document and hence validate ordinary people's memories as a democratising corrective to official historical accounts, one of the co-founders of the Center, Joe Lambert, defines the aims of digital storytelling in the following terms:

> We need a sustained effort of digital literacy to maximize the potential of the current technologies, and to create an informed consumer who can help to shape the technologies of tomorrow. Our experience has demonstrated that project-based learning within the context of personal story greatly accelerates the learning process of multimedia technologies. (Lambert, 2006, p. 16)

Both in a more specific and in a wider use of the term, digital storytelling captures the processual perspectives, rather than the results or products, and in that sense the term is attuned to contemporary narrative practices. But, unlike the more sustained forms of community-based learning, the term digital storytelling, as I use it in the following pages, covers the multitude of ongoing, often ad-hoc and haphazard everyday narratives that people give shape to through their appropriation of portable devices and online services like blogs, wikis and social filesharing and networking sites like Flickr, Facebook and YouTube.

The term web 2.0 is a contested catch phrase for these services and their very rapid take-up in many parts of the world, especially by young people. As such, the term serves to illuminate particular aspects of an already complex and interlocked digitised media ensemble. These aspects impact on digital storytelling and they may be summarised as follows:

- web 2.0 services are a set of digital, semiotic practices since they operate through sign systems that today are 'born' digital or may be technologically digitised (text, numbers, sound, live and still images).
- web 2.0 services advance semiotic remixing and reorganisation of existing media expressions (genres, modes of address, graphic style) since all digital signs may be combined.
- web 2.0 services advance social co-production since the Internet and satellites facilitate immediate and ubiquitous social interaction.
- web 2.0 services advance immediate social exchange, participation and possible reflection since the Internet and satellites facilitate synchronous and continuous forms of communication.
- web 2.0 services advance recombinations of production and reception processes, since they facilitate easy appropriation of heavily templated

production software.

- web 2.0 services push boundaries between professional and lay defini-
tions of media output since they facilitate extended, and often syn-
chronous, sharing of output-in-the-making.

As is evident, none of these aspects constitutes inherently novel media practices; rather, I would like to suggest, it is the scale of uptake, the semiotic complex- ity and the immediacy and ubiquity of exchange that are the most significant features of web 2.0 in a socio-cultural sense. Scholars of mass media may focus on the ways in which the personal computer and the Internet serve to redefine audiencing because of the widespread use of inexpensive production facilities such as editing software and templated homepage tools. But print media offer similar tools of production in the form of writing, and media audiences have been potential media producers from the early days of writing letters to news- paper editors or to the so-called agony columns of women's magazines.

The decisive challenges brought about by digitisation in general, and web 2.0 services in particular, are of an institutional more than a technological na- ture, since the widespread use and immediate exchange of complex semiotic resources serve to question established forms of organising social meaning- making. For example, in the bloggosphere, professional editors and journalists are replaced as acknowledged gatekeepers of public debate and meaning-mak- ing by more invisible content and service providers such as News Corpora- tion, the owner of MySpace, and Google, the owner of YouTube. According to Sonia Livingstone and Magdelena Bober, focusing on children's Internet uses, 'a key point of contestation [in digital media cultures] is how far to devolve responsibility from the state to the industry (via self-regulation) or to the in- dividual citizen (here, mainly parents, although also children)' (Livingstone & Bober, 2006, p. 95).

For users of web 2.0 services, the lack of institutional power transparency in online and mobile forms of communication easily nurtures a sense of per- sonalised flows of interaction marked by freedom of expression and untram- melled participation. Regular users come to expect and contribute to digital forms of communication that involve a diversity of identity markers such as personal photos, likes and dislikes. Empirical evidence is still too scarce to validate the implications of these expectations and uses in a personal sense— for example, it is a contested issue whether or not blogging and social network sites operate as spaces for reflexive explorations of identity, or what Vincent Hevern terms explorations in 'the dialogical self' following Bakhtin (Hevern, 2004; see also Brake, Chapter 16 of this volume). More systematic forms of digital co-production such as video diaries and animation narratives do seem

to make room for more extensive identity work, if often short-lived and haphazard (see Nyboe & Drotner, Chapter 9 of this volume). On a larger canvas, web 2.0 services serve to advance users' assumptions that digital forms of communication involve 'the person' as producer, participant and performer in ongoing processes of co-construction and flexible modification, processes that often take a narrative form.

The paradox of digital competence formation

Seen from a scholarly perspective, there is an evident gap between many young end users' immediate appropriation of mobile and Internet services and the commercial, political and institutional priorities made by content and service providers (Selwyn, 2004; Livingstone & Bober, 2006). However, the social challenges following from the reorganisation of meaning-making processes go beyond issues of legitimacy and transparency. Fundamentally, the increasing range of communication channels available and the complexity of their uses help push social boundaries of knowledge formation. Established institutions such as the education system, the workplace and broadcast media increasingly need to demonstrate their position as loci of socially accepted discourses and legitimate meaning-making practices. We see a distribution of discursive sites—across different online communities; across broadcast, web-based and interpersonal forms of communication; and across ad-hoc networks and established organisations. One result of this redistribution is a renewed contestation of what counts as legitimate forms of communication and knowledge and which institutional frameworks best promote relevant forms of knowledge.

Paradoxically, this contestation of relevant forms of knowledge and knowledge sites coexists with a pervasive discourse that societies may increasingly be defined in terms of immaterial rather than material forms of production. Over the last two decades, contemporary societies have variously been defined as, for example, information societies, learning societies, knowledge societies and network societies (Masuda, 1980; Husén, 1986; Stehr, 1994; Castells, 1996). Irrespective of scientific traditions, these definitions focus on Information Communication Technologies (ICTs) as the crucial technological levers of future economic development and hence societal survival. In tandem with these theoretical deliberations, and indicative of their surmised implications, have been intensive economic, technological and political initiatives and interventions on a national as well as an international scale to help further what is perceived as a massive transformation from an industrial society to a society based on the immaterial forms of production whose vital tenets are the storage, formation,

processing and increasingly global communication of signs—be they figures, text or images.

The empirical validity of this transformation has been widely critiqued along with the underlying view that technologies are its neutral drivers (Robins & Webster, 1999; Garnham, 2000). Still, it should not be underestimated that the discourse of the knowledge society, to pick one of the most currently used terms, has had what Roland Barthes once termed a 'reality effect' in the sense that it has decisive commercial and policy implications, and in many parts of the world. Some of the important implications involve the approach taken to childhood and to children's competence formation. Since children are tomorrow's wage-earners and citizens, some of the most hotly debated issues have centred on the definition of the skills that are necessary to carry out those future functions: do children need specific ICT literacies that are different from those trained through print media such as the book? Must schools teach new forms of cooperation through virtual networks and distance learning? What are the challenges posed to adults in general, and teachers in particular, when new modes of learning and forms of organisation are required?

The answers to questions such as these are mostly provided by public and private stakeholders who play out different socio-cultural scenarios of the future while they speak to very real current tensions between proponents of established forms of literacy (reading, writing and numeracy) and proponents of new forms of literacy. The latter are often among the most optimistic advocates of the perceived social transformations brought about by offering 'one laptop per child', as MIT professors Nicholas Negroponte and Seymour Papert favour, or by paving the way for 'the information superhighway', a term that is attributed to Al Gore, former vice-president of the United States.

The debates on competence have had considerable, if conflictual, policy implications. For example, Singapore is currently reforming its school system to allow for more child-centred and creative work processes stimulated by virtual forms of collaboration and participation; while in the United States and most of Europe, the pendulum is swinging in the opposite direction: here policy-makers put increasing emphasis on national tests and on evidence-based learning along well-defined steps in order to counter what is perceived as over-permissive frameworks of education.

Within a European policy framework, the OECD is an important stakeholder. In 1997, the organisation launched a project to define key competences in knowledge-based economies and noted the three most important to be (1) interactive use of tools, (2) interaction in heterogeneous groups and (3) autonomous action (OECD, 2005). Evidently, digtial media are crucial levers for interactive use of tools, and in many parts of the world educational policies

favour such uses in attempting to integrate into the curriculum computer-assisted teaching, learning management systems and pupil evaluation of digital sources. In addition, I would argue, digital media may be crucial catalysts for the formation of the other two key competences. But, in order to substantiate that claim, we need to look to digital communication practices beyond the school walls.

One of the important implications of the dispersion of discursive sites and the contestation of knowledge formation is that school no longer holds a monopoly on future-directed competence formation. Thus, several studies demonstrate that young people's out-of-school uses of digital resources are more varied, more advanced and less task-oriented than are their uses at school (Livingstone & Bovill, 2001; Levin & Arafeh, 2002; Erstad, 2005; Arnseth, Hatlevik, Kløvstad, Kristiansen & Ottestad, 2007). Gaming, digital forms of communication and participation as well as programming and content creation are among the dominant, domestic engagements, many of which involve narrative interaction with unknown others such as is the case when users give shape to and act through avatars in Second Life or participate in Massively Multi-User Online Role-Playing Games (MMORPGs). Moreover, out-of-school digital practices draw on, for more than educational uses, other genres and media such as TV series and news, magazine entertainment and radio music channels.

Taken together, a good many of these more varied and more advanced media engagements may catalyse the formation of the OECD's key competences, namely, interaction in heterogeneous groups and autonomous action. Being able to interact in heterogeneous groups basically involves an ability to handle confrontations with otherness—manoeuvring between familiar and foreign elements without siding with either. Being able to act autonomously involves an ability to reflect on these practices so that one is able to modify future actions. Crucially, both of these competences will increasingly be formed in virtual communities of education, work and leisure.

Digital practices in out-of-school contexts confront users with social and semiotic complexities that they must be able to handle in order to remain users. Social complexity may mean being able to manoeuvre within digital communities of practice (Lave & Wenger, 1991), where some actors may appear unfamiliar and some actions initially strange. Semiotic complexity may mean being able to locate and recombine music, image and text so that the result seems 'right' for one's purposes (Gilje, 2008; Perkel, 2008). In both a social and a semiotic sense, then, many digital engagements act as resources for future competence formation. Unwittingly, many youngsters are busy rehearsing for their adult existence through digital storytelling in gaming, blogging, and

through multimodal editing of visuals, graphics and sound.

Digital divides as educational challenge

The rapid take-up of digital devices for storytelling in out-of-school contexts does not mean an even distribution of the resources needed for giving shape to narratives that are found relevant for the tellers and their potential audiences and co-participants. Recent studies of digital divides note the intimate connection to familiar fault lines in terms of class, gender, ethnicity, age and region (Fox, 2005; Peter & Valkenburg, 2006). Broadly speaking, the digital elites are young Caucasian people from middle-class backgrounds, with women having a slight critical advantage in terms of digital forms of communication such as phoning and blogging while their male counterparts are more avid gamers. These results confirm previous studies of new media technologies, and in three important ways: technological availability does not guarantee equal access; access to a particular media technology does not equal use; and, most important in the present context, use of particular media resources does not equal competence (Rogers, 1962; Buckingham, 2000; Livingstone & Bovill, 2001).

Unlike earlier times, however, it may be argued that digital divides of today are economic, social and political divides of tomorrow. This is because advanced handling of digital resources is key to future competence formation in globalised societies whose interconnectedness increasingly hinges on interlocking networks of media. Several studies note how this complex media ensemble serves to reframe the articulations of inequality both within and between societies so that symbolic exclusion for some segments becomes as important as material exploitation. For example, Scott Lash speaks about an 'underclass' which is excluded in both material and symbolic terms, and in a similar vein, Zygmunt Bauman speaks about first and second world inhabitants, defined not in terms of positions of place but of symbolic space and resources of articulation and action (Lash, 1994; Bauman, 1998). Manuel Castells extends this mode of reasoning to also include areas of cities and entire regions into what he terms a 'fourth world' (Castells, 1998). However, in noting that digital divides are basically social divides, Castells also stresses that education plays a key role both in the formation and the potential dissolution of these divides.

Education systems in democratic societies serve a dual function in that they operate as a primary means of social selection while at the same time being one of the only social sites of sustained learning across boundaries of age, class and gender. The ways in which competences are defined and deployed by education systems are therefore of vital importance to schools' abilities to mini-

mise digital divides that pupils bring to the classroom. How do schools today sustain and advance pupils' competences in handling the meaning-making resources offered by an increasingly interlaced media culture, so that they may be competent participants of tomorrow's societies? As an inroad into specifying new educational strategies in this respect, I will turn to two dominant conceptual underpinnings of these strategies, namely mediation and mediatization.

Mediation in education studies

Several schools of thought and theoretical traditions make claims to defining the concepts of mediation and mediatization, and greater conceptual clarity is certainly needed (see Couldry in Chapter 3 and Erstad & Wertsch in Chapter 2 of this volume). For my purposes, the conceptual correlations and contradictions between the two terms as they materialise in education studies and media studies, respectively, are of particular relevance for the simple reason that both of these areas of research inform current notions of digital competence formation. Attempt to unravel these conceptual relations are not made with an aim of demarcating fixed boundaries, since, in my view, the seeming conceptual untidiness is a welcome indication that both traditions speak to a common set of key empirical issues. These are to do with the constitutive position occupied by communicative practices that take shape through technological means, and to do with the possibilities of socio-cultural transformations brought about by these practices. What I hope to do, rather, is therefore to map out some key areas of tension between the concept of mediation and mediatization within the two traditions.

In education studies, the term mediation develops within a cultural-historical tradition of psychology in which human development is basically defined in relational and pragmatic terms as a social practice. With Lev Vygotsky as the acclaimed source of theoretical inspiration, scholars focus on the ways in which humans develop and act in the world and, in that respect, a key interest is placed on how links are made between subjects and objects, between inner states and external practices. Mediation is the term used for these bridges, and mediation comes about through the handling of tools as part of socially situated practices. These tools may be material, as in the case of cars and coffee machines, and they may be immaterial as in the case of sign systems.

Vygotsky termed immaterial tools of mediation 'psychological tools', and he saw the two categories of mediating tools as serving different functions. A material tool he defined as 'the conductor of human influence on the object of activity; it is *externally* oriented; it must lead to changes in objects. It is

a means by which a human external activity is aimed at mastering, and tri-umphing over, nature' (Vygotsky,1978, p. 55). By contrast, psychological tools 'are directed toward the mastery or control of behavioral processes—someone else's or one's own—just as technical means are directed toward the control of processes of nature. The following can serve as examples of psychological tools and their complex systems: language; various systems for counting; mnemonic techniques; algebraic symbol systems; works of art; writing; schemes, diagrams, maps, and mechanical drawings; all sorts of conventional signs; etc.' (Vygotsky, 1981, p. 137). Vygotsky, then, acknowledges all sign systems as psychological tools, although his own studies focused mostly on language as an interpersonal form of communication.

The categorisation of mediating tools, their relations and functions are among the most intensely debated aspects of Vygotsky's theories, and these debates have sparked important new theoretical developments, such as the more systems-oriented activity theory (Engeström, 1987), and socio-cultural theories specifying the role of immaterial tools such as print literacy for learn-ing (Scribner & Cole, 1981; Wertsch, 1985; Säljö, 2000). Not least, Roger Säljö has been instrumental in taking these professional interests in the direction of today's more complex range of tools for situated meaning-making through his theory-driven empirical studies of, for example, computer-assisted learning processes (Bliss, Säljö & Light, 1999).

But, while several learning theorists are very conscious of the way in which increasingly globalised, online media are instrumental in changing the ramifi-cations of learning, few venture into conceptual specification of what charac-terises the resulting meaning-making practices. The concept of mediation, as it is applied in current learning theories, has most to say about the interpersonal, social and institutional aspects of meaning-making through digital means. This leaves important limitations to our understanding of these practices, since we are in a poor position to answer what distinguishes these forms of meaning-making in relation to reading a book or listening to the radio, for example. We need a more precise conceptual exploration and understanding of what charac-terises digital meaning-making and its semiotic complexities.

Mediatization in media studies

The term mediatization derives from Jürgen Habermas' *Theorie des kommunika-tiven Handelns* [The Theory of Communicative Action] in which it denotes one of the modernising forces that act as constraints on deliberative forms of democratic participation (Habermas, 1987, p. 305). From the outset, then, the

term is closely connected to macro-level critiques of the ways in which particularly commercial media operate as social forces in modern societies, and it is tied to visions of transformative democratic deliberation. The term has since been developed in more conceptual and empirical detail by media scholars influenced by Habermasian takes on media sociology (e.g., Mazzoleni & Schulz, 1999; Hjarvard, 2004; Schulz, 2004). In that respect, the concept of mediatization makes no claims to more middle-range explorations of actual media forms, although Hjarvard does offer examples of empirical analyses that are loosely coupled to his conceptual understanding.

We therefore need to turn to theorisings that are more attuned to conceptualising meaning-making practices in complex and increasingly global and digitised environments. The concept of mediation seems no feasible alternative, and for two reasons: first, it focuses on meaning-making practices as social practices and thus offers no sustained understandings of what meaning-making entails in those environments (see Couldry, Chapter 3 of this volume). Second, mediation is a key term in learning studies, as we have seen, and hence its application in the present context is likely to obscure more than illuminate the possible learning resources involved in digital meaning-making practices.

One way of entering into a more concrete discussion about the properties of digital learning resources is to locate them in relation to one of the classical definitions of media, offered by James Carey (1989). According to Carey, media are both material artefacts and immaterial processes of meaning-making. Organising meaning-making is crucial to all media, be they analogue or digital. Media are particular technologies that facilitate the storage and modification, articulation and exchange of signs, be they text, images, numbers or sound. Signs are tools of meaning-making, and so media may be defined as meaning-making technologies. Media are material tools, and mostly commercial tools (books, television sets, mobile phones), and as such, media are like many other tools such as cars, toothbrushes and saucepans. But, unlike such object-like tools, media are immaterial tools of signification, of meaning-making. This dual definition of media as both material and immaterial tools places them at a particular cultural vantage point: media are selective cultural resources, in that they mostly require a bit of money, some free time and sometimes also some formal knowledge of the semiotic codes (reading, writing) as prerequisites of use. Media are also general means through which we may express ourselves and reflect upon the world; and they are means through which we may connect to other people, times and places beyond our immediate reach.

In line with the cultural-historical and socio-cultural definitions of cultural tools outlined above, Carey's definition of media operates with both material and immaterial properties. But, crucially, Carey defines media according

to both of these properties, thus avoiding the limitations found in concepts, mostly influencing learning theories, that distinguish between material tools through which we (inter)act upon the world, and immaterial tools through which we make sense of these practices. This dual definition facilitates our future thinking about digital meaning-making practices in relation to learning in two important ways. First, it addresses the need for specifying the ways in which different technologies give *semiotic* shape to particular forms of meaning according to their specific affordances (Gibson, 1977) and the ways in which these forms may mix in different constellations of image, sound and text. Second, it addresses the need for specifying the ways in which different technologies give *social* shape to particular forms of meaning, and the ways in which these forms are embedded within larger socio-cultural frameworks of legitimation and power.

Advancing meaning-making resources in education?

Here, I would like to suggest two theoretical approaches that go some way in following such a joint research perspective. One is multimodal learning and the other is media literacy. Both of these approaches revolve around new ways of defining and developing *literacies as particular meaning-making competences* geared towards emerging technological and social capabilities and constraints, and both address how literacies may impact on education in future.

Multimodality is a concept developed by the so-called New London Group whose primary figures are Gunther Kress and Theo van Leeuwen and which has clear affiliations to earlier attempts, for example within so-called New Literacy Studies, to investigate reading and writing as context-specific practices (Gee, 1991; Barton, 1994). From an intimate dependence on linguistic theory, the New London Group and their consorts increasingly seek to categorise how particular modes, or resources for meaning-making (image, movement, speech, sound-effects), may be combined according to the users' criteria of relevance. More interestingly, perhaps, these categorisations include how users design new acts of meaning in addition to the more conventional interest in practices of semiotic representation and interpretation (Kress & van Leeuwen, 2001; Kress, 2003). However, the wider social implication of these practices is dealt with in a more cursory fashion.

Proponents of media literacy have more to say on those matters. Media literacy is an old concept closely connected to didactic movements for the ad-

vancement of media education, movements that have existed with varying success and vigour in different countries since the formative days of popular film-going in the 1920s. David Buckingham is one of the most outspoken current advocates of media literacy. Taking on board discussions of literacies beyond the so-called three Rs, reading, writing and (a)rithmetic, he forcefully engages with the wider socio-cultural implications of learning cultures that have not only become more interactive, multimodal and dispersed across a range of media and sites, but which have also become increasingly dependent upon commercial content providers and distributors both in school settings and in out-of-school contexts (Buckingham, 2003, 2007). Like most other scholars of media education, Buckingham calls for critical engagement as a key component of training at school, and he cautions against celebratory assertions of content creation as a pedagogical panacea. Similar stances are adopted by other recent discussions of 'new' literacies, such as those on digital literacy (Gilster, 1997) and multiliteracies (Unsworth, 2001).

These perspectives reflect back on one of the key tensions involved in current practices of digital storytelling mentioned earlier, namely, that they are primarily exercised as voluntary and entertaining engagements in out-of-school contexts. On the one hand, learning through such practices is advanced by personal motivation and may involve spells of introspection and creativity, although less than technological optimists might lead one to expect—young people's portable and online practices are often of a fleeting and routinised nature (Livingstone & Bober, 2006; Brake, Chapter 16 of this book). On the other hand, most out-of-school media practices depend on uneven distribution of economic and socio-cultural resources and hence tend to reflect, and even further, existing divides of race, gender, class and region, as noted.

School is the most important institution in the formation and validation of competences for all. One of the urgent challenges facing educational policy-makers and practitioners is therefore to specify more precisely how literacy as a technologically mediated meaning-making competence should be defined and developed so as to minimise digital and social divides (Drotner, 2007). Furthermore, this challenge must be handled in a situation marked by the paradox that I hinted at in my introduction, namely, that sites and settings of learning are dispersing alongside the appearance of an intensified discourse on knowledge economies and knowledge societies. In short, rarely have societies been so obsessed with learning and knowledge formation, and rarely has it been so difficult to define the 'whats', 'hows' and 'wheres' of these processes.

With the risk of overly reducing organisational and substantive complexities, I would argue that in most westernised societies the current handlings of these tensions and paradoxes result in educational policies that currently

follow a functionalist updating of traditional literacy competences (the three Rs). E-learning, computer literacy (Turner, Sweany & Husman, 2000) and information literacy (Bruce, 1997) are among the 'hyphenated literacies' that are advocated and which fit the following criteria:

Aim	Efficient online collaboration and solution of well-defined problems
Means	The personal computer and the Internet (ICTs)
Technology	ICTs as stand-alone and transparent tools applied in order to reach educational goals
Substance	Integration of ICTs in all subjects
Pupil	Personalised learning styles for all pupils and in all subjects
Teacher	Technical guide.

Importantly, the criteria noted here focus on policy priorities and say nothing of educational practices. But with their functionalist focus they do seem to fit dominant organisations of learning in education with explicit power hierarchies between teachers and pupils, with clearly demarcated subjects, and with neat divisions of the school day. Such organisations of learning benefit pupils' trust in the familiar and the expected, features that seem important as cognitive bases for learning. The downside is that such familiarities rarely unleash bouts of creative energy or introspection which stem from confrontations with the unfamiliar and unexpected, elements that I have argued to be vital to future competence formation, and which are integral to the creation of digital narratives, for example (Drotner, 2007; Nyboe & Drotner, Chapter 9 of this volume). On a broader canvas, the current literacy definitions at school may ultimately constrain more advanced formations that are needed in the future.

Ambiguous literacies: narration, identity, reflection

Whether or not educational policy-makers and practitioners follow well-trodden paths or rise to new vistas in their various strategies and practices, they acknowledge that literacy, the handling of semiotic resources, is key to future competence formation. As I see it, we need a holistic, or synthetic, definition of literacy, encompassing all main semiotic modes and media, and involving aspects of analysis, production and collaboration. In this chapter I have charted some of the main arguments for such a definition. First, the handling of othernesses—people, places, practices—is a vital overall competence in the future

both in an economic, a social and a cultural sense. Second, the interlaced and complex media ensemble is a key catalyst for such competence formation, since it offers ongoing interactions with distant others through modes of representation, communication, creation and participation. Third, education plays a key role as a joint platform for resourcing all citizens, present and future, with the requisite literacies.

Evidently, these arguments bring us up sharply to the prevalent educational priorities in developing new literacies or reinvigorating old ones. To debate the possible routes of action would take me beyond the aims of this chapter (but see e.g., Coir, Knobel, Lankshear & Leu, 2007). Let me therefore limit myself to mentioning a valuable policy move in Europe, whose consequences are still too early to judge. In December 2007, the European Commission issued an official recommendation that all member states adopt policies to advance holistic media education that incorporates new and old media, analysis, evaluation and creation (Commission, 2007). The recommendation is based on a comprehensive report on current trends and approaches to the field in Europe (Media Literacy Expert Group, 2007). Given the Commission's prior commitment to functionalist understandings of e-learning and ICT literacy, this statement may be taken as an indication of wider remits for change.

Part of this change has clear commercial reasons. Self-regulation and co-regulation are measures eagerly advanced by online industries as a replacement for public regulation, and such measures need informed consumers in order to work (Livingstone & Bober, 2006). Still, the EU statement does offer a platform that public bodies such as education may also stand on and from which different perspectives on media literacy may be developed along the lines sketched above. As the contributions to this volume demonstrate, digital storytelling offers a richness of resources that may be mined as part of such developments. Storytelling practices, if sustained and guided, are important forms of identity work involving aspects of creativity, evaluation and possibly reflection, all of which imply handling of a range of semiotic and social othernesses. As such, digital storytelling is a goldmine for future competence formation. Still, by way of conclusion, allow me to point to two aspects for consideration if narrative practices are to form more sustained elements in media education, namely, the aspect of identity work and of reflection.

The more inclusive incorporation of identity work into didactic processes is a two-way process. As I have noted, it does offer pupils a new perspective on themselves and others that may be of use as a tool of handling othernesses. But, to speak with Foucault (1988), this management of the self is also a demand for ongoing regulations that fall back on the individual, so to speak, and from which there seems no outlet. As such, identity work as a didactic tool runs the

risk of internalising the functionalism that a more holistic media education sets out to counter in the first place. One route to pursue is to handle identity processes as aesthetic issues (see Nyboe & Drotner, Chapter 9 of this volume), because this perspective offers both pupils and teachers a joint performance space for *semiotic* action, a space that is not defined in psychological terms as too intimate, one-sided or problematic.

Handling othernesses through semiotic content creation, such as is the case in the more extensive forms of digital storytelling, may arguably incorporate elements of reflexivity, both of a personal and an interpersonal nature, and both as part of creation and participation. This begs important questions of the ways in which such elements are defined and subsequently handled by participants, teachers and evaluators. Although still sparse and inconclusive, empirical evidence suggests that the moments of reflexivity incurred by digital narration are similar to what Elisabeth and Ulrich Beck call hit-and-run reflexivities (Beck & Gernsheim-Beck, 2001), that is, brief spells of intuitive self-attention, which they claim may unleash human creativity and unforeseen actions that serve to renew social structures. This take on reflexivity is rather different from the reflexive autonomy popularised through, for example, Anthony Giddens' work (Giddens, 1991). Giddens' armchair introspection may be more attuned to academic definitions of the term, and its unquestioned acceptance and analytical application could therefore easily slide into denunciation or disregard of the more mundane examples of reflexivity involved in digital practices.

Telling research

As in all analytical endeavours, we should be careful to be as self-reflexive about our practices as we are of the practices we study. In further advancing scholarship on digital narration, one way ahead is clearly to advance more systematic interaction between socio-cultural learning studies and media and ICT studies. Hopefully, this chapter has indicated that fertile common ground exists for such interaction. Both traditions define meaning-making as socially situated practices that take place through the handling of culturally embedded tools. Equally, both traditions conceptualise these tools as catalysts of change, since tools are not only part of social practices but also partake in the formation of these practices.

When it comes to the more specific understanding of tools as catalysts of mediation or mediatization, differences begin to appear. Here, we need more sustained interdisciplinary exploration of how material and immaterial aspects are combined. In today's complex media culture, it does not seem quite suf-

ficient to uphold Vygotsky's distinctions between material and immaterial, or psychological, tools such as speech. As semioticians have been at pains to stress, signs have material properties too, and, as learning theorists note, material tools such as bricks and birthday cakes are culturally embedded. Still, some tools, the media, give shape to meaning-making between distant others across time and space, and we need to develop on the work of, for example, Mertz and Parmentier, advocating a joint perspective on the material as well as the immaterial, or semiotic, aspects of tools, and on Roger Säljö's concept of discursive tools (Mertz & Parmentier, 1985; Säljö, 2000). Digital storytelling offers a significant area within which such explorations may be advanced. In that process, much is to be culled from learning theorists re-reading audience studies, where they may detect a range of tacit learning processes in the everyday practices of reading, listening and watching. By contrast, recent methodological innovations within media and ICT studies such as virtual ethnography (Hine, 2000) may benefit from the longstanding discourses on observation and interaction in learning studies in general and design-based educational research in particular (Brown, 1992; DBRC, 2003).

The significant advancement of digital media tools in recent years has clearly enabled new forms of knowledge production, social networking, communication and play. Digital storytelling, in my view, touches at the heart of these processes, giving rise to new debates on civic participation and social inclusion, competence formation and identity work. Learning and media studies offer just some of the objects to think with, in Lévi-Strauss' famed sense, although it is hoped that closer interlacing of these objects will offer new and powerful tools for scholars as well as practitioners.

Notes

I would like to thank the participants of the international research project 'Mediatized Stories', directed by Professor Knut Lundby and funded 2006–10 by the Research Council of Norway, for constructive discussions and criticisms following an oral presentation on which this chapter is based.

1. It is debated whether the voice may be defined as a medium for meaning-making (Peters, 1999; Finnemann, 2000). The prerequisites for meaning-making are signs, and language is perhaps the most important sign system, permeating all aspects of human life. Language is, indeed, mediated in the sense of organising sound through physical means such as the tongue and larynx. In line with John Thompson (1995), I limit my definition of meaning-making media to technologies that allow for storage across time and space and hence for transfer of meaning-making practices between co-located social relations. Such a definition excludes oral narratives which operate as the prime empirical material for anthropological and psychological theories of narrative. An important challenge for media scholars is to

draw on such theories in attempting to outline ways in which meaning-making technologies in the more limited sense applied here both appropriate and accomodate oral narrative conventions.

References

Arnseth, H. C., Hatlevik, O., Kløvstad, V., Kristiansen, T., & Ottestad, G. (2007). *ITU monitor 2007: skolens digitale tilstand 2007* [ITU monitor 2007: the digital state of education 2007]. Oslo: Universitetsforlaget [University Press].

Barton, D. (1994). *Literacy: An introduction to the ecology of written language.* Oxford: Blackwell.

Bauman, Z. (1998). *Globalization: The human consequences.* Cambridge: Polity.

Beck, U., & Gernsheim-Beck, E. (2001). *Individualization: Institutionalized individualism and its social and political consequences.* London: Sage.

Bliss, J., Säljö R., & Light, P. (Eds.). (1999*). Learning sites: Social and technological resources for learning.* Oxford: Pergamon.

boyd, d. (2007). 'Why youth ♥ social network sites: The role of networked publics in teenage social life. In D. Buckingham (Ed.), *Youth, identity and digital media* (pp. 119–142). Cambridge, MA: MIT Press. The MacArthur Foundation series on Digital Media and Learning. Retrieved December 2007 from http//:www.mitpressjournals.org/toc/dmal/-/6

Brown, A. L. (1992). Design experiments: Theoretical and methodological challenges in creating complex interventions in classroom settings. *The Journal of the Learning Sciences, 2*(2), 141–178.

Bruce, C. (1997). *The seven faces of information literacy.* Blackwood: Auslib Press.

Bruner, J. (1990). *Acts of meaning.* Cambridge, MA: Harvard University Press.

Buckingham, D. (2000). *After the death of childhood: Growing up in the age of electronic media.* Cambridge: Polity.

Buckingham, D. (2003). *Media education: Literacy, learning and contemporary culture.* Cambridge: Polity.

Buckingham, D. (2007). *Beyond technology: Children's learning in the age of digital culture.* Cambridge: Polity.

Carey, J. W. (1989). *Communication as culture: Essays on media and society.* Boston, MA: Unwin Hyman.

Castells, M. (1996). *The rise of the network society. The information age: Economy, society and culture,* vol. 1. Oxford: Blackwell.

Castells, M. (1998). *The end of the millennium. The information age: Economy, society and culture,* vol. III. Oxford: Blackwell.

Coir, J., Knobel, M., Lankshear, C., & Leu, D. J. (2007). *Handbook of research on new literacies.* New York: Lawrence Erlbaum.

Commission of the European Communities (2007). *Communication from the Commission to the European parliament, the council, the European economic and social committee and the committee of the regions: A European approach to media literacy in the digital environment.* Brussels: The European Commission. Retrieved December 2007 from http://ec.europa.eu/avpolicy/media_literacy/studies/index_en.htm

Design-Based Research Center (DBRC) (2003). Design-based research: An emerging paradigm for educational inquiry. *Educational Researcher, 32*(1), 5–8.

Drotner, K. (2007). Leisure is hard work: Digital practices and future competences. In D. Buckingham (Ed.), *Youth, identity and digital media* (pp. 167–84). Cambridge, MA: MIT Press. The MacArthur Foundation series on Digital Media and Learning. Retrieved December 2007 from http//:www.mitpressjournals.org/toc/dmal/-/6.

Drotner, K. (2008). Children and digital media: online, on site, on the go. In J. Qvortrup, W. Corsaro, M.-S. Honig & G. Valentine (Eds.), *Handbook of childhood studies.* London: Palgrave Macmillan. In press.

Engeström, Y. (1987) Learning by expanding: An activity-theoretical approach to developmental research. Retrieved August 2007 from http://communication.ucsd.edu/MCA/Paper/Engestrom/expanding/toc.htm

Erstad, O. (2005). *Digital kompetanse i skolen: en innføring* [Digital competence at school: An introduction]. Oslo: Universitetsforlaget [University Press].

Finnemann, N. O. (2000). The new media matrix: The digital revolution of modern media. In I. Bondebjerg (Ed.), *Moving images, culture and the mind.* Luton: Luton University Press.

Foucault, M. (1988) *Technologies of the Self: A Seminar with Michel Foucault* (L. Martin, H. Gutman & P. H. Hutton, Eds.). Amherst: The University of Massachusetts Press.

Fox, S. (2005) *Digital divisions: The Pew Internet and American Life Project.* Retrieved August 2007 from http// www.pewinternet.org/PPF/r/165/report_display.asp

Garnham, N. (2000). Information society as theory or ideology. *Information, Communication and Society, 3*(2), 139–152.

Gee, James P. (1991) *Social linguistics: Ideology in discourses.* London: Falmer.

Gibson, J. (1977) The theory of affordances. In Robert Shaw & John Bransford (Eds.), *Perceiving, acting, and knowing.* Hillsdale, NJ: Lawrence Erlbaum.

Giddens, A. (1991). *Modernity and self-identity.* Cambridge: Polity.

Gilje, Ø. (2008). Googling movies: Digital media production and the 'culture of appropriation'. In K. Drotner, H. S. Jensen & K. C. Schroeder (Eds.), *Informal learning and digital media: Constructions, contexts, critique.* Cambridge: Cambridge Scholars Press.

Gilster, P. (1997). *Digital literacy.* Indianapolis, IN: Wiley Publishing.

Habermas, J. (1987) *The theory of communicative action: The Critique of functionalist reason,* Volume 2. Cambridge: Polity Press [1981].

Herring, S. C., Scheidt, L. A., Bonus, S., & Wright, E. (2004). Bridging the gap: A genre analysis of weblogs. *Proceedings of the 37th Annual Hawaii International Conference on System Sciences, 5–8 January,* 11 pp.

Hevern, V. W. (2004). Threaded identity in cyberspace: Weblogs and positioning in the dialogical self. *Identity, 4*(4), 321–335.

Hine, C. (2000). *Virtual ethnography.* London: Sage.

Hjarvard, S. (2004). From bricks to bytes: The mediatization of a global toy industry. In I. Bondebjerg & P. Golding (Eds.), *European culture and the media* (pp. 43–63). Bristol: Intellect.

Huffaker, D. (2004). Spinning yarns around a digital fire: Storytelling and dialogue among youth on the internet. *First Monday 9*(1). Retrieved August 2007 from http://www.firstmonday.org/issues/issue9_1/huffaker/index.html. Rpt. in *Information Technology in Childhood Education Annual 2004,* 63–75.

Husén, T. (1986). *The learning society revisited.* Oxford: Pergamon Press.

Kress, G., & Leeuwen, T. van (2001). *Multimodal discourse: The modes and media of contemporary communication.* London: Arnold.

Kress, G. (2003). *Literacy in the new media age.* London: Routledge.

Lambert, J. (2006). *Digital storytelling: Capturing lives, creating community* (2nd ed.). Berkeley, CA: Digital Diner Press.

Lash S. (1994). Reflexivity and its doubles: Structure, aesthetics, community, in U. Beck, A. Giddens, & S. Lash (Eds.), *Reflexive modernization* (pp. 110–73). Cambridge: Polity.

Lave, J., & Wenger, E. (1991). *Situated learning: Legitimate peripheral participation.* Cambridge: Cambridge University Press.

Levin, D., & Arafeh, S. (2002). *The digital disconnect: The widening gap between internet-savvy students and their schools. The Pew Internet and American Life Project.* Retrieved August 2007 from http//www.pewinternet.org

Livingstone, S., & Bovill M. (Eds.). (2001). *Children and their changing media environment: A European comparative study.* Mahwah, NJ: Lawrence Erlbaum.

Livingstone, S., & Bober, M. (2006). Regulating the internet at home: Contrasting the perspectives of children and parents. In D. Buckingham & R. Willett (Eds.), *Digital generations: Children, young people and new media* (pp. 93–113). Mahwah, NJ: Lawrence Erlbaum.

Masuda, Y. (1980). *The information society.* Tokyo: Institute for the Information Society.

Mazzoleni, G., & Schulz, W. (1999). 'Mediatization' of politics: A challenge for democracy? *Political Communication,* 16, 247–261.

Media Literacy Expert Group (2007). Study on the current trends and approaches to media literacy in Europe. Brussels: The European Commission. Retrieved December 2007 from http://ec.europa.eu/avpolicy/media_literacy/studies/index_en.htm

Mertz, E., & Parmentier, R. J. (1985). *Semiotic mediation: Sociocultural and psychological perspectives.* Orlando: Academic Press.

OECD (2005). Definition and selection of key competencies: Executive summary. Retrieved August 2007 from www.oecd.org/dataoecd/47/61/35070367.pdf

Perkel, D. (2008). Copy and paste literacy? Literacy practices in the production of a MySpace profile. In K. Drotner, H. S. Jensen, & K. C. Schroeder (Eds.), *Informal learning and digital media: Constructions, contexts, critique.* Cambridge: Cambridge Scholars Press.

Peter, J., & Valkenburg, P. M. (2006). Adolescents' internet use: Testing the 'disappearing digital divide' versus the 'emerging differentiation' approach. *Poetics,* 34, 293–305.

Peters, J. D. (1999). *Speaking into the air: A history of the idea of communication.* Chicago: Chicago University Press.

Robins, K., & Webster, F. (1999). *Times of the technoculture.* London: Routledge.

Rogers, E. (1962). *Diffusion of innovations.* New York, NY: The Free Press.

Schulz, W. (2004). Reconsidering mediatization as an analytical concept. *European Journal of Communication,* 19(1), 87–101.

Scribner, S., & Cole, M. (1981). *The psychology of literacy.* Cambridge, MA: Harvard University Press.

Säljö, R. (2000). *Lärande i praktiken: ett sociokulturellt perspektiv* [Learning in practice: A sociocultural perspective]. Stockholm: Prisma.

Selwyn, N. (2004). Reconsidering political and popular understandings of the digital divide. *New Media & Society,* 6(3), 341–362.

Stehr, N. (1994). *Knowledge societies.* London: Sage.

Thompson, J. B. (1995). *The media and modernity: A social theory of the media.* Cambridge: Polity.

Thurlow, C. (2006) From statistical panic to moral panic: The metadiscursive construction and popular exaggeration of new media language in the print media. *Journal of Computer-Mediated Communication,* 11(3), 667–701.

Turner, G. M., Sweany, N. W., & Husman, N. (2000). Development of the computer interface

literacy measure. *Journal of Educational Computing Research, 22*(1), 37–54.

Unsworth, L. (2001). *Teaching multiliteracies across the curriculum: Changing contexts of text and image in classroom practice.* Buckingham: Open University Press.

Vygotsky, L. S. (1978). *Mind in society: The development of higher psychological processes.* Cambridge, MA: Harvard University Press.

Vygotsky, L. S. 1981. The instrumental method in psychology. In J. V. Wertsch (Ed.), *The concept of activity in Soviet psychology* (pp. 134–143). Armonk, NY: Sharpe.

Wertsch, J. (1985). *Mind as action.* New York: Oxford University Press.

PART II

REPRESENTING ONESELF

'It's good for them to know my story'
Cultural mediation as tension

NANCY THUMIM

Introduction

This chapter focuses on one aspect of the 'broader field of mediations' (Martín-Barbero, 1993). Interviews and observations with participants, in the Museum of London's oral history project, *London's Voices* and BBC Wales' digital storytelling project, *Capture Wales,*[1] are drawn on to explore the cultural formations—expectations, views, experiences—of participants producing self-representations. The term 'self-representation' refers here to the construction of a text that represents the maker; this is of course related to many kinds of textual production: from readers' letters in newspapers, to audience emails displayed on television programmes, to blogs (Griffen-Foley, 2004), and indeed to the many contributions now taking place on the Internet, described by the term 'Web 2.0'. This chapter is specifically concerned with self-representations that are (1) produced as created pieces of work (as distinct from communications) such as photographs, poems, digital stories, and (2) made through collaboration between publicly funded institutions and members of the public. In what follows it is argued that *processes of cultural mediation* are constituted through

tensions in four areas: the purpose of the projects; the construct 'ordinary person'; the construct 'community' and; the definition and achievement of quality. It is suggested that understanding processes of mediation as constituted through tensions in these four areas shows precisely how complex any process of democratisation, either of or through media (Wasko & Mosco, 1992, p. 7, in Carpentier, 2007, p. 88), must be.

Processes of cultural mediation constituted through tensions in four areas

Processes of cultural mediation

Scholars have taken the concept of mediation in a number of directions (see for example, Martín-Barbero, 1993; Corner, 1994; Thompson, 1995; Silverstone, 1999; Fornäs, 2000; Couldry, 2006). These approaches have in common the use of the notion of mediation as an orientation which emphasises both the multiple factors that shape meaning, and the open-ended nature of meaning making. The concept of mediation builds on insights from research that recognises the roles of producers, texts, audiences and contexts in the production of meaning—even where not attending equally to each of these sites.

In this chapter 'processes of cultural mediation' refers to one dimension—within a much broader set of mediation processes—this concerns what participants bring to the production of their own self-representation in terms of abilities, expectations, understandings.[2] The notion of *processes of cultural mediation* involves a specific and purposeful use of the term culture, which does not intend to deny that cultural formations shape all aspects of the mediation process.

Tensions surrounding purposes

Individual participants in *Capture Wales* and *London's Voices* understand the purpose of their participation in the projects and the production of their self-representation, according to their own varied criteria. Some participants take up the opportunity to represent themselves because the process offered fits well with something they were already doing or wanting to do. For example, members of a reminiscence group already met regularly to share memories when they were invited to take part in *London's Voices*.[3] This group of elderly people found that the process of producing self-representations prompted memories

and the discovery of commonalities:

[Names have been changed to protect privacy]

Madge: You had quite forgotten. And when you talk about things, seeing how, erm 'Mandy' said 'oh yes I used to live there', we found we'd lived in the same road in just a little sort of square but we both, there were only about thirty houses there, yet you didn't know, you see. Lots of things came up, that was very interesting to us.

Interviewer: So that was an advantage of the actually talking all together?

Madge: In the group, in as much as that was yes. You see and then you found out where people had been born or married which we had no idea about so it interested us all everybody else's story.

Group interview, Reminiscence group *London's Voices*

For the project *16–19*, the museum invited a range of youth groups from across London to produce different kinds of self-representation for the dedicated *16–19* website. One youth worker's comments show how the project fitted with the already-existing purposes of the group:

Cause they were drifting at the time so they weren't doing anything, you know, they weren't at school, they weren't at college, they weren't really engaging in . . . many activities. Although they were still, occasionally still visiting their youth club. But apart from that, most of their time was not, erm, you know they weren't looking for a job, they weren't looking for college, it was just spent floating. So it was just trying, you know, it was really just to see whether or not this would sort of get them re-engaged . . .

Individual interview, Youth Worker *London's Voices*

This particular group participated because of the opportunity afforded by the photography project for the young people to take part in an interesting activity, and to learn a new skill:

Vijay: Basically you learn how to take proper good pictures, how to print them and everything.

[. . .]

Kimberley: I'm going to. My cousin is getting me work experience with one of his friends with photography and I want to go to college to do it now.

Interviewer: And that's since you did this project?

Kimberley: Yeah.

Group interview, Youth group *London's Voices*

Similarly many of the *Capture Wales* participants were motivated, at least in part, by the opportunity to develop specific skills. For example, participants were interested in learning how to use the computer programmes, Adobe Pho-

toshop and Premier, either for themselves, or, in some cases, also because they intended to teach these skills to others. Skills acquisition can be understood as contributing to the development of media literacy (Livingstone, Van Couvering & Thumim, 2005; Silverstone, 2007) and these participants' desire to equip themselves with these skills indicates a recognition on their part of the view that such skills are likely to be increasingly vital not only to active citizenship but also to employment opportunities (Rice, 2002).

London's Voices participants did not *use* 'new technologies', rather new technologies were used by the museum curators to collect and display the self-representations. In *Capture Wales* participants are trained in the use of new technologies, as well as new technologies being used to display the self-representations. Vaguely articulated notions about the promise of technology and the necessity to 'keep up' inform understandings of the purpose of the projects:

> *Sylvia:* I think more, for me, the key word is, it's 'new media'. This is a, we are going through a digital revolution, we may not be noticing it, but it is happening and it's the future.
> Group interview, participants in *Capture Wales* workshop

> *David:* Yeah I think it's a good thing. You can't stop technological progress anyway, can you? Really it's unstoppable isn't it, you know, that technology is going to take place anyway.
> Individual interview, *Capture Wales* participant

Further, for some participants, facilitating the public's use of new technology is seen as fitting for the BBC, a public institution:

> *Sylvia:* And I think because, looking at the future now it's, it's not just TV and radio anymore. I mean the internet is probably the most powerful communication device we have since the invention of the telephone and that this is just the beginning of, it's looking towards the future as well, they're setting a great foundation for the future. Because I believe that this is the way broad, public broadcasting is going to go. Because it's still broadcasting, it's just with a different media. So, to me, it's new media and the BBC have to be pioneers in that because they always have been.
> Group interview, participants in *Capture Wales* workshop

There is the notion that it is increasingly important to have the skills to use new technologies; there is the view that new technologies make it possible for there to be audiences for the self-representations who are separated by time or by space. Audiences are imagined on a global scale—some participants men-

tioned the pleasure of hearing from people around the globe who saw and re-
lated to their digital story. And audiences are imagined that do not yet exist—
future audiences: the ability to imagine audiences of the future rests on the
(familiar) assumption that the promise of digital technology is that these self-
representations will be 'there' forever—it seems then that participants want a
representation of themselves to be 'there' forever. For some elderly participants
in *London's Voices*, new technology is almost the stuff of science fiction:

> *Pam*:　　　He's taken a copy of what I've, you know, VE day, what I said about VE
> day. But he could do the rest.
> *Poppy*:　　Can he bring it up on the website and get it?
> *Pam*:　　　Yes. Yes.
> *Poppy*:　　Yes, cause you've only got to tap in that number haven't you, the w w w
> dot, if you've got the proper equipment. And that's all over the world isn't
> it?
> *Interviewer*: mm.
> *Poppy*:　　I mean I was in New Zealand and I mean they could've done it there.
> It's absolutely extraordinary how once it's on that website it's there for
> eternity it seems.
> <div align="right">Group interview, Reminiscence group London's Voices</div>

These comments foreground the question of whether, and where, 'new' char-
acteristics of digitisation are actually experienced, and commented on, by par-
ticipants. As the above excerpts illustrate, participants employed a familiar
discourse about the onward march of technological development (see, for ex-
ample, Jankowski, 2002).

While the Internet provided the exhibition space for many of the *London's
Voices* projects, participants in the reminiscence group focused in some cases on
the process of speaking to each other about their memories, and in some cases
on learning skills.

While some comments conjured up imaginary audiences in the future as
an important reason for representing oneself, others viewed the projects as
entirely private and individual:

> *Maria*:　　Ask how people, on the workshops experience, rather than the motiva-
> tion of the BBC. I think, for me, I haven't even questioned that, I've just
> focused on how it's impacted on me and my experience of it. You know,
> rather than you know, the most obvious thing would be to, you know,
> portray anyone who takes part in a workshop as being some sort of victim
> of some . . . agenda of the BBC.
> <div align="right">Group interview, participants in Capture Wales workshop</div>

For Maria the production of her self-representation was an important private

activity, facilitated by the BBC; she did not have strong thoughts about using new technology to represent herself in a public space to a contemporary or a future audience. In a similar vein, some participants in the projects talked about making a record for private use. Here, the making of the self-representation is spoken of as the making of a kind of (technologically) updated family album. For example, Vikram, a participant in *Capture Wales*, spoke in his interview of the opportunity the workshop gave him to delve into family history and, by that route, also personal identity,[4] and Rebecca explained that it had not even occurred to her to think about her digital story being exhibited in public:

> Yeah it was much, much more for me. Something I wanted to do for myself, yeah. I mean I didn't even think about it being on the website and people viewing it.
>
> Individual interview, *Capture Wales* participant

For participants who spoke about their participation in these terms, self-representation in *Capture Wales* or *London's Voices* provided an opportunity to make something whose important purpose was private—viewed in this light self-representation is not about connecting with others.

However the experience of hearing other people's stories in the intimate workshop setting was also seen as important; for example, Eric, a participant in the *London's Voices* project Holidays of a Lifetime was dismissive of the exhibition part of the project:

> *Eric*: Yeah I remember there was one guy who had a map of a city, New York?
> *Unidentified participant*: Yes that's right, yes.
> *Eric*: I thought that was fascinating.
> *Unidentified participant*: Yeah yeah.
> *Eric*: I mean he told us of the, what was it, the hostel or something where he stayed
> *Unidentified participant*: Yes.
> *Eric*: Something like that. You know memories like that I'll take with me rather than the, the actual . . . exhibition, whatever it was.
>
> Group interview, Holidays of a Lifetime, *London's Voices*

For Joanna, a participant in a poetry writing group, part of the *16–19*, the *London's Voices* sub-project, the fact that her work was exhibited on the internet, her name appearing on Google, provided a thrill, but this was about impressing friends, not a wider unknown audience:

> *Joanna*: Yeah. I was at school and we were in IT and I typed in my name on Google and it came up and everybody was like, 'oh my gosh'.
>
> Individual interview, *London's Voices*

Often, as the above examples of Eric and Joanna illustrate, the appeal of the production and display of self-representation is in the opportunity it provides for communication and connection to people in the local, offline, material here and now.

Some participants saw the purpose as giving the public institutions access to their stories:

> *Interviewer*: So you were invited, and did you think it will be good, it will be interesting to learn the technology or just you would like to go and see.
> *David*: No the most important thing I would have thought, that it was . . . good for them to know my story, not for me to learn the technology
> Individual interview, *Capture Wales* participant

The way some participants speak in interview about the importance of their own 'stories' fits into a discourse about authenticity, whereby the authentic is understood to be reached through 'real', and personal, experience (see, for example, Dovey, 2000; Corner, 2002; Renov, 2004).

Self-representation is also understood in more explicitly political terms, thus participants talked about having a voice and 'being heard', suggesting that the process of taking part in the projects afforded them valuable recognition of their point of view and experience. It seems a short step to assume that the result of 'having a voice' might be some form of social change, or that 'having a voice' in itself constitutes pressure for social change. After all, the phrase 'having a voice' comes from a popular discourse about democracy. Thus, the young people who participated in one of the *16–19* projects as part of *London's Voices* explained that they took the opportunity afforded by participating in the photography project to show what needed to change in their run down local area:

> *Kimberley*: No, it had to be about our local area but what we wanted to do. But we seen it as like how we wanted it to change. We like, we seen it like as we're showing the bad things what we want to change.
> *Interviewer*: Ok.
> *Clifford*: To improve our area.
> *Kimberley*: Yeah, to improve it. So we were showing the good things that's like changed and then the bad things that need to be changed.
> Group interview, Youth group, *London's Voices*

Of course, the Museum of London cannot propose to regenerate the area of London where these young people live. This raises the question of whether self-representation—'having a voice'—takes place instead of change, as the youth worker for this group of young people put it:

I think young people in this area are probably sort of growing used to the fact that, you know, it is probably more in vogue now for people to go out and ask young people what they think, it's probably not yet completely in vogue to then go and act on it. But they're at least now asking the questions.

<div align="right">Individual interview, Youth Worker, London's Voices</div>

Vikram, a Capture Wales participant, hoped his digital story might prompt people to reconsider their attitudes to refugees; while participants in London's Voices hoped the project would counter stereotypes. Unsurprisingly, it was members of minority groups who tended to express these kinds of views.[5]

Tensions surrounding the notion 'ordinary people'

The participants in Capture Wales set out to distinguish their digital stories as 'different' from what others had produced. The following comment exemplifies this tendency:

> Violet: We saw all the efforts that other people had made and we were told to look on the website, but I thought I'd prefer not to because I didn't want to be influenced by other people's . . .
> Interviewer: Mm.
> Violet: stories, I wanted to make mine as original as I could.

<div align="right">Individual interview, Capture Wales participant</div>

Violet's implication that the 'other people' who make digital stories are 'ordinary', but that they themselves are not is often implied by participants; in the two Capture Wales workshops observed, everyone wanted to make distinctive digital stories.[6] We are reminded of the paradox at the heart of the notion of the 'ordinary', as discussed by Highmore: if everyone considers their experience as unique and extraordinary, and by definition each individual's experience is unique, then the notion of the 'ordinary person' is destabilised (Highmore, 2002).

Conversely, participants perceived each other's lives as extraordinary as, for example, Rebecca, a Capture Wales participant, observed in an interview:

> It was quite interesting, one lady was from Pakistan and she'd come here when she was 15, had an arranged marriage and she actually was more shocked at my parents' green shed, and I was so shocked at her story and she was really shocked at mine and I thought, well mine's not half as shocking as yours but [laughs] she seemed to think it was and I mean that was quite interesting, the sort of feedback you get from the other people.

<div align="right">Individual interview, Capture Wales participant</div>

Self-representations deliver everyday experiences and while these are all, always, unique, at the same time there are universal aspects to these stories. In some of the interviews the participants explicitly invoked the notion of 'ordinary people' to explain what the stories were. To return to David, the following comments from his interview show him knowingly invoking and destabilising the notion of the 'ordinary person':

> David: At the beginning is the real family with the usual groups and the usual graduate thing and all that and all that and all that. And then you change it completely then. The second family is got to be different because that's where they get you the space isn't it.
>
> [...]
>
> David: Yeah, yes, it is, showing an ordinary family, and showing, you know, where is he then, well he's out there with the other family, you know [laughs].
>
> Interviewer: [laughs]
>
> David: You know, out of the way kind of thing [laughs].
>
> Individual interview, *Capture Wales* participant

As this excerpt illustrates, the participants both see themselves as 'ordinary people' and, at the same time, absolutely do not see themselves as 'ordinary people'. Participants define themselves, sometimes invoking this notion strategically where it is useful to them to do so. And yet, we must remember that the framing of so many self-representations by members of the public does function to construct the 'ordinary person'. Tension around the notion of the 'ordinary person' is demonstrated, for example, by the young people's reaction (discussed below) to the museum display of their photographs in the *16–19* showcase event which displayed those photographs on a TV in a corridor. Thus, the definition 'ordinary' is not a stable and unchanging one but, rather, one that always comes undone.

Vikram[7] shows how the process of producing his self-representation led to his delving into, and becoming absorbed by, family history and personal identity:

> Vikram: But I'd sort of told the story from my Grandmother's point of view yeah.
>
> Interviewer: Mm.
>
> Vikram: Somebody who I'd never met, but who I then met really through that. So it was sort of beneficial, you know. I mean okay, the BBC got a little story out of it but for me it was much bigger. Much bigger, because I, I then learnt so much about her, I then got into doing our family history also.
>
> Individual interview, *Capture Wales* participant

Vikram shares this interest in family and identity with other participants in

Capture Wales and so, in that sense, it marks him as 'ordinary'—like others in Wales. Exactly at the same time, however, the content of Vikram's particular concerns marks him as extraordinary. Here, I suggest that there is a simultaneous undoing and constructing of the notion of the 'ordinary person', even though the term itself is not used. Vikram shows himself to be 'ordinary', and seeks to encourage empathy and thoughtfulness in the Welsh population/wider audience, on the basis of this shared 'ordinariness'; at the same time, he distinguishes his experience from the rest of the population by virtue of its particular content.

Young people who participated in the *London's Voices 16–19* project, and who live in a deprived area of London, also playfully address media representation and, I think, claim their 'ordinariness' against the ubiquitous foregrounding of racial difference in media representations:

> *Kimberley*: This is 'the difference between black and white'. [*Pointing to a photograph of two boys—one black and one white—sitting on a wall with graffiti in the background,] Laughs.*
> *Interviewer*: What is the difference?
> *Kimberley*: I'm joking, that's my brother. And then there's the graffiti.
>
> <div align="right">Group interview, Youth group, <i>London's Voices</i></div>

Here Kimberley plays with me, the interviewer. In the above interview excerpt, Kimberley, a participant in the *London's Voices 16–19* project, describes one of her own photographs. She employs a slogan which invokes those found in mainstream media representations: 'the difference between black and white'. When asked to elaborate, Kimberley shows that she had me fooled: 'I'm joking'; she undermines the kind of labelling she has referred to by humanising the people in the photograph, implying by her comments that such a label could only be a joke. In this way Kimberley challenges this kind of media discourse and, indeed, anyone who might take it seriously.

Without actually using the term 'ordinary people', participants claim their ordinariness, and uniqueness, and counter media representations, and this insertion into mainstream media representation and media discourse makes self-representation an important contributor to processes of democratization both of and through the media (Wasko & Mosco, 1992, in Carpentier, 2007).

Tensions surrounding the notion of 'community'

When members of the public are invited to represent themselves in *Capture Wales* and *London's Voices*, they do so as individuals. However, both *Capture*

Wales and *London's Voices* construct representations of communities through bringing together individual self-representations in the displays. These individual self-representations are generally made in group settings and so, to some extent, emerge from the interactions between individuals. Indeed, the group interaction in the workshops is described by those involved in digital storytelling projects as 'community building', a key aspect of the digital storytelling form (Lambert, 2006). In *London's Voices*, the museum worked with already existing groups that they referred to as communities. This 'community-building' intention on the part of the producer is noted by participants:

> *Interviewer:* So you feel like you got to know him quite well now.
> *Kimberley:* Yeah.
> *Interviewer:* More about his life and stuff.
> *Kimberley:* Yeah. Cause we went into like a half an hour's conversation about one thing, so. . .
> <div align="right">Group interview, Youth group London's Voices</div>

> *Interviewer:* So but do you, as a more general user of the BBC, do you think it's something you would hope that they would continue to do, more people would get the chance to do, or?
> *Violet:* Well it does in a way bring the community together, which is really what the BBC's about I suppose, isn't it.
> <div align="right">Individual interview, Capture Wales participant</div>

At the same time the self-representations are of individuals: individual members of the community, the workshop, the local, or the ethnic group. In these projects individuals represent themselves, and those self-representations are located in/come out of, what project producers/policy makers/cultural commentators describe as 'communities'.[8]

'Community' functions as a uniting term: as one of the participants, Amy, who is herself a community arts worker, put it:

> I was going, and that's the whole other thing about the project is that everybody is equal. And that's the whole thing about community actually. We're all equal—in the community we're equal.
> <div align="right">Group interview, participants in a Capture Wales workshop</div>

But, as these interviews attest, there is not *one* united community, rather people understand themselves as members of distinct communities, and indeed the notion of community is predicated on exclusion (Bauman, 2001). Further, in a similar way to what I have described as taking place with the concept of 'ordinary people', the concept of 'community' is broken apart by the uniqueness of the individual self-representations that are brought together under that label:

So who can legitimately speak for whom and how can the interests of the least powerful and most marginal be represented as well as the interests of the most articulate? (Mayo, 2006, p. 394)

In the sphere of cultural representation (as opposed to political representation), the facilitation of self-representation goes some way towards addressing the problem Mayo raises here of 'who can legitimately speak for whom' (ibid.). The individual members of the groups taking part in *London's Voices* and *Capture Wales* represent their own, individual experiences and points of view. But, at the same time, once the self-representations are produced and displayed, they might well be read (by a wider audience) as standing in for wider communities, whose experiences these self-representations appear to represent. So while the problem of who speaks for whom in a community is not resolved, it *is* raised in potentially productive ways.

When we look at the way participants talk about producing self-representations as part of *London's Voices* and *Capture Wales*, their comments suggest positive aspects; for example, members of an Asian women's group who participated in the *London's Voices* project, *Holidays of a Lifetime*, said that they were proud to represent themselves to 'the public':

Chendani: So when the exhibition was held in ****** also we did go when the opening ceremony was there. Which was a thrill, really, really nice. Our name in the book our displays on the, on the board, her items.
[Everyone agreeing]
Chendani: It was really nice.
Interviewer: So tell me why it was nice, what, how did it make you feel?
Maya: We felt proud that our things have been shown . . . to the public. And our stories have been shown. People are there, they'll come and read the stories, whatever life stories and . . .
Kesar: Yeah people read our poems, people read our stories.
Chendani: We are recognised, you know, by the public [*laughs*].
Kesar: Because that is, it's our name, it's written down [*****] . . . Asian . . . women's group, so we feel proud. We achieved something.
[Murmurs of agreement]

The validation that the women speak of in this excerpt seems to lead participants to feel that they are a legitimate part of 'the public', and yet they do not say this explicitly; what they say actually distinguishes them from that public: 'our things are shown to the public' and 'we are recognised by the public'. Throughout the interview, the women make comments that show that they consider themselves a group (a community) outside of the British Public, which they present as a unified whole in their discourse. At the same time, they

claim their place as part of that public, in that they feel that their participation in a project like *London's Voices* legitimises their voices in public. Ideas of community as local, as ethnically based, as national, work to undermine the coherence of the notion of community. There is a tension in how the notion of 'community' works in these projects to highlight, to allow, and even to celebrate, difference on the one hand and to emphasise commonality on the other. The notion of community raises contradictions, ones which it is important, and useful, to bring into the light.

Tensions over how to define and achieve quality

In the interviews with participants in *London's Voices* and *Capture Wales*, quality is ascribed to production processes and/or outcome. Some participants emphasised the quality of the process of production, even to the extent where they were completely disinterested in the outcome:

> *Madge*: Amanda asked us would we be willing to do it. And we all said we would. And we found it very interesting in as much as it brought back. This is a reminiscence group.
> *Interviewer*: Mm.
> *Madge*: And it brought back reminiscence that we thought we had forgotten. You see she starts to ask, well, when were you married or when were your children born or what job did you do, and all that sort of thing brought things back that we had not thought of for years.
> *Unidentified participant*: No never think . . .
> *Madge*: So it was sort of therapeutic in a way, to us, as well as helping her to do her project.
>
> Group interview, Reminiscence group, *London's Voices*

For this group of participants, their evaluation of the quality of the experience rests on their enjoyment of, and interest in, the process by which the self-representations were produced, note Madge's comment: 'helping her to do her project'. Some group members said that they would have liked to spend more time with the museum curator who was working with them on their reminiscences, but this was not in regard to any particular desire to improve the quality of the outcome but, rather, because they enjoyed the process.

Participants across the projects noted that the process was often extremely emotional and in some cases actually upsetting as well as rewarding. People talked about the process as being therapeutic; participants described the impact of hearing fellow group members' personal stories as well as the time spent thinking about their own in this light.

For other participants producing self-representations, quality of process is emphasised as important but in order to produce high quality outcome. Thus, participants in *London's Voices 16–19* expressed appreciation at working with professional photographers and writers. Similarly, participants in *Capture Wales* repeatedly emphasised the process and talked about the quality of the expertise available to help with the production of the self-representations.

Some participants linked quality of expertise with quality of equipment. This view fits with the producers' intention to use the highest quality equipment and expertise in order to create both the highest possible quality experience of process and the highest quality outcome.

Other participants emphasised that the quality of the process raised the value that they saw attached to their efforts, through the ways in which the processes culminated in different forms of display. In this way, quality of process is linked to quality of outcome. Members of an Asian women's group spoke proudly of the exhibition in which their self-representations were displayed in the local library; clearly the outcome was an important part of the process for these women, because it was the culmination of being listened to, first by the museum personnel, and then by a wider public. Participants in *Capture Wales* also drew particular attention to the screening at the end of the workshop, in which their self-representations were displayed formally to workshop members, friends and family. The *Capture Wales* participants in this particular workshop felt valued by this process, and its formal execution was seen as another sign of the quality of the process.

Conversely, some participants experienced the outcome as not living up to expectations. For instance, some participants in *16–19* were disappointed by the showcase event in which their self-representations were displayed at the Museum of London:

Clifford: A normal TV with about five chairs for people to sit and there was about thirty people.
Interviewer: And whereabouts in the museum was it, when you come in the museum?
Clifford: When you come, go right, it was just there.
Interviewer: That sort of entrance.
Kimberley: In the corridor like no one even cared about us. They didn't even put us in properly, just in the corridor.
Clifford: I thought our pictures were gonna be on the wall.
Kimberley: That's what I thought. it wasn't . . .
 Group interview, Youth group, *London's Voices*

It is not that the museum curators ever promised a formal exhibition of the young people's photography, in a main gallery of the Museum of London. The

showcase event was always intended as a celebration of the process, and as a launch for the *16–19* website, which was to be the main outcome of the *16–19* project. However, from the point of view of these participants, they were learning professional photography and associated the quality of the display with professionalism. They recognised that their photographs were displayed in the museum as, to borrow the BBC phrase, 'amateur content', and found this disappointing.

While we might regard this wish for a formal exhibition of quality prints of their work in a proper gallery space as unrealistic, it is also possible to see this view as the logical progression of the idea that members of the public are told that their views are important, and their self-representations are being taken seriously. This complaint, even if it is a wilful misunderstanding on the part of these young people, does actually represent a challenge to the linkage of 'ordinary people's' self-representation with a lesser quality (in terms of production values). Moreover, this challenges their physical and symbolic location as 'ordinary people' (Couldry, 2000) and shows people wanting to take the idea that they have been valued, further.

Participants also thought about quality in terms of outcome, in the more familiar sense whereby quality is associated with high production values. Participants in *16–19* discussed the gradual improvement of the quality of the photographs and writing that they produced as they became more experienced:

> *Interviewer:* And then did you read them to each other and change them and . . .
> *Joanna:* Yeah. Like we evaluated them and all the other group members helped us like to make it better.
>
> <div align="right">Individual interview, London's Voices</div>

In this way the participants associated the quality of the outcome with the skills they developed in making the self-representation. It was striking that many participants felt they could have produced a 'better' self-representation if they had had a second opportunity, now that they had some experience in doing so, and had developed the necessary skills—technical, intellectual, emotional, etc.—but also, they said, in terms of now knowing 'what was required'. That is, we could say, participants had learned some of the necessary skills to produce texts conforming to the genre of self-representation.

Quality of outcome is not only associated with people's abilities to master technologies but also with the capabilities of the technology per se. Thus particularly IT literate participants in *Capture Wales* talked about the 'poor quality' of the shorts viewed through RealPlayer on the Internet and saw the BBC website's reliance on RealPlayer as a drawback. For other participants in *Capture Wales* and *London's Voices*, the technology presented a barrier, in terms of

problems of access and ability to use. Moreover, it was clear that some people do not use the Internet, have no interest in doing so, and would prefer to view the shorts on television, implying that the 'quality' of the television viewing experience was preferable. This lack of interest in using new media technologies echoes other research findings (see, for example, Haddon, 2000; Selwyn, 2003).

Quality is also understood as being inherent in the *content* of the self-representation, which is understood as the property of the person making the self-representation:

> *David*: But they can be worried about their stories now and again.
> *Interviewer*: Yeah?
> *David*: Because if you're looking for the quality story, they don't come very often. Because . . . they're like leaves on a tree, they're all the same, but they're all different.
> *Interviewer*: Mm.
> *David*: But, er, some particular leaves will stand out from the other leaves.
> Individual interview, *Capture Wales* participant

In this account, the ascription of quality changes direction. That is, quality is not about the production of the self-representation, and the way experts facilitate this; instead, quality is innate to the self-representation—coming from the raw material provided by the participant. This takes the notion proclaimed by the institutions—that there is so much of value in people's experience—and suggests that, in amongst all these 'ordinary' accounts, there will be some material of sufficient quality to compete with the rest of BBC content. What is notable is the way in which this refuses the generic boundaries of self-representation in a similar way to the refusal expressed in the disappointment of some of the participants in *16–19*, discussed above.

Conclusions: Self-representation and democratic potentials

The foregrounding of personal, experiential perspectives unites the self-representations produced in *Capture Wales* and *London's Voices* with self-representations in other forms, for example, personal webpages (Cheung, 2000); phone-ins (Coleman, 1997); talk shows (Livingstone & Lunt, 1994); reality TV (Van Zoonen, 2001). In some cases, people participated in *Capture Wales* and *London's Voices* precisely because the process afforded them the opportunity to speak—and think—about personal experience. This value placed on

personal experience in public recalls Van Zoonen's argument that the visibility of 'humdrum experience' in public is valuable, because it changes the bounds of what is an acceptable part of public discourse (Van Zoonen, 2001).

While these projects can be understood as part of a much wider shift in terms of what is considered to be appropriate public subject matter, it does not follow that the division between what is deemed public and what is deemed private, subject matter is being challenged. That is because, first, private subject matter is associated with the genre of self-representation. Second, private subject matter is associated with the constructions of 'ordinary people' speaking from, and/or located in, 'communities'. Finally, private subject matter is associated with texts that identifiably fall within the genre of self-representation.

Thus, while the self-representations explored in this chapter contribute to a widening of what is deemed worthy of public exhibition, at the same time, the question is raised as to the implications beyond representation, of this change in public subject matter. Carpentier makes a distinction between participation 'in' and participation 'through' the media, and argues that participation *in* the media allows citizens to be active in daily life and to exercise their right to communicate, while participation *through* the media, he suggests, '[. . .]allow[s] people to learn and adopt a democratic and/or civic attitude, thus strengthening (the possible forms) of macro participation' (Carpentier, 2007, p. 88). In a related discussion, Livingstone suggests

> The resources, the competences, the motivations which lead people to participate in public draw—in a manner little understood—on the lived experiences and activities, the conditions and constraints, the identities and relationships of people in their status as private individuals. In other words, rather than denigrating certain kinds of sociality as 'less than public'—as pre- or proto- or quasi-public—we could ask, what does it take for people to participate in public, what does the public require, what are its preconditions? (Livingstone, 2005, pp. 28–29)

Livingstone is talking here about the audience in terms of their activity as private individuals; she goes on to cite family discussions as an example of where opinions are formed. I am deploying Livingstone's argument here in a slightly different direction, to suggest that we should not dismiss the self-representations produced because they always come from an experiential perspective and focus on personal experience. The implication of both Carpentier's and Livingstone's remarks for my argument, is that the audience activity of producing self-representation *could* indeed lead *from* the personal *to* the public. However the value of public funding to facilitate and produce self-representations by members of the audience does not only lie in the potential there is for leading to action in public, or changing the status of private subject matter, or building

skills, though clearly all these are real benefits. The research presented here suggests that self-representations are of value because they are a different kind of media output from that produced by professionals, and their existence provides an example of how media and culture can be used in different ways, *to different ends,* and by different people. While the fact that individuals perceive value in making self-representations is evident in the explosion of so-called unmediated self-representations described by the term Web 2.0, we should remember that participation in Web 2.0 requires particular levels of media literacy in terms of access to, and ability to use, the Internet.

As this chapter has shown, contradictions appear in all of the self-representations discussed here. I suggest that these contradictions produce tensions which are intrinsic to the processes of mediation, shaping the self-representations produced by public institutions in the cultural sphere. There are tensions over the purpose of the institutions, inviting, facilitating, producing and displaying self-representations; tensions surrounding the invocation of the 'ordinary person'; tensions surrounding the idea of community and, tensions over how to define and achieve quality. However, the observation that, in the examples of the public institutional invited projects discussed in this chapter, processes of cultural mediation are constituted through tensions over purposes, ordinary people, community and quality, suggests that while the hope that forms of self-representation are an exciting development for democracy can never be simply and finally arrived at, such hopes are justified not least because of the evident value of these processes to individual participants and therefore arguably to all of us as citizens.

Notes

1. *Capture Wales* is a digital storytelling project run by BBC Wales' New Media Department, and Cardiff University's Centre for Journalism Studies. The project used and developed the model developed by the Center for Digital Storytelling in California, which first coined the term Digital Storytelling. The project began in 2001, fully funded by the BBC initially for three years; the project is ongoing. The *Capture Wales* project teaches people to make short 'digital stories' for exhibition on one or other of the two *Capture Wales* websites (English language, and Welsh language) which can be found at http://www.bbc.co.uk/wales/capturewales. The Museum of London's *London's Voices* project was a three-year project run by the museum's oral history and contemporary collecting division and funded by the Heritage Lottery Fund. The project began in 2001 and consisted of eighteen small projects which experimented with using the museum's existing oral history archive in new ways, and which built on who is represented in that archive, and in the museum more generally. The *London's Voices* website, reached via the Museum of London's homepage, provides a publicity platform for all the projects as well as exhibition space for the web exhibitions, and can

be found at http://www.museumoflondon.org.uk

2. This chapter draws on my doctoral research in which I conceptualise three dimensions of the process of mediation: processes of institutional mediation; processes of textual mediation; processes of cultural mediation. Processes of textual mediation are explored in Hartley, J. & McWilliam, K. (forthcoming). *Story Circle: Digital Storytelling Around the World*, Oxford: Blackwell.

3. This sub-project involved collecting photographs and memories from a range of groups in South London; these were displayed on a dedicated project website.

4. Individual interview with Vikram, *Capture Wales* participant, middle-aged journalist originally from Fiji, long-term resident of South Wales.

5. Individual interview with Vikram, *Capture Wales* participant, middle-aged journalist originally from Fiji, long-term resident of South Wales; Group interview with participants in London's Voices' Holidays of a Lifetime.

6. Two workshops were observed, one English language workshop in a South Wales town on the border with England, and one Welsh language workshop in a North Wales town.

7. Individual interview with Vikram, *Capture Wales* participant, middle-aged journalist originally from Fiji, long-term resident of South Wales.

8. In contrast, see Beeson and Miskelly's work on the use of digital storytelling processes to tell a communal 'story', rather than bringing together individual stories (Beeson & Miskelly, 2005).

References

Bauman, Z. (2001). *Community: Seeking safety in an insecure world*. Cambridge: Polity Press.

Beeson, I., & Miskelly, C. (2005). Digital stories of community: Mobilization, coherence & continuity. Paper presented at *Media in Transition 4: The Work of Stories*, MIT, Cambridge, US.

Carpentier, N. (2007). Section two: introduction. Participation and media. In B. Cammaerts & N. Carpentier (Eds.), *Reclaiming the media: Communication rights and democratic media roles* (pp. 87–91). Bristol; Chicago: Intellect Books.

Cheung, C. (2000). A home on the web: Presentations of self on personal homepages. In D. Gauntlett (Ed.), *Web studies: Rewiring media studies for the digital age* (pp. 43–51). London: Arnold.

Coleman, S. (1997). *Stilled tongues: From soapbox to soundbite*. London: Porcupine Press.

Corner, J. (1994). Mediating the ordinary: The 'access' idea and television form. In M. Aldridge & N. Hewitt (Eds.), *Controlling broadcasting: Access policy and practice in North America and Europe*. Manchester: Manchester University Press.

Corner, J. (2002). Performing the real: Documentary diversions. *Television and new media, 3*(3), 255–269.

Couldry, N. (2000). *The place of media power: Pilgrims and witnesses of the Media Age*. London: Routledge.

———. (2006). *Listening beyond the echoes: Media, ethics and agency in an uncertain world*. Boulder, CO: Paradigm Publishers.

Dovey, J. (2000). *Freakshow: First person media and factual television*. London: Pluto Press.

Fornäs, J. (2000). The crucial in-between: The centrality of mediation in cultural studies. *European Journal of Cultural Studies, 3*(1), 43–65.

Griffen-Foley, B. (2004). From tit-bits to Big Brother: A century of audience participation in the media. *Media Culture and Society, 26*(4), 533–548.

Haddon, L. (2000). Social exclusion and information and communication technologies. *New Media and Society, 2*(4), 387–406.

Highmore, B. (2002). *Everyday life and cultural theory.* London: Routledge.

Jankowski, N. W. (2002). Creating community with media: History, theories and scientific investigations. In L. Lievrouw & S. Livingstone (Eds.), *The handbook of new media* (pp. 34–49). London: Sage.

Lambert, J. (2006). *Digital storytelling: Capturing lives, creating community* (2nd ed.). Berkeley, CA: Digital Diner Press.

Livingstone, S. (2005). On the relation between audiences and publics. In S. Livingstone (Ed.), *Audiences and publics: When cultural engagement matters for the public sphere* (pp. 17–41). Bristol: Intellect.

Livingstone, S., & Lunt, P. (1994). *Talk on television: Audience participation and public debate.* London: Routledge.

Livingstone, S., Van Couvering, E., & Thumim, N. (2005). *Adult media literacy: A review of the research literature.* London: OFCOM.

Martín-Barbero, J. (1993). *Communication, culture and hegemony: From the media to mediations* (E. Fox & R. A.White, Trans.). London: Sage Publications.

Mayo, M. (2006). Building heavens, havens or hells? Community as policy in the context of the post-Washington Consensus. In S. Herbrechter & M. Higgins (Eds.), *Returning (to) communities* (pp. 387–400). New York; Amsterdam: Rodopi.

Renov, M. (2004). *The subject of documentary.* Minneapolis, London: University of Minnesota Press.

Rice, R. E. (2002). Primary issues in Internet use: Access, civic and community involvement, and social interaction and expression. In L. Lievrouw & S. Livingstone (Eds.), *The handbook of new media* (pp. 105–129). London: Sage.

Selwyn, N. (2003). Apart from technology: Understanding people's non-use of information and communication technologies in everyday life. *Technology in Society, 25,* 99–116.

Silverstone, R. (1999). *Why study the media?* London: Sage.

———. (2007). *The media and morality: On the rise of the mediapolis.* Cambridge: Polity Press.

Thompson, J. B. (1995). *The media and modernity: A social theory of the media.* Oxford: Polity Press.

Van Zoonen, L. (2001). Desire and resistance: Big Brother and the recognition of everyday life. *Media, Culture and Society, 23*(5): 669–677.

Wasko, J., & Mosco, V. (Eds.) (1992). *Democratic communications in the Information Age.* Toronto and Norwood, NJ: Garamond Press & Ablex.

SIX

Mediatized lives
Autobiography and assumed authenticity in digital storytelling

BIRGIT HERTZBERG KAARE AND KNUT LUNDBY

Introduction

Digital self-representational narratives might be seen as creative responses both to individual life experiences and to traditions of narration. From this perspective they are narrative constructions with implications on both a personal and a socio-cultural level (Hoover, 2006, chapter 4). There are several genres of digital narratives and various forms of digital storytelling. Two main characteristics, shared by various forms of digital self-representational narratives, are their assumed authentic forms of expressions and the expectations that the content of the stories should be based upon the autobiographies of the narrators. This chapter explores the relation of assumed authenticity and autobiography in Digital Storytelling. However, we also consider the following discussion to be relevant for the study of other genres of digital narratives and self-representations.

We walk in the footsteps of the Center for Digital Storytelling in California with their strict script for people's production of short self-representational mini-films (Lambert, 2006; Hartley & McWilliam, forthcoming). This is what

we refer to as 'Digital Storytelling' (thus with capital D and S). We will use the production of Digital Stories in a congregation in Norway as an empirical example (Lundby & Kaare, 2007). This case will be introduced later in the chapter.

In a variety of institutional settings, people tell short, self-representational stories, using standard digital equipment (Hull, 2003; Meadows, 2003; Lambert, 2006; Hull & Jones, 2007; Thumim, Chapter 5 of this book). These stories do not fit into formal theories of narratives from literature and film studies. They are usually made with self-sourced images and told by the self with the own voice. In the main they follow the paradigmatic principles as they were developed in California in the 90s (Lambert, 2006).

Digital Storytelling is, in most formats, an activity expected to take as a point of departure a selected event from the life of the storyteller. It might be characterised as a narrative activity using the experiences of the narrator as the raw material. Because of this tight connection to the autobiography of the narrator, Digital Storytelling is often regarded as a genuine or authentic activity, condensed in the slogan 'Everybody has a story to tell', as presented in the paradigmatic principles from the Center for Digital Storytelling (Lambert, 2006). This genre specification makes it relevant to see Digital Storytelling as a multimodal version of the seemingly universal practice of turning life events and experiences into narratives (Stahl, 1989).

What are the implications of constructing stories with themes from the narrators' own lives, when these are made into multimedia products that are fixed (Hull & Katz, 2006) and may be distributed as digital objects on the Internet or on a CD (Meadows, 2003, p. 189)? How do we formulate a set of issues about life experience, narrative and textuality when it appears in a multimodal format? According to Glynda Hull and her team, we have to ' . . . focus particularly on the interfaces between new media, narrative and identity construction' (Hull, Kenney, Marple & Forsman-Schneider, 2006, p. 7).

Digital stories represent the performance of mediated identities perceived as 'authentic' (Scannel, 2001; Tolson, 2001; Guignon, 2004). Authenticity is a concept usually connected to fine art products and sometimes to products of popular culture (Scannel, 2001; Tolson, 2001). It is also used in relation to concepts like lifeworld (Habermas, 1987) and identity (Guignon, 2004). Hence, it is often used to characterise those cultural products that are assumed to represent the personality and identity of its creator (Deuze, 2007, p. 240). In this chapter, the assumed authenticity in digital narratives will be discussed as an important perspective in Digital Storytelling. The autobiographical perspective in Digital Storytelling will be discussed in relation to narrative genres that are expected to express the life story of the individual. We raise the following

research question:

- How is the claim of authenticity to be fulfilled within the construction of digital stories that are retelling and reconstructing events from the life story or lived life of an individual?

Theoretical perspectives

The perspective of multimodality is the key to understanding the type of narratives that are created in Digital Storytelling (Meadows, 2003; Hull & Nelson, 2005; Lankshear & Knobel, 2006). Multimodal composing is not an additive art, 'a multimodal text can create a different system of signification, one that transcends the collective contribution of its constitutive parts' (Hull & Nelson, 2005, p. 225). Digital Storytelling should not be understood as a phenomenon equivalent to either oral storytelling or to written narratives (Scheidt, 2006). The multimodal aspect of Digital Storytelling must be seen in connection with theories of mediation and of mediatization (Lundby, Chapter 1 of this book; Couldry, Chapter 3 of this book). The format of Digital Storytelling is above all a consequence of the time constraints of the genre. Among the multiple and flexible stories that together might constitute the autobiography or life story of the narrator, one specific story has to be highlighted, told within 2–3 minutes with the narrator's own voice, and fixed; available either on a CD or as a file on the Internet.

Mediatization

In this chapter, we take as our point of departure 'mediatization' as related to media *form*. This is to focus on 'a particular transformative logic or mechanism that is understood to do something distinctive to (that is, to 'mediatize') particular processes, objects and fields' (Couldry, Chapter 3 of this book). 'Mediatization' implies a process through which core elements of a social or cultural activity assume media form (Hjarvard, 2004, p. 48).

Telling stories about your own life is regarded as an authentic, universal and age-old human activity (Meadows, 2003, p. 191). It is reasonable to regard such storytelling as a core element of the cultural activity of most societies, regardless of time and place. In the production of Digital Storytelling, this eternal human activity assumes media form because it is performed through interaction with a medium. In Digital Storytelling, the symbolic content and the structure of the activity of telling stories about your own life are heavily in-

fluenced by the digital tools used. The question to be examined here, therefore, is not *if* these stories represent a mediatization of storytelling, or even of the life stories of the narrators, but in *which ways* these processes can be described. As such, it stands as our hypothesis that the Digital Stories and the lived experiences presented in Digital Storytelling are being 'mediatized'. We will be looking for the transformative logic inherent in the relationship between the assumed authenticity and the autobiographic point of departure in the genre of Digital Stories. Together, they make up key aspects of Digital Storytelling as media form.

Autobiography

Digital Stories are mediated self-representations (Neisser & Fivush, 1994; Meadows, 2003; Roth, 2005; Thumim, 2006, pp. 261–262). They might be categorised as topical autobiographies (Bertaux, 1981). An autobiography, from the Greek 'auton' meaning self, 'bios' meaning life and 'graphein' meaning write, is a biography written by the subject, sometimes with a collaborative writer. Several types of life stories are named autobiographical (Bohman, 1986, p. 3). Nancy Thumim points to Plumer's (2001) description of current society as an 'auto/biographical society'; the telling of personal stories of the self has become ubiquitous, she argues. She points to the fact that 'ideas of auto/biography, self-speaking and self-representation have in common the notion that members of the public are telling personal stories, *in public*' (Thumim, 2006, p. 261).

Interesting questions appear when we compare the sharing of multimodal expressions in digital narratives to the performance of oral storytelling, or to the distribution of written stories about the self (Johnsen, 1989; Denzin, 2001; Scheidt, 2006). Within literary studies there are several genres covering storytelling of the self, such as autobiography, memoirs, diaries and letters, but also genres like essays and autobiographical novels. Historical research in the 1970s and 1980s put much emphasis on the lives of 'ordinary' people. The tendency was to favor 'people telling their own stories' (Bohman, 1986, p. 4). In his famous book of oral history, *The Voice of the Past*, the historian Paul Thomson argues that such stories can counteract the limitations of ordinary historical sources (Thomson, 1977). The interest in autobiographical life stories in sociocultural studies is due to the fact that the individual as a social and cultural actor has become more of a focus in the last decades, at the expense of macrostructures and collective representations (Mikaelsson & Stegane, 1992, p. 1).

Autobiographical stories include many different types of narratives; what they have in common is that they all are stories connected to the life course of

an individual, to the whole or parts of that life (Bertaux, 1981). These stories can have many layers of reality: the event, the varying memory of that event, and reflections about the memories of the event. The telling of the event is dependent on the context, the genre of the narrative, the selections of memories and reflections of the narrator (Bohman, 1986). The autobiographical text, in all its possible versions, illuminates culture as an experienced reality, seen from the point of view and personal position of the individual in society (Mikaelsson & Stegane, 1992, p. 2).

A life story will normally be constructed by the narrator according to the circumstances of the life situation at the point when the story is told. Events in the past are reinterpreted to be meaningful in light of the present situation of the narrator, which implies that a person may not tell one and the same story about their life on different occasions and at different times. Thus, a recounted life story is only one of many possible versions, although, many narrators tend to retain some fixed anecdotes in their life stories.

Regardless of whether the autobiography describes outer events or reflections about the self, it is done from the privileged position of the subject; the connection between text and reality is through the author (Mikaelsson & Stegane, 1992, p. 1). Many researchers, using autobiographical narratives as sources for different purposes, claim that such stories should be regarded as problematic or opaque. In *Interpreting Women's Lives* the authors claim that 'When talking about their lives, people lie sometimes, forget a lot, exaggerate, become confused, and get things wrong. Yet they *are* revealing truths. These truths don't reveal the past "as it actually was", aspiring to a standard of objectivity. They give us instead the truths of our experiences' (Personal Narratives Group, 1989, p. 61).

Several of the Digital Stories produced might also be categorised as 'personal narratives'. The American folklorist Sandra Stahl defines a personal narrative as 'a single-episode personal story' (Stahl, 1989, p. 13). The personal narratives of one individual are multiple, but Digital Storytelling implies that among the many and flexible stories that together might constitute the autobiography or life story of the narrator, one specific story is highlighted and fixed.

Authenticity

According to Joe Lambert, one of the founders of the Center for Digital Storytelling, 'the idea of digital storytelling has resonated with many people because it speaks to an undeniable need to constantly explain our identities to each other. As we improvise our ways through our multiple identities, any tool

that extends our ability to communicate information about ourselves to others becomes invaluable', he says (2006, p. 17). Digital stories represent the performance of a mediated identity which might be perceived as 'authentic'.

The philosopher Charles Taylor looks for the 'sources of authenticity' (Taylor, 1991). In the nineteenth century it was the elites who sought an authentic way of living or expressing themselves. But, according to Taylor, what is new is that this kind of self-orientation seems to have become a mass phenomenon, 'we see a steady spread of what I have called the culture of "authenticity". . . . That each of us has his or her own way of realizing one's own humanity . . .' (Taylor, 2002, p. 83). He points to the fact that we now have a widespread 'expressive' individualism.

According to Andrew Tolson, there is a quest for an authentic *mediated* identity today (Tolson, 2001, p. 456). We have to look at the issues of image management, and if the performance is to be seen as 'authentic'. Tolson holds that the notion of 'being yourself' is an intriguing concept: 'In this definition individuals are said to possess an inner, irreducible essence, a "real self" behind whatever public face, or mask, they might project' (Tolson, 2001, p. 445).

'Authenticity might seem a relatively straightforward concept. Yet, looking more closely, contradictions and problems emerge, stemming from the fact that it is ultimately an evaluative concept', Theo van Leeuwen (2001, p. 392) notes. The concept of authenticity is often used to denote the quality of being genuine or not corrupted from the original (Deuze, 2007). The concept is used by philosophers and psychologists to indicate the degree to which one is true to one's own personality or identity (Guignon, 2004, p. 126). Charles Guignon in his book *On Being Authentic* writes about 'The Story-Shaped Selves' (Guignon, 2004, pp. 126–145). 'Starting from an attempt to find meaning and fulfillment in life by becoming authentic, we end up with a disjointed, fragmented collection of semi-selves living out episodic, stuttering, and other-directed lives', Guignon (2004, p. 126) says. The project of being authentic usually involves two main components, the task of introspection or self-reflection and, second, 'living in such a way that in all your actions you express the true self you discovered through the process of inward-turning' (Guignon, 2004, p. 146). Guignon argues *against* this common use of the concept and propose that we think of authenticity as being fundamentally a social virtue (2004, p. 151). This opens up for an understanding of authenticity as a relation between the individual and the collective. In the following pages we want to explore the possibility of using the concept 'authenticity' in this way while studying a case where Digital Storytelling is practised as an experiment in religious education.

The case

In 2003, the Norwegian Parliament decided to fund a reform of religious education. The envisaged activities should stimulate the formation of (religious) identity of young people and help them to master their lives and to understand their cultural heritage and religious traditions. Among a variety of different educational projects, the Church of Norway initiated an experiment of Digital Storytelling in the autumn of 2005. Our case study follows youth in a local congregation who apply the principles of Digital Storytelling in experiments with new and modern approaches to religious education.[1] The case study is located in the parish of Haslum, close to the capital of Norway, an area with a high level of income and education.

Seven 16–18-year-olds took part in the first year of the project. Within the period covered in this research, up until mid-2007, two more groups produced Digital Stories. In this period four DVDs, containing 25 stories altogether, were produced and handed to selected persons for use on appropriate occasions, mostly for educational purposes within the congregation. Some of the Digital Stories were even show on large screens in the church on special occasions like a confirmation service.

The project is headed by the youth minister, assisted by the catechist and a well-trained technical assistant. These adult supervisors are very enthusiastic about the project and regard it as a relevant and important experiment to develop their competence in questions concerning the lifeworld (Habermas, 1987) of the youths in the congregation. The motivation of the youths for partaking in the project is above all the excitement of being allowed to produce a mini-film of an autobiographical character. The youths chosen have a much stronger connection to the church than most in the area and mostly attend because they already participate in other activities in the congregation. They are all at high school; some of them go to special classes for media education. Since they all had their own computers with internet access and mobile phones of their own, they are familiar with the use of digital technology, are media literate and able to master digital tools.

The producers of the Digital Stories have the copyright of their digital objects. The supervisors, as well as Norwegian authorities (The Data Inspectorate), put restrictions on dissemination of the digital narratives, due to privacy on topics related to religion, which is why these stories are not made available on the internet.

Research methods

In order to get behind the surface of the produced narratives, we apply multiple qualitative methods in this study. It is our priority to examine the experiences and views of all the participants of this production of Digital Stories and to apply the perspective of the actors in the analysis of the empirical material. Therefore, our most important data are created in 14 reflexive in-depth interviews with both the young narrators and the adult leaders, who also produced Digital Stories (The interviews are numbered DFS 1–14 in the following quotations). Eleven of the fourteen young storytellers in the first two groups agreed to be interviewed. We asked them several questions, some of them about how they experienced the creating process of their stories, what connections there were between their narratives and their life stories, what inherent meanings they ascribed to them, what values they wanted to mediate in their narratives (Roth, 2005) and how they felt about sharing their personal narratives with others.

The case study is largely documenting itself, producing several reports. It is also commented on in mass media and the newsletters of the congregation. We collect all documents connected to the case. Even more important, we take care to create various types of relevant data, in the main by discussions with the supervisors and partaking in board meetings of the project. We finished collecting our field data for this chapter by interviewing the first two groups participating in the project. We also interviewed the youth minister who left the project after this period. We still go on observing the activities and collect all stories produced (2007–2008).

The narratives and the storytellers

This section describes the narratives in the Haslum case, how they were produced and interpreted by the storytellers and their leaders, while the next section, "Discussion," will bring an analytical perspective on this empirical material.

Interviews with the supervisors reveal that their intention is to develop a new narrative genre fit for expressing religious life experiences, named 'Digital Faith Stories'. As one of the supervisors put it, 'It is important not to make copies of stories already accepted as true stories of faith. We are not interested in stories like testimonies that are more outspoken and instructive'.[2] In spite of these intentions, so far most of the 'Digital Faith Stories' produced can hardly be differentiated from other Digital Stories following the format outlined at

the Center for Digital Storytelling (CDS) in California.³ We observe that their paradigmatic principles of 'Digital storytelling' are followed strictly in the case under study.⁴

The construction of the stories

A professional team, inviting and cultivating stories in the so-called 'Story Circle' that opens all workshops, led the first workshop. After the first round of narratives had been produced, the adult leaders had learned how to make Digital Stories, and being shown the films already produced gave the young storytellers of the following groups some ideas of what was to come. 'It became easier to make the story, when I was shown all the others,' one of the girls stated (DFS 8). When asked if she had got any help finding a theme for the narrative during the Story Circle, one of the girls answered, '[we] were sitting and tried to sum up what had happened in life and what had meant a lot to us'(DFS 11).

With the help of the supervisors in the Story Circle session, the youths soon grasped the most essential characteristics of Digital Storytelling: to characterise a good Digital Faith Story, the young narrators felt it should be personal and that it should be about something one wants to share with others. To quote one of the girls, 'I was a bit uncertain about what to say. But I realised that it should be a bit about me; not only from a distance. I had to use something that was great in my own life. . . . The episode I chose was important to me. . . . [and I] attached to it something that had to do with my personality The supervisors helped me to choose and to construct a story around [the event]' (DFS 3). The Digital Faith Stories are supposed to have a positive message, and the supervisors use their influence to discuss with the youths how they might interpret their narratives in a positive way (DFS 14), thus putting their impress on both the content and structure of the narratives.

Using digital tools

Digital tools are central to the project. The supervisors hold that the process of digitalisation, like using your own voice and your own photos, gives the youths an opportunity to construct stories that they never would have told without such technological tools. They regard the Digital Faith Stories as a valuable and relevant mode of expression, culturally familiar to the youths because of its multimodality. In one of their flyers they presented the making of a film by using digital tools as a goal in itself. 'When you have your own pictures, it is

like dotting the i. It is much better than anything else to use one's own pictures. Then all becomes more personal. Then you share something you maybe usually do not share with others', one of the girls said (DFS 11).

Another girl formulated her experiences of the digital dynamics in her filmmaking like this, 'I think that what is really great with a digital story is that, instead of having a lot of memories in your head all the time, you can put them on a "tape" and show them to others. It is so much in your head all the time that is never transmitted to others' (DFS 2). Her underlining of the fact, that the digital story is also an artefact, is striking. One of the boys pointed to digitalisation as essential because it makes it possible to share his story with many, 'Many [young] people will watch the stories. They will be more exciting [because they are digitalised]. And since the form is fixed, it will not alter from time to time' (DFS 7). When asked if he thought pictures from his own life and the use of his own voice was doing something with his story, he said, 'It means you can be more convinced that it is true'. 'It seems real,' one of the others said. (DFS 8).

What these young people emphasise about their use of digital tools connects the digitalisation process of their stories to values like being *cool*, to personal excitement, and above all as a guarantee of the authenticity and truthfulness of their narratives.

The content of the narratives

The supervisors hold that the strength of the method of using Digital Storytelling in educating the youth is that it catches what is happening here and now in the lives of those who are present. '[W]e can catch it and structure it to a text and a film' (DFS 1). Further, the method is a step away from traditional religious authoritative storytelling. 'What I found exciting was that we were challenged to use our own words and not read poems or use the thoughts of other people', one of the adults said (DFS 1).

When choosing the themes of their narratives, the young storytellers felt free to use whatever subject was important to them. 'We just made a film about something we thought was important in life, '(DFS 4) one of the girls said. 'But the supervisors managed to focus on belief', she added. When supervising the youths, the adult leaders did not push them to talk about belief in their Digital Stories; speaking of one's personal belief is not customary among most Norwegians, and the supervisors also did not want to tell the youth what they should believe. 'We are working hard to elicit the thoughts they might have, They have to experience it [belief] themselves. . . . It has to be experienced

as true', they said (DFS 1).

So, what did the young storytellers choose for the themes of their stories? An analysis of the stories reveals that the content varies widely. Several of the boys made films about being good in sports like skiing, football or swimming, one about playing music and creating a band, while another tells the sad story of a friend who died. The girls made films with more 'feminine' content like how to make a 'Surprise Party', the pleasure of singing to an audience, or the striving to become a dancer, but they also made films about travelling or the importance of learning. The content analysis shows that there are few explicit meaning statements or references to religion or the sacred in the stories. The youths themselves most of all wanted to tell about something that they regarded as an important event in their lives and something that would communicate their personality and inner feelings. Many made films about friendship; as one of the boys said, 'I felt that it was a rather important theme I had taken up. . . . I don't think I would be what I am today without those [friends]' (DFS 7).

The Digital Faith Stories that have been produced so far end with a kind of 'punch line': the reflections of the storytellers are condensed into a statement which focuses on existential themes like dreams for the future, joy, curiosity, friendship and love.

The autobiographical perspective

The perspective of the Digital Faith Stories is the autobiography of the storyteller. The youths were encouraged to develop a story based on some event from their lives. This perspective is experienced as an exciting challenge; to quote one of the youths, 'This is exciting. I am allowed to put together sounds and pictures to a story about myself' (DFS 8). In his reflections on the autobiographical perspective, one of the supervisors said, 'It is inherent in the [genre] that it should be autobiographical. Then you have to talk about your thoughts or experiences. The fact that you can share your thoughts makes the story strong in the community. And that is of enormous value. If you were to abandon the requirement for being autobiographical, then you could just make a story of anything. Then you would just get a lot of boring videos. . . . So, I think that it is precisely the demand that the story has to be autobiographic that gives the genre its right to exist' (DFS 5).

Like many of the others, one of the boys made a story about changes in his life; 'It was a huge turning point in my life', he said. 'Now I am in a phase of life when you wonder what will become of you' (DFS 6). We asked the youths if they found it difficult to make a film about their own lives. '[Yes], if it had

turned out very personal. It is a difference between being private and being personal,' one of the boys said (DFS 9). The adult leaders helped the youths to sort out what might be too private to be included in the narratives. One of the girls explained that 'even if it is personal, you have to watch out that it does not become so personal that you really don't want to talk about it. . . . Because we are so young, we do not know what is too personal' (DFS 10).

The dangers of being too personal in the film preoccupied several of the young narrators. Two of the girls distanced themselves from the need to be personal in their second production of Digital Faith Stories. They chose the strategy of using humour to maintain a certain distance in their films.

Authenticity

The narratives of the young are interpreted as authentic and valid expressions of their experiences and reflections by the supervisors. To quote one of the supervisors, 'We should put away our own voices . . . there are more voices coming into the Church, the voices of young people. The Digital Faith Stories are lifting the veil. They help us to figure out what young people think, what is going on inside them'.[5] The youths felt assured that the adults watched their films in this way. 'Then they can see what is on our minds. . . . They can see that we too have profound thoughts', one of the girls said (DFS 12). 'It is something special that you are telling. Then you get a short insight into the life of adolescents,' another added (DFS 11). Several of the young narrators had a strong feeling of being authentic when telling their stories; 'The form is not that important, what is important is that it shows who I am', (DFS 4), as one of them states very clearly.

The ideology of sharing is important in the process of making Digital Stories. Sharing is a kind of safety net before the Digital Faith Stories are eventually shown to an audience. In the sharing process, they watch the films and reflect on the life experiences of the others in the group. Several of the youths mentioned that a good digital story should offer reflections that other young people could recognise as relevant to their own lives. In watching one of the Digital Faith Stories they had produced, one of the girls recognised her own experiences. She said, 'this story is just like my own experiences. That is why I really liked this narrative so much' (DFS 12). 'A Digital Faith Story must include more that just yourself', one of them concluded (DFS 3). One of them said that it was very exciting to see what choices the other narrators had taken during their lives.

As these films are meant to be watched by others, the question of authen-

ticity becomes vital. The youths are very concerned about what impression they may make on others by telling about their lives: 'It doesn't matter if strangers see my Digital Story. I think it is worse if someone whom I know well sees it. Because then I feel "Am I perfectly honest now?", or "Do I disclose something I should not give away?"'(DFS 3). The interviews show that the question of authenticity is of great concern to several of the young storytellers; they know that they are expected to be personal and open up to an audience their inner thoughts and reflections, which might be very hard for young people: 'I think we, who are young, are afraid of saying too much, because it is very personal. It is so that you are a bit afraid of opening up too much. It is a bit fragile, and to be criticised or get feed back on your story can be a difficult thing' (DFS 3).

When asked what use these narratives might have, a girl made the following reflection, 'I think that they might help people to go on' (DFS 10). The storytellers see the value of having made a digital story about their lives and keeping it for their own comfort. One of the boys put it this way: 'They are also useful in situations when you are down and all, then you can watch them. . . . If you are depressed, then you can see on the film that your life is not that bad, really' (DFS 7).

Discussion

What implications can be observed when the claim of authenticity is combined with the construction of Digital Stories retelling or remaking events from your lived life, from your life experiences? What happens to the 'authenticity' of these personal narratives when they are made into Digital Stories? Our hypothesis was that the stories, and the lived experiences presented in the stories, are being 'mediatized'. This we expected to appear in the construction as well as in the sharing process, and we wanted to examine this hypothesis by analysing the relations to authenticity and autobiography in the narratives.

The analysis of the interviews leads us to hold that the Digital Faith Stories should be seen and interpreted in the context of their relation to the collective traditions of the national church of Norway. This case makes an interesting point of exchange between the subjective 'me'-focus of contemporary culture and diffuse collective strands of society. By participating in the Story Circle, and negotiating how their stories should be constructed and interpreted, the young narrators are connected to the collective identity of the congregation. 'Identity in practice is defined socially not merely because it is reified in a social discourse of the self and of social categories, but also because it is produced as a lived experience of participation in specific communities. What narratives

. . . come to mean as an experience of participation is something that must be worked out in practice', Etienne Wenger states in *Communities of Practice* (Wenger, 1998, p. 151).

'Digital *Faith* Stories' as a specific genre, different from 'Digital Stories', does not yet exist when judged by such analytical tools as the genre criteria developed for Digital Storytelling (Lambert, 2006). Nevertheless, to the participants from the church, it is a new narrative genre, used for establishing contact with the youth and integrating them into the religious community by constructing stories about themselves; a process which implies both negotiations of their experience of self and negotiations of authenticity in the narratives. The main argument for naming these narratives 'Digital Faith Stories' lies in the fact that they are produced under the direction of the congregation, in a 'religious' setting. Although the genre of the Digital Faith Stories is not obviously different from other Digital Stories to anyone from the outside, often not even in the content of the narratives, it is the community of interpretation that is ascribing the content of these narratives a distinct authenticity.

The interviews revealed that it was the Story Circle and the shared interpretations in the group of storytellers and supervisors that gave these narratives a potential for authenticity (Guignon, 2004, p. 163). To quote the youth minister, 'we, who have taken part in the process, know what meaning the young narrators ascribed to their stories, and therefore it is maybe easier for us to interpret the stories as being authentic' (DFS 14). It is the intentions of the young narrators of being part of a community that initiate their interest for the project (Hull and Katz, 2006, p. 45). Hence, they aspire to appear as authentic as possible in order to reach the others with their messages in their narratives. Authenticity is regarded a social value (Guignon, 2004, p. 151); that's why the young storytellers aspire to make 'authentic' stories.

Moreover, the supervisors point out that because they are interpreting the content of the narratives of the young as authentic, it opens up for a deeper understanding of the lives of the young.[6] They get insight into the inner thoughts of the youth, about their mastering of life, about their faith and their beliefs, that is, the lifeworld of the youth (Habermas, 1987; Ziehe, 2001), as they are expressed in the Story Circle and later, maybe in a more disguised form, in the Digital Faith Stories themselves. Adults standing outside do not easily reach such notions, especially those who have a position as teachers of religion, supposed to have a handle on the right beliefs and the authorised words of faith.

The interviews with the storytellers definitely showed that these narratives should be analysed in relation to the context of their creation in order to understand what might be behind their outer form. Most of the Digital Faith Stories produced are not discernible from other Digital Stories produced

elsewhere. In addition, their young producers often apply the stylisation, the stereotypes and even the posing attitudes and self-play they have internalised from the language of the popular media culture (Tolson, 2001; Lankshear & Knobel, 2006).

Analysis of the produced narratives alone, as they appear on the DVDs, would give neither an understanding of the reasons behind the content of the narratives nor of the intended meanings of the stories. The life experiences of the narrators are being discussed and revised in the workshop and attached to something larger than casual experiences and impulsive responses to events. Through the strict form of the genre and the supervision of the adults, the youths are led towards deeper self-reflection and identity development, not solely in the sense of individual development but also towards the common values and traditions of the community. The meanings, the experienced authenticity and reflections of these digital personal stories, are therefore to be found in their context, in this case in the sense of belonging to the church regardless of how diffuse this relation may be.

Conclusion

Our analysis of the case leads us to claim that one cannot make too definite statements about the relations of Digital Storytelling to concepts like authenticity and autobiography. The analysis of the narratives that were created in the case under observation, as well as the interviews with the young narrators and the supervisors, lead us to hold that Digital Stories, as a genre, is a strictly defined form of multimodal expression which is up to the individual narrator to fill with content connected to an authentic personal experience. This means that the authenticity inherent in this genre will depend more on how, and under what circumstances, the story is told than on the references to the life story of the narrator, that is the autobiographical evidences.

Our case study reveals that one storyteller might refer to several facts from the lived life but nevertheless produce a narrative that only shows a mere façade of the lived life and thus an inauthentic representation of the narrator's experiences. Another storyteller might fill the Digital Story with content that shows reflection and commitment to something outside the self (Guignon, 2004, pp. 163–167). The extent of authenticity in the narrative will depend on the degree and type of reflection of the lived life that is narrated in the story. The digital form might give the reflections an even stronger dimension of authenticity by using visual and auditory expressions that might reinforce what is shown of the authentic 'I'—the reflexive 'I' who connects its life and its nar-

ratives to a community and collective values which give meaning to the life of the individual. 'Stories have a larger purpose than an individual one', to quote Joe Lambert.[7] The mediatization of the life experiences of the young, expressed through multimodal narratives about their mastering of life (Hull et al., 2006), has a potential to lift the experiences of the individual beyond the private and self-centred towards exemplary narratives which are not only integrated in the collective culture of the congregation, but are even contributing towards shaping their traditions for the future. In this way the Digital Faith Stories are to be seen as socio-cultural embodiments of authenticity (Guignon, 2004, p. 163).

Digital Stories, as an autobiographical genre, have been analysed by using the concept of authenticity as an analytical tool to get some insight into the processes of mediatization. The analysis shows that the potential of authenticity inherent in the genre is not just a matter of course. Even if it is a claim of the genre that the theme of the narrative should be the lived life of the narrator, that it should be autobiographically rooted, this claim alone is no guarantee of authenticity. We observe a distinct ambivalence inherent in the genre: on the one hand the danger that the storyteller can fall into an individualistic, self-centred presentation, and on the other hand the huge potential for creating an authentic narrative due to the workshop, the ideology of sharing and the interpretations that are made within the community (See Guignon, 2004, p.163).

As a narrative activity, the method of Digital Storytelling is able to mediate authentic, reflexive stories about the self and the life experiences of its narrators. However, the genre also offers a form open to producing narratives showing unauthentic lives where surface and self-play dominate, following patterns so well known from the presentations of celebrities and popular idols of the mass media (Tolson, 2001). Digital Stories might be characterised as a media form that leaves it to the individual narrator to fill it with content and even such a very limited and firmly defined genre as Digital Stories might therefore contain completely disparate types of expressions and reflections.

Notes

This study was financed by the University of Oslo, the Research Council of Norway, and the Church of Norway National Council.

1. This case is part of the larger research project 'Mediatized Stories. Mediation perspectives on digital storytelling among youth' http://www.intermedia.uio.no/mediatized/
2. Seminar 28 March 2006.
3. (www.storycenter.org) (Lambert, 2006).
4. (www.storycenter.org/principles.html)
5. Seminar 28 March 2006.

6. Report to the annual board meeting 2006. 'Digital Faith Stories are an expression of the lifeworld of the narrators.'
7. Paper presented to the ICA preconference Berkeley, 24 May 2007.

References

Bertaux, D. (Ed.) (1981). *Biography and society. The life history approach in the social sciences.* Beverly Hills, CA: Sage.

Bohman, S. (1986). The people's story. On the collection and analysis of autobiographical materials. *Methodological Questions, 3,* pp. 3–24. Ed. by K-O Arnstberg. Stockholm: Nordiska Museet.

Denzin, N. K. (2001). *Interpretive interactionism* (2nd Ed.). Thousand Oaks, CA: Sage.

Deuze, M. (2007). *Media work. Digital media and society.* London: Blackwell.

Guignon, C. (2004). *On being authentic.* London: Routledge.

Habermas, J. (1987). *The theory of communicative action, Lifeworld and system: A critique of functionalist reason,* Vol. 2. Boston, MA: Beacon Press.

Hartley, J., & McWilliam, K. (Eds.). (forthcoming). *Story circle: Digital storytelling around the world.* Oxford: Blackwell.

Hjarvard, S. (2004). From bricks to bytes: The mediatization of a global toy industry. In I. Bondebjerg & P. Golding (Eds.), *European culture and the media* (pp. 43–63). Bristol: Intellect.

Hoover, S. M. (2006). *Religion in the media age.* London: Routledge.

Hull, G. (2003). At last, youth culture and digital media: New literacies for new times. *Research in the Teaching of English, 38*(2), 229–233.

Hull, G., & Jones, M. A. (2007). Geographies of hope: A study of urban landscapes, digital media, and children's representations of place. In P. O'Neill (Ed.), *Blurring boundaries: Developing writers, researchers and teachers. A tribute to William L. Smith* (pp. 255–289). Cresskill, NJ: Hampton Press.

Hull, G., & Katz, M.-L. (2006). Crafting an agentive self: Case studies of digital storytelling. *Research in the Teaching of English, 41*(1), 43–81.

Hull, G., Kenney, N. L., Marple, S., & Forsman-Schneider, A. (2006). *Many versions of masculine: An exploration of boy's identity formation through digital storytelling in an after-school program.* Oakland: The Robert Bowne Foundation.

Hull, G., & Nelson, M. E. (2005). Locating the semiotic power of multimodality. *Written Communication, 22*(2), 224–261.

Johnsen, B. H. (1989). Tradition–milieu, and cultural values. In R. Kvideland & H. Sehmsdorf (Eds.), *Nordic folklore. Recent studies* (pp. 150–162). Bloomington, Indiana University Press.

Lambert, J. (2006). *Digital storytelling. Capturing lives, creating community* (2nd ed.). Berkeley, CA: Digital Diner Press.

Lankshear, C., & Knobel, M. (2006). New literacies as remix. In C. Lankshear & M. Knobel (Eds.), *New literacies. Everyday practices and classroom learning* (pp.105–136). London: Open University Press.

Leeuwen, T. van (2001). What is authenticity? *Discourse Studies, 3*(4), 392–397.

Lundby, K., & Kaare, B. H. (2007). The sacred as meaning and belonging in digital storytelling.

In I. Furseth & P. Leer-Salvesen (Eds.), *Religion in late modernity. Essays in honor of Pål Repstad* (pp. 69–86). Trondheim: Tapir Academic Press.

Meadows, D. (2003). Digital storytelling: Research-based practice in new media. *Visual Communication. Reflections on Practice, 2*(2), 189–193.

Mikaelsson, L., & Stegane, I. (Eds.) (1992). *Leve og skrive. Artikler om livshistorier.* [To live and to write. Articles about life stories.] Senter for humanistisk kvinneforskning. [Center of humanistic woman's research.] Skriftserien no. 4, 1992 [Series of prints no. 4, 1992]: Bergen.

Neisser, U., & Fivush, R. (Eds.) (1994). *The remembering self. Construction and accuracy in the self-narrative.* Cambridge: Cambridge University Press.

Personal Narratives Group (Eds.) (1989). *Interpreting women's lives. Feminist theory and personal narratives.* Bloomington: Indiana University Press.

Plummer, K. (2001). *Documents of life 2: An invitation to a critical humanism.* London: Sage.

Roth, W. M. (Ed.) (2005). *Auto/biography and Auto/ethnography: Praxis of research method. Bold visions in educational research,* Vol. 2. Rotterdam: Sense Publishers.

Scannel, P. (2001). Authenticity and experience. *Discourse Studies, 3*(4), 405–411.

Scheidt, L. A. (2006). Adolescent diary weblogs and the unseen audience. In D. Buckingham & R. Wilett (Eds.), *Digital generations. Children, young people and new media* (pp. 193–210). London: Lawrence Erlbaum Ass.

Stahl, S. D. (1989). *Literary folkloristics and the personal narrative.* Bloomington: Indiana University Press.

Taylor, C. (1991). *The ethics of authenticity.* Cambridge, MA: Harvard University Press.

———. (2002). *Varieties of religion today. William James revisited.* London: Harvard University Press.

Thomson, P. (1977). *The voice of the past. Oral history.* Oxford: Oxford University Press.

Thumim, N. (2006). Mediated self-representations: 'Ordinary People' in 'Communities'. In Herbrechter, S. & Higgins, M. (Eds.), *Returning (to) communities. Theory, culture and political practice of the communal* (pp. 255–274). New York: Rodopi.

Tolson, A. (2001). 'Being yourself': the pursuit of authentic celebrity. *Discourse Studies, 3*(4), 443–457.

Wenger, E. (1998). *Communities of practice. Learning, meaning and identity.* Cambridge: Cambridge University Press.

Ziehe, T. (2001). De personlige livsverdeners dominans. Ændret ungdomsmentalitet og skolens anstrengelser. [The dominance of personal lifeworlds. The changed mentality of the youth and the efforts of the school]. *Uddannelse* no. 10. http://udd.uvm.dk/200302/http/udd.uvm.dk

Self-presentation through multimedia

A Bakhtinian perspective on digital storytelling

MARK EVAN NELSON AND GLYNDA A. HULL

Introduction

This chapter attempts to apply conceptual tools drawn from the work of Russian literary theorist Mikhail Bakhtin (1981, 1986) to the problem of understanding processes of meaning making in the electronically enabled, often autobiographical literacy practice known as digital storytelling (e.g., see Lambert, 2006), perhaps conveying implications for digital, multimodal communication more broadly. In the main, we concern ourselves with interrogating the imbricated concepts of "heteroglossia" and "addressivity," integral features of Bakhtin's theoretical explanation for how literary texts *mean*. In so doing, we hope to both shed a new interpretive light on Bakhtin's highly influential framework and generate novel and applicable understandings of the presence of and interactions among the many "voices" and "languages" (in the particular senses of the terms intended by Bakhtin) at play in such increasingly prevalent, popularly authored, and semiotically multifarious texts as digital stories. The empirical basis for this investigation is a set of case studies, conducted in Japan over a period of four months, of the digital storytelling processes of two Japa-

nese university undergraduates. Ultimately we suggest that digitally afforded forms of new-media multimodal authorship, of which digital storytelling is a compelling example, may involve authors in such a complex and "double-articulated" composition process as to particularly encourage conventionalized forms of self-presentation over inventive and idiosyncratic forms. Thus, at the same time that we celebrate newly available compositional media and hope to find ways to experience and share their potential, we are mindful of the challenges and complexities that attend their use.

Heteroglossia and addressivity

Bakhtin's (1981, 1986) theoretical formulations for what he termed "heteroglossia" and "addressivity" represent only bands in the broad spectrum of his intellectual project as we have come to know it; however, in the few decades since Bakhtin's writings have been widely available to western audiences, these concepts have attained a particular currency in the fields of language and literacy pedagogy, among scholars and practitioners alike (e.g., see Ball & Freedman, 2004; Pleasants, 2008). Bakhtin was utterly dissatisfied with what he saw as an orientation on the part of post-Saussurian linguistics and literary studies toward isolating and dissecting the formal and semantic properties of language within an artificial, theoretical vacuum, that is, the assumption that meaning in the spoken or written word could be ascertained without accounting for the historical, functional, and, above all, sociocultural dimensions of language. Rather than the arbitrary grammatical unit of the "sentence," Bakhtin took the "utterance"—which could be equally well represented by a throaty "ahem" in conversation as by an eight-hundred-page novel—as the appropriate unit of linguistic and literary analysis. This is a choice premised upon the assumed necessity of socio-pragmatic[1] criteria for determining when a speech act, a spoken or written "turn-at-talk," is concluded, as opposed to the structural terminus of sentence-final punctuation.

This is not at all to suggest, however, that Bakhtin's utterance is so *polymorphous* as to be effectively generically *amorphous*. Utterances may be said to invoke "stable discourse types," each of which is formed of numerous lexical, grammatical, syntactic, semantic, and stylistic features that have accrued to these so-called "speech genres" (Bakhtin, 1986) as a product of historical, cultural use. Added to these are such linguistic elements as those that derive from unique contexts of communication (e.g., particular aspects of knowledge shared among interlocutors), personal aesthetic preferences, and individual expressive intentions. As we understand Bakhtin's formulation for meaning making, these

resources are, in essence, the many metaphorical "voices" and "languages" that inhere in any utterance, a condition which Bakhtin calls "heteroglossia," the "many-languaged-ness" of the utterance. Actually, heteroglossia is much better described as a dynamic tension than a condition, which perhaps implies a static nature; the fluid balance between convention and invention in language use is constantly being negotiated and managed, productively and receptively, consciously and unconsciously.

A critical factor in negotiating the interaction of these conservative and innovative tendencies—which Bakhtin (1981) respectively describes as "centripetal" and "centrifugal" (pp. 270–273)—is the quality of "addressivity," referring to the fundamentally "dialogic" or audience-oriented nature of the utterance. In his well-known essay entitled "The Problem of Speech Genres," Bakhtin (1986) explains:

> As distinct from the signifying units of a language—words and sentences—that are impersonal, belonging to nobody and addressed to nobody, the utterance has both an author . . . and an addressee. This addressee can be an immediate participant-interlocutor in an everyday dialogue, a differentiated collective of specialists in some particular area of cultural communication, a more or less differentiated public, ethnic group, contemporaries, like-minded people, opponents and enemies, a subordinate, a superior, someone who is lower, higher, familiar, foreign, and so forth. And it can also be an indefinite, concretized *other*. (p. 95, italics in original)

Bakhtin goes on to assert that particular audience groupings, or authors' expectations of these, are effectively constitutive of particular speech genres, the reciprocal implication of which is that this broad range of potential addressees, listed above, is typically, differently delimited according to speech-genre type:

> Both the composition and the style of the utterance depend on those to whom the utterance is addressed, how the speaker (or writer) senses and imagines his addressees, and the force of their effect on the utterance. Each speech genre in each area of speech communication has its own typical conception of the addressee, and this defines it as a genre. (ibid.)

Applying Bakhtin's theory to many common genres of oral and written communication, one may find its appeal is readily apparent. The kinds of audiences typically implied in the informal personal written letter (speech) genre, for instance, seem undoubtedly different from those associated with the political campaign speech, and, equally well, these distinctions in addressivity naturally exert a formative (or, perhaps, dynamically re-formative) influence on the typical forms and functions of these genres themselves. A personal written letter is constructed to be most easily read by one pair of eyes at a time, for example.

Also, as an artifact of the relative intimacy of interlocutors, one may expect of the informal letter that its messages are perhaps more implicit, its rhetorical structure more elliptical, than is ordinarily the case with many other genres.

Yet, one may be given to ask, as we herein do, as to the applicability of these Bakhtinian concepts to newer and more characteristically hybrid forms of communication. Can Bakhtin's notions of heteroglossia (or multivocality) and addressivity be seen to clarify and/or helpfully complicate understandings of new and emerging speech genres like digital stories, for instance? Yes, we suggest, as detailed below.

The multi-languaged-ness of digital stories

Though Bakhtin first formulated these notions of heteroglossia and addressivity many years ago, he may be thought to have presaged and addressed, if unknowingly, some fundamental issues facing new-media theorists today. Arguably foremost among these issues is *multimodality*, defined very simply by van Leeuwen (2005) as "the combination of different semiotic modes—for example language and music—in a communicative artefact or event" (p. 281). In recent years Kress (1997, 2000, 2003, 2005), Kress and van Leeuwen (1996), Stein (2004, 2007) and others have made important strides in conceptualizing the role that multimodal forms of textual mediation play in twenty-first century communication and education. Notably, Kress (2003) has put forth a theoretical framework for multimodality that describes the differential organizing logics that underpin each particular semiotic mode. This is to say that spoken language, for example, by its nature offers up potential meaning that is temporally and sequentially organized, which is fundamentally different, in Kress's view, from the typical way meaning is made in still imagery, the elements of which are inclined to be apprehended in a spatial, holistic, and simultaneous manner.

The problem of understanding the combinatory, multiplicative[2] meaning-making potential of multimodal expression is yet elusive, however. Multimodality, as a construct, is complex enough when considered in the abstract, that is, taking for granted the theoretical discreteness of different modes; yet, with the new electronic media comes good reason to question the assumedly stable nature of individual modalities. The paradigmatic example of this is suggested in the emergence of a new, digitally supported "secondary orality," posited by Walter Ong (1982), who describes it thus:

this new orality has striking resemblances to the old in its participatory mystique, its

fostering of a communal sense, its concentration on the present moment, and even its use of formulas ... but it is essentially a more *deliberate and self-conscious orality*, based permanently on the use of writing and print, which are essential for the manufacture and operation of the equipment and for its use as well. (p. 136, emphasis added)

We emphasize "deliberate and self-conscious orality" in the excerpt above because there is a vital point to be made here. While secondary orality, according to Ong's formulation, is "participatory" and "communal," oriented to the social domain, it is not organically or comfortably so, which is to say that many kinds of new-media utterances must be designed, composed, as with written texts. Ong also points out that "despite their cultivated air of spontaneity, these [electronic] media are totally dominated by a sense of closure, which is the heritage of print" (ibid., p. 137). The essence of Ong's message is that orality and literacy, and the oral and written language modes by direct implication, have undergone an amalgamation of sorts, a general process of semiotic melding. New media have emerged as the crucible within which qualities traditionally associated with literacy, like fixity and autonomy[3] (Olson, 1977, 1994), have become characteristic of oral communication, best exemplified perhaps by the ubiquitous voice-mail message. By the same token, written texts, for example the SMS, have assumed qualities heretofore primarily attributed to the oral language mode, such as in the presence and importance of what Malinowski (1935, 1939) termed "phatic communion." In this sense, Ong might have usefully coined an expression like "primary literacy" as an adjunct to his "secondary orality."

All this goes to suppose that a truly helpful understanding of multimodal meaning making must be one that sees all semiotic resources as distinct yet also comparable and combinable, individual yet social, innovative yet also conventional. Fortunately, accommodating seemingly dichotomous tensions such as these is something that Bakhtinian theory does very well. By shifting the analytic focus away from formalistic understandings of oral and/or written language per se and onto the utterance, Bakhtin creates a common conceptual space in which to consider all modes of communication as communicative utterances. In the concept of heteroglossia, we find a theoretical mechanism for understanding diverse resources, which may combine to form multimodal "heterogeneous stylistic unities" (Bakhtin, 1981, p. 261) that may both reinforce convention and foster innovation. And the notion of addressivity allows us to consider how the social world may reflexively shape and be shaped by processes of multimedia composition. Next, we detail the investigation which provided the context in which to empirically test these suppositions.

Research design

Setting and participants

The case studies discussed hereafter were conducted in 2005/2006 in the context of a digital storytelling course entitled *Multimedia "Me": Telling Our Stories in Image, Sound and Word*, designed and taught, in English, by Mark Nelson. The course was offered at a small private Japanese university of foreign languages, "Daigaku University" (a pseudonym) in a Tokyo suburb. It met twice weekly for ninety minutes each time, and there was an additional optional forty-five minutes of work time available to students after the second class of each week. Lessons mainly consisted in equal parts of activities, that allowed students to reflect on how meanings are made in various modes and in multimodal texts, and of "lab time," that is, time to develop an individual digital story, which was the central project of the course. There were no strict specifications for this project, other than to create a multimedia text that served to represent the author's personal "story," whatever he or she deemed that to be. The other activities included discussion of principles of semiotics, a visit to an exhibition of photographic interpretations of fairy tales by Japanese artist Miwa Yanagi and a comparison of a PowerPoint version of Lincoln's Gettysburg Address with the original speech (cf. Tufte, 2003).

The participant group included nine Japanese undergraduate English majors, six females and three males from twenty-one to twenty-two years in age.[4] Students chose the course from among a number of English-language electives based on a brief description that was publicized prior to registration. Eight of the nine students were juniors and one was a senior. All had satisfied the basic requirements for taking courses in English beyond the level of basic proficiency. We hasten to add that the course was not organized around English-language proficiency development per se, although this was an expected entailment.[5] The main thrust of the course was the exploration and development of broader semiotic capacity, in line with the Multiliteracies project initiated by the New London Group (1996) and following on our own prior, similar work (see Hull & Nelson, 2005; Nelson, 2006). This selection of particular setting and population was based on the presumption that students using a language other than their primary one would have an authentic need to explore and tap into the communicative potential of nonlinguistic resources.

The two focal informants specifically discussed in this paper are identified by the pseudonyms "Nagako" and "Mutsuko." Nagako and Mutsuko are both female and were twenty-one at the time of their participation. Both of these

authors created digital stories (integrating a sequence of still and video imagery with a voice track and music) that dealt thematically with their experiences of self-discovery and growing into adulthood.

Method

This project relied on qualitative methods and focused principally on case studies of the nine students' respective story development processes. The project was theoretically informed by constructionist (cf. Papert, 1980, 1994) and design experiments traditions (cf. DiSessa, 1991; Brown, 1992; Collins, 1992; DiSessa & Cobb, 2004), to the extent that the students and Nelson collaboratively engaged in technology-oriented practices for purposes of accomplishing a real-world goal (textual self-expression in an English-language context) as well as coming to a better understanding of the nature of multimedia communication itself. While design experiments methodology is practically and conceptually diverse and ordinarily connected with science education research, its general emphasis on discovery, on "learning by designing" (DiSessa & Cobb, 2004), is appropriately applicable to the kind of literacy and multimodal work described here as well.

Regarding the data set, some participant interactions and periodic in-process group critiques were videotaped, and successive versions of stories and related artifacts were collected each week. Also, each participant was expected to write and submit a weekly journal for the purpose of reflecting on her/his learning, creative inspirations, challenges, experiences of collaboration, and so forth. Most often, students were given question prompts on which to write. In addition, regular field notes were taken; surveys of students' technology- and media-use habits, interests, and other personal information were conducted; and numerous original or scanned artifacts and photographs were collected. Yet, the core of the data was the three interviews conducted with each student at pivotal points in the process. These points include the *prewriting/previsualization, rough construction*, and *completion* phases of the creative process, by which we respectively mean the point at which ideas for the story were being simultaneously generated by means of manipulating language, imagery, and sound; the point at which the rough correspondences of image and language had been tentatively arranged; and the point at which the piece was complete. The first two of these interviews were audiotaped and the final one was videotaped. Interviews and in-class critiques were transcribed, and all data sources were iteratively coded and cross-coded according to open, axial, and selective approaches (Miles & Huberman, 1994). Hereafter we detail aspects of the

cases of the digital storytelling processes of Nagako and Mutsuko as these relate to the Bakhtinian conceptual framework already described.

Nagako: Experience is a verb

Nagako commuted to campus each day from a mid-sized city in Saitama prefecture, a densely populated bedroom community outside Tokyo. She was the youngest and only girl of three siblings, which she explains as having shaped her predilections toward what she calls "boys' things," particularly skateboarding and skate culture, and her disdain for skirts and dresses. While she often made reference, proudly, to her tall stature and "strong power" relative to her female friends, her demeanor, in and out of class, was normally calm, thoughtful, and serious. She also expressed an abiding interest in the visual arts—especially independent film, the field in which she hoped to pursue a career—and international travel. With her mother, also an avid traveler, she would go abroad annually, having visited such places as Australia, the United States, and a number of countries in Europe and Asia. Her favorite destination, however, was Vancouver, Canada, where she spent several months with a homestay family while studying English at a large public university.

Nagako titled her eight-minute multimedia story "Food for my Mind," referring to the formative influence of several experiences she had had over the course of her life: traveling abroad, attending an all-girls high school, and living and studying in Canada. Nagako was extraordinarily committed to making the most of her digital story project—she was one of only two participants who invariably stayed in class each week for the extra lab time, most often resisting shutting down her computer even as the lights in the common areas of the building were being turned off by staff. Notably, Nagako seemed concerned with making a story that was "cool," that is, congruent with the up-tempo, intensely visual brand of cool that, for her, professional skateboarding videos epitomized. Another interesting feature of Nagako's multimodal composition process was her apparent comfort with expressing ambiguous meanings to her intended audience, whom she identified in our first interview as "my classmates, my family, my friends, and myself." In her sixth journal entry, in response to the question of what her overall approach was to designing relationships between images and language in her piece, she writes:

> In my video project, I use images which make sense with the writing to spectators and also make nonsense. Then I have lots of different purposes to make this video. For example, understanding myself, cheering me up that everything was good for me,

cheering people up by giving my idea with examples, introducing myself to spectators, showing my thanks to people I met and leaving as my memory. For that I am going to use lots of images. However as I mentioned at former paragraph, coherence is very important. If the whole piece of video has coherence, even though the relationship between images and language doesn't make sense to spectators, they still can understand in the end. Therefore in order to make coherence, I want to manipulate effects and music. Also I am going to use lots of images because image has big impact.

Nagako embraces the heteroglossia, the multivocality, of multimodal meanings in her story; she does not see that a preset, standard collection of potential meaning relationships among co-deployed modes will, or should, be actualized in the minds of all intended "spectators." She seems consciously aware of the diversity and complexity of her audience, members of which are differentially privy to the potential meanings she sets forth in the piece. This accords to such factors as the level of shared knowledge of what is depicted in the incorporated personal photographs and the level of access to English, in which the oral-linguistic portion of the piece is encoded. She also intends, however, that whichever respective subsets of understandable and "nonsense" meanings a viewer may actualize, s/he will also recognize a global coherence in the piece, prefigured by design, as she mentions, through the purposeful integration of video effects, music, and plentiful imagery—the generic textual touchstone, again, being the slick MTV-type skater video. To the same end, Nagako took pains in successive written drafts of her story to ensure the clarity and coherence of the linguistic component. In sum, the guiding principle of Nagako's *addressivity management plan* seems to have been that an appropriate balance between meaning that is broadly publicly accessible and that which is personal or targeted toward particular audiences could best be achieved through creating coherence across *intra-modal* linkages (e.g., between images or between paragraphs), thereby supporting or off-setting the necessary degree of ambiguity that obtains in the *inter-modal* relations (e.g., between images and words or sentences).

As Nagako's text-creation process concluded, however, she had become somewhat discontented with this approach. When asked in Interview 3 how she felt about her digital story and the process of creating it, she forthrightly stated, "No, I'm not satisfied with my project." The first point of dissatisfaction was the length of her written story. She bemoaned the inclusion of what seemed in retrospect to be an unnecessary degree of detail. A longer monomodal (viz. linguistic) story requires proportionally greater effort to purposefully coordinate with imagery, music, and so forth, which in Nagako's case caused frustration at times. Still, her dissatisfaction seems to have stemmed principally from a more complicated, semiotic root.

Also in Interview 3, Nagako reflected on the orchestration of language and images in her story and how she felt her project went awry:

Nagako: Yah, like, my, the essay was very detailed. And, then, I don't know why, I put pictures on, how do you say, we had three kinds of mode. If, for example, if I write "computer" in my essay, I just use the picture of the computer.

Interviewer: Okay.

Nagako: How do you say that?

Interviewer: A kind of icon?

Nagako: Yah, icon.[6] I used a lot of icons. That's why I put too much pictures, then/[7]

Interviewer: /Why did you decide to do that?

Nagako: I don't know. Unconsciously.

Interviewer: Hmm.

Nagako: Then, the end of my project, I started to be annoyed of too much, too many pictures. It's going to be, like, messy. It's not clear to see.

Interviewer: What would make it messy?

Nagako: I mean, too many pictures, is like too many information. And, I think it gives some complex feeling or impression to others. And to me, too.

Evidently, Nagako's language design, or specifically the comprehensiveness that characterized it, set in motion a series of interactions among several dependant factors in her process. Naturally, the very detailed nature of her written/spoken piece necessitated the inclusion of a lot of visual material, but it was Nagako's employment of iconicity as a semiotic bridge between the language and images in her piece that likely put the image quotient over the top, effectuating the "messiness" discussed above. Through her experience, Nagako intuited a consequential property of iconic forms of representation as they relate to digital storytelling: that they are more likely, as compared to indexical and symbolic forms, to be deployed in correspondence with individual content words—especially nonabstract nouns, like "computer"—which can easily be displayed with a co-occurring language label. The semantic content of longer linguistic units is understandably more difficult to bound with a single image, and language with abstract thematic content that much more so. Nagako explains:

Nagako: If I use icons for each word, just one word, then I have to use pictures a lot, for each word. But if I imagine something for each sentence, it's going to be clearer than using images from the one word. I think it's difficult to choose one picture for one sentence. . . . It happened to me when I was talking about, like one paragraph, which doesn't use like icon, which I can't use icon. I thought many things, but I couldn't find one specific picture. It was difficult.

Interviewer: Yah. But why do you think it's difficult?

Nagako: Well, before you asked me about it, I couldn't answer. Because one sentence doesn't have an image. The part ((in her story)) which I talked about how I appreciate or I experience about something, it was difficult to get the idea or image/

Interviewer: /Uhm hm/

Nagako: /because/ experience is, experience is a verb.[8] Like, noun is easy to find the image because it's an object.

Strictly grammatically speaking, experience is not a verb, of course, but Nagako's observation is quite telling nonetheless. Experiences, feelings, abstractions—verb-like in their dynamism and evanescence—are hard to contain in an image. Attempting such requires concentrated cognitive work and, perhaps, a modicum of daring as well.

Whatever the cause, reaching beyond perceived constraints of iconic multimodal representation was something Nagako felt unprepared to do, at least within the parameters of this project. In spite of her original determination, which was to have each mode operate independently within an overarching coherent semiotic structure, addressing multiple audiences in respectively appropriate ways, her design was undone in her estimation by unforeseen intermodal interactions and the semiotic strictures incident to these. "I wanted my video to be cool," she ultimately said. "I wanted to make my video like a skateboard video. But like here, no." Ironically, one of the distinguishing characteristics of skateboard videos that Nagako most liked and wanted to emulate, the fast pace and quick visual transitions, was what, in a somewhat different form, she found least satisfying in the video she made herself.

Mutsuko: Sakura, sushi, ramen

In terms of her background, Mutsuko was something of a *rara avis* among Daigaku University students, and the populace of Japan at large for that matter. Mutsuko was a Taiwanese national, who had come to Japan at the age of twelve after her Taiwanese mother married a Japanese man. She attended high school in a regional capital approximately one hundred kilometers northeast of Tokyo and then matriculated at Daigaku. Though she became a permanent resident of Japan, she maintained strong connections to Taiwan, returning often to her home city of Kaohsiung to visit extended family and friends.

Mutsuko's reasons for taking the course were both practical and personal: "I am interested in multimedia, so I want to gain knowledge about it and learn the better way to present myself using multimedia," she explained in her

participant profile. Signally, too, at the end of her process she reported having indeed made a successful go, in her opinion, of multimedia self-presentation. Asked in the final journal entry prompt what she liked and disliked about her piece as she was finishing and if there was something she wanted to do but felt unable, she responded that though she felt a bit frustrated at times with her inability to make full use of photo-editing software, she "always did my best while creating the story, and I realized it was a thoughtful task but fun. Frankly, there are not any parts that I dislike in the story I am creating now." Her fairly unqualified approval of her completed composition stood in contrast to the responses of the other participants, who each identified at least one aspect of the product and/or process they would have liked to change in some way.

Mutsuko's story was a reflection on her life and how she came to be and think as she presently did. She titled her piece "Cosmopolitan," referencing the gradual broadening of her cultural horizons through experience with different people(s) and places. She began her composition process, as did the others, by engaging in brainstorming activities in different modalities, for example, free writing and collecting images that expressed essential aspects of herself. Mutsuko was especially interested in the pictorial brainstorming because she, along with a few other participants, was a photography enthusiast. More than once she asserted in class her opinion that the quality of images produced by her single-lens reflex 35mm camera was far-and-away superior to anything digital, which she would never use. The images that Mutsuko chose to represent herself included a Taiwanese magazine ad for the 2009 World Games in Kaohsiung (a representation of her birthplace); a photo she took at a Shinto shrine (a representation of Japan); a Japanese magazine cover featuring Charles M. Schulz (a representation of "Peanuts," a comic strip from which she drew encouragement); and two photographs she took at the "Ground Zero" site in lower Manhattan (a very impactful experience). These images, to Mutsuko, were artifacts suffused with memories of the most affecting influences and experiences of her life.[9] (See Figures 7.1 and 7.2.)

The visual brainstorming exercise in itself proved quite interesting in that it demonstrated, albeit limitedly, the aforementioned differences in "organizing logics" for meaning making such as Kress (2003) discusses: the distinction between the logic of "display," accordant to images, and that of "narrative" which operates within the purview of language. With the exception of only one participant, who used her five images as the actual thematic platform upon which to build her story, each of the other participants felt compelled to abandon one or more of these five images after developing the linguistic aspects of their stories. They mainly did so on the grounds that though all five images continued to represent pivotal moments, experiences, associations, and so forth in their

lives, some of the images came to not fit, in other words there was no part of the narrative to which they were felt to be appropriately anchorable. These participants were ostensibly directed by an implicit sense that the semiotic cohesion that can unify a collection of images, even when seemingly unrelated, loses its grip when a narrative is introduced.

Figure 7.1: (clockwise) Kaohsiung world games magazine ad, photo of Ground Zero site from afar, photo of visitors to Ground Zero, Charles Schulz magazine cover.

Like these others, Mutsuko eliminated one of her original five images from the corpus of pictures that would be introduced into her digital story; however, the impetus did not come from a semiotic source of the type described above. The image is a black-and-white photo, taken by Mutsuko herself, of a young

woman wearing a coat and scarf praying for good fortune at a Shinto shrine (Figure 7.2). In her third journal entry, Mutsuko explains the choice of this image:

This is a black and white picture, which I took in Yujima Shrine, Tokyo. Many Ema (votive picture tablets of horses) is mainly used in praying for success in passing entrance exams in this shrine. This was one of typical Japanese cultures that I had have known after I came to Japan. I remember when I was a third-year high school student in 2003 I went to shrine on the New Year's Day and bought Ema to pray for my success of [Daigaku] entrance exam. In fact, I took this shot last year when I took a walk with my single-lens reflex camera because this scene reminded me how really I wanted to come to [Daigaku University].

This image is clearly imbued with personal meaning for Mutsuko, as she mentions the memory of praying for her own success in university entrance exams and also of taking this photo a few years later while reminiscing over that earlier period of anxious anticipation. And in terms of her digital storytelling project, again, this image was at first selected to represent a pivotal growth experience in her life, as one of only four, and, in fact, to more broadly symbolize her "bittersweet"—a modifier Mutsuko herself uses in the text of her story—transition into the Japanese chapter of her life. When asked in Interview 3 to explain her ultimate omission of this image, she replied:

Figure 7.2: Students praying for success at the Yujima Shrine.

Mutsuko: It's nonsense! ((She laughs.)) I realized that.
Interviewer: Why was it nonsense?
Mutsuko: I have no idea about it after I scanned that picture. While I am thinking deeply about my story and images, I found that oh it's a mistake.
Interviewer: And what was the clue, or what was the hint that told you, oh this doesn't work?
Musuko: No feeling.
Interviewer: No feeling. Okay.
Mutusko: No feeling that, uh, fit my story.
Interviewer: But you took that picture yourself, didn't you? And what, uhm, what was it about that picture that didn't work? Or maybe the opposite way to say that is what was it about your story that made that picture not fit?

Mutsuko: At first I think it would be used in the part of when I am talking about Japan, but actually that scene could be anywhere, no only about Japan, so I chose to erase and use like the flag of Japan or you know when I talk about *seiza*,[10] I used the picture of like this one ((She brings up a photo of a "sakura" or cherry blossom.)). This is also from the Internet. [Figure 7.3]

Interviewer: So is that related directly to what you are talking about?

Mutsuko: To Japan! When I say Japan, what comes up to your mind? Sakura! Sushi! Ramen![11]

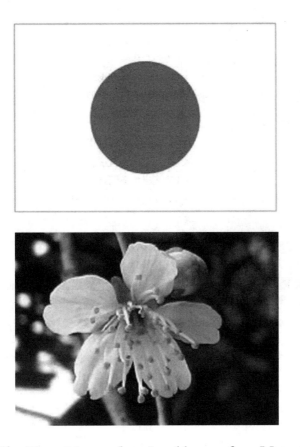

Figure 7.3: The *Hi-no-Maru* and a *sakura* blossom from Mutsuko's story.

It is interesting to note that Mutsuko employed the term "nonsense" in much the same sense that Nagako did, to mean an ambiguous relationship between image and copresent language. Also revelatory, we believe, is the conventional semantic import of the term, indicating a total lack of sense or mean-

ing, rather than an openness to interpretation. Mutsuko reported her intended audience to be friends, classmates, the course instructor, and herself. Surely, to her, as one of her own expected addressees, the image of praying at the shrine was not nonsense. Quite the opposite, it seems.

In essence, in making the decision she did, Mutsuko exchanges an image reflective of her own experience of Japan and her own point of view—both metaphorically and literally, as she herself took the photo—for premade, publicly available, highly generic, if not also stereotypical representations of Japanese-ness, namely the "Hi-no-Maru," or Japanese flag, and the cherry blossom. What seems significant here is not so much that Mutsuko changed her mind, but rather that she replaced what can be argued to be a deeply, personally meaningful image with images that convey meaning which is superficial and most widely accessible, with Taiwanese, Japanese, and "foreign" audiences in mind. To her way of thinking, a visual expression of her own memories and impressions of acculturating to Japan was "nonsense" to the extent that it did not plainly read as "Japan"; it did not jibe literally enough with her expectations for what her broad, multicultural audience would in turn generically expect of a visual image coupled with a discussion of her Japanese experience. So, she felt obliged to rein in the heteroglossic quality of her multimodal utterance, to tip the scale in favor of conventional, centripetal meaning making.

Discussion

According to Bakhtin, one cannot truly "speak" without orienting toward an addressee, even in the case that one is addressing oneself. And one cannot but speak in a variety of "languages" and a chorus of "voices," for oral and written language, and all other semiotic modes, we submit, are "not neutral [media] that [pass] freely and easily into the private property of the speaker's intentions; [they are] populated—overpopulated—with the intentions of others" (Bakhtin, 1981: p. 294). Clearly, both Nagako and Mutsuko, in creating their digital stories, undertook to "say" something uniquely, personally meaningful—multiple things, via multiple modes, to multiple addressees, in fact. However, in replicating an organic communicative process—to wit, layering an artificial, compositional form of heteroglossia onto its natural counterpart, which Bakhtin describes—these authors set for themselves a task that might be understood as a form of double articulation,[12] negotiating the mediational influences on intended meaning of two levels of multivocality, two strata of polysemy, two "populated" dimensions of intentions. Recall that this is a situation that Mutsuko notably recognized and acted to manage.

Added to this *hyper-heteroglossia*, to coin a term, are the multiple sets of

constraints imposed on the digital storyteller and digital storytelling process by the effectively multi-generic character of the digital story itself. Multiple "stable discourse types" (the written story, the film, etc.) are integrated within a single digital story, along with their respective semiotic entailments, which may well conflict, as was Nagako's experience. This is another form of double articulation and the obverse of the first.

Discernable here is not merely a situation wherein convention and innovation exist in a dynamic, productive tension, as Bakhtin suggests; rather, in these cases of digital storytelling, our analysis suggests, there are multiple *tensions-in-tension* with which multimedia authors are pressed to contend. And judging by the experiences of Nagako and Mutsuko, albeit obviously very limited and preliminary evidence, when faced with the challenges of navigating this labyrinth of resources and meanings, of "expropriating," to use Bakhtin's (ibid.) phrase, some space within the multimodal utterance for one's own expressive intentions, the pull of centripetal forces may be strengthened. Strict accommodation of simple formulas and social norms may appear to many to be the most practical option and tenable position. Many are enthusiastic about the power of new media and multimodality as tools for the creation of powerful meanings, and we are among them. Yet, our work with multimodal composers such as Nagako and Mutsuko, as well as with children and adults in the United States (e.g. Hull & Nelson, 2005), make us aware as well of the complexities and challenges that also attend those who would be authors in a new media age.

Notes

1. The linguistic subfield of pragmatics did not exist as such when Bakhtin began writing; however, his work may be seen as an important harbinger of it.
2. Jay Lemke (1998a, 1998b, 2002) is credited with coining the term "multiplying meaning" in relation to multimodal communication.
3. Here we employ the term "autonomous" in the sense of Olson's (1977, 1994) use of the term in relation to the written text, in which a complete meaning is meant to reside, as opposed to the oral utterance, the meaning of which is conveyed by the speaker, and not the language alone. To this way of thinking, written language exists in the form of an *autonomous* text. This is not to be confused with Street's (1984) "autonomous model of literacy," which regards literacy as individual, mentalistic, and skills-based, rather than as a "social practice," which he discusses in terms of an "ideological model."
4. This research program received the approval of Berkeley's Committee for the Protection of Human Subjects. As well, participants have given full, written permission to publish the information and artifacts included herein.
5. *Multimedia "Me"* was listed as an advanced content course in integrated-skills English

proficiency and was conducted in English. Specific measurement of proficiency gains was neither expected nor implemented.

6. We use the terms *icon, index,* and *symbol* in the narrowly defined, interrelated senses that philosopher and semiotics theorist C.S. Peirce (1940/1955) intends. According to Peirce's formulation, an *icon* is a sign in which the form bears a direct, mimetic likeness to its object, such as a picture of a ski slope to represent "ski slope". An *index* is a sign in which the form is physically or causally connected to, or "points to" (hence the name) its object, such as a picture of skis to represent "ski slope." A symbol in the Peircian taxonomy is a sign in which the form bears a purely conventional and arbitrary relationship to its object, such as a picture of a black diamond to represent "ski slope."

7. We have not intended to produce fine-grained transcriptions of interviews, so special transcription conventions are employed minimally. Here and hereafter, we use a comma [,] to indicate a short pause, a forward slash [/] to indicate an overlap, and double parentheses [(())] to indicate an interviewer comment.

8. Nagako's comment bears a striking similarity to Street's (1993) assertion that "Culture is a verb," by which he means that culture is a dynamic process of meaning making, rather than something static or institutional.

9. While "Peanuts" may seem a bit less weighty than the other influences, these characters did play an ostensibly vital role in Mutsuko's life and story.

10. "Seiza" (正座), meaning "sitting correctly," is the Japanese practice of sitting or kneeling in a particular, formal way.

11. We expect that our reader will readily understand the meaning of the word "sushi." "Ramen," while also well known, may be comparatively less familiar. It refers to a typical Japanese noodle soup dish that is an interpretation of Chinese noodles (which is somewhat ironic in light of Mutsuko's evocation of the term).

12. This is not to be confused with Bakhtin's (1981) concept of "double voicing."

References

Bakhtin, M. (1981). *The dialogic imagination: Four essays.* Austin, TX: University of Texas Press.

Bakhtin, M. (1986). *Speech genres and other late essays.* Austin, TX: University of Texas Press.

Ball, A. & Freedman, S.W. (2004). *Bakhtinian perspectives on language, literacy, and learning.* Cambridge, UK: Cambridge University Press.

Brown, A. L. (1992) Design experiments: Theoretical and methodological challenges in creating complex interventions in classroom settings. *Journal of the Learning Sciences, 2*(2), 141–178.

Collins, A. (1992) Towards a design science of education. In E. Scanlon & T. O'Shea (Eds.), *New directions in educational technology* (pp. 15–22). Berlin: Springer.

DiSessa, A. A. (1991). Local sciences: Viewing the design of human-computer systems as cognitive science. In J. M. Carroll (Ed.), *Designing interaction: Psychology at the human-computer interface* (pp. 162–202). New York: Cambridge University Press.

DiSessa, A. A., & Cobb, P. (2004). Ontological innovation and the role of theory in design experiments. *Journal of the Learning Sciences, 13*(1), 77–103.

Hull, G. A., & Nelson, M.E. (2005). Locating the semiotic power of multimodality. *Written Communication, 22*(2), 224–261.

Kress, G. (1997). *Before writing: Rethinking paths into literacy.* London: Routledge.

Kress, G. (2000). Multimodality. In B. Cope & M. Kalantzis (Eds.), *Multiliteracies: Literacy learning and the design of social futures* (pp. 182–202). London: Routledge.

Kress, G. (2003). *Literacy in the new media age.* London: Routledge.

Kress, G. (2005). Gains and losses: New forms of text, knowledge and learning. *Computers and Composition, 22,* 5–22.

Kress, G., & van Leeuwen, T. (1996). *Reading images: The grammar of visual design.* London: Routledge.

Lambert, J. (2006). *Digital storytelling: Capturing lives, creating communities.* (2nd ed.). Berkeley, CA: Digital Diner Press.

Lemke, J. (1998a). Metamedia literacy: Transforming meanings and media. In D. Reinking, M. McKenna, L. Labbo, & R. Kieffer (Eds.), *Handbook of literacy and technology: Transformations in a post-typographic world* (pp. 283–302). Hillsdale, NJ: Lawrence Erlbaum.

Lemke, J. (1998b). Multiplying meaning: Visual and verbal semiotics in scientific text. In J. R. Martin & R. Veel (Eds.), *Reading science* (pp. 87–113). London: Routledge.

Lemke, J. (2002). Travels in hypermodality. *Visual Communication, 1*(3), 299–325.

Malinowski, B. (1935). *Coral gardens and their magic.* London: Allen & Unwin.

Malinowski, B. (1939). The group and the individual in functional analysis. *American Journal of Psychology, 44,* 938–964.

Miles, M., & Huberman, A. (1994). *Qualitative data analysis: An expanded sourcebook* (2nd ed.). Thousand Oaks, CA: Sage Publications.

Nelson, M. E. (2006). Mode, meaning, and synaesthesia: Multimedia L2 writing. *Language Learning and Technology, 10*(2), 56–76.

New London Group. (1996). A pedagogy of multiliteracies: Designing social futures. *Harvard Educational Review, 66,* 60–92.

Olson, D. (1977). From utterance to text: The bias of language in speech and writing. *Harvard Educational Review 47,* 257–281.

Olson, D. (1994). *The world on paper: The conceptual and cognitive implications of reading and writing.* Cambridge, UK: Cambridge University Press.

Ong, W. (1982). *Literacy and orality: The technologizing of the word.* New York: Routledge.

Papert, S. (1980). *Mindstorms: Children, computers, and powerful ideas.* New York: Basic Books.

Papert, S. (1994). *The children's machine: Rethinking school in the age of the computer.* New York: Basic Books.

Peirce, C. S. (1940/1955) *Philosophical writings of Peirce.* New York: Dover Publications.

Pleasants, H. M. (2008). Negotiating identity projects: Exploring the digital storytelling experiences of three African American girls. In M. Hill and L. Vasuvedan (Eds.), *Media, learning and sites of possibility* (pp. 205–234). New York: Peter Lang.

Stein, P. (2004). Representation, rights, and resources: Multimodal pedagogies in the language and literacy classroom. In B. Norton & K. Toohey (Eds.), *Critical pedagogies and language learning.* Cambridge: Cambridge University Press.

Stein, P. (2007). *Multimodal pedagogies in diverse classrooms: Representation, rights and resources.* London: Routledge.

Street, B. (1984). *Literacy in theory and practice.* Cambridge, UK: Cambridge University Press.

Street, B. (1993). Culture is a verb: Anthropological aspects of language and cultural process. In D. Graddol, L. Thompson, & M. Byram (Eds.), *Language and culture* (pp. 23–43). Clevedon, UK: Multilingual Matters.

Tufte, E. (2003). *The cognitive style of PowerPoint.* Cheshire, CT: Graphics Press

van Leeuwen, T. (2005). *Introducing social semiotics.* London: Routledge.

 PART III

STRATEGIES OF DIGITAL NARRATION

Digital storytelling as a 'discursively ordered domain'

KELLY MCWILLIAM

Digital storytelling is one part, albeit a comparatively small one, of the larger Australian mediasphere (Hartley, 1996; Hartley & McKee, 2000). This is true of (what I refer to as) both the *generic* and *specific* conceptions of digital storytelling. To distinguish, the *generic* conception of digital storytelling is epitomised by writers like Carolyn Handler Miller who, in her *Digital Storytelling* (2004), uses the term broadly to refer to any media form that digitally facilitates interactive storytelling (from online games to interactive DVDs). The *specific* conception refers to the co-creative filmmaking practice developed by Dana Atchley, Joe Lambert and Nina Mullen in California in the early 1990s, now homed in the Center for Digital Storytelling (www.storycenter. org). Organised around a pedagogical goal of teaching 'ordinary' citizens basic media productions skills, *specific digital storytelling* takes a standard form; it is a workshop-based format that teaches attendees how to create a 2–5 minute digital film, comprised in its simplest form of a voice-over and self-sourced photographs, about a particular moment in their lives. Here, the process of creating a digital story is interactive, but the digital story itself is not.

This chapter focuses on *specific digital storytelling* in Australia. Although

practised throughout the United States, the United Kingdom, Europe and, increasingly, in parts of Asia, *specific digital storytelling* only began to be taken up in Australia in significant ways in the early 2000s, or almost a decade after its emergence in California. Digital storytelling is now widely used in five (out of eight) Australian states or territories—New South Wales, Queensland, South Australia, Victoria and Western Australia—in a range of public and private organisations, across a range of sectors, and with a range of intentions and foci.[1] There is even a national network of practitioners, the "Digital Storytelling Network" (www.groups.edna.edu.au/course/view.php?id=107), which was formed to share methodological innovations. Even so, despite the apparent diversity of digital storytelling practice, *most* digital storytelling programmes in Australia tend to occur in (or be targeted at) educational institutions (schools, universities, etc.), community organisations (community centres, local arts associations, etc.), and, to a lesser extent, cultural institutions (libraries, museums, etc.). The digital storytelling programmes that I focus on in this chapter bear out this observation, although in unusual ways.

This paper examines two Australian digital storytelling programmes: the first by the Australian Centre for the Moving Image (www.acmi.net.au), a cultural institution located in downtown Melbourne, Victoria; the second by tallstoreez productionz (www.tallstoreez.com), a media production company that works with youth and school groups around South Australia. I have chosen these two programmes not because their practices are typical of Australian digital storytelling—if anything, they are atypical—but because, in many ways, they represent different ends of the national digital storytelling spectrum, spanning, as it does, the public-private and cultural-economic divides. In looking at these two projects, I am interested first and foremost in drawing attention to the two most significant digital storytelling programmes (or suite of programmes) currently operating in Australia. While international programmes like those offered by the Center for Digital Storytelling and the British Broadcasting Corporation, particularly its *Capture Wales* programme, have by now been discussed in some detail (e.g., Meadows, 2003; Thumim, 2005; Lambert, 2006; Ying, 2007), little has yet been written on their Australian counterparts (Klaebe, Foth, Burgess, & Bilandzic, 2007 offer one of the few published exceptions). Beyond a project of critical visibility, I am interested in examining the nuances of ACMI's and tallstoreez productionz's digital storytelling programmes as discursive constructions, paying attention to the intra-discursive interaction of 'institution', 'participant' and 'text', before considering what these examples might reveal, if anything, about broader discourses surrounding digital storytelling in Australia. To adapt Colin Hay (1996), it is less the 'descriptive accuracy (or otherwise) of the presentation' of digital storytelling

in each programme that is interesting here; rather, what is 'far more significant is their narrativisation, the subject positions constructed and the resulting . . . discursive selectivity imposed by such narratives' (pp. 265–266). The purpose of this approach is to develop an understanding of Australian digital storytelling not simply as part of the Australian mediasphere, but also specifically as a *discursively ordered domain* or 'field of relations among a set of organisations which interact around some shared issue(s) or set of concerns' (Selsky, Spicer, & Teicher, 2003). I expand on this later.

But first, what are the Australian Centre for the Moving Image and tallstoreez productionz?

Australian Centre for the Moving Image

The October 2002 opening of the Australian Centre for the Moving Image (hereafter referred to as ACMI), a publicly funded cultural institution, represented a major addition—A$90 million worth to be precise—to the central arts precinct in Melbourne, Victoria (*The Age*, 2004). Built as part of the A$451 million dollar Federation Square development, on which ACMI is sited, ACMI is housed in a multi-storey building comprised of a screen gallery (the largest in the world), interactive learning spaces, digital studios, two multi-format cinemas, a (member's only) lending library and the Special Broadcasting Service's (SBS's) radio station. In other words, as cultural institutions go, ACMI is leading edge. In Australia, moreover, ACMI is the only centre dedicated to the preservation and exhibition of the moving image in all of its diversity, catering for film, television, games and new media (including 'screen-based media of the future', meaning yet-to-be-conceived-of forms). As a public facility, ACMI is the site of exhibitions, lectures and workshops and is primarily charged with engaging the community through its role as an educative and memorial resource on the moving image.

One of the ways ACMI has engaged the community since opening its doors is through its suite of digital storytelling workshops. ACMI currently hosts four different digital storytelling programmes: a three-day standard digital storytelling programme which was, to adopt the rhetoric of the 2007 ICA pre-conference on the topic, 'imported' from California (including the temporary import of Joe Lambert, who helped to set up the first programme); a four-day 'train the trainers' digital storytelling programme, also a Californian import; a one-day 'express' digital storytelling programme; and 'mystory', a two-day programme designed to teach Victorian high school teachers how to use digital storytelling in the classroom as part of addressing the state cur-

riculum (or VELS, the Victorian Essential Learning Standards). The latter two are more recent additions. Read together, ACMI not only has the largest suite of digital storytelling programmes in the country (and one of the largest in the world), it also has the longest-running Australian programme, with its five-year-old standard programme.

In those five years, ACMI has become an influential site for the practice and propagation of digital storytelling, not only in Australia—ACMI describes itself as the 'national centre for Digital Storytelling' (ACMI, 2006, n.p.)—but also internationally. ACMI is a member of an international digital storytelling network, led by the Center for Digital Storytelling (CDS), and hosted the first international digital storytelling conference held in the country, 'first person: international digital storytelling conference', which took place in February 2006. ACMI's Screen Events Manager, Helen Simondson, also continues to maintain close links with both industry and the academy (in terms of the latter she is, for example, discussing the development of ACMI's digital storytelling programmes in a forthcoming academic collection; see Hartley & McWilliam, forthcoming). Thus, ACMI remains one of the most interesting sites from which to investigate the ongoing development of Australian digital storytelling.

tallstoreez productionz pty ltd

tallstoreez productionz pty ltd is an independent, though heavily subsidised, media production company, which specialises in the production of documentary video and multiplatform digital art. Tallstoreez productionz also runs the largest Australian digital storytelling programme for youth, namely 'The Hero Project' (previously 'Directing the Hero Within', www.directingthehero.com). 'The Hero Project', which began in 2004 and is largely funded by the South Australian Film Corporation, targets school and youth groups around the state with participants typically aged between 13 and 18. Unlike ACMI, however, there is no central physical site or location for tallstoreez productionz's digital storytelling programme; rather, in the tradition of the BBC's *Capture Wales* programme (for more on which, see www.bbc.co.uk/wales/capturewales), tallstoreez productionz 'have workshop, will travel'. Tallstoreez productionz have facilitated digital storytelling workshops around the state, including in regional and, sometimes, remote areas. But rather than rely solely on workshops, 'The Hero Project' is an umbrella project comprised not only of its core digital storytelling workshops (including 'train the trainer' workshops, which target school

teachers and youth group leaders), but also of four other programme elements (Lyons-Reid & Kuddell, 2007, pp. 108–111). These elements include

- an interactive website, where participants are encouraged to upload their digital stories and engage in (supervised) discussions not only about each others' stories, but also to share technical hints and creative ideas, thus creating a youth-led (teacher-mediated) digital storytelling discursive community;
- a youth film festival (which is to be part of a larger festival, 'Come Out: The Australian Festival for Young People'), where participants can potentially screen their digital stories and engage in a larger digital storytelling culture;
- regional youth media centres, where schools or youth groups are provided with the digital equipment, training, space and infrastructure to develop their own digital storytelling culture; and
- a 'how-to' DVD for classroom use, with which schools and youth groups can continue to teach digital storytelling outside of the core digital storytelling workshops, the traditional reliance upon which has become a major obstacle to the wider proliferation of the form (as John Hartley notes in Chapter 11 of this collection).

Tallstoreez productionz can be understood as attempting something quite ambitious: their workshops, media centres and training DVD (production), website (distribution) and film festival (exhibition) together form a digital storytelling cultural network for Australian youth, which might offer the first glimpses of a sustainable digital storytelling practice. In a similar vein, Daniel Meadows argued in 2003 that the BBC's *Capture Wales* programme is more than 'just a visiting roadshow' and is instead 'part of a wider digi-nation project' where 'participants can visit one of a growing number of . . . community studios and continue to make films long after the initial workshop is over' (Meadows, 2003, p. 193). Indeed, Meadows (2003) went on to argue that sustainability was the most pressing issue facing the new form (p. 193). And, by all accounts, it continues to be: tallstoreez productionz face familiar funding challenges, their work currently bound to and dependent on Australian funding cycles. Even so, they are the subject of increasing industry and academic attention, having won a spate of youth media awards and sponsorships and, as such, are an innovative, but very different site from which to consider digital storytelling in Australia.

Similarities

Digital storytelling emerged as part of a wider shift away from one-way, top-down models of communication (traditional broadcast media) towards two-way, bottom-up models of communication (community and/or participatory media), the latter, according to Charles Leadbeater and Paul Miller (2004), 'one of the defining features of developed society' (p. 22) and epitomised by social networking sites like YouTube (see Jenkins, 2007). Yet, digital storytelling, a 'tractable, engaging and seemingly popular form for the average person to use' (Salpeter, 2005, n.p.), is consistent with neither model: it occupies a middle ground as a user-consulted, but expert-led media pedagogy that developed through and alongside these emerging technologies, but not because of them (Lambert, 2006). As a facilitation of 'everyday' stories, digital storytelling emerged from the community-activist theatre backgrounds of its founders, despite having since developed into an institutionally dependent practice, relying as it does on access to expert trainers in digitally equipped teaching space, for days at a time. Unlike the Californian model proffered by the Center for Digital Storytelling (CDS), but like most other examples around the world, there are no major organisations or institutions devoted solely to digital storytelling in Australia.

Thus, digital storytelling is not the only programme of ACMI or tallstoreez productionz, although it is clearly one of their most significant programmes in terms of the amount of people that participate in their programmes, the amount of resources they put into those programmes and the degree to which they are locally and nationally recognised as digital storytelling organisations. However, before I discuss the differences between these programmes, I want to first be very clear about the similarities between them (and thus the basis on which I am comparing them). To be precise, when I describe the programmes offered by these organisations as *specific digital storytelling*, I am referring not only to the fact that both organisations articulate what they do as 'digital storytelling'—in their promotional material, on their websites and/or in their wider discussions of their programmes (see, for example, ACMI, 2006 and Lyons-Reid & Kuddell, 2007)—but also that both programmes

- adopt a standard workshop-based pedagogy (one of the key features developed in the Californian model, on which see Lambert, 2006);
- facilitate the production of, by and large, short personal films;
- facilitate the production of these films in, by and large, one major form (video) and one major style (realism);
- promote their programmes around a community-centric agenda of

giving 'ordinary' communities (or sub-sections of communities, as in the case of youth) a way and a means to tell their own stories;

- structure their programmes around both narrative (script-writing, storyboarding, etc.) and technological (scanning photographs, using basic editing software, etc.) skill building; and
- provide their participants with the final product, a 2–5 minute digital story, in VHS, CD and/or DVD formats, which participants can, at the very least, share with their family and friends (or, for the more ambitious, post on YouTube or Jumpcut).

But while ACMI and tallstoreez productionz share these features and are broadly consistent with the Californian model, how do their differences reveal divergent constructions of the practice? And what are the implications of their differences? To address these questions, I want to briefly consider the differences between these programmes in relation to three sites—institution, participant and text—before discussing an example of a digital story produced within each programme.

Differences: Institution, participant and text

The discourses circulating around digital storytelling are substantively constructed, circulated and sustained in institutions, among participants and within texts. And there are some significant differences between ACMI and tallstoreez productionz as digital storytelling organisations (or, loosely, institutions). To begin with, ACMI is a cultural institution in the public sector and tallstoreez productionz is a media production company in the private sector, a sectoral difference that results in ostensibly different operational agendas. Most obviously, ACMI has a public-service agenda that is policy oriented (public-cultural), while tallstoreez productionz has a business agenda that is market oriented (private-economic). Yet, most of tallstoreez productionz's funding is secured from public organisations—arts council funding, youth council funding, state film corporation funding—and most of its participants are from the public sector (school groups and their teachers). Consequently, tallstoreez productionz are also dependent on the public sector, in the sense that they are publicly accountable and competing in a publicly populated market. These agendas also gird the discursive construction of each programme's preferred participant.

According to its website, ACMI serves 'the public', and while it is presumably a media-interested, or at least media-curious public that participates in

ACMI's digital storytelling programmes, ACMI promotes their digital story-telling broadly: digital stories are 'created and edited by people like you—using computers, cameras, scanners, and photos' (ACMI, 2006, n.p.). The approach is direct ('like you') and inclusive, from the point of distancing digital storytelling as an outcome ('created and edited', past tense) from its multimedia construction ('using computers'). 'People like you' is grammatically and tacitly separated from 'using computers' and, by extension, from the media literacy it flags (see Jenkins, Purushotma, Clinton, Weigel & Robinson, 2006; see also Hartley, McWilliam, Burgess & Banks, 2008). So, while scholars like Knut Lundby (2006) have emphasised that digital media participants, including those in digital storytelling workshops, do 'develop competence' that is 'part of a more general media literacy' (p. 12), ACMI downplays this aspect of its training with little mention of it elsewhere in its promotion. Instead, in the descriptions of their workshops on their website, ACMI emphasises that there are 'no technical prerequisites', that everyone has a 'story to tell', and, in a slightly different vein, that their workshops make a 'perfect gift for a loved one'. Here, ACMI's discursive construction of digital storytelling implies a preferred participant that is characterised by a desire to participate culturally or experientially—the latter a part of the 'experience economy', where consumers purchase a memorable activity rather than a tangible product (Pine & Gilmore, 1999)—rather than by an interest in formal media training per se.

However, one of ACMI's more recent programmes, the 'mystory' programme that targets Victorian high school teachers and aims to help them introduce digital storytelling into the classroom, certainly indicates an increasing engagement with formal schooling applications of digital storytelling. ACMI's development of the 'mystory' programme speaks to the United States, where digital storytelling is widely used across the breadth of K-12 schooling, including after-school and/or vacation care settings (see, for example, Banaszewski, 2002; Hull, 2003; Davis, 2005). In these contexts, digital storytelling is often seen as an important tool in building media literacy, narrative development and self-presentation skills, but also as a means of engaging students who might otherwise be struggling socially and/or intellectually (see Hathorn, 2005). Like many programmes in the United States, tallstoreez productionz's 'The Hero Project' is also centrally organised around school students. Specifically, tallstoreez productionz caters to school-aged youth, with their workshops described on their website as being suitable for 'all ages across primary and secondary levels', meaning youth aged between 5 and 18. More often than not, however, their participants are in the upper range of that age group with high school students, aged between 13 and 18 years, dominating their promotional material. Nevertheless, in all their workshops, there is an assumption of if not

curriculum-based learning, as ACMI's 'mystory' programme is, then at least curriculum-relevant learning.

These programmes' focus on youth is part of both a wider shift in media availability and in patterns of institutional engagements with youth, as digital storytelling trends in the United States demonstrate. According to Lundby, for example, 'digital media' is now a "natural" part of the social cultural environment of young people' (2006, p. 13). Indeed, a recent Pew report on 'Teen Content Creators and Consumers' notes that more than half of 'online teens have created content for the internet' (Lenhart and Madden, 2005, p. iii), a fact that leads Marc Prensky (2007) to observe a parallel paradigm shift in education, 'from "being taught" to "learning on your own with guidance"' (p. 1). And, to some extent, this paradigm shift is played out in the different discursive constructions of ACMI's and tallstoreez productionz's participants as particular kinds of learners or at least as participating in different kinds of learning outcomes. By and large, ACMI constructs its participants as *amateurs*, or as learners that need to 'be taught', whereas tallstoreez productionz constructs its participants as *experts-in-training* or as learners whose active learning is facilitated by tallstoreez productionz. The difference is significant. On the one hand, ACMI frames digital storytelling as a finite process that ends, rather than begins, with the production of a digital story. For instance, their website lists their digital storytelling programmes as one of four types of 'production workshops', alongside, for instance, its 'flash-animated manga workshop', emphasising production over any larger distribution of the text or developmental process for the participant. This is analogous to the way other Australian cultural institutions construct their digital storytelling programmes. The Powerhouse Museum in Sydney, for example, hosted a two-day digital storytelling workshop as part of the 2007 Sydney Writers' Festival, which cast digital storytelling as a novel-writing tutorial—one among many others at the festival—which culminated in the production of a digital story, rather than began any larger development of the participant. On the other hand, tallstoreez productionz explicitly frames its programme as 'training' that 'empower[s] young people' through digital storytelling, playfully framing that process as having the potential to uncover the next 'Ken Burns or Steven Spielberg', or the next major film director. Consequently, tallstoreez productionz casts digital storytelling as a developmental stage that, through guidance, encouragement and facilitation, has the potential to lead participants to expertise. Hence, tallstoreez productionz emphasises incremental (even aspirational) skill building, with a view to the future; ACMI emphasises short-term storytelling, with an eye to the past.

Ultimately, these differences also manifest themselves textually, demonstrating, negotiating and, to some extent, constituting each institution's differ-

ent discursive constructions of digital storytelling. For example, there tends to be, at the very least, a recurring textual difference in visual media: digital stories produced at ACMI tend to be based on photographs and other scanned 2D objects (certificates, drawings, etc.), while those at tallstoreez productionz tend to be based on digital video footage. Perhaps relatedly, ACMI digital stories also tend to employ retrospective narratives that are contemplative and function as cultural memoria (a symbolic stillness), while tallstoreez productionz' digital stories tend to examine the present or look to the future in exploratory ways (a symbolic sense of movement). For instance, 'Australia per forza e per amore' (translated from Italian as 'Australia by necessity but with love'), is a digital story by elderly Melbourne resident Giovanni Sgro, created in one of ACMI's standard digital storytelling workshops. Sgro's digital story is currently available on ACMI's website (see www.acmi.net.au/dsaustraliaperforza.aspx), where he describes it as follows:

> I arrived in 1952 from Calabria as an assisted migrant. My family arranged the passage without my knowledge. Upon arrival in Australia I was sent to Bonagilla military camp where they housed . . . assisted migrants. . . . From there I settled in Cobram getting work as a painter. My first real contact with Australians was with an Aboriginal family camping along the Murray River—they became my best friends. Moving from Cobram to Melbourne, I became a strong unionist; many years later I became the first Italian Member of [Victorian] State Parliament. I have always worked for the three million Italian migrants in Australia and my maiden speech was in Italian.

Sgro's digital story begins with quiet stillness: a black title screen and soundtrack, which features the strains of a traditional Italian fiddle, fades in. Sgro's voice-over, an elderly man's voice with a strong Italian accent, begins as the title screen fades out and a sequence of black and white photographs fade in that show, first, his family in Calabria and the ship he would sail on to Australia. It is a long story, at approximately ten minutes, and a dense one: Sgro's story begins with his move to Australia in 1952 and charts his life, in broad-brush strokes, since then, from getting a job, to his work with the union movement, to joining parliament, with only a passing reference to his wife and three children. It is a retrospective story told through photographs—first black and white, later colour photographs—of important moments in Sgro's life. It is meditative and expositional, dominated with past-tense phrases, including the penultimate phrase: 'I have enjoyed my life'. Sgro's reflective narrative about the course of his noteworthy but nonetheless 'ordinary' life echoes the institution's (ACMI's) dominant discourse about digital storytelling as an essentially memorial tool to facilitate community storytelling. This discourse is also taken up in many Australian community organisations' uses of digital storytelling, like Tuggeranong Community Art's 'Hungarian Digital Storytelling Project' (see www.art-

saroundcanberra.com.au), which uses digital storytelling to collect and exhibit the memories of elderly Hungarian residents as part of a broader promotion of (historically framed) cultural diversity.

In contrast, 'Pinnaroo Surfer' is a digital story by Kade Richardson and Danah Ribbons, two teenagers from Pinnaroo, a small regional town in South Australia, and created as part of one of tallstoreez productionz's workshops. Their digital story is currently available on Apple's Student Gallery Australia (see http://edcommunity.apple.com.au/gallery/student/item. php?sec=1&itemID=63), where it is described as follows:

> 'Don't be limited by where you are or where you're from—anyone can surf.' Kade is not your usual surfie, but when you're stuck in a small country town, it's exciting to plan your escape to the beach. When you push yourself to the limit and follow your heart, you can ride the surf regardless of place and fear of sharks.

Kade and Danah's digital story begins with movement: the camera is sitting on the dashboard of a truck providing a perspective shot as it is driven along a dirt road, with a lively (and self-composed) guitar composition on the soundtrack. As the title fades, the digital story cuts to a mid-shot of Kade, a young, white, male teenager, talking to the camera about his passion for surfing, as he prepares for an apparently imminent surf. He discusses the need to have eaten a good meal and rested well before surfing and a fear of sharks that he tries not to think about, as he takes his shoes and glasses off, puts sunscreen on, picks up his boogie board, and walks towards the 'beach'. However, the joke's on us: the next shot shows Kade jumping on his boogie board as he 'surfs' down a large sand-dune in the bush on the outskirts of Pinnaroo, a rural town more than 200 kilometres east of Adelaide. He is, of course, nowhere near a beach, as he tells viewers with a wide grin that 'anyone can surf!'. The emphasis on surfing where there is no water—or, extrapolated further, of achieving an end goal where there are obstacles—is clearly part of Kade and Danah's crafted narrative, even as it equally reflects the institution's (tallstoreez productionz's) larger aspirational discourse about the application of digital storytelling to facilitate 'youth empowerment'. In other words, Kade and Danah's digital story is both consistent with and reflective of the dominant discourse circulating about digital storytelling within this institution and perhaps also about apposite childhood. While digital stories are never 'straightforward examples of the discourses of dominant 'institutions'' (Burgess, 2006), they can nevertheless be understood as the product of a discursive engagement with their producing institution. Thus, digital stories like Kade and Danah's do represent a 'constitutive elemen[t]' of the digital storyteller's 'participation in or membership of' the institution's dominant discourse, in this case tallstoreez productionz's (Knobel

& Lankshear, 2007, p. 6).

Interestingly, Kade, 18, is the only one seen or heard in their digital story (Danah, 17, is behind the camera), but the story is presented as though he is in conversation. Kade, for example, begins sentences as though he is respond-ing to a question, such as, 'Oh yeah, you know, I'd call myself a surfer'. The use of *in media res*, meaning 'in the middle' (a technique where a scene is begun when action has apparently already commenced), provides an immediate sense of momentum. The lively music, deadpan humour, action shots and emphasis on play (and playfulness) culminates in a very different, and (at 2 and a half minutes) decidedly shorter, digital story than Giovanni Sgro's. While it is im-portant not to overstate the 'representativeness' of these two digital stories, which have come from programmes that have collectively produced hundreds of digital stories, they are nevertheless a useful point of comparison for draw-ing together some of the recurring differences between these programmes.

These differences are presented below in tablular form:

	ACMI	tallstoreez productionz
Institution	public sector	private sector
	cultural institution	production company
	culture	economy
Participant	'the public' (diverse/abstract)	school-aged youth (5–18)
	urban	urban, regional & remote
	fixed	mobile
Text	exhibited (internal), publicly published (website) &/or self-circulated	exhibited (external), privately published (website) &/or self-circulated
	photo-based	video-based
	retrospective	present/future-oriented
	memorial	exploratory
	finite—amateur	*infinite—expert in training*

But if there are reasonably consistent differences between these two pro-grammes, particularly around the three discursive hubs of institution, partici-

pant and text, then what do these differences ultimately mean, if anything?

A discursively ordered domain?

'Discursively ordered domain' is a concept coined by Selsky, Spicer and Teicher (2003), which integrates scholarship on domain theory and discursive sensemaking in an organisational context. Domain theory takes a broad inter-organisational perspective, such that a domain is a constructed, as opposed to a predetermined, 'field of relations among a set of organizations which interact around some shared issue(s) or set of concerns' (Selsky et al., 2003, p. 1731). Domains come into being when different organisations recognise their common interest or connection to a particular matter (say, around enabling communities to tell their stories through digital storytelling) and structure discursive patterns around that idea, issue or, perhaps, product (say, digital storytelling workshops or digital stories themselves). However, the construction and circulation of discourse are also ideological and iterative, restricting the subject positions possible within it, as numerous scholars have shown (see, for example, Hardy & Phillips, 1998 and Reed, 2000). Thus: 'Over time', Selsky, Spicer and Teicher (2003) continue, the 'interplay of internal and external forces produces an emergent trajectory for a domain in terms of the particular issues and institutions that rise and fall' (p. 1731). In other words, one practice can become discursively dominant and, in that dominance, shape the course of emerging discourses and related actions or practices. But where discourse studies traditionally cast the interaction between 'discourse and action', at least in an organisational setting, as being about 'dominance and marginalization', the concept of a discursively ordered domain re-casts that relationship as, among other things, a site of discursive negotiation (Selsky et al., 2003, pp. 1733–1735).

Applied to the topic of this chapter, then, we can begin to see ACMI's and tallstoreez productionz's digital storytelling, a shared practice that is constructed in different ways within each organisation, as 'contexts and pretexts for enacting and refining memberships of' their respective discursive constructions of the practice (Knobel & Lankshear, 2007, p. 6). For ACMI, this is the construction of digital storytelling as a finite facilitation of memorial storytelling by amateurs, which is echoed in a number of other Australian cultural and/or community digital storytelling organisations, a handful of which I mentioned earlier. For tallstoreez productionz, this is the infinite construction of digital storytelling as an aspirational, capacity-building facilitation of empowered youth trainees in the private-economic sector. Read together, and within the broader context of Australian digital storytelling, ACMI and tallstoreez pro-

ductionz not only offer glimpses of the breadth of the Australian digital story-telling spectrum, bridging the public-private and cultural-economic divides as they do; they can also be understood as part of a discursively ordered domain that has formed at the nexus of their shared interest in digital storytelling.

Within this discursively ordered domain, ACMI, tallstoreez productionz and their numerous counterparts around the country, are engaged in a constant negotiation over what, precisely, digital storytelling is, how it is best applied, what it is for, and where it should be located (geographically and sectorally). An example of this discursive negotiation is ACMI's recent introduction of 'mystory', a programme that targets high school teachers by using digital sto-rytelling to address the high school curriculum. ACMI's recent introduction of this programme, and its announcement of plans to offer a mobile digital sto-rytelling service in Victoria in the near future, can be read as a response to the increasing presence of tallstoreez productionz and their construction of digital storytelling within the Australian digital storytelling discursively ordered do-main. In fact, the recent changes by ACMI, a major cultural institution, likely indicate a shift in the dominant discourse around digital storytelling in Aus-tralia: away from a construction of digital storytelling as a finite production of cultural memory, and towards digital storytelling as a more aspirational, or at least developmental instruction of school-aged trainees, the latter epitomised by the work of tallstoreez productionz.

While it will take some time to see how widely this discourse is (or is not) taken up by other Australian digital storytelling organisations, its emerging prominence raises a number of questions. For example, does, and if so how does, the apparent dominance of a school-focused discourse around digital storytelling in Australia reflect an engagement with international discourses surrounding digital storytelling (for more on which, see McWilliam, forth-coming), most obviously with the United States where formal schooling ap-plications have been the dominant application for some years? To what extent do ACMI and tallstoreez productionz's discursive negotiations indicate the potential for a wide-scale integration of public and private sectors, of cultural and economic motivations, and of expressive and instrumental pedagogies? And finally, how might such an integration lead Australian digital storytell-ing towards 'best practice' and, indeed, what might that even look like? While these questions are beyond the scope of this chapter, they are a useful reminder of the larger context in which digital media practices, like digital storytelling, operate and their larger social, cultural and economic significance.

Note

1. For instance, digital storytelling is taught in the public sector in schools (such as Cherbourg State School) and universities (such as University of South Australia and Queensland University of Technology); is used by local governments to promote community, cultural and/or civic engagement (such as the City of Whitehouse's 'Untold Stories of Civic Participation', which used digital storytelling to celebrate the civic role that people with disabilities play in their community); and is used in the private sector by commercial design companies (such as lab.3000, who offer digital storytelling as a professional development tool), among many other uses.

References

ACMI (2006). 'About'. Australian Centre for the Moving Image, accessed 2007. Retrieved 14 September from http://www.acmi.net.au/5201BF1B10C34CB580714F09E02AF034.htm

The Age (17 January 2004). 'Hang the expense', Retrieved 10 September 2007 from http://www.theage.com.au/articles/2004/01/14/1073877895371.html

Banaszewski, T. (2002). Digital storytelling finds its place in the classroom. *Multimedia Schools*, 9, pp. 32–35.

Burgess, J. (2006). Hearing ordinary voices. *Continuum: Journal of Media & Cultural Studies*, 20(2), 201–214.

Davis, A. (2005). Co-authoring identity: Digital storytelling in an urban middle school. *THEN: The Journal about Technology, Humanities, Education and Narrative*, 1 (Summer). Retrieved 10 September 2007 from http://thenjournal.org/feature/61/

Hardy, C., & Phillips, N. (1998). Strategies of engagement: Lessons from the critical examination of collaboration and conflict in an interorganizational domain. *Organizational Science*, 9(2), 217–230.

Hartley, J. (1996). *Popular reality: Journalism, modernity, popular culture*. London: Arnold.

Hartley, J., & McKee, A. (2000). *The Indigenous public sphere: The reporting and reception of Indigenous issues in the Australian media, 1994–1997*. Oxford: Oxford University Press.

Hartley, J., & McWilliam, K. (Eds.). (forthcoming). *Story circle: Digital storytelling around the world*. Oxford: Blackwell.

Hartley, J., McWilliam, K., Burgess, J., & Banks, J. (2008). The uses of media: Three digital literacy case studies. *Media International Australia*, forthcoming.

Hathorn, P. (2005). Using digital storytelling as a literacy tool for inner city middle school youth. *The Charter Schools Resource Journal*, 1(1) (Winter). Retrieved 20 September 2007 from http://www.ehhs.cmich.edu/%7Ednewby/article.htm

Hay, C. (1996). Narrating crisis: The discursive construction of the 'winter of discontent'. *Sociology*, 20(3), 252–277.

Hull, G. (2003). Youth culture and digital media: New literacies for new times *Research in the Teaching of English*, 38(2), 229–233.

Klaebe, H., Foth, M., Burgess, J., & Bilandzic, M. (2007). Digital storytelling and History Lines: community engagement in a master-planned development. In M. Docherty (Ed.), *Proceedings 13th international conference on virtual systems and multimedia (VSMM'07)*, pp. 1–15. Brisbane.

Jenkins, H. (2007). From participatory culture to participatory democracy (part one). *Confessions of an aca-fan: The official weblog of Henry Jenkins* (March 5). Retrieved 14 September 2007 from http://www.henryjenkins.org/2007/03/from_participatory_culture_t.html

Jenkins, H. with Purushotma, R., Clinton, K., Weigel, M., & Robinson, A. (2006). Confronting the challenges of participatory culture: media education for the 21st century. An occasional paper on digital media and learning. MacArthur Foundation. Retrieved 14 September 2007 from http://www.digitallearning.macfound.org

Knobel, M., & Lankshear, C. (2007). *A new literacies sampler*. New York: Peter Lang.

Lambert, J. (2006). *Digital storytelling: capturing lives, creating community*. (2nd ed.). Berkeley, CA: Digital Diner Press.

Leadbeater, C., & Miller, P. (2004). *The pro-am revolution: how enthusiasts are changing our economy and society*. London: Demos.

Lenhart, A., & Madden, M. (2005). Teen content creators and consumers. *Pew Internet and American Life Project* (2 November). Retrieved 10 September 2007 from http://www.pewinternet.org/pdfs/PIP_Teens_Content_Creation.pdf

Lundby, K. (2006). Transforming faith-based education in the Church of Norway: Mediation of religious traditions and practices in digital environments. *Studies in World Christianity, 12*(1), 5–22.

Lyons-Reid, J., & Kuddell, C. (2007). Returning the gaze: the Hero project, how to join politics, youth empowerment and entertainment. In F. da Rimini (Ed.), *A handbook for coding cultures*, pp. 108–111. Sydney, NSW: dLux Media Arts.

McWilliam, K. (forthcoming). The global diffusion of a community media practice: Charting digital storytelling online. In J. Hartley & K. McWilliam (Eds.), *Story circle: digital storytelling around the world*. Oxford: Blackwell.

Meadows, D. (2003). Digital storytelling: Research-based practice in new media. *Visual communication, 2*(2), 189–193.

Miller, C. H. (2004). *Digital storytelling: A creator's guide to interactive entertainment*. Oxford: Focal Press.

Pine, J., & Gilmore, J. (1999). *The experience economy*. Boston: Harvard Business School.

Prensky, M. (2007). Changing paradigms from 'being taught' to 'learning on your own with guidance'. *Educational Technology* (July-August), pp. 1–3.

Reed, M. (2000). The limits of discourse analysis in organizational analysis. *Organization, 7*(3), 524–530.

Salpeter, J. (2005). Telling tales with technology. Retrieved 14 September 2007 from http://www.techlearning.com/story/showArticle.jhtml?articleID=60300276

Selsky, J., Spicer, A., & Teicher, J. (2003). 'Totally un-Australian!': Discursive and institutional interplay in the Melbourne Port dispute of 1997–1998. *Journal of Management Studies, 40*(7) (November 2003), 1729–1760.

Simondson, H. (forthcoming). Digital storytelling at the Australian Centre for the Moving Image. In J. Hartley & K. McWilliam (Eds.), *Story circle: Digital storytelling around the world*. Oxford: Blackwell.

Thumim, N. (2005). Mediating ordinary peoples' stories. Presented at MiT4: The work of stories, Fourth media in transition conference, 6–8 May 2005. Cambridge, MA.

Ying, L. (2007). Making sense of facilitated media: A theoretical exploration on digital storytelling. Presented at 2007 International Communication Association (ICA) conference, Berkeley, San Francisco, USA.

NINE

Identity, aesthetics, and digital narration

LOTTE NYBOE AND KIRSTEN DROTNER

Introduction

Today, digital narration is part of everyday life, and children and young people are responding enthusiastically to the new possibilities offered by user-driven content creation. Visual imagery, music, homepages, animation film—the outcome of digital narration takes many forms, dependent on the users' individual resources and the affordances of the software used. For example, half of all Americans aged 12–17 have created content for the Internet, from sharing self-authored material to blogging and re-mixing text, music and visuals (Lenhart & Madden, 2005, p. 2). Similarly, 43 per cent of Norwegians aged 13–17 have created their own homepages or edited images and music, while more than two-thirds of them use email or social network services (Erstad, Kløvstad, Kristiansen & Søby, 2005, p. 67).

In attempts to explain and understand this rapid take-up and the diversity of digital production, notably by the younger generation, many scholars draw upon one of two main theoretical discourses, namely a discourse on cultural identity and a discourse on creativity. Both are based on qualitative methodolo-

gies and interpretive traditions of analysis, focusing on the meaning-making properties of users' engagements as particular socio-cultural practices. The cultural identity approach tends to foreground social aspects of media production such as giving voice, negotiating roles and forging social networks (Sefton-Green, 1999; Kearney, 2006; Noor, 2007). The creativity approach tends to focus on the creative process within particular fields such as the arts, sciences or popular culture and on individual abilities, although some scholars have recently stressed the communicative and communal properties of creativity (Kearney, 1988; Negus & Pickering, 2004; Gauntlett, 2007). In the following chapter we also stress the processual character of creativity; in addition, we explore the particular aesthetic aspects of digital content creation and how these aspects are played out in identity work within a participatory youth culture.

In an ethnographic study, conducted in a provincial town in Denmark in 2005, pupils aged 12–13 and 15–16 from two school classes, over a period of three weeks, produced their own narratives by means of computer animation, the software programme Photoshop or stop-motion animation. The digital animation project formed part of a larger cultural venture, incorporating also professional drama, oral storytelling and museology—a venture with the ambition to empower the young culturally by introducing them to different professional forms of aesthetic and artistic expression as well as inviting them to participate in different creative and expressive activities. The project was facilitated by professional animators and storytellers and took place at three local media workshops: the Media School, the Computer Clubhouse and the Animation School. The Media School facilitated production by means of Photoshop; the Computer Clubhouse focused on computer animation in Flash; while the Animation School was the site for stop-motion animation. At some point, all groups went to the Computer Clubhouse to produce the soundtracks to their film. While organised by professionals, the project was a school project as it took place during school-hours, and, in the three weeks earmarked to the project, the pupils worked both at their schools and at the media workshops.

Our methodological approach is media ethnography (Schrøder, Drotner, Kline & Murray, 2003), and we combine a user and a media perspective. As for media, we have been at pains to include both material and symbolic properties in our analysis, following James Carey's ([1989]1992) classic definition. In order to attain a holistic framework of analysis, we have triangulated ethnographic observation, interviews and film analysis. During the three weeks we observed the participants' individual behaviour and group interactions; we conducted individual interviews with teachers and professional animators after the storyboard phase; and did focus-group interviews with pupils after the production phase. In our analysis of the films, we focused on material proper-

ties, thematic elements and formal aspects such as multimodal recombinations, editing and the use of sound.

In the following, we direct our attention to digital technologies as resources for producing, performing and sharing new forms of identity work and to aesthetic production as a site for identity-formation and exploration. The chapter first addresses the different phases of the creative process, and second, we analyse the aesthetic dimensions of identity work in young people's interactive processes of narration. Finally, we situate our findings within prevalent discourses on young people's digital content creation and discuss the wider socio-cultural implications of digital narration in knowledge-based societies. Important questions will be addressed and exemplified along the way: what aesthetic resources can young people draw on and appropriate in their digital processes of narration; how these resources are re-contextualised through the production process; and what the implications of the increased digitisation of narrative resources and repertoires are for the wider community. In theoretical terms, we build on, and seek to integrate, theories of situated learning and design-based theory with theories of everyday aesthetics and cross-media theories.

The work process: Practice and performance

The work process comprised four separate phases: introduction, storyboarding, production and screening. In the introduction phase the pupils were given practical information and divided into groups. Professional animators and storytellers from the three media workshops visited the schools and discussed the different types of production software and their individual affordances with the pupils. During this phase, the pupils also watched different animation films and music videos and discussed genres and aesthetic rules and conventions. In the next phase, the storyboard phase, the pupils began working on their narratives and their storyboards. In advance, the project directors had chosen mirrors as a common theme for all the productions. The theme operated as a scaffold for the groups' endeavours of narrative construction and it had a structuring effect on the authoring of the storylines.[1] The mirror became an effective and important object to think with, a vehicle for brainstorming and for the exploration of narrative elements, and in all films the mirror forms part of the plot. Having negotiated their narratives, often through strong arguments, the groups began storyboarding and the process of transforming words into visual images. The drawings were arranged on a big sheet of cardboard and single images and ideas (e.g., boy falls in love with girl) were organised and

developed into sequences of action (e.g., the boy tries to win the heart of the girl by changing his appearance in different ways). With an almost complete storyboard at hand, the groups were supervised by professional animators and storytellers, final disagreements were resolved and decisions made. Supervision took place at the schools and took the form of a dialogue between the professional storytellers and the groups of pupils.

In the production phase, the groups went to the media workshops in order to animate their narratives; which they visited depended on the types of production software the groups wanted to use for their production. The particulars of the work process depended on the production software used. At the Animation School, the pupils working with stop-motion animation spent much time moulding figures and creating scenery and backgrounds using different physical materials such as clay, cardboard and paint. Within these sets they moved the figures a bit at a time, taking pictures of each move. In the process, the pupils discovered the great paradox of animation: in order to create natural movement and the illusion of the moving image, stillness must be achieved. One group found that the moulded figures kept falling over and, in order to keep them steady, the pupils decided to enlarge the feet. In their film, therefore, the characters have very large feet, not as a result of narrative choice but of technical necessity. The pupils producing in Flash worked most of the time on-screen and with non-physical objects. The objects were built of layers which were scripted with individual actions. As in stop-motion animation, and in contrast to live action film, computer-animated images are based on still image designs. The age of the pupils tended to determine how the images were produced: the younger pupils preferred to draw their images and background designs by means of paper and pencils, while the older pupils used mouse and computer. Working with Photoshop offered yet another type of production process: the pupils took pictures with digital cameras or found them on the Internet and edited and manipulated them in Photoshop. As in Flash animation, the pupils worked with different layers in the composition, but, unlike Flash animation, they could not use movement. The narratives produced in Photoshop therefore appear more like photo-montages than animation film.[2]

In the last phase, the screening phase, the groups made a physical installation for the screening of their films; and so, in this phase, the pupils worked with yet another mode of representation. Two rooms at each school were divided into separate sites which the individual groups decorated and furnished. The groups went to flea-markets and to different stores in town to buy things for their installations. To some of the pupils this was the most amusing part of the process; the girls, especially, enjoyed buying stuff and decorating the sites. Making a physical installation forced each group to reflect on and evaluate the

content of their film and symbolically represent it by means of physical objects and space. The screening event was important to the pupils, and they proudly and happily showed their friends and families the results of their hard work and struggles over the past three weeks.

Taken together, the phases of the process made up the full creative experience of the digital animation project: negotiating the plot and drawing the narrative; creating individual still images by means of paper and pencil or computer and mouse; animating and composing the moving images; and, not least, negotiating the narrative and organising the production by dividing the different tasks between the members of the group. Two important points about the working-process should be noted. First, although defined as a *digital* animation project, the work process afforded the use of both physical and non-physical materials and both digital and analogue technologies. Clay, paper, and pencils were used to produce images, along with computers, mouse and pixels; and for sound production the pupils were rapping and recording, ripping and manipulating digital clips and sound-effects. The process of digital narration implied a varied register of creative tasks and performances which were not exclusively related to digital tools and technologies. The pupils were in fact quite surprised at how much time they had to spend performing non-digital tasks such as drawing and moulding. Their work process indicates that digital production technologies do not replace more traditional technologies or media; rather they subsume them, as Andrew Burn and David Parker (2001) found in their study of the creation of an animation film. As a corrective to the celebratory note often voiced by technological optimists, they emphasise that the digital future is not a 'uniformly bright, unscathed surface of neo-technology' (Burn & Parker, 2001, p. 162). Second, our observations support Julian Sefton-Green's assertion that the software used in digital content creation influences not only what is made but also how it is, in fact, created. In our Danish animation project, the aesthetic form of expression varied in accordance with the software used. Some of the narratives appear as traditional clay animations while others appear as cartoons or art filmish photo-montages. The software influenced what was produced but also the work process itself, as noted, provided different platforms for aesthetic experience.

Competence formation and digital narration

The different practices and tasks comprising the work process activated the young participants' resources and helped nurture specific competencies, which may be grouped as social, technical and cultural competencies. While a three-

week project does not offer systematic learning processes that result in explicit competences, we venture to use the term in order to illuminate important aspects of learning that could be taken up and developed in ordinary education. The pupils' social competence included skills in offering opinions, criticisms and defences, as well as questioning, arguing and rethinking ideas within the group. Such competences were developed particularly during storyboarding when the groups negotiated their narratives and organised their productions. In the interviews following the production phase, where the pupils reflected on and evaluated what they had experienced and learnt during the three weeks, many of the pupils explicitly emphasised that they had learnt something about social collaboration, responsibility and commitment. Social skills were, in fact, regarded as a prerequisite for aesthetic production; as Lea expressed it: 'You have to be able to collaborate. . . . You have to be able to talk with the others about things . . . instead of just getting angry or, like, yelling and stuff. You have to be able to talk about it'. In another group of pupils aged 12–13, one participant noted: 'I think in any case that we [the members of the group] have become better at offering opinions. . . . We are not just sitting there saying, "well, that's okay". We are, like, saying more, "but I don't think that works, I think it should be like this and this", and then we can mix it a little'.

Negotiating ideas and thoughts, working in practice on producing something quite concrete, the group grew into a community of thought and practice with specific knowledge-economies and patterns of knowledge-exchange.[3] As a pupil aged 12–13 explained in one of the interviews: 'When we ran into problems, we first asked one another . . . how we should go on. But if we couldn't solve the problem we tried to find Lars [one of the professional animators]. If he wasn't there, we tried to solve the problem ourselves again, but if we really couldn't, then . . . then we started yelling at Lars!' Following certain patterns of knowledge-exchange in their respective groups, the pupils collaborated on finding solutions to problems, and they helped each other out in the sometimes difficult process of animating and constructing images and sound. During the process they actively supported each others' learning processes. As Joseph H. Kupfer (1983) has cogently remarked, aesthetic experience is about 'playful practice in "community organization" in which we learn to work our contribution into the fabric of what another presents to us' (p. 5). This was clearly the case in the project where the group became a community of thought and practice, a testing-ground for new practices, explorations and inquiries as well as relations.

The whole process also activated and developed the pupils' technical competence. With only brief introductions to the software, the pupils' technical skills were developed through practice when needed as the acquisition of tech-

nical skills was based on a trial-and-error basis. In the interviews most of the pupils, especially those who had been working with Flash and Photoshop, asserted that they felt they had become 'better at computers'. The phrase was, however, understood and used in different ways: to some it meant quite basic skills in saving and storing files on the computer, to others it referred to more complex activities of, for instance, encoding and manipulating sound and image. Rarely using computers at school, most of the pupils lacked even the most basic skills—an observation that conflicts with many adults' idea of the media-savvy net generation or digital generation (Papert, 1996; Tapscott, 1998). As one of the girls aged 12–13 said, elaborating on the group's assertion that they had become better at computers, 'well, we hardly knew anything in advance, did we!' During the two weeks of production, the pupils clearly developed their technical competence, although, needless to say, the project did not turn the inexperienced young user into a computer geek or nerd in three weeks. Still, they all experienced new ways of using a computer and gained confidence in their own skills of use.

The development of technical competence was clearly related to the software used. Both Flash and Photoshop elicited processes with higher potential for developing the pupils' technical skills than stop-motion. Moreover, it may be argued that Flash led to a deeper digital learning experience than Photoshop due to the character of the technical operations (see Sefton-Green, 2005, for a comparative discussion of the two types of software). However, the programme clearly had the drawback that the pupils working with Flash were quite dependent on the professional animators' help because of the complexity of the programme, while the groups working with Photoshop and especially stop-motion animation were less dependent on professional assistance; low complexity, for example, allowed more time to discuss the aesthetic qualities and choices of the images produced.

Last, but not least, was the pupils' cultural competence activated and developed during the production process. They trained their abilities to select and recombine different modes of representation—sound, image, graphics and textual elements—and to play with different symbolic repertoires, often of a commercial kind. During the interviews, the pupils reported that their production experience made them watch film and commercials on TV a bit differently. A pupil from one of the groups which had made a clay-animation film said: 'The other day, I turned on television and there was a clay-animation film on. . . . And then you start thinking, wow—they have certainly spent a lot of time producing this film—just to produce this short film'. From another group, which had used Flash for their production, a pupil noted that he had got Flash on his brain, meaning that he had started thinking in terms of the programme's

functionalities and expressive possibilities: 'Every time I see something [on television] I think in terms of Flash. . . . I think about how they have made the film'. Another member from the group added: 'Yeah, those mouths and how they are just in sync with the sound'.

New forms of representation: Resources for narrative construction

Not only does digital narration call for new kinds of competences, it also offers new forms of representation. The sources of these forms of representations are the lived experiences of everyday life as well as media culture. These were the resources that the pupils drew on and creatively put to use in the process of narration. The resources were played out in the narratives, both implicitly and explicitly—implicitly as underlying themes of love and appearance, explicitly in the form of, for instance, film clips and images. The pupils aged 12–13 were most evidently inspired by media culture, for instance television programmes such as *Popstars* and *Star Search*, and music channels such as MTV; the pop star Beyoncé appears in one of the films, for instance. In the pupils' aesthetic practices and narrative constructions, the resources applied were re-contextualised in different ways, and although the pupils' narratives focused on fictional or real-life characters such as football heroes and pop stars, they were also self-narratives through which personal experiences and aspects of identity-formation in (pre-)adolescence were explored, performed and negotiated.

In one film made by pupils from the 12–13 age group, the overall theme is boy-meets-girl. A princess and a football player living next to each other are quite self-centred and each occupied with their mirror. They believe that the mirror shows the future, as a voice-over explains. The princess fantasises about romance, as in the great love stories, and the film shows the famous clip from *Titanic* with Kate Winslett and Leonardo di Caprio at the stem of the ship. This is what the princess sees in her mirror—this is her dream. The football player dreams of success and fame on the football pitch, and in his mirror he sees himself with a cup. Walking around outside their houses, looking in their mirrors, they literally bump into one another and fall in love as the film fades. The narrative very explicitly plays out the antagonism between dream and reality. In the two other narratives made by pupils from this group the theme is appearance. In one of the films, the main character, an Egyptian football player, keeps changing his looks in order to win the heart of the pop star Beyoncé. Apparently, looks are not everything and the Egyptian football player has no

success with the girl. The narrative is humorous, centring on the football play-er's quite ludicrous attempts to change his looks to fit what he thinks the girl desires. In the other narrative on appearance, the main character is concerned with a pimple on his cheek—a concern which is put into perspective by televi-sion and the mediatization of the world's catastrophes exemplified by clips of starvation, 9/11 and tsunamis. The constant mediatization of global events and disasters is part of young people's everyday lives and experiences, and the film may be seen as a reflexive articulation of 'risk society' as a condition of being modern.[4]

In general, the sentiment of the narratives created by the pupils aged 12–13 is light and often humorous. This is also the case with one of the films produced by a group of pupils aged 15–16—a film strongly influenced by com-mercial animation films such as *Help, I'm a Fish* (2000) and *Finding Nemo* (2003). The narrative concerns a small fish who is bullied by the other fish in the sea. She meets a little sea horse and they become friends. The little fish swims along with the sea horse and comes up to the surface where the light transforms her into a beautiful fish. She swims back and confronts the fish who used to bully her. Through this film the pupils reflect on a common school issue, harassment, and, drawing on popular modern animation films, they re-configure Hans Christian Andersen's tale about the ugly duckling that grew into a beautiful swan. Unlike this warm and humorous film, the two other narratives produced by pupils from the group display a more sombre tone. In one film, as a girl walks along a street full of people, she sees in their faces her own distorted reflection. The film is full of despair, showing dark pictures with a layer of animated rain over the surface and a soundtrack that blends music with sarcastic laughter and the sound of rain. But there is a twist in the tale: the girl saves a beetle from drowning in a sink in the toilets at the local supermar-ket and as a result she feels some relief. The film is grave and sincere, dealing with the feeling of marginalisation. The girl from the group who performs in the film had a different cultural background than Danish, a background which may explain the choice of theme. In the other film—a colourful clay-anima-tion-production—the main character walks around a park, looking at all the couples kissing and feeling lonely; all the flowers she touches wither away. She walks to her house and attempts suicide. She is shown dying, melting on the floor but then is brought back to life by a man who comes by and touches her. As in a fairy tale, she is saved by a man who offers her his love, yet the narra-tive is far from a fairy tale; the narrative was inspired by one of the pupils who had recently experienced the suicide of a relative. During the storyboarding phase, other group members expressed and explored their recent experiences of bereavement, and they referred to a mutual friend from school, killed in a car

accident. The narrative clearly drew on these mutual everyday experiences, but, importantly, through the production process these resources were transformed and articulated in a fictional form.

As should be evident from our short run-through of the different plots and themes, to construct a narrative the young producers draw on and transform elements from media culture as well as from their everyday lives. With this dual departure, the production of digital narratives serves to reframe the act of storytelling both in terms of content (what is generated) and in terms of process (how it is generated). We need to specify the particulars of this process of creation in order to illuminate more precisely how digital storytelling operates in young people's identity work.

Aesthetic practice as a learning process

Digital storytelling is a creative socio-cultural practice in which the participants appropriate cultural repertoires and push boundaries of expression and experience. But it is a particular form of creativity in the sense that the objects of appropriation are signs generating meaning through embodied manipulations. We may define such processes as forms of aesthetic production, following a German tradition of work on children's mediatized expressiveness. As noted by Maria and Gunther Otto (1986): 'Aesthetic education is serious about the ways in which participants relate to their life-world through particular forms of perception and sensemaking' (p. 17). Like other German media practitioners, the Ottos attempt to disinter the concept of aesthetics from its long tradition of 'disinterested perception' following Kant and to relocate it within its original Aristotelian definition, with its focus on productive practices that unite cognitive and emotional faculties through embodiment.

As a learning process, aesthetic practice involves processes where sensemaking, perception and manipulation of objects come together in one and the same experience—it is a 'thinking with one's hands' (Drotner, [1991] 1995). Such processes allow important connections to be made between the external world (i.e., material objects and signs) and the internal world (i.e. thoughts, feelings and experiences). When the objects of manipulation are signs, which are sensemaking tools, the results may be transformative narratives, pushing perceptual boundaries of self and others and generating new forms of knowledge.

The animation project clearly demonstrated that the forms of knowledge generated through aesthetic production are quite distinct from the forms of knowledge generated by means of systematic studies of particular facts or gen-

eral issues at school. Following Michael Polanyi (1983), we can distinguish between explicit and tacit forms of knowledge. To Polanyi, explicit knowledge relates to theoretically acquired skills, while tacit forms of knowledge connect to bodily experience and everyday phenomena. In other words, explicit knowledge concerns that which we know we know and know we can do, while tacit knowledge concerns that which we know and can do but might not be aware of as such or, even, may be beyond articulation. Unlike school-based learning, aesthetic learning processes connect to and develop both explicit and tacit forms of knowledge. As one of the pupils aged 12–13 expressed it: 'In the two weeks of production, I have done a lot and learned a lot about myself—that I can do things . . . if only I want to'. In a similar vein, a girl aged 15–16 noted: 'I have learned from the project that one is capable of more than one sometimes thinks'. Another girl from the group added: 'Yes, one is capable of more than one expects. . . . I have learned, I think, that one just has to try something and then see how it goes'. To try something and see how it goes is a process-oriented and explorative form of learning which connects to both explicit and tacit forms of knowledge. In the project, the pupils sometimes knew exactly which types of knowledge were called for, at other times they had to experiment and explore and see how it went and hence discovered that they could do more than they expected.

The participants experienced the open-ended nature of the aesthetic practice as being both unnerving and confusing. They often had a hard time coping with the uncertainties involved in the work process and wanted answers to what they were going to learn and why they needed to perform certain tasks. With exams coming up, the older pupils were especially eager to know what they were going to learn and how this learning would benefit them in terms of their education.

The process provoked joy and satisfaction as well as anger and frustration. As one of the girls aged 12–13 graphically expressed it: 'Joy and happiness and then great despair and knocking one's head into the table . . . it [the process] was like a roller coaster where you are going up and down'. Sometimes everything worked out just perfectly, at other times nothing seemed to work, and feelings of success and satisfaction thus naturally accompanied feelings of failure and frustration. During their three-week project the participants never reached what Hubert and Stuart Dreyfus (1986) term the 'intuitive expertise' of the professional who masters the materials at hand. In terms of the Dreyfus' five stages of expertise, the young animators were still at the beginner's stage where phases of creative flow were still outweighed by phases of frustration—when the computer was not performing as was intended or the drawings turned out wrong, and when the participants could not match their expressive desires by

appropriate forms of articulation. What made the pupils go on despite these drawbacks was ultimately the wish for narrative expression through processes that re-activated and blended different types of understanding and allowed new forms of collaboration.

Aesthetic practice and identity-formation

As we have already noted, aesthetic production offers a bridge between internal and external worlds of knowing, and the results are tangible manifestations of the process. As such, aesthetic production may be seen as a particular way of performing one's cultural identity if we follow Stuart Hall's (1996) definition of cultural identity as a form of symbolic articulation. To articulate internal experiences by means of words, images and sound makes these experiences visible to others, and articulation thus involves both visibility and exchange. Aesthetic production is a particular form of articulation, as we have seen, because it involves manipulation of existing signs and co-production of new signs. To perform one's cultural identity through aesthetic practices, therefore, invites new perspectives and allows for a transformation of existing perceptions. The young animators' short narratives clearly revolve around pertinent issues of teenage life such as romance, loneliness and looks. But very importantly, the narratives do not thematise these issues as personal problems but as issues to do with plot, genre or technique. When participants' ideas and products were up for discussion and evaluation, aspects of identity-formation were discussed and handled as differences of opinion about colour grading, sound or editing structure. Paradoxically, the fictional distance allowed the participants new perspectives on their own identity work precisely because 'it is not about us'.

In the animation project, the aesthetic practice involved personal investment in the form of disclosure and articulation of inner states and lived experiences, and, to some of the pupils, this investment implied a rather strong sense of ownership. The narratives were theirs and not the professional animators' and storytellers', as a pupil carefully stressed in one of the interviews where the group discussed to what extent the professional adults should interfere with their construction of narratives. The sense of ownership was expressed quite distinctly in one of the groups during the production phase when one of the girls got really angry with the professional animators and storytellers. When the group was interviewed afterwards, she evaluated her own reaction: 'Well, it is just that I got really angry, and not that I can't see that it [the professional animator's suggestion] was better or anything. But . . . two strangers appear, who we don't know at all and haven't talked a lot with, and then they just start

judging us on what we have been doing and stuff . . . when I think that it [the narrative] is really cool and stuff. So . . . , I think, that has been quite difficult'. From her perspective, what were critiqued were not random aspects but aspects to do with the experiences she had had and the emotional investments she had made.

Reactions of this kind relate to the sense of ownership and personal investment—but also to the fact, as one of the professional animators stressed when interviewed, that Danish school children are not used to working creatively through aesthetic practices that imply a readiness to modify ideas by the responses of others. Sometimes such a readiness implies throwing an idea away and finding a new one. Since much school-based learning builds on pre-given assumptions and answers, it falls short of preparing pupils to work innovatively and creatively in processes that involve give and take and openness towards the uncertain.

Giving voice or training competences? Social implications of digital participation

The animation project described in this chapter is just one mundane example of the diverse forms of participatory content creation that digital media facilitate. The dramatic uptake of web 2.0 (and 3.0) technologies, not least by the younger generation, in most western societies gives cause for consideration both for practitioners and researchers. So far, two trends stand out. One trend is to analyse and understand these engagements within a critical discourse of democracy and citizenship, stressing that young people are entitled to be heard and should be encouraged to have a voice in public spaces, and also when these spaces are digital (boyd, 2007; Goldman, Booker & McDermott, 2007). The other trend is to situate digital communication and participation within a discourse of knowledge societies, focusing on the socio-cultural resources that these practices nurture and which are seen as key to future competence development (Erstad, 2005; Nyboe, 2006; Drotner, 2007).

By way of conclusion, we would like to argue for a holistic perspective on young people's digital resources, a perspective which may incorporate the citizen as well as the competence components. The insistence that young people are, or should be, considered full members of society offers an important corrective to perceived notions of competence formation as have been developed in relation to, for example, ICT and e-learning. Traditionally, these notions focus on the ways in which distance learning or virtual collaboration may enhance efficiency and reliability at work or in education, and competence forma-

tion is defined along these lines as training in effective information processing and production. As a growing body of theory-driven literature demonstrates, digital communication in general, and digital production in particular, serve to challenge such definitions of competence (Gilje, 2008, in press; Perkel, 2008, in press). Rather, what these engagements nurture is what may be termed competences of complexity. Particularly, children's self-styled digital practices catalyse their handling of complexity. The often intricate interlacings of mass-mediated and interpersonal forms of communication, of reception and production, global and local interactions, operate as symbolic and social meetings grounds between the familiar and the foreign, inviting and demanding users to position themselves in relation to those experiences and expressions. Young people have different resources in tackling such complexities, and they react in different ways—avoidance, negation, inclusion and reflection are some of the reactions that we found in our animation study. However, irrespective of their reactions young people's digital practices are one of the key areas in which they train competences of complexity.

We would argue that one of the key global challenges of the twenty-first century is to nurture human resources with capacities to deal with economic, political and cultural complexities. Today, such capacities are primarily exercised in out-of-school contexts and hence left open to individual differences of development rather than equity of opportunities. In order to be transformed into competences, such capacities need systematic development, and the main site for that is education. Schools would do well to acknowledge and take on board digital resources and to widen existing definitions of competence to include both citizenship and employment, both voice and vocation. One way ahead is that scholars map more systematically the scale and scope of users' self-defined media practices and determine which of these practices are relevant resources for their future and thus merit educational attention.

Notes

We would like to thank the participants of the international research project 'Mediatized Stories', directed by professor Knut Lundby and funded 2006–10 by the Research Council of Norway, for constructive discussions and criticisms following an oral presentation on which this chapter is based.

1. The notion of scaffolding stems from the work of Wood, Bruner and Ross (1976).
2. See Sefton-Green (2005) for thorough accounts of using Flash and Photoshop.
3. Etienne Wenger (1998) uses the notion *community of practice*.
4. Ulrich Beck (1992) has coined the term 'risk society'. His risk thesis is part of his work on reflexive modernisation.

References

Beck, U. (1992). *Risk society: Towards a new modernity.* London: Sage.

boyd, d. (2007). Why youth ♥ social network sites: The role of networked publics in teenage social life. In D. Buckingham (Ed.), *Youth, identity and digital media* (pp. 119–142). Cambridge, MA: MIT Press. The MacArthur Foundation series on Digital Media and Learning. Retrieved December 2007 from http//:www.mitpressjournals.org/toc/dmal/-/6.

Burn, A., & Parker, D. (2001). Making your mark: Digital inscription, animation, and a new visual semiotic. *Education, Communication & Information, 1*(2), 155–179.

Carey, James. (1992). *Communication as culture: Essays on media and society.* London: Routledge. (Original work published 1989).

Dreyfus, H. L., & Dreyfus, S. E. (1986). *Mind over machine: The power of human intuition and expertise in the era of the computer.* New York: Free Press.

Drotner, K. (1995). *At skabe sig—selv: ungdom, æstetik, pædagogik* [Self creation: Youth, aesthetics, pedagogics]. Copenhagen: Gyldendal. (Original work published 1991).

———. (2007). Leisure is hard work: Digital practices and future competences. In D. Buckingham (Ed.), *Youth, identity and digital media* (pp. 167–184). Cambridge, MA: MIT Press. The MacArthur Foundation series on Digital Media and Learning. Retrieved December 2007 from http//:www.mitpressjournals.org/toc/dmal/-/6.

Erstad, O. (2005) *Digital kompetanse i skolen: en innføring* [Digital competence at school: An introduction]. Oslo: Universitetsforlaget [University Press].

Erstad, O., Kløvstad, V., Kristiansen, T., & Søby, M. (2005). *ITU Monitor 2005.* Oslo: Universitetsforlaget [University Press].

Gauntlett, D. (2007). *Creative explorations: New approaches to identities and audiences.* London: Routledge.

Gilje, Ø. (2008). Googling movies: Digital media production and the 'Culture of Appropriation'. In K. Drotner, H. S. Jensen, & K. C. Schroeder (Eds.), *Informal learning and digital media.* Cambridge: Cambridge Scholars Press.

Goldman, S., Booker, A., & McDermott, M. (2007) Mixing the digital, social and cultural: Learning, identity and agency in youth participation. In David Buckingham (Ed.), *Youth, identity and digital media* (pp. 185–206). Cambridge, MA: MIT Press. The McArthur Foundation series on Digital Media and Learning. [http://www.mitpressjournals.org/toc/dmal/-/6?cookieSet=1]

Hall, S. (1996). Introduction: Who needs identity? In S. Hall & P. DuGay (Eds.), *Questions of cultural identity* (pp. 1–17). London: Sage.

Lenhart, A., & Madden, M. (2005). *Teen content creators and consumers. Pew Internet and American Life project.* Washington, DC. Retrieved 1 August 2007, from www.pewinternet.org/pdfs/PIP_Teens_Content_Creation.pdf

Kearney, R. (1988). *The wake of imagination: Ideas of creativity in western culture.* London: Hutchinson.

Kearney, M. C. (2006). *Girls make media.* London: Routledge.

Kupfer, J. (1983). *Experience as art: Aesthetics in everyday life.* Albany, NY: State University of New York Press.

Negus, K., & Pickering, M. (2004). *Creativity, communication and cultural value.* London: Sage.

Noor, H. (2007). Assertions of identities through news production: News-making among teenage Muslim girls in London and New York. *European Journal of Cultural Studies, 10*(3),

374–388.

Nyboe, L. (2006). Multimedieværkstedet som lærested: æstetik, interaktivitet og kompetence, [The Multimedia Lab as learning lab: Aesthetics, interactivity and competence]. *Skrifter fra KulturPrinsen*, 4, 42–69.

Otto, M., & Otto, G. (1986). Ästhetisches Verhalten. *Kunst und Unterricht*, 107, 13–19.

Papert, S. (1996). *The connected family: Bridging the digital generation gap*. Atlanta, GA: Longstreet Press.

Perkel, D. (2008). Copy and paste literacy? Literacy practices in the production of a Myspace profile. In K. Drotner, H. S. Jensen, & K. C. Schroeder (Eds.), *Informal learning and digital media*. Cambridge: Cambridge Scholars Press.

Polanyi, M. (1983). *The tacit dimension*. Gloucester: Peter Smith.

Schrøder, K. S., Drotner, K., Kline, S., & Murray, C. (2003). *Researching audiences*. London: Arnold.

Sefton-Green, J. (Ed.). (1999). *Young people, creativity and new technologies: The challenge of digital arts*. London: Routledge.

———. (2005). Timelines, timeframes and special effects: Software and creative media production. *Education, Communication & Information*, 5(1), 99–110.

Tapscott, D. (1998). *Growing up digital: The rise of the net generation*. New York: McGraw-Hill.

Wenger, E. (1998). *Communities of practice: Learning, meaning, and identity*. Cambridge: Cambridge University Press.

Wood, D., Bruner, J. S., & Ross, G. (1976). The role of tutoring in problem solving. *Journal of Child Psychology and Psychiatry*, 17, 89–100.

TEN

Narrative strategies in a digital age
Authorship and authority

LARRY FRIEDLANDER

Introduction

The concept of authorship has had a troubled history in the last century. Writers and critics alike have betrayed unease with traditional notions of an all-controlling author. Modernist writers have stretched to reimagine what it means to be an author (cf. Joyce's author who like a god stands back and pares his fingernails), while postmodern critics have tried to undermine or even deny the role the author plays in establishing meaning in a text.[1] But all this discomfort with authorship is nothing compared to the havoc being wrought by contemporary digital narratives. With the appearance of these interactive experiences, we get stories that don't eliminate authors: they multiply them, distribute their energy across a wide field of participants (including some nonhuman agents), redefine their powers and limits, and in general rewrite all the rules. In doing so, they usher in a radical new era of storytelling, one that reflects in exciting but uncomfortable ways the cultural transformations of our time.

Most stories we know are written by an author, preserved in a text, and then transmitted to a reader. This author-text-reader triad is so familiar that we

seldom reflect on the point of authorship in this scheme. It seems banally obvious that books must be written by someone whose task is to create a shapely story: one with a beginning, middle, and end; one that seizes, holds, and entertains us; and one that has a satisfying and compelling resolution.

But authorship functions in other ways as well. I don't very much care who made the fork or lamp I am using, but I do care who writes the book. An author does not only tell a story; she brings the world, or at least a world, into my consciousness, and serves as a broker between the broader cultural "out there" and the intimate realm within. Reading is quite an intimate transaction. After all, I am inviting a stranger to enter my mind and flood it with potentially disturbing images, ideas, and events. Accordingly, I want the author to imbue the text with at least a minimum of insight or authority. Reading is also is a reciprocal transaction: I not only consume the product, I engage in a relationship with its maker. The author "gifts" me with her labor and her vision. In return, I offer trust in the author's skill, motives, and authority. Because I trust and I enjoy, I relax into a state of active receptivity that allows the words to seize my imagination and to stir my feelings. This reciprocity is vitally important to the success of reading as an imaginative process. It forms the basis of that suspension of disbelief, and that immersion in the fictive world, that makes the reading experience possible. Reading, in other words, is an act founded on intimacy, trust, and surrender that leads to an encounter with a differing consciousness. It is a collaborative process of meaning-making to which both author and reader contribute.

A text is the site of and the pretext for a dynamic exchange. The author gives us not only a story but also a world. By engaging with the author, we gain an entry into an other's experience, and through this other we gain access to the largest realms of experience. Hans-Georg Gadamer (2004), in his phenomenological hermeneutics, argues that reading involves fusing one's personal perspective or horizon with another's (p. 268)[2] and that this process of fusing horizons is fundamental to our understanding of anything at all. Each of us has a perspective or horizon that organizes our personal experience, but each perspective is in continual engagement with other perspectives. Meaning is not preexistent, as though it were already fixed in place and merely waiting for us to discover and retrieve it. Rather it unfolds and reveals itself as an event. It emerges from connection to people, events, and objects and gets played out in time, specifically in the meeting and dialogue between text and reader. For Gadamer then, all understanding flows from an interpersonal and intercultural participation (*Teilhaben*) that is a historical engagement with the world—a participation that presupposes solidarity with others. [3] When we read a text, the author is not physically present, but nevertheless we encounter her em-

bodied, so to speak, in the particulars of the text. Her sensibility is revealed to us as the elements of plot, setting, and language gradually unfold. Narrative so conceived is a relationship, a passing back and forth between author and reader, and a game in the broadest sense.

The author's voice, in particular, invites us into conversation. Take a famous example, the opening sentence of Jane Austen's *Pride and Prejudice*. "It is a truth universally acknowledged, that a single man in possession of a good fortune must be in want of a wife" (Austen, 1989, p. 1). This voice introduces the implied narrator/author[4] and establishes her credentials. We hear that she is smart and funny—indeed wittier than we are—knowledgeable about the world, and in sophisticated control of tone. Her cultural authority is evident in the ironic way she echoes and undermines established attitudes. We admire her skill and feel grateful that she is confiding in us, generously sharing—or rather performing—her intelligence, warmth, and imagination. Her generosity of spirit persuades us, in turn, to expend the effort it takes to listen and engage sympathetically.[5]

Because this text is a conversation it is not solipsistically self-enclosed nor is it shut off from other texts and from ordinary life. The voice that speaks to us seems to emerge from the deepest matrices of society, is resonant with the plenum of those other experiences, and marks out its own space within that larger arena of stories. Though the voice is authoritative, it is also familiar and confiding; it invites the reader into relationship. Austen's tone implies that she and the reader share a cultural repertory; that they know how to talk with each other; that they share a world. So narrative situates us vis-à-vis the world through the dialectical experience of storytelling.

Digital stories,—interactive fictions of all kinds and in video games[6]—radically alter the familiar triad of author-text-reader and in the process produce new kinds of narrative. In the digital realm, authorship is dispersed, collaborative, and unstable. Instead of issuing from the labor of a single author, the story emerges from the encounter between designer-writers, programmers, users, and the computer itself. The resulting collaboration is so many-sided and shifting that it is no longer clear who is telling the story, nor who is in control, nor where the story begins and ends. The reader does not passively receive the text but aggressively intervenes in both the form and content of the story, changing it in major ways. As for the medium, a pulsating electronic field replaces the stable text of the printed book. The resulting interplay of the user and the digital environment produces an improvisatory, seat-of-the-pants, narrative.

Coming from the world of modern narrative we may be hard put to see how story is at all possible in light of these modifications. How can we have a coherent story if the authorship is shared, if the plot is open-ended, if the

story itself incorporates physical and spatial play? Can a story that is not firmly shaped and controlled by an authorial hand deliver the delights of one by a Tolstoy or Austen? How do we compensate for the loss of the author figure whose comforting presence holds the traditional story together? In short, does an interactive medium subvert the basics of storytelling or can we invent new strategies that will produce satisfactory, aesthetically persuasive stories?

This chapter suggests that in a digital story (which seems to be evolving as a kind of amalgam of narrative and game), the reader/user/player takes over some of the functions of the author. In these new forms, it is the user's[7] playful engagement with the digital environment that creates the sense of mastery and commitment that makes for a coherent narrative. The user's self-authentication through this playful activity provides the structural glue that holds together the story experience. These new roles for author and reader are responses to profound changes in the concept of individuality, identity, and community in our global world. These new roles also, in surprising ways, return us to premodern storytelling, as they integrate the author into the community and make storytelling a collaborative and public act.

Narrative and cultural change

Like everything in this inconstant world, stories change from culture to culture, and from epoch to epoch. As our world evolves, so too do the formal strategies and the social purposes of our narratives (Cobley, 2001, p. 33). Historically, stories have been told in quite varied settings: bards improvise to warriors in a great hall, children frighten each other with ghost tales at a campfire, or—the "primal" scene of narrative—parents whisper a tale to a sleepy child. The way we receive and evaluate stories changes according to the situation of their telling. Creation stories change their significance depending on whether we hear them on our parent's lap, or in a Sunday school lesson, or study them in a textbook on comparative religion. The purposes for which narratives are fashioned vary as well. Oral cultures, for example, depend on stories to preserve and transmit important data, such as those genealogical lists we find in the Bible. A literate culture no longer needs to preserve history in this way, so those lists of "Begats" hardly seem like stories at all to our modern minds. In short, narratives are historically determined, and what counts as a good story in one era may seem pointless or malformed in another.

New narrative forms seem to arise when societies need to articulate large-scale economic and cultural shifts. The rise of the novel in the eighteenth century reflected, and helped consolidate, a shift from an aristocratic society with

its emphasis on honor, courage, and the transformed will to a bourgeois society with an emphasis on the value of everyday experience, on the central importance of the family, of work, and of personal desire (Taylor, 1989, p. 35). The novel ushered us into the modern world of private and individual consciousness, a world where the solitary individual peers at life through the narrow window of an autonomous awareness. With the novel, we move from the oral tale, a fundamentally communal medium, to the book—which can be read in private, hidden away from prying eyes, sold, and treated as an individual commodity. Accordingly, the novel does not present the exemplary images of heroic endeavor found in epic and romance genres but rather teaches the manners and the social skills needed to advance in an urban, capitalist world.

But even more significant for our understanding of how stories work is the radical changes in the notion of authorship ushered in by the modern (eighteenth century onward) period. As the forms of narratives change, so too do the meanings and functions of authorship. In most earlier cultures, the teller of the story was present and in communion with his audience. Homeric bards recited and sung their stories in midst of great communal feasts, and they adapted their performances to the audience's reactions. They did not claim to be originators of the tales but merely channels for the transmission of culturally validated stories, and so they were more like jazz musicians riffing on some standard tune than the omniscient narrators of the nineteenth century novel. Even when we move from epic performance to written literature, the tale is communicated orally and socially. Pease (1995) traces the history of the concept of the author and shows how in the Middle Ages *auctores* meant the transmitter of a standard and authoritative account (pp. 105–117). The author did not originate the text; rather his authority stemmed from his access to absolutely veracious texts. In the university, professors read these authoritative texts to students and thus performed the work for others.

A new notion of authorship arising in the eighteenth century suggested that the author was not a transmitter of eternally valid truths. Rather, her authority derived from her originality and from the special creative powers that flowed from her artistic sensibility and mastery. As such, the author acquired proprietary rights to her work, which now becomes a product transferred between individual subjects. The author now is an invisible but intimate presence, a gnat whispering into the reader's ear. Our reverence for and distrust of authorship stem from this paradoxical absence and closeness. The author is not there, but because of the private nature of reading, she miraculously penetrates our personal barriers and spreads her magic in the very seat of consciousness. Our sense of the author derives from our apprehension of her presence in the text, in the details of storytelling: plot, character, setting, tone of voice.

We are now encountering a shift in the nature of narrative as radical as the one that gave rise to the novel. In an amazingly short time, narratives in digital form (in particular those in videogames) have swept through the globe. They are a cultural phenomenon of undoubted importance, but their status as stories is more problematic. These digital narratives seem, when viewed through the lens of our "traditional" notion of story, incomplete, crude, formless—hardly stories at all. I would argue that these digital productions are not so much "bad" stories as new kinds of stories suited to new kinds of times. Indeed, their popularity suggests that they, in some important way, express the rifts and disjunctions of a newly global world and that they are a narrative response to a culture that resembles, as one critic puts it, "an aquarium of floating, evanescent forms."[8]

One way to grasp these stories' novelty is to examine the changes that are appearing in the nature and function of authorship. In digital story, the pact between teller and reader undergoes profound mutation. Authorship, that acted as an anchoring presence for the transmission of values through an encounter with an authoritative other, is now replaced by an unstable, swiftly shifting, cacophony of voices that receive transmit, alter, and create in quickly forming and dissolving collaborations. In place of the dialectical conversation of author-reader we get ephemeral, networked, multinodal relationships. The nonhierarchical, improvisatory, open-ended, or non-ended nature of these narratives undermines authority and ownership. In a networked world all texts can be appropriated, so the very notion of proprietary authorship becomes problematic.

Critics have battled over the last decade over the very notion of story in digital environments. Just to use the term interactive narrative plunges us into controversy and confusion. First to what specific texts are we referring? To interactive fiction (IF), hypertext pieces, stories embedded within video games, video games themselves as a narrative genre? Then there is the matter of nomenclature: should we call these new "beasts" interactive story, participatory narratives, or digital stories? Are they best understood as an evolutionary variation of traditional stories, or are they a new breed altogether? In fact, is it a misnomer to call these stories? Are they not better understood as just radical versions of games? Perhaps any narratives found within the game such as back stories and cut scenes are trivial incidental to the real point of the game, the gamers' battle to win and complete the game? And as IF seems to depart so completely from the conditions that have produced successful stories in the past, perhaps to try to make stories out of this new medium is neither possible nor desirable. Finally, is it useful to take paradigms drawn from traditional stories and reproduce them in a digital medium, or are we merely obscuring

how new this medium is and its emerging forms and paradigms? While I am aware of these controversies, I focus in this chapter in the most general way, on stories that allow the audience to intervene in nontrivial ways in the nature and unfolding of the narrative.[9] When "readers" have the power to radically alter the narrative, we enter into a new form of story, whether it be videogame, IF, or any other subset of digital story telling.

I would suggest that we have problems recognizing these new forms as stories because we are thoroughly immersed in the conventions of modern authorship, as I have described it above. In interesting ways, digital stories seem to return us to earlier forms of authorship and that this move has been brewing a long time in our culture.

Anticipations of digital narrative

There seem to be two major ways in which the novelty of digital narrative has been anticipated in our time, one in the practice of high modern literature, and the other in postmodern criticism.

First, let us look at the high modern novel. The fragmentation and montage-like quality that characterize digital narrative seems to echo the conditions of modern, late-capitalist society. For Walter Benjamin, (Tambling, 2006) to take one example among thousands, "modern experience is the experience of ruins (involving) the loss of a communicable past, the loss of storytelling, and the erasure of memory" (p. 145). This fragmentation extends from the public culture and its institutions to our sense of our selves as coherent and stable identities. Great modern artists, such as Joyce or Beckett, have tried to convey their vision of this fragmented world by subverting the formal order of earlier novels. In the process they created works vibrant with an extreme tension between the conventional frame of the narrative and its inner disequilibrium. This is an art of protean transformations, disrupted and unresolved plots, and characters who have a weak and wavering sense of a self. Such highly unstable fiction mirrors the shifting, phantasmagoric quality of modern experience.[10] And, yes, all this formal instability can sound quite like a foreshadowing of the digital world.

But unlike digital art, modern art is fundamentally an art that yearns for centralized order. It places the author at the heart of this project. Reacting against the fragmentation of society, it reconstitutes the world through highly structured and tightly organized works. The heterogeneity and multicultural dazzle of styles in Joyce's *Ulysses* is balanced by an intensely, almost pedantically, ordered formal structure that connects everything to everything else, and

uses repetitions and references to insure that the work is held together. So too, much of the greatest modern art—Proust, Eliot, Beckett and so on—confronts social disorder with an urgent desire for formal authorial control.

Contemporary digital artists, however, face a different environment and an opposite task. The digital medium, unlike the printed text, is in itself—in the way it exists and functions—pluralized, centerless, and disrupted. Such a medium does not constrain artists and force them to rebel. On the contrary, given the already decentered nature of the digital environment, the digital artists' task is to invent new principles of narrative coherence that do not rely on the author's shaping sensibility. They need to invent new principles of order.

Postmodern critics have also attacked the traditional notions of text and of authorship, and offered a view of narratives that seems to prefigure the digital ones. These critics start by assuming that the power of narratives over our minds is dangerous, and that narratives are instruments of capitalist domination. This postmodern turn was signaled by Barthes (1977) in his seminal article, "Death of the Author."[11] Barthes argued that the notion of authorship conferred an illegitimate authority to the text and allowed it to exert control over the readers' responses and hence over their freedom to think for themselves. "To give a text an author is to impose a limit on that text, to furnish it with a final signified, to close the writing" (p. 147). So, the argument went, while narratives are the very building blocks of reality, they are also in some way to be resisted. But if we could just cut the ties that bind the story to its origins, in other words to the shadowy figure of the author which looms behind the words on the page, we could regain our mastery over the narratives and prevent them from colonizing our minds. So critics have sought to neutralize narratives by insisting that texts are isolated language artifacts, unmoored from authorial control and floating freely in the shifting space of signification. As Sell (2000) notes, "some recent commentators have virtually reduced literature to a kind of anonymous orality." Hence, Lyotard's attack on those grand narratives which he saw as a principal strategy of authoritarian domination and the turn to a deconstruction of texts and of history of such prominent contemporary critics such as Derrida and Foucault. In the process of describing a nonfoundational, "writerly" text, these critics seem to anticipate the floating unmoored virtual world, with its anonymous authors and its shifting forms.

The postmodern solution to the social/narrative problem seems to me to be an exercise in wishful thinking. It does not describe how texts actually exist. Narrative is a social and interpersonal event and authorship cannot be simply erased from the picture. While the postmodern turn has brought us enormous insight into the nature of language and the complexity of meaning-making, it does it by denying the connection between text and its origins in human

situatedness. A text is a relationship and is deeply implicated in questions of trust and connection. Gadamer contrasted the "hermeneutics of suspicion," as Ricoeur termed it (Coyne, 1999, p. 239), with that of a "hermeneutics of good will." He argues that authority is not always oppressive but that we confer authority to those whom we believe to be more skilled and knowledgeable than we are. To have a conversation is, at least minimally, to accept that the other can be understood, and that she might be right. Every time I listen to a teacher, consult the weather report, or ask for directions to the railroad in a foreign city I am acknowledging someone else's authority and opening myself to her point of view. Granting provisional authority does not mean abandoning my ability to reflect and evaluate on what is offered. I am not coerced into accepting the truth. But unless I make an initial gesture of responsiveness I can go no further. All texts therefore imply a relationship, however negotiated and provisional.

So it is no use dreaming of a totally disengaged literature. Digital worlds cannot function without some equivalent to the relationships of authority and trust we have described above.

As we see, both the modernist and postmodern positions do not offer solutions to the problems of the digital sphere. The modernist acknowledges disorder only to try to abolish it. The postmodern critique exalts the instability of the text but leaves no room for the variegated human relationships that thread through all narratives. How then can we find and describe a new order in the digital environment? How will these stories furnish us with the basic prerequisites for narrative—a trusting relationship between the participants, an anchoring sense of authority, a strategy for fusing the self and the other?

We can begin by isolating three ways digital narratives differ from their predecessors: they exist as worlds rather than as isolated texts; they are events or happenings rather than fully formed finished objects; and they find unity in the reader/user's playful activity. Out of these differences we may be able to glimpse the elements of a new approach to narrative.

Narratives as worlds

Digital narratives aspire to the variety and plentitude of a "world" rather than to the fixed structure of a text.[12] By a world I mean an articulated space that simulates the heterogeneity, variety, and three-dimensional configurations of our world. The digital world is maintained by enormous information and technical resources and offers the user a huge repertoire of actions and ways of engaging (Jenkins).[13] When we enter such a "world" we feel encompassed by it. We can only grasp this world by exploring it; as we move along it spreads all

about us, behind us, and in front of us, and its variety is not exhausted by our passage. Though we may uncover the world by following one path through it, we are aware that that we can go back and choose to explore differently. This "world" is not equivalent to a well-made story or to any formal structure at all. It is a boundary around structures, a circumference that delimits an inexhaustible field of possibilities. If you covered the Earth with a smooth layer of asphalt you would no longer have a world, you would have an object. A world is where things happen.

Though the digital world may seem to be a simulation of our physical universe, it does not divide—as the "real world" does—into things we can alter (our moods, our relationships) and things that resist us (gravity, a stone wall, other people's minds). Rather it is a work of art whose purpose is to express. It is totally and thoroughly artificial. Each of its elements—space, time, objects, beings, and actions—can be selected, arranged, and transformed for the needs of an aesthetic experience. Thoughts can become visible, objects can metamorphose according to emotional and aesthetic rules, and background elements (such as floors or skies) can suddenly communicate symbolic meanings. Within the world, all obey the law of transformation; all is choice and interaction. The power of such an environment for narrative purposes resides both in its ability to mimic appearances and in the way it confounds those mimetic expectations. Upon entering a digital world, we may feel we are in an astonishingly convincing reproduction of reality. We are surprised when the environment reveals its thoroughly artificial and contingent nature: we encounter a mountain and then find that we can fly above it, or we notice that our clothing has changed shape when we shot at another being.[14]

Designing a digital narrative means establishing a set of possible dynamic interactions that will be set in motion by different users. It is creating a scenario of options rather than a plot and characters. Experiencing this dynamic and unstable world is like entering a hall of mirrors. Players confront a dauntingly complex environment that, at the same time, they can alter with ease.[15] Everything is doubled and yet blurred. The world is both real and virtual, the story is a both a human and a technological production, and the user both makes and consumes the product.

Where is authorship in this world? It does not function as an agent external to the text, producing the world as the potter does his vessel. Rather, it appears as an innate feature of a radically interconnected environment. When users, algorithms, rules, and procedures meet they produce the world. They are all authors and are both embedded in the world and exterior to it. So, for example, the user is connected to the ongoing narrative both by a "real" interface device and by the virtual avatar that the device controls. "The player is not

outside the game and the game is not outside the player—both ↄ loop through which information and energy flows" (Dovey & Ke p. 109). Yes, it is this one algorithm that controls the world but also ᴄᴏ... the "flesh and bones" of this landscape, providing its contours and the very laws of its existence. Authorship is inscribed in every element of this environment. One might say the whole world is mutually coproducing itself.

Narratives as events and interaction

We read a text, but we interact with a world. An interactive narrative is a story that is played out. To enter into the digital world is to interact with the world of possibilities richly arrayed in this space (Jenkins, 2004, p. 118). Though this world appears stable and complete, the entire environment is in fact constantly adjusting to users' actions. The actual course of this narrative is not predetermined but emerges from the coordinated activity of many participants, human and nonhuman, in a procedure-driven universe. As users interact with the digital environment, their decisions unleash events that give rise to a dynamic unfolding of narrative. New situations, not foreseen by the designers, spontaneously arise. The full story, or rather this version of the narrative, is only realized as the game proceeds.

By exercising their interactive powers, users become true cocreators of the narrative event. The actual extent of their creative power depends on the kinds of choices offered them by the program. Initially, in the eighties and even into the nineties, most programs offered the user only narrow choices between alternatives. Now, however, the user has at hand nontrivial choices that resonate through the whole system. The repertoire of choices is large: users can create sequences of actions, construct and alter objects, and even choose how to represent themselves to others. As users encounter the world, their choices create individual stories, micro-narratives within the larger story: *their* fight with the dragon, *their* solution to the puzzle of the locked room. In addition, they may appropriate the story for their own purpose by capturing and editing sequences of moves as stand-alone narratives for later use. Because of these capabilities to control and transform, some critics have proposed substituting the term "configuration" for "interactivity" to emphasize the users' dynamic and synthesizing activity.

To play with narrative is to play with identity. Users are not simply focusing on experiencing a narrative, they are equally intent on exploring and modifying themselves. Their interactions are implicated in their constructions of digital identities.

Most obviously, their choice of avatars determines how they will be perceived and what kind of agency they will command within the story. Will they be Dwarf, Knight, or Wizard? Will they fly, heal, or shoot? People choose avatars that mirror both who they are and who they would wish to be. Choosing or designing an avatar is an adventure in self-definition. A newly published book, *Alter Ego: Avatars and Their Creators* (Cooper, 2007), shows photos side by side of avatars and their creators: fat men choose to be petite Asian girls; disabled people appear in armor that mimics yet transforms the orthopedic devices they wear in real life; children become powerful monsters or wizards. New personal identities facilitate new forms of connection and community. Avatars, for example, unite with others to form close-knit fighting tribes or to enter into virtual marriages. What emerges from this intimate fusion of ego and alter ego is a kind of synthetic social life—part art and part reality. Haraway (2006) terms the phenomenon of these virtual lives "networked and collective selves" (p. 7). These modes of self-representation both complete and overturn reality, complicating an already complex situation.

What perhaps challenges us most about these protean identities might be termed the "Cyborg dimension."[16] Users act in dynamic partnership with the resources, laws, and conventions of a nonhuman environment.[17] In the course of interaction and immersion in the environment, they can develop an intimate sympathy with the algorithm that controls the experience.[18] As the users master the logic of the story's algorithms, they almost begin to think like a machine, an ability that helps them feel strong, important, and fully at home in this world.

What is attractive about turning yourself into a machine? The delight in new identities is closely linked to the user's quest for personal mastery.

We affirm our autonomy by skillfully navigating through these worlds. Our success within the game/narrative makes us feel powerful and visible.[19] For this reason, many users prefer digital worlds peopled by small-scale tribal groups where they can exercise substantial control in a distinctive community. Hybrid narrative sites that maximize the user's sense of mastery and authorship (for example, YouTube and Second Life) are increasingly popular. These formats mix storytelling with self-display, and appeal particularly to those who feel lost in depersonalized mass media and who want their stories to be acknowledged by others.

The effect of these powerful representations of world and self is to endow the user with presence and value, to lend her actions impregnable authority, to change narrative into a *play of self-mastery.*

Narrative as play and festival

As we are discovering, cultural changes link up with changes in narrative strategies. As culture becomes global, the digital narrative grows to resemble a world. As daily life grows increasingly dependent on vast and ephemeral networks, so do pluralized and heterogeneous digital identities become routes to personal mastery. And, finally, as we move from a work-centered to a play-centered society, so do digital narratives become play.

Play is as fundamental to human experience as is narrative, but play has a special historical significance for our culture. Many critics have noted that our culture replaces seriousness, the great bourgeois virtue, with game and play.[20] Under the influence of Nietzsche, many important modern thinkers—such as Bergson, Huizinga, and Heidegger—found in the extravagant excesses of play a means to release the human spirit from the narrow constrictions of a utilitarian society. Play now replaces reading as the preferred way we access narrative.

Play has always figured in aesthetic experience. While in reading it is the author's playful mastery of plot and character and language that sweeps us along, in digital narratives it is we who skillfully perform through our interaction with the environment. Absorption in play parallels in some sense the reader's imaginative immersion in the story. As we react to the challenges of the environment, pressing keys and pushing joysticks, we may enter a "flow state" where "self-consciousness disappears, perceptions of time become distorted, and concentration becomes so intense that the game or task completely absorbs us" (Douglas & Hargadon, 2006, p. 204). In the heat of play, reactions and perceptions seem heightened and effortless. Time seems to stand still; we feel we could do anything. It is like the exhilaration a great player feels in a fast-moving tennis match or a professional dancer feels executing a difficult turn in the air. We have suspended disbelief and have entered wholly into the "reality" of the event.

Paradoxically, while play demands that we exert the full powers of our self in a focused and sustained way, it also makes that self disappear. In play, we move "outside" of ourselves, for playing involves a loss of the separate self through a rapt immersion in the game. "For Gadamer, the notion of 'play' goes beyond the notion of subject or object. In playing, we have to learn to lose ourselves in order to remain true to the game" (Moran, 2000, p. 282).[21] The loss of self furthers the process of immersion. It allows us to merge with others and to effect that fusion of horizons that Gadamer has described. When we collaborate with others, as, for example, in massive multiplayer games, individual play transforms into the communal form of festival.

Festival is the most profound exemplification of art we have, for art is a form of excess, a manifestation of superabundant (*ueberschluss*) and overflowing energy.[22] Nowhere in our experience is this overflowing more evident than in festival. Festival brings people together in a goalless, focused, democratic experience that releases all the participants. Communities renew themselves through festivals precisely by temporarily erasing ordinary social demarcations. In festival, kings are beggars, and whores are transformed into madonnas. Within festival, ordinary time is abolished, and a new time arises from the rhythms of desire, expression, and fulfillment.[23] For all its spontaneity, festival is not without structure. Rather, it absorbs ordinary structures and reimagines them, replacing them with free-floating arrangements that arise out of joyous action. In festival, crowds break into dance; actors jump off the stage to engage with spectators; bodies promiscuously merge and separate. For Aristotle, narratives are held together by the coherence of their internal parts; in festival-like story, structures arise and dissolve in the play of interaction as objects and events dissolve and recombine. [24]

Self-authentication

In textual narratives, the author's energetic efforts effect an encounter with the reader, fusing their two horizons into an imaginative unity. In the digital narrative, however, it is the user *qua* author who invigorates the narrative. As Jenkins (2004) points out, game players fluctuate between states of immersion and engagement (p. 197). What holds together this fluctuating dynamic is the energy that emanates from the user's activity. As the user plays, she affirms the space of the play and commits herself to its fiction. Instead of submitting to the authorial voice, she rejoices in her own voice, and in the challenges facing her. The user's delight in her own mastery authenticates the game/narrative, by feeding the exuberance of her action back into the environment as an affirmation of the narrative's unfolding.

The user's activities, unlike those of the reader, are not simply *mental* events: a user's choice has palpable consequences in the digital landscape. Each moment in the unfolding of the story is the outcome of the various choices made by all the agents involved, and every interaction alters the state of the world. The story thus becomes an outward representation of the inward movements of the participants. As the digital environment is a thoroughly expressive one, it can represent both mental and physical realities equally. Encounters between different agencies are rendered as public and accessible spaces. The user's desires, fears, and hopes are instantiated in the actual rendering of the world. No

wonder the player feels authenticated by the landscape: it is a projection of her own self as it encounters the world.

Narrative can survive without the author's shaping control if it contains a powerful center for its varied perspectives and potent means to realize those perspectives. Those capabilities are already present in the digital world. The digital environment brings us back in interestingly novel ways to the communal art of earlier times, and integrates authorship back into community. We now must await the artists who will exploit this new/old configuration to create the masterly stories of tomorrow.

Conclusions

I have painted a perhaps overoptimistic picture of digital narratives but in service of a good cause: I want to emphasize their potential as the breeding ground for accomplished, persuasive, and radically new experiences. Of course we are not yet there. First, the medium, as all media, has its own innate dangers and pitfalls. It is anarchic and chaotic; its forms are continually fraying under the pressure of massive participation and bewildering technological shifts, its pleasures can be addictive and mind numbing. As a wildly popular medium, it can strengthen the narcissistic, nonreflective bent of our society and create generations of people immersed in fantasy who have little ability to transfer the digital experience that absorbs their energies and time to the mundane travails of life. But other media have overcome similar shortcomings. It was widely believed that the novel put people at a dangerous remove from reality. In fact, one of the greatest novels—*Madame Bovary*—is about the effects of novel reading on a susceptible young lady. But the achievements of the novel far outweigh such dangers. As Plato knew, art is always somewhat suspect, but it is also indispensable. Second, because no one has yet written the digital *Great Expectations* it does not mean no one will. We are at the beginning of a new form, born out of the old but with an unpredictable future ahead of it.

The past history of genres teaches us not to place too much faith in prophecies of disaster. In his "Defense of Poesy" of 1582, Sir Philip Sidney, a very smart and articulate critic, lamented the rise of the public theater, a "mongrel" form then rapidly gaining popularity in the brothel areas of London. He described how the theater violates all the reasonable rules of art and "poesy," and he judged that it would be consigned to the ditches of history.

> Where you shall have Asia of the one side, and Afric of the other, and so many other
> under kingdoms, that the player, when he comes in, must ever begin with telling where

he is, or else the tale will not be conceived . . .

But, besides these gross absurdities, how all their plays be neither right tragedies nor right comedies, mingling kings and clowns, not because the matter so carrieth it, but thrust in the clown by head and shoulders to play a part in majestical matters, with neither decency nor discretion; so as neither the admiration and commiseration, nor the right sportfulness, is by their mongrel tragi-comedy obtained. (Sidney, 1989, p. 244)

This was written just a few decades before Shakespeare shaped, out of the trashy elements of this mongrel form, the greatest tragedy ever written in English, or indeed any other language. For what is *King Lear* about but the mingling of fools and kings? Shakespeare seized the absurd limitations of this new form to register a seismic shift in cultural perception, perfecting an artistic form that could convey to a widespread audience in accessible terms the melting away of hierarchical distinctions under the pressure of human suffering.

Notes

1. Hence, Barthes' battle cry, "Death to the Author!"
2. Indeed, phenomenology is helpful in its insistence on the pregiven nature of experience. Life is already there for us. We emerge in it and it is given to us in its immediacy. Cf. Heidegger "all understanding has forestructure, a set of already formed experiences." See Ferietter, in Wolfreys (2006, p. 150).
3. Gadamer asks us both to recognize and to reaffirm this participatory solidarity in all dimensions of human life (pp. 262–263).
4. Of course there is a difference between the two, as critics have noted for almost a century, but the effect for the reader is a voice that tells a story and is at hand, so to speak.
5. On an empirical note, Bruner's work on infant communication also emphasizes that the game-like conversation of parents and infants prepares the way for language to emerge. Taylor, citing Bruner, sees in these conversations the origin of art itself, arising from social rituals and constructing conversations even across time.
6. There has been much debate over whether videogames are narrative. For an overview of the discourse between Ludologists and Narratologists, see the extensive discussions in Wardrip-Fruin and Harrigan. My view echoes that of Jenkins (2004), that games are narratives or contain stories, but that they are not necessarily fully accomplished ones. But in theory there is no reason they cannot be narratives of the highest kind.
7. I will refer to the reader/user/player as user for simplicity's sake, but it is wise to realize that all three terms are applicable to the participant in a digital narrative.
8. Perry Anderson, *The Origins of Postmodernity*, London 1998, p. 86. Quoted in Eagleton, 2003, p. 16.
9. See discussions in Douglas & Hargadon (2004) *First Person*, especially articles by Montfort, Murray, Jenkins et al.
10. Eagleton (2003), for example, notes that our culture is "dependent in its everyday operation on myth and fantasy, fictional wealth, exoticism and hyperbole, rhetoric, virtual reality and sheer appearance" (p. 67).

11. Starting perhaps with Barthes, critics have interrogated the claims of narrative to both ideological and aesthetic authority. First is the problem of power. Noting that the authority of the text seems to imply a certain submission on our part, many critics see in the author a will to repression and control. Second, the question of how a text means leads into profound interrogations of the linguistic foundation of meaning. Many find it difficult to explain how a clear meaning can emerge from the shifting and unstable matrix of language. They want to pry us away from our unconscious reliance upon the author as the source of meaning and make us aware of the unstable, shifting, and irresolvable stew of meanings we encounter.

12. Hayles notes, "Computers are not tools, they are environments" (Harrigan, 2004, p. 291)

13. Wark (2007) notes that the digital world renders space and time quantifiable and therefore collapses difference. (073)

14. Designers have become aware that they need to design an environment that dynamically models not only space and time but also the interaction of those elements with the dynamic activity of users. Architects in Second Life, for example, realize that their goal is not only to reproduce physical structures but also to create buildings that dynamically interact with their inhabitants (the new art of reflexive architecture).

15. As one critic notes, the user aspires to god-like powers "simulating mastering, redefining, manipulating, and controlling space, time, community, thought, and life" (Coyne, 1999, p. 4).

16. See Gray (1995) for an extensive set of articles on the cyborg dimension.

17. Morris, 2003: "The game is not just a . . . program that players use, but an assemblage created out of a complex fusion of the creative efforts of a large number of individuals" including the player.

18. Wark (2007): "gamers are not like readers because they must discover the rules of the universe of the game" (030).

19. Bergson (1910, p. 176) argues that choice is not an either-or procedure, going down one road or the other. Rather choice grows organically from the multitude of experiences that surge through every moment ("the self which lives and develops by means of its very hesitations until the free action drops from it like an overripe fruit").

20. Dovey and Kennedy (2006) distinguish between work-based and play-based economies and societies and trace a "historical development from work-based structures of social organization to play-based forms of commodity and meaning production" (p. 19).

21. Taylor (1989), in discussing Derrida, also stresses the possibility that playfulness is a means of transcending human separation in a site of unconstrained freedom, "a mode of thinking that affirms free play and tries to pass beyond man and humanism" (p. 590).

22. See Gadamer, 1986, for a full discussion of festival, especially pp. 22, 40, 42, 139.

23. No doubt why people can spend five to ten hours a day playing games!

24. When players marry a virtual avatar, they are mirroring and subverting social form by playing with it in a new kind of seriousness.

References

Aarseth, E. (1997). *Cybertext perspectives as ergodic literature.* Baltimore, MD: Johns Hopkins University Press.

Austen, J. (1989). *Pride and prejudice.* London: Virago Press.

Barthes, R. (1977). *Image, music, text: Essays selected and translated by Stephen Heath.* New York: Hill and Wang.

Bergson, H. (1910). *Time and free will.* New York: Macmillan.

Cavarero, A. (2000). *Relating narratives: Storytelling and selfhood.* London and New York: Routledge.

Cobley, P. (2001). *Narrative.* London and New York: Routledge.

Cooper. R. (2007). *Alter ego: Avatars and their creators.* London: Chris Boot.

Coyne, R. (1999). *Technoromanticism.* Cambridge, MA and London: MIT Press.

Critchely, S., & Schroeder, W. R. (Eds.). (1999). *A companion to continental philosophy.* Oxford: Blackwell.

Douglas, J. Y., & Hargadon, A. (2006). Pleasures of immersion and interaction. In N. Wardrip-Fruin & P. Harrigan (Eds.), *First person.* Cambridge and London: MIT Press.

Dovey, J., & Kennedy, H. W. (Eds.). (2006). *Game cultures.* Maidenhead: Open University Press.

Eagleton, T. (2003). *After theory.* New York: Basic Books.

Gadamer, H-G. (1986). *The relevance of beauty.* Cambridge: Cambridge University Press.

Gadamer, H-G. (2004). *Truth and method.* London and New York: Continuum.

Gray, C. H. (Ed.). (1995). *The cyborg handbook.* New York: Routledge Press.

Haraway, D. (2006). Simians, cyborgs, and women. In J. Dovey & H. W. Kennedy (Eds.), *Game cultures.* Maidenhead: Open University Press

Hayles, N. K. (2004) Metaphoric networks in lexia to perplexia. In N. Wardrip-Fruin & P. Harrigan (Eds.), *First person.* Cambridge, MA and London: MIT Press

Jenkins, H. (2004). Game design as narrative architecture. In N. Wardrip-Fruin & P. Harrigan (Eds.), *First person.* Cambridge, MA and London: MIT Press.

Moran, D. (2000). *Introduction to phenomenology.* London and New York: Routledge.

Pease, D. E. (1995). Author. In F. Lentricchia & T. McLaughlin (Eds.), *Critical terms for literary study.* Chicago and London: University of Chicago Press.

Schiesel, S. (May 4, 2007). Finding fellowship (Hairy Feet Optional), *New York Times.*

Scholes, R.; Phelan, J., & Kellogg, R. (2006). *The nature of narrative.* Oxford and New York: New York University Press.

Sell, R. D. (2000). *Literature as communication.* Amsterdam and Philadelphia: John Benjamins Publishing.

Sidney, Sir P. (1989). The defense of poesy. In *Major Works.* Oxford: University of Oxford Press.

Tambling, J. (2006). Walter Benjamin. In Wolfreys, Julian (Ed.), *Modern European criticism and theory.* Edinburgh: Edinburgh University Press.

Taylor, C. (1989). *Sources of the self.* Cambridge, MA: Harvard University Press.

Wark, M. (2007). *Gamer theory.* Cambridge, MA and London: Harvard University Press.

Wolfreys, Julian. (Ed.). (2006). *Modern European criticism and theory.* Edinburgh: Edinburgh University Press.

PART IV

CHALLENGING
AUTHORITIES

Problems of expertise and scalability in self-made media

JOHN HARTLEY

DST

The term 'digital storytelling'(DST) can be used generically to describe any computer-based narrative expression, including 'hypertext fiction' and game narratives as well as YouTube and the like. Here however it refers only to the practice whereby 'ordinary people' participate in hands-on workshops using computer software to create short personal films that privilege self-expression; typically narratives of realisation of identity, memory, place and aspiration.[1] Digital storytelling fills a gap between everyday cultural practice and professional media that was never adequately bridged during the broadcast era (Carpentier, 2003). Digital stories are simple but disciplined, like a sonnet or haiku, and anyone can learn how to make them. They reconfigure the producer/consumer relationship and show how creative work by non-professional users adds value to contemporary culture (Burgess & Hartley, 2004). A genealogy for this mode of digital storytelling (henceforth DST) has become established; it is indeed a 'Californian export', as the 2007 ICA pre-conference in San Francisco aptly put it.[2] However, in one important respect the form of DST in Austra-

lia, including the R&D that we do at Queensland University of Technology (QUT), departs from that original as will be discussed below in the discussion of scalability and expertise.

Scalability has two aspects: (1) the bundling of stories and (2) the propagation of the method of making them. *Expertise* also has two aspects: (3) the role of the expert facilitator and (4) the expertise of the user. The argument of this chapter is that addressing these problems would translate digital storytelling from a phenomenon locked into the 'closed expert paradigm' to one active in an 'open innovation network'.

Scale: little or large?

How is it possible to bundle *myriad self-made stories* in such a way that they are accessible to and valued by some larger group, whether that is understood as a community, a public, a market or a network? This is by no means an easy question to answer. Broadcasting and cinema completely failed to manage it. For many decades they didn't try to scale up *stories* because they were too busy scaling up *audiences*. Scale and organisation were focused around *distribution* rather than *production* (unlike in manufacturing industries). Although the publishing industry had evolved a business model in which *repertoire* and *backlist* (a sort of analogue long tail) allowed for myriad individual titles, time-based media like cinema and television never did 'scale up' their content beyond a few hours of new material per month (cinema) or day (television, on a good day).

Although they were 'popular' in the sense that their content was widely noticed, broadcasting had a very limited 'supply side' that was not popular at all. Consumers did not supply stories to networks; networks supplied stories to consumers. Networks relied on (but also controlled) a highly specialised array of satellite production houses and trusted individuals. The 'market' in stories did not include consumers; it was organised around trade fairs in Los Angeles, Cannes, and so forth. As a result story-*telling* became competitive and professional, undertaken by highly trained (and very lucky) experts. They heeded Wilkie Collins's (or was it Charles Reade's?) famous formula for fiction: 'make 'em cry, make 'em laugh, make 'em wait' (in that order). They reassured each other that there were only seven basic plots.[3] They knew what audiences liked and wanted. Oddly enough, this resulted in a culture that saw itself through the eyes of celebrities running away from explosions,[4] and could recognise friend from foe by the quality of their orthodontics (cinema has evolved from 'white hat vs black hat' to 'perfect teeth vs hideous teeth'—so it is OK to kill 'those

awful orcs'). In other words, expert competition in a vertically integrated industry, with monopolistic tendencies rather than an open market, produces semiotic poverty, not choice.

Enter the Internet. The stream of content-supply began to expand, to resemble first a telecommunications network, and then a language community. So the question became: Is there something between the 'closed expert system' of traditional showbiz and the hive-like buzz of the Internet that might allow individual voices to be voiced, bundled and distributed in such a way that they attract the attention of a significant number of other such individuals? In economic terms, was it possible to evolve from an 'industry' model of monopolistic control to an 'open market' model of exchange?

Is digital storytelling such a means? Early utopian hopes suggested that it might hold just such possibilities. Here is Daniel Meadows:

> The promise of these big ideas for those of us formerly-known-as-the-audience is that we will be recast as the viewer/producers of a new participatory culture. Well, what I say is: 'Bring it on'. (Meadows, 2006)

How does DST 'bring it on'? It universalises the individual voice. It employs an aesthetic that seeks to balance democratic access (to both production and viewing) with communicative impact. Stories are around two minutes long, using voice-over scripts of around 250 words and a dozen still images, sometimes with video inserts. The idea is that a restricted palette facilitates the production of 'elegant' stories (Meadows's word) by people with little or no technical or aesthetic experience. The storyteller's unique voice is central to the process and is given priority in the arrangement of symbolic elements. Narrative accessibility, personal warmth and metaphysical 'presence' (Derrida, 1976) are prioritised over formal experimentation or innovative uses of technologies (Burgess & Hartley, 2004). The idea is that personal authenticity can reach out without sentimentality to touch others.

The first *problem* of scalability then is this: can enough stories be made and enjoyed by enough people for the form to sustain the level of ambition imagined for it by the pioneers—to be as democratic as speech, as connected as the Internet and as compelling as . . . (say) . . . *Pan's Labyrinth*?[5] Current developments suggest that early ambitions have not been realised; in fact they've been scaled back. Imagined as an alternative to broadcasting, DST has been hard put to achieve the status of community media. Perhaps it has failed to spread because the requisite investment—public, private, intellectual—has not been made.

Propagation: A Welsh export?

The second problem of scalability is the propagation of the method. At the centre of DST is the workshop. It is labour-intensive, time-consuming, and intimate, working best with about eight participants and one or two facilitators. It requires a fair amount of kit; one computer per person, plus cameras, sound-recording and editing packages. But more than this, it requires a *dialogic* approach to production, relying on a tactfully handled exploitation of a highly asymmetric relationship: the formal, explicit, professional, expert knowledge of the facilitator, and the informal, tacit, 'amateur' or 'common' knowledge of the participant. *Both* are crucial to the exercise. The pedagogy most suited to this set-up is a Socratic method rather than the 'knowledge transfer' model beloved of technological fixers, from whose perspective the DST workshop must look costly and inefficient. For participants to make a successful story, the formal workshop element must call out their implicit or tacit knowledge, a process of 'outing' that aligns DST directly with the field of democratised innovation imagined by Charles Leadbeater (2002, pp. 28–36).

Hence the most important element of the workshops is not the training in computer use or editing, but the so-called 'story circle' (Hartley & McWilliam, forthcoming) a series of dialogic games in which people draw on their own and each other's embedded knowledge of stories, narrative styles, jokes and references. Much of this tacit knowledge is cultural rather than individual of course, as witness the difference between age-cohorts observed in QUT workshops: older participants tended to emphasise facts and detail, linear time, an almost entirely referential use of images, and a journalistic tone, whereas the younger participants 'instinctively' used images metaphorically, in ways that provided a harmonic counterpoint to the spoken narrative, tended towards colloquial, everyday speech styles, and were more comfortable with the use of personal and emotive themes (Burgess & Hartley, 2004).

Is DST a 'Californian export'? The Californian model—as I understand the tradition of Dana Atchley and Joe Lambert—is based loosely on *independent film practice*, in a tradition going back to Lenny Lipton in the 1970s and to the film workshop movement in British independent cinema (Lipton, 1974), where individuals produce work for distribution via festivals or cultural institutions. This is an *artist + festival* model, often with a radically democratised notion of 'artist'.

In contrast, the model of distribution pioneered by Daniel Meadows in Wales, and imported into Australia by ACMI and QUT alike, is based not on arts festivals but on *broadcasting*. From the start (even though he learnt his

DST at the feet of Dana Atchley), Meadows sought to associate his version of DST not with the film-festival circuit but with a broadcaster.[6] In the UK context that meant his funding/distribution agency was not the BFI but the BBC. He experimented with various ways of incorporating the stories into TV and radio schedules as well as on the BBC website, innovations which are a significant component of his method of propagation.

The difference between Wales and California (both isolated on the western margins of metropolitan cultures, one in the rain, the other in the sun), reflects the fact that, unlike the United States (but like Australia and Europe), Wales has strong traditions of public-service broadcasting (PSB) and subsidised arts. PSB is available in Europe and Australia as a widely assimilated and institutionalised model of cultural practice, whereas the Californian model of 'independence' seems more libertarian and individualistic, based on music and film festivals under the stars in the desert. That is harder to emulate in Wales. Even so, Meadows's team has turned to a festival version of DST at Aberystwyth Arts Centre: at the time of writing two such festivals (DS1 2006 and DS2 2007) had occurred. The DS2 festival blurb promotes it thus: 'DS 2 aims to inspire, encourage, and show the exciting possibilities of Digital Storytelling whether you work in *education, the community or as an artist*.'[7] Heroic though such a venture may be, it may also signal that the *broadcasting* ambitions of DST in Wales have diluted, perhaps because it never received more than marginal support from the BBC, despite winning awards for them.[8]

The broadcast or Welsh variant of DST has been 'recaptured' by an amalgam of education and community arts. It has developed as a *cultural practice* rather than as a *media format*. DST (the form) shows no sign of developing in the open market. Unlike YouTube (the platform) it is not visible as part of the general entertainment diet. It has not been commercialised; it is not owned or branded. It is neither 'hot' nor 'cool' in the 'economy of attention' (Lanham, 2006). It does not share the ethic of iterative and collaborative knowledge like the Wikipedia or Creative Commons. Nor—despite Meadows's best endeavours—has it been adopted as part of PSB provision in countries with public-service and cultural institutions.

DST does have something in common with existing initiatives in 'media literacy'. But its pioneers tend to be libertarians (on the Californian model) with an allergic response to formal schooling, so even in the context of schooling it has been taken up by activist educators inside the education system, rather than being pushed by 'DST entrepreneurs' as part of a societal distribution strategy in a 'social network' market. Thus, wherever DST has taken root, a publicly assisted cultural or educational institution is usually involved.

An unresolved question remains, therefore: whether the DST *form* is bet-

ter suited to distribution via festival, broadcasting or network, and whether the *method* can succeed without relying on the resources of education or community arts/media organisations. At QUT those resources were crucial; without them we could not have 'imported' Daniel Meadows himself. We had him over several times (2003–2005) to offer master-classes and to 'train the trainers'; generally researchers who wanted to deploy the workshops in youth or community development R&D initiatives, but also academics who introduced it into degree-level teaching. Meadows trained two groups from QUT, who in turn went on to adapt the technique in projects supported by the Australian Research Council, QUT itself, and various state agencies.

How can DST—as a 'method' to 'bring it on'—be propagated throughout the community? Social networking sites like YouTube skip formal tuition and encourage users to go straight to online-publishing (or archiving), which itself differs from publishing 'as such' by being much more in the here-and-now and part of a conversation, resulting in many more 'anthropological' postings ('raw' videos from everyday life like Bus Uncle),[9] as well as rip-offs, mashups, and tribute 'vids' from other media. DST, on the other hand, requires bandwidth and bundling, and it also needs to be taught. It requires a workshop, especially (but not only) for people who are currently inactive in relation to digital media. The finished product is generally a big file that is shared among people already formed into a community—but not a public—like family, friends, or an interest-group. It is propagated via local organisations, cultural institutions and activist agents (like education and art). Compared with other exports like YouTube, MySpace and the Wikipedia, that doesn't seem very 'Californian'. However, YouTube is available (as it was not when DST was invented) as a platform for stories generated elsewhere, so there is no need to see them as opposed 'business models'.

Even so, DST is not 'native' to the Internet and is yet to develop efficient means of distribution or self-sustaining growth (as compared to blogs, for example). Nor does it readily exploit some of the more innovative capabilities of the Internet, for instance iterative content, open to reuse and re-appropriation by other users. Digital stories are relatively closed texts; i.e., they are not hypertexts (Burgess & Hartley, 2004). They are bandwidth-intensive, so they are still more easily propagated by DVD than download: there's a 'hand-made' or 'manuscript' feel to them even when they appear on websites (e.g., Capture Wales).[10] If DST is to gather its own momentum and to play a significant role in public culture, the next step is to move beyond the focus on production at the local level, however much the participants benefit from being part of the workshops, and however much the cultural institutions benefit from engaging members of the community as cocreators. DST needs to address the question

of how to scale up content for audiences, and how to propagate the method as part of universal education (though not as *schooling*!). This step leads to the problem of expertise.

The expert: Bully or pulley?

Turning to expertise, the first problem here is the role of the facilitator in the production of self-made media. Often motivated by both artistic and political considerations, the facilitator is in a position analogous to that of the documentarist, with a community-arts educator (or *animateur*) thrown in. Why is that a problem? Because *self-made* media ought not to need input from the expertise of someone external to the self whose story is being narrated. And we have the example of YouTube to show that hundreds of millions of users (and climbing) don't need it. Can 'ordinary people' successfully get on with what they want to do when their hand is being held, however 'helpfully,' by a well-meaning facilitator? In documentary this is a problem that goes back many decades to Flaherty,[11] Grierson,[12] and *cinema verité*[13] in cinema, and the same applies to still photography too, where the rights and role of the 'subject' have long been in dispute. So that is the most obvious problem: you think you are going out there to empower Florrie and Nora, but you come back with *Night Mail*. Indeed, such 'documentary' endeavours often look highly authored, no matter how strong the voice of the subject. For instance the entirely authentic stories catalogued on the Capture Wales site nevertheless 'speak' of Daniel Meadows (himself a noted documentary photographer since the 1970s). How can untutored populations 'speak for themselves'?

This is part of a larger problem. In general, across industrial cultures, the 'expert paradigm' has been an impediment to the development of self-made meaning and self-representation by lay populations. Any *representative* system (including both politics and cinema) tends to discourage direct participation, even while it piles up honour and reward for the representatives and experts. Whether it is in the mode of production (e.g., the making of TV/film and entertainment) or in political participation (i.e., journalism; representative politics), the *closed expert system* has produced a serious gulf between the high level of talent among the best '*practitioners*' and the impoverished 'media literacy' of the *punters*.

And there's the rub. Work produced by the imaginative elite is excellent by any standard; it is granted that status not least by the approval and enthusiasm of the punters themselves. So when experts do seek to facilitate the 'universal' voice of individual humans, the result can be brilliant. Such experts include

Dana Atchley and his Californian compadres, Daniel Meadows and his Welsh wizards, not to mention the film documentarists, among whom I personally place Humphrey Jennings at the top. Jennings used ordinary people to illustrate larger themes. His 1943 propaganda film *The Silent Village*[14] is an early example of 'pro-am' or interactive production in the making of movies, what might now be called 'consumer co-creation'. His own skills and passions were vital to the enterprise, but they were successfully subsumed into the service of a greater work, one which cast the ordinary citizen as actor—an actor in history as well as in the film. He turned the major mass medium of his day into a means of communication for its own consumers to send a message of hope across the world. The result is great *collaborative art* imagining genuinely *popular culture* (see Hartley, 2006, for a full account of this earlier Welsh export).[15]

So the *problem* of the expertise of the facilitator—turning the 'authenticity' of others into the 'authorship' of the expert—would not be solved by simply firing all the filmmakers and letting consumers get by on their own. It is important not to fall for an 'either/or' model of digital storytelling: either *expert* or *everyone*. Instead of choosing between the expert paradigm and self-expression, objective and subjective knowledge, it would be preferable to hold fast to both. To do that, it is necessary to abandon the linear model of communication and to replace it with one founded in dialogue:

> Human intelligence ... cannot switch itself on by itself. For an intelligence to function there must be another intelligence. Vygotsky was the first to stress: 'Every higher function is divided between two people, is a mutual psychological process'. Intelligence is always an interlocutor. (Lotman, 1990, p. 2)

According to Yuri Lotman, the development of 'human intelligence' is necessarily dialogic; everyone is an 'interlocutor', even when expressing their 'inner self'. This applies to digital as well as to oral and print communication. It follows that there will be uneven competences, ambitions, and levels of 'literacy' in play but also that dialogue is still possible. Indeed, Lotman argues that what he calls 'bipolar asymmetry of semiotic systems' is the generative mechanism of meaning in any semiotic system, from single texts to languages and culture (i.e., everything from mother/infant 'language of smiles' to the reception-transmission turn-taking between entire cultures, for instance Russian/French):

> It has been established that a minimally functioning semiotic structure consists not of one artificially isolated language or text in that language, but of a parallel pair of mutually untranslatable languages which are, however, connected by a 'pulley', which is translation. A dual structure like this is the minimal nucleus for generating new messages, and it is also the minimal unit of a semiotic object such as culture. (Lotman, 1990, p. 2)

His model is helpful for understanding the role of the expert as a 'translator', especially for those who are culturally 'monoglot' when it comes to literacy—that is, they have print but not media or digital literacy (and vice versa). In DST there is a clear asymmetry between facilitator and participant, but it doesn't have to be construed in terms of differential *power* (Gibson, 2007). Instead it invokes that most important attribute of the literary translator, which is knowledge not only of the technical aspects of both the home and target 'languages' but also (ideally) a wide knowledge of their literary, journalistic, scientific and popular-cultural elaborations and a facility for translating the strengths of one into the strengths of the other, even where there is 'mutually untranslatable' asymmetry. In short, the expertise of the filmmaker or documentarist when coupled with a 'parallel' intelligence from the lay population can result in new and compelling stories that do credit to both parties.

Expertise: 'Gawd! It looks like it could talk to me!'[16]

Among the successors of Humphrey Jennings is Australian filmmaker Mike Rubbo. Rubbo came to international prominence with *Waiting for Fidel* (1974),[17] which is said to have inspired Michael Moore's documentary style. He has released films in every decade since the 1960s, recently winning an AFI Award for *Much Ado about Something* (2001).[18] But it is as 'Mike the helper' that he figures in this story. In 2006 Rubbo made a documentary called *All About Olive* for ABC-TV, featuring Olive Riley, who was 107 years old. Later he assisted Olive to produce her own blog—*The Life of Riley*[19]—in which she claimed to be the world's oldest blogger. A typical entry is 'It's a Likeness', the story of Olive going to have her portrait painted, an adventure that includes the trip to the studio, a parking ticket and a pie, recorded in transcribed dialogue and still photos by Rubbo. When Olive sees the finished portrait she exclaims: 'Gawd, it looks like it could talk to me!'; which is a good epithet for her blog. The site has attracted worldwide attention and high levels of visits (192,000 in the first month), along with many comments (nearly 500 on the first three entries in February 2007). The format is that Rubbo records dialogue with Olive and types it up, interspersed with photos old and new, and with occasional commentary in italics from 'Mike the helper.' The result is a new hybrid form—part blog (since it uses the first person although it is written by someone else), part DST transcript, part multiplatform publishing. Rubbo replies to almost every comment posted on the site, maintaining a conversation

that extends the themes of Olive's current adventure and sometimes producing new information or photographs that are themselves shared with the community of interest that has gathered around Olive. Presumably because of Rubbo's own media savvy, the 'oxygen of publicity' has included both press and broadcast coverage. Some of this is also used to solicit participation by others (e.g., appealing for photos of places in Olive's life), which in turn attracts visitors to the site, including those who've seen press coverage in Poland, the United States, the United Kingdom, Germany and so forth.

A notable feature is that Rubbo—who was himself nearing 70 years old at this time—is no more a 'digital native' than Olive. He is an expert filmmaker and has a fine documentary sensibility, but computers are another matter. He shares his learning curve with visitors, explaining to one why he doesn't podcast the conversations with Olive: 'Just getting this far, pictures and words, has been an effort. I'm going to need help with podcasts. I'm a senior too and way out of my previous comfort zone already. Mike the helper.'[20]

Rubbo's position as a 'helper' shows how professional expertise can be deployed in a convivial way. It demonstrates how the asymmetrical relationship between expert (Rubbo) and first-person storyteller (Olive) can produce something new that stretches both of them. Meanwhile, the blog and its associated media coverage calls a sizable 'conversational public' into being, for whom the personal contact with Olive and side-bar chats with Rubbo are both of value. It is a multiplatform 'open innovation network' in miniature.

The Riley-Rubbo mode of digital storytelling developed by happenstance, not by workshop, and its one-to-one relationship between facilitator and user would be hard to replicate. But it does point the way towards a 'dialogic' development of expertise among users, based on a conversational ethic and 'parallel intelligence' applied to concrete but nevertheless objective issues. Olive's blog is actively producing and sharing new expertise among all parties. It helps us to visualise a digital storytelling 'system' in which the myriad producer-citizens who are doing it for themselves can build their own expertise, call in that of others, and use their new-found 'digital literacy' to do previously unimagined things; unimagined by the expert providers of mainstream media and by consumer-users themselves, especially as individuals.

This means that DST is not an end in itself but part of a larger cultural process—which may be 'natural' but also needs effort—both to *extend the users* of digital literacy across whole populations, and to *elaborate the uses*, so as to democratise public engagement with digital media, and to contribute generally to the growth of knowledge, especially of the kinds most suited to digital media. It is only one step along the way, because to date it has been concerned almost exclusively with 'first-person' narratives—stories of identity, emotion

and self-realisation. Fair enough, but there's more to language than self-expression and communication: there is also knowledge. In fact, the philosopher Karl Popper has produced a typology of the 'levels' of language:

1. Self-expression
2. Communication
3. Description
4. Argumentation (Popper, 1972, chapter 3)

For Popper, the first two levels produce subjective knowledge; the second two lead to objective knowledge. For us, it is noteworthy that DST, in common with the media-entertainment complex in general, is obsessively focused on the first level. To take a further step towards the two 'higher' levels of language, the question of expertise needs to be pressed: how can *everyone* in a given community be in a position to contribute to the growth of objective knowledge?

Here print literacy is an instructive antecedent. Over a long timeframe (the seventeenth to the nineteenth centuries in Europe), print literacy escaped from instrumental purposes like religion, business and government, to become a culture-wide capability. It is worth noting that this was possible only because of massive *public* investment in schooling, whose aim was universal print literacy. But what it could be used *for* also escaped the institutional and individual purposes of the early proselytisers. As a social resource—a form of embedded human capital—print-literacy enabled science, literature, journalism and entertainment. The Enlightenment, modernity, industrialisation and mass media were all founded on it. What will be the forms of expertise that grow up among those who take for themselves the power of self-expression in digital media? That is the second problem of expertise.

Conclusion: DST for science, journalism, imagination?

Karl Popper has linked the evolution of objective knowledge and thence science, modernity and the open society, to the invention of printing. This is one reason why universal education was thought wise. It is worth asking whether the invention of digital media may be enabling a further evolutionary step in the growth of knowledge. If so, two things need to happen.

First, the 'ordinary people'—the punters, participants, the inexpert consumers—need to be able to develop and share expertise of their own, such

that they too can contribute to the life of science, imagination and journalism, as well as that of self-expression and communication. In other words, Olive's experiential and tacit knowledge of places and themes are interesting in themselves but, especially when taken up by her interlocutors, they are also capable of producing new 'objective' knowledge, for instance about places where she has lived, filling in the historical and archival record in ways that local galleries and libraries value. This is Lotman's 'parallel intelligence' in the realm of knowledge: uniting subjective and objective, experience and expertise, in dialogic asymmetry.

The second thing is that digital storytelling needs to be used for more than self-expression and communication. Digital media need to be exploited to generate new 'objective' description, new argumentation (Popper's negative or falsifiable method of scientific enquiry), and while we are at it, new forms of journalism and new works of the imagination too. Now of course all of this is already happening; choose your own favourite examples. The general point I am trying to make is that such initiatives need to be understood coherently as an *extension* of the possibilities of knowledge, even while their experiential self-expression is an assault on the closed expert system as such. The emancipation of large numbers of otherwise excluded (or neglected) people into the 'freedom of the internet' will, if successful and if pushed beyond a 'look at me' stage, assist not only in self-expression and communication but also in the development of knowledge in an open innovation network. DST is an excellent initiative for recruiting new participants into that open network, and for lifting levels of digital literacy and popular expertise. It may be modelling for the coming century the role—if not the methods—of public schooling in the early period of print literacy.

But it shouldn't be seen as an end in itself, as if knowledge of the personal is all that is necessary for people outside of the existing professional elites. It is no advance to reinforce the barriers between popular and expert culture; to *substitute* 'self' for 'science'. The consequences of doing that are already part of the crisis confronting contemporary societies. The cultivation of the personal as a sufficient ambition for the majority (while those 'in the know' disappear behind closed institutional doors) can lead to the very evils of relativism that experts rail against, encouraging the general public to believe that anything goes, that knowledge is only a matter of opinion, or that self-expression is the highest form of communication. Cutting people off from it means that despite the wonders of science the punters are more sceptical about it than ever. As the late Kurt Vonnegut once put it, 'I began to have my doubts about truth after it was dropped on Hiroshima' (Vonnegut, 1981, p. 223). Not only are the fruits of scientific research often rejected or delayed in the court of public

opinion—GM foods, nuclear energy, global warming—but even the underpinning commitment to rationality and the open society are being 'white-anted' from within by resurgent religiosity, 'me'-culture and a politics of fear.

The need is not to separate 'science' (description & argumentation) and 'popular culture' (self-expression & communication) further from one another but to find ways of holding them together. At the moment the way that professional scientists tend to do this is by speaking very slowly and clearly (public understanding of science), or ventriloquising through celebrities and pop-stars (Bono). The expert paradigm is still in place; maybe more so as more expert intermediaries are hired to 'manage' public knowledge.

Meanwhile, over in popular culture, knowledge has been growing all by itself. The shift from broadcast to interactive media in particular has democratised self-expression and complicated the entire edifice of 'representation' in both symbolic and political communication. We are no longer satisfied with deferring to representatives; we want direct voice, action, creative expression—and, increasingly, knowledge. If the problems of scalability and expertise are well-handled, digital storytelling can play a progressive role in this endeavour, not by pandering to the metaphysics of individual presence or by convincing the public of the expertise of others, but by democratising both self-expression and expertise, such that presently unthought-of innovations can occur in the growth of knowledge, and the general public can join the life of science, imagination and journalism, as well as that of self-expression and communication.

Notes

I acknowledge the Australian Research Council Federation Fellowship which supported the research on which this paper is based; and the ARC Centre of Excellence for Creative Industries and Innovation at QUT which is home for the research. Our work on digital storytelling has been distributed, iterative, collaborative and conversational, and thanks are due to many colleagues, especially Jean Burgess, Helen Klaebe, Kelly McWilliam, Angelina Russo, Jo Tacchi and Jerry Watkins.

1. In the spirit of participation, I am a DST practitioner, having made *Perfect Rock* (2004) in a QUT-run workshop, and cocreated (with Sandra Contreras and Megan Jennaway) *Brisbane's Best Tree* (2005) in a masterclass run by Daniel Meadows.
2. 'Digital Storytelling—Critical Accounts of a Californian Export' (organizer: Knut Lundby, University of Oslo). Pre-conference of the International Communication Association Annual Conference, 24 May 2007. University of California, Berkeley Graduate School of Education.
3. Namely: overcoming the monster; rags to riches; the quest; voyage and return; comedy; tragedy; rebirth (Booker, 2004). But see www.telegraph.co.uk/arts/main.jhtml?xml=/arts/2004/11/21/boboo21.xml: 'There may be only seven basic plots, but there are thou-

sands of stories. What we call the greatest of these are works that stand out from the crowd, and their greatest readers are those who give due weight to each one's own peculiarity.'

4. Phrase attributed to actor Richard E. Grant (www.imdb.com/name/nm0001290/bio).

5. See www.panslabyrinth.com/: I chose this as an example of a compelling story, not only because it is a Shakespearean achievement in dramatic terms, but also because it features the dreams of self-actualization of a young person in difficult times, which is a common feature of digital stories (in this case a 12 year-old girl under fascism).

6. See his own version of the story at: www.commedia.org.uk/about-cma/cma-events/cma-festival-and-agm-2006/speeches/daniel-meadows-speech/.

7. 'Mae DS 2 yn anelu at ysbrydoli, annog a dangos i chi bosibiliadau cyffrous y maes Adrodd Straeon Digidol *os ydych yn gweithio mewn addysg, y gymuned neu fel artist.*' (www.aberystwythartscentre.co.uk/information/Digitalstorytelling.shtml); my emphasis.

8. E.g. Best New Media at BAFTA Cymru, 2003.

9. See www.youtube.com/watch?v=RSHziqJWYcM and the Wikipedia.

10. See www.bbc.co.uk/wales/capturewales/about/.

11. See Derek Malcolm on Robert Flaherty's *Nanook of the North*: film.guardian.co.uk/Century_Of_Films/Story/0,,160535,00.html.

12. *Night Mail* is Griersonian rather than Grierson; see www.screenonline.org.uk/film/id/530415/index.html; and on the problems of expertise in documentary see my chapter on *Housing Problems* in Hartley, 1999, pp. 92–111.

13. E.g. Frederick Wiseman's *Titicut Follies* (1967); on this, see Miller (1998).

14. See www.imdb.com/title/tt0139612/

15. The film itself is available here: www.moviemail-online.co.uk/films/9186

16. Olive Riley (then aged 107), on seeing her portrait: see www.allaboutolive.com.au; and see www.smh.com.au/news/web/seniors-circuit/2007/05/16/1178995169216.html?page=2 (news story on Olive, Rubbo and the blog from the *Sydney Morning Herald*); and see abc.net.au/tv/guide/netw/200602/programs/ZY7518A001D13022006T213500.htm (Rubbo's film); and see www.abc.net.au/westqld/stories/s1881943.htm (feature on ABC Western Queensland about the blog, with call for photo-contributions).

17. See www.imdb.com/name/nm0747808/

18. See www.amazon.com/Waiting-Fidel-Michael-Rubbo/dp/B0002XL1P8.

19. www.allaboutolive.com.au

20. Rubbo replies to almost every comment on the blog. The following exchange explains his relationship with the technology (note that the comment is addressed to Olive but Rubbo replies in his own voice): 'May 18th, 2007 at 2:06 am Liisa Rohumaa says: Dear Olive, I, too, am an admirer of your blog! I would love to hear your thoughts on why more older people don't blog. (I am doing an MA at Bournemouth University and doing some research on 'silver surfers' and the web). Regards, Liisa

Hi, Liisa. I am thinking about your question ever since one of our readers in the US discovered how old I am, and expressed surprise that I'm so plugged in to blogging. Actually, I'm still very much at my limits everyday but somehow have overcome fear of the computer and its manipulation. It's very much a mind set I think. Once I decided that it was do-able and I would learn, it began to be a lot easier.

Knowing Eric Shacle, who's the world's oldest electronic journalist most probably at 87, has helped. But Eric professes not to be able to do what I can now do, and has an 'I can't go much further' attitude. I think he'll probably change that.

I very much enjoy being able to take a photo for instance and know that with a few steps, I

can get it (1) out of the camera, (2) saved into My photos, (3) into photoshop for cropping and color balancing, and then soon afterwards, (4) into a new post on the blog.

But ask me how to wrap text around that same photo, instead of just having text and photo alternating as I now do, and I'm lost again.

Going that extra step seems as mysterious and remote as did the things I now know so well. But, of course the difference is that now I think, 'well, that must be easy too actually, just a matter of further learning like before.'

The worst experience is something going wrong, not knowing why and losing loads of confidence in the whole business. But that is happening less and less these days. I seem to be more tuned to the computer's moods and vagaries. Mike the helper.'

References

Booker, C. (2004). *Seven basic plots: Why we tell stories.* London: Continuum.

Burgess, J., & Hartley, J. (2004). Digital storytelling: New literacy, new audiences. Paper presented at *MiT4: The Work of Stories* (Fourth Media in Transition conference). Cambridge: MIT (6–8 May) (web.mit.edu/comm-forum/mit4/subs/mit4_abstracts.html).

Carpentier, N. (2003). The BBC's *Video Nation* as a participatory media practice: Signifying everyday life, cultural diversity and participation in an online community. *International Journal of Cultural Studies, 6*(4), 425–447.

Derrida, J. (1976). *On grammatology.* Baltimore, MD: Johns Hopkins University Press.

Gibson, M. (2007). *Culture and power: A history of cultural studies.* Oxford: Berg.

Hartley, J. (1999). *Uses of television.* London & New York: Routledge.

———. (2006). The best propaganda: Humphrey Jennings's *The Silent Village* (1943). In A. McKee (Ed.), *Beautiful things in popular culture* (pp. 144–163). Oxford: Blackwell.

Hartley, J., & McWilliam, K. (Eds.) (forthcoming 2008/2009). *Story circle: Digital storytelling around the world.* Oxford: Blackwell.

Lambert, J. (2006). *Digital storytelling: Capturing lives, creating community* (2nd ed.). Berkeley, CA: Digital Diner Press.

Lanham, R. A. (2006.) *The economics of attention: Style and substance in the age of information.* Chicago: Chicago University Press.

Leadbeater, C. (2002). *Up the down escalator: Why the global pessimists are wrong.* London: Viking.

Lipton, L. (1974). *Independent filmmaking.* San Francisco: Straight Arrow Books (Rolling Stone); London: Cassell (Studio Vista).

Lotman, Y. M. (1990). *Universe of the mind: A semiotic theory of culture.* Bloomington: Indiana University Press.

Meadows, D. (2006). New literacies for a participatory culture in the digital age. Community Media Association Festival & AGM (www.commedia.org.uk/about-cma/cma-events/cma-festival-and-agm-2006/speeches/daniel-meadows-speech/).

Miller, T. (1998). *Technologies of truth: Cultural citizenship and the popular media.* Minneapolis: University of Minnesota Press.

Popper, K. (1972). *Objective knowledge.* Oxford: OUP.

Vonnegut, K. (1981). *Palm Sunday: An autobiographical collage.* London: Jonathan Cape.

TWELVE

Agency in digital storytelling

Challenging the educational context

OLA ERSTAD AND KENNETH SILSETH

The Web 2.0 era offers creative potential for content production and communicative practices of sharing and remixing different semiotic resources (Jenkins, 2006; Lankshear & Knobel, 2006; Erstad, Gilje & de Lange, 2007. In a cultural-historic perspective, these media developments have happened in a very short time span. During the last two to three years we have seen a massive increase in registered users of different social networking sites such as 'Myspace', 'YouTube' and 'Facebook'. However, the potentials and implications that these social and cultural phenomena represent for young people's learning and identity constructions have not yet been fully grasped.

In this chapter we will frame a discussion on the polarities between *formal* and *informal* ways of learning (Bekerman, Burbules & Silberman-Keller, 2006) by exploring the practice of digital storytelling inside schools. From being defined as an activity outside of formal educational settings, in order to detach the activity from the formal rules and regulations of schools, there is a tendency that teachers start to use digital storytelling with their students in the classroom.[1] Digital storytelling represents an important and interesting way of engaging young people in practices of production in a more personal way. Our interest is linked to the educational setting and how developments of

new technologies challenge traditional formal settings for literacy and learning (Kozma, 2003), and we will use the concept of *agency* to raise some reflections on the use of digital storytelling inside schools.

We want to raise two interrelated issues of relevance to our discussion of agency in digital storytelling. The first is to explore the notion of agency framed within debates about democratic participation and citizenship. It has been stated that processes for democratic participation have to be reconceptualised as a consequence of technological developments (Poster, 2001), as well as how we perceive the role of education in our society (Bereiter, 2002). As Gert Biesta (2004) has stated, 'If education is indeed concerned with subjectivity and agency, then we should think of education as the situation or process which provides opportunity for individuals to come into presence, that is, to show who they are and where they stand' (p. 78). The second issue is to look at agency from a more epistemological perspective, raising reflections on how digital storytelling might challenge the traditional perspective on knowledge-building within the educational context. When young people are given the opportunity to blend the informal 'cultural codes' with the more formal ones in their own learning processes, agency might be fostered in a new way, with implications for democratic participation.

Our empirical data, presented later in this chapter, is taken from an ongoing research project on digital storytelling in schools. This particular data is taken from one Lower Secondary school in Norway, which actively uses digital storytelling as a way of enhancing a student focus in the educational context. However, we start this chapter with some reflections on the implementation of information and communication technologies (ICT) in educational settings and student-centred learning environments, which can be seen as the foundation for increased interest in digital storytelling in schools.

ICT and student-centred learning environments

During the last decade, one key characteristic of school development in many countries has been the implementation of information and communication technologies (Kozma, 2003). The expectations following increased access to technology in schools have been huge, and several critical voices (for example, Cuban, 2001) have raised questions as to what extent the implementation of ICT has had any real impact on learning activities in schools. A lot of attention has been directed towards the technology, almost in a technologically deterministic fashion. However, there also exist initiatives where the focus is more directed towards how to change conditions for learning, where ICT is

defined as one of several factors initiating such changes (Bransford, Brown & Cocking, 2000). One interesting example is the increased interest in what is called 'student-centered learning environments' (Jonassen & Land, 2000). It is within these developments that digital storytelling becomes relevant and an interesting method of engaging students in a more personal way using digital technologies.

Traditional learning environments often focus on mapping what students do not know on different age levels and then providing them with the proper information. To a lesser extent we have been oriented towards creating learning environments that might challenge students in their knowledge-building (Scardamalia & Bereiter, 2006) and engage them on a personal level. Jonassen and Land (2000, p. viii) discuss a transition from 'instruction' to a 'student-centered learning environment'; environments that are designed to support individual efforts to negotiate multiple points of view, while engaging in authentic activities. In this conception of learning, technology might be used as a tool to support and enhance the learning environments.

Innovative use of new technologies is often first developed in the informal spheres of social life and not the institutionalised ones (Rheingold, 2002). Research that addresses the situation of educational technology in Norwegian education shows that schools are lagging behind in the active and creative use of such technologies compared to the home setting (Erstad, Kløvstad, Kristiansen & Søby, 2005; Arnseth, Hatlevik, Kløvstad, Kristiansen & Ottestad, 2007). The epistemic cultures that students take part in outside of school are not made relevant in the epistemic culture of schools (Hull & Schultz, 2002; Erstad, 2005). Digital storytelling might represent a new way of integrating these contexts and might bypass a categorical division between the formal and the informal paths of learning.

Agency in digital storytelling

In general, storytelling might be perceived as a method of sharing experiences using different tools that are available in a particular situation. Digital storytelling, in our context, is characterised as a genre of audio-visual stories consisting of still pictures, voice-over and music/sound, that are composed on the basis of a personal narrative storyline.[2] This genre of digital storytelling has its origin in California in the milieu connected to Dana Atchley and Joe Lambert, and builds on an idea of giving ordinary people a voice that can be heard by others.

These audio-visual stories are also characterised as being multimodal. Mul-

timodality is a concept that is often used to analyse digital texts as a combination of different modalities and semiotic resources in one expression (Kress, 2003). The term implies more complexity in the way texts are made and how we 'read' them. In part, multimodality can be analysed as semiotic texts and final products and can also be understood as the process of combining different available resources, for example, downloaded from the Internet, in which young people are often involved.

Studying digital storytelling as a methodological approach in schools raises several important issues. On a personal level the objective is to engage students for learning in new ways, taking advantage of their 'digital literacy' (Tyner, 1998) from outside school. Important questions that concern the role of education for empowerment and citizenship in a democratic society with increased use of digital tools, and knowledge-building that challenges traditional conceptions about the way we organise formal learning in schools, are brought up to date. Agency, in this context, becomes an important perspective to link overall issues of empowerment and participation and epistemological issues among agents.

Some seek to locate the origin of *agency* in various relationships between self and structure (Cooren, 2004) or explicate various forms of agency, including the technological, human and textual (Hardy, 2004), or various dimensions of the agentic process. We interpret the concept of agency as 'the capacity to make a difference' (Castor & Cooren, 2006) linked to certain institutional and cultural practices. The concept of agency might be perceived as closely connected to the concept of identity (Hull & Greeno, 2006); in our context it implies a focus on the stand people take when working with, and expressing themselves through, digital storytelling. Through composing these stories they get the opportunity to 'craft an agentive self' (Hull & Katz, 2006), where they actively take part in a social construction of their own identity.

Our perspective is based on a 'sociocultural approach to agency' (Wertsch, Tulviste & Hagstrom, 1993).[3] This implies that agency is not attributed to the isolated individual but rather to what Wertsch, Tulviste and Hagstrom (1993, p. 352) describe as that which 'extends beyond the skin'. It can be understood on two levels. First, agency is seen as socially distributed and shared. Second, human agency involves mediational means or what can be termed mediated agency.

A democratic potential

By producing digital stories, the subject goes from having solely a consumer

role to having a role of a producer of mediated content. In its original phase, digital storytelling had a strong democratic motivation in the sense that it intended to engage people and communities and provide tools to express their personal stories (Lambert, 2006)—a method that allows ordinary people to distribute and represent an authentic and personal (not individualistic!) voice. This democratic potential is still there, something which makes it particularly important for educational purposes.[4]

The American pragmatist John Dewey (1859–1952) was in the vanguard of the past-century educational theorists who warned against the problems in maintaining a categorical division between the activities that take place inside the educational context and what evolves outside of the schooling arena (see, for example, Dewey, 1959). One might argue that the dominating view on democracy and education in Western societies has been that this form of governing is dependent on free rational individuals who are able to make responsible decisions and that the role of schools inside this constitutional form is to *produce* this kind of citizen (Biesta, 2006).

Lawy and Biesta (2006) problematise this traditional understanding of citizenship by advancing two different concepts, namely *Citizenship-as-achievement* and *Citizenship-as-practice*.[5] *Citizenship-as-achievement* is meant to signify 'an assumption that young people should act and behave in a particular way in order to achieve their citizenship status' (p. 37), an assumption which corresponds with the traditional understanding of the process of becoming a citizen. But according to Lawy and Biesta an understanding of democracy and what it means to be a citizen, is *created* in the different arenas of communicative action in which young people at any given time participate. Citizenship, accordingly, cannot be taught as an *a priori* item. It cannot be handed over, or developed outside spheres of action that constitute the 'totality' of young people's lives. The concept of *Citizenship-as-practice* has to do with the understanding of citizenship as 'a practice, embedded within the day-to-day reality of (young) people's lives, interwoven and transformed over time in all the distinctive and different dimensions of their lives' (Lawy & Biesta, 2006, p. 47). It is through the actions that we carry out in our daily life that we develop into citizens. The implication would then be that, if a progressive cultivation of citizenship should take place in school, the formal educational context has to take the activity that goes on in the informal context into account. As Schugurensky (2006) puts it, 'The development of political capacities . . . takes place through the process of participation itself, and this is certainly a process of informal learning' (p. 170).

This relates to Dewey (1916/1997), who described democratic society as marked by two essentials, namely, a large portion of *varied shared interests* and

the possibility of *free interaction* between members of different social groups. The digital technology that is provided by the Internet (such as blogs, newsgroups, social networking sites) quite clearly gives the individual greater opportunities to produce and distribute his/her own personal and authentic voice. It allows a large number of voices to exist and be distributed and therefore principally increases the possibility for a democracy to be democratic. When it comes to free interaction among different social groups, it is not difficult to imagine how, principally, digital technology has a great potential. Online places like, for example, LunarStorm, Facebook, SecondLife, Piczo and so forth give individuals greater access to other voices.

One might claim that these digital expressions are often just individualistic and perhaps narcissistic and nothing else—just introverted sentimental self-realising expressions. However, as for example Glynda Hull and Mira-Lisa Katz show in their article "Crafting an Agentive Self: Case Studies on Digital Storytelling" (2006), both social and political aspects might be located in young people's seemingly personalised stories. The stories that are composed in the young people's work on digital storytelling are often located in the field of tension between their own and other's lifeworlds.

Digital storytelling, then, both gives students the opportunity to learn how to use technology to make their own voice heard and the opportunity to use knowledge and experience acquired outside of school in the process of becoming citizens—a potential way to foster agency. Working on digital storytelling might cultivate an understanding of citizenship as *Citizenship-as-practice,* where the personal and authentic voices of the students are recognised as important in the conceptual and institutional context. The democratic potential of digital storytelling lies both in the way people might learn to express themselves and the way it challenges traditional conceptions of formal versus informal ways of learning.

Epistemic agency in digital storytelling

The concept of *epistemic agency* has been used in relation to the implementation of ICTs in schools and has been linked to an increased focus on more active student roles. This is described as a transition from teacher-dominated classroom activities towards the students taking more responsibility for their own learning (Sandholtz, Ringstaff & Dwyer, 1997), where participation in progressive inquiry requires epistemic agency. Marlene Scardamalia (2002) points out that epistemic agency might be related to a learning situation where the participants 'set forth their ideas and negotiate a fit between personal ideas

and ideas of others, using contrasts to spark and sustain knowledge advancement rather than depending on others to chart that course for them. They deal with problems of goals, motivation, evaluation, and long-range planning that are normally left to teachers' (p. 10). Rather than subsuming their thinking under the teachers' cognitive authority, students engage in dialogical activity and take more responsibility for their own knowledge-building and problem solving. Digital storytelling is a good example of how these questions come to the surface, especially how young people make use of knowledge they acquire in different epistemic cultures (Knorr-Cetina, 1999)—and which addresses the recognition of several forms of learning and knowledge (Gee, 2003).

The attentive reader has probably already noticed that we have used the term 'voice' to some extent, something we have deliberately done with Mikhail Bakhtin (1895–1975) and his concept of *multivoicedness*, in mind. With Bakhtin (see for example, 1981), a fundamental dialogicality is rooted in all kinds of human expressions, which always consist of several different voices. As James Wertsch (1991) puts it, 'Because any utterance entails the idea of addressivity, utterances are inherently associated with at least two voices.' (p. 53). Any utterance might also be principally perceived as an answer to other utterances (Dysthe, 1995). Wertsch stresses that the notion of voice in Bakhtin's view 'applies to written as well as spoken communication, and it is concerned with the broader issues of a speaking subject's perspective, conceptual horizon, intention, and world view' (1991, p. 51). In principle, one might say that 'meaning can come into existence only when two or more voices come into contact' (1991, p. 52). It is actually this multivoiced quality that gives meaning to the expression. The concept of voice might also be said to bear connection to the notion of identity, which signifies a particular way the personal is represented (Hull & Greeno, 2006).

In this context epistemic agency might be understood as the ability to create new knowledge and craft an identity by drawing on different voices—'using contrasts to spark and sustain knowledge advancement' (Scardamalia, 2002, p. 10). In the educational context the student is an epistemic agent in the sense that he or she draws on different voices that are located both inside and outside the classroom. As we will see, epistemic agency might display itself in the student's ability to compose digital stories that consist of different and divergent voices.

Digital storytelling in the classroom

The data that we base our analysis on stems from a local project at a Lower

Secondary school in a medium-sized city in Norway, which actively uses digital storytelling as a way to enhance the focus on the student in the educational context. The project is called 'Young today', where eighth grade students (13 to 14 years old) have been working on a theme related to being young, in the past and the present. Our methodological approach builds on insights developed by the New Literacy Studies (Cope & Kalantzis, 2000; Lankshear & Knobel, 2006), which has its point of departure in the presumption that one has to analyse the use of technologies within the context in which it is being applied. We have studied one particular class that got the opportunity to decide themselves what kind of medium they would employ and present the assignment through, for example, a lecture, a PowerPoint presentation or digital storytelling. The assignment was to be carried out in groups.

In addition to interviewing the teacher in charge of the work on digital storytelling, we have analysed several digital stories and undertaken interviews with different groups of students about their stories. However, our focus will be on one group of students and their digital story, supplemented with contextual information and reflections by the teacher. In what follows, different agencies and voices from the teacher and the students are expressed.

The teacher's voice

This specific teacher, here named Mary, has in recent years become one of the key people with competence on digital storytelling in the educational context in Norway. Based on former projects working with digital media, Mary was invited to take part in a course on digital storytelling in Wales, held by Joe Lambert. In the interview one clearly gets the impression that she is a teacher who has a positive perception of working with multimodal texts and connecting with youth cultures of today.

Mary expresses the belief that digital storytelling works as an engaging method for both low-performing and high-performing students. She claims that digital storytelling is a progressive way to motivate the traditionally low-performing students: 'we are able to stimulate the writing process of more students, when it does not centre around these long compositions. If I can tell a student that he might write about something that he is preoccupied with in the subject English, and we speak of approximately 150 to 200 words, then it is manageable'. Mary further explains that if a student struggles in writing a manuscript, the student can write down cues, and together with a tutor try to formulate a verbal story, which the student afterwards reads into the programme in which she makes the digital story. For these students, there ex-

ists an empowering and agentic potential in digital storytelling; they are low-performing in regard to the traditional written assignments, but get the opportunity to express themselves in new ways by using technologies other than the written text.

Mary emphasises that the students should be active and self-governing in the work on digital storytelling. This implies open-ended assignments. For her, digital storytelling is more than just a tool for presenting subject matter; she believes it is an important tool for personal engagement in knowledge-building: 'Instead of just for example answering questions from the book', one is supposed to 'work more with the material and . . . put personal expression into it'. At the same time she expresses that it often can be difficult to get the students to be personal in their learning activities at school and to let the personal enter their stories, and not just compose a strictly professional story that is a mere rendering of facts. Still, she advances several examples of how students have drawn personal elements into seemingly professional stories, and crossed the boundaries between the formal and the informal spheres. For instance, she talks about a student who created a historical story about World War II, where the student came across an historical artefact from that particular period in the attic at home and which became central to her digital story:

> it was a helmet, a German helmet that was in the attic, right. And then they had to talk about this at home, 'why is it lying around in our attic'? What is the reason for this? 'It once belonged to a German soldier'. And then they had this conversation at home, right. And these stories, which are mediated from one generation to another, and then the young people digitalize it. . . . It is not actually the student that has experienced this, but he eventually tries to express this experience that makes up the background for this . . . (Teacher)

This is an example of stories told by students that are situated outside the traditional division between the formal and the informal spaces of knowledge-building.

A digital story

The group of students we will focus on here made a digital story about the multiplayer online role-playing game World of Warcraft (WoW). The group consisted of 3 young boys, who, according to the teacher, were all low-performing students. However, the teacher believes they made the most advanced story of the different groups. What is interesting is that the theme of the story is very much part of youth culture today. In this way the story might be interpreted as

a reflection upon the students' own media culture.

In making the story, the students used voice-over, still pictures of different gaming situations and written messages that appear between some of the pictures. They wrote the storyline themselves, and the final product lasts approximately 4 minutes. Most of the pictures are downloaded from the Internet, but they have also used screenshots of their own gaming, something that gives evidence to the fact that these youngsters are in possession of technical skills that reach outside of what is expected in the classroom. The narrative in the story is composed of 6 sequences:

1. The introduction consists of simple facts about WoW, for example, what kind of game category it belongs to and how to construct your own avatar or character.
2. In the next sequence the students elaborate on why playing this game is more suitable for youth than younger kids. We are told that the game has a complex structure, and that the younger Norwegian kids would have difficulties with the fact that the language used in the game is English.
3. In the third passage the students explain the intentions the producers of the game had when they released it. On the soundtrack of the digital story one of the students says that: "first and foremost to earn the money they have spent in the making of WoW'."
4. In the next sequence we are told how young people have broken the rules of the game and invented a software programme where you can buy certain artefacts that one might use in the game, by paying real money.
5. In the fifth part of the story the students have staged an interview with a WoW-player (one of the students in the group), where the interviewee answers a series of questions regarding what it means to play WoW—for example, what he likes about the game, and why he continues to play it.
6. Finally the students advance an ambiguous yet interesting comment: 'What can you do to stop young people from playing World of Warcraft? They can start with a hobby or sport! But it is of course important that they appreciate the hobby or the sport.' The statement is both a warning, and an answer to this warning.

This digital story gives evidence to the fact that expressions of this kind have several layers of analytical positions. It is close to the formal setting of school through its factual description on how WoW works. It reflects on how age dif-

ferences are a relevant topic in regard to playing the game. We get the players' own story on why this is such a fascinating game. It has some kind of critical edge in regard to the producer's intentions to make money and how young people are able to work against these intentions. And at the end, an ambiguous and perhaps ironic 'warning' about playing the game is expressed.

The student's voice

In the interview with the students, they elaborate on what playing WoW is all about. In the interview they fill out each other's sentences—somehow sensing each other's standpoint and articulating in collaboration a story about making a digital story. What it shows is that these students are quite literate when it comes to using the technology to create a story. In addition to having used screenshots, they have also experimented with the possibility of integrating a YouTube-video in their story. Because they were not satisfied with the result, they decided against bringing the video into the final product.

In one passage of the interview the students respond to questions about a possible audience. They articulate something that might be interpreted as an underlying call for recognition in the digital story:

Interviewer: . . . who have you made it for? Have you thought about that?
Student 1: People that believe WoW maybe isn't that cool, but maybe want to start playing
Interviewer: Mm
Student 1: Yes, who believe we are like nerds, then they can see more of how . . .
Student 2: How it is
Student 1: . . . without having played it. There are actually people that haven't even tried it, that say we are nerds
Interviewer: Hm
Student 2: And they know less themselves
Interviewer: Yes, exactly
Student 2: . . . how it really is

The students articulate a desire to show others through this digital story what they are doing when they are playing WoW—'how it really is'. They explain how some people in their *milieu* are prejudiced about this way of spending their time and how these people perceive them as 'outsiders', or to use their own term, 'nerds'. By composing the digital story about this specific game and game culture they get the chance to give others an insight into what goes on in this activity, and the opportunity to achieve social recognition from others. Since they operate in relation to a medium they themselves master and use in

their daily interactions with other young people outside school, it gives them the opportunity to advance a more authentic and personal story than would a traditional, written composition—it has given them the possibility of making their own voice heard, a voice that seeks recognition. In another passage of the interview the students address this issue from a slightly different angle:

> *Interviewer:* What then is the advantage of doing it in this way; couldn't you just have written it like a composition in school? Is it better to work in this way?
>
> *Student 2:* Yes, maybe if you are going to present it, then you avoid having to sit in the front and read out loud.
>
> *Interviewer:* Yes
>
> *Student 2:* Then they can just watch what you have done instead
>
> *Student 1:* That is better
>
> *Interviewer:* Is it like more fun to make this kind of story, than to write a composition?
>
> *Student 2:* Yes, but that depends on the theme we work on

Here the students are asked questions regarding the differences between making digital stories and making stories as written presentations. It is particularly interesting that they do not necessarily believe it is 'more fun' to use technology in the classroom—that depends on the theme. However, technology makes it easier for them to actually present what they want to express (see also Buckingham & Harvey, 2001). For these students, digital storytelling has a lower threshold for expression and communication than traditional media like written assignments. The students are low-performing in the traditional context. They do not feel comfortable having to read their product out loud, but get another opportunity to present their product through digital storytelling. The fact that these students might present their story in their own way also makes it simpler to integrate more personal elements in the story that otherwise may not have been presented if they had to confront the whole class, face-to-face, in a session of reading out loud.

In one interview passage, the students were asked a question that more directly addressed the division between the use of digital technology in the formal and the informal context: how they would have made a digital story about WoW outside of school?

> *Interviewer:* But if you were to make it in your spare time . . . if you . . . ?
>
> *Student 1:* not having homework?
>
> *Interviewer:* Yes
>
> *Student 1:* Then we hadn't done it [smiling]
>
> *Interviewer:* How would you then have done it?
>
> *Student 2:* Completely differently, I believe
>
> *Interviewer:* Yes, how?

Student 1: Wouldn't have been that serious. Don't believe we would have made it about youth. I believe we would have had many pictures and music maybe . . . Made more out of it, if we had made it in our spare time

It is interesting that student 1 explains that if they had made the story outside of school it 'wouldn't have been that serious' and follows up this remark with the statement that they would have 'made more out of it'. One gets the impression that the students feel they must restrain themselves when making the story at school—tune down their own 'cultural codes'. The fact that they state they would have 'made more out of it' might indicate that they consider their own 'cultural codes' as more complex and comprehensive than the more formal ones. This might raise questions regarding the personal and authentic aspect of their digital story.[6] But when the students are given the opportunity to construct this 'semi-informal' story about their informal activities in the educational context, they are also given the opportunity to reflect upon their own practice—to place their relationship to WoW inside a conceptual framework and build new knowledge in a way that they would not have done on their own. Consequently, one might understand the digital story as a fusion of the personal and the conceptual, and the informal and the formal.

Challenging the educational context

In our case the students make an ambiguous, and slightly ironic, statement at the end of the digital story. On the audio we hear a voice saying the following: 'What can you do to stop young people from playing World of Warcraft? They can start with a hobby or sport! But it is of course important that they appreciate the hobby or the sport.' At the same time they show a screen shot of the logo for World of Warcraft where they have made a cross covering the logo.

In the interview the students articulate the following in regard to the statement:

Interviewer: Why, exactly, do you say this last part, or what were you thinking of?
Student 1: What were we thinking of? We thought that . . . they like to play, we have to understand that. . . . But it is important to move your body and stuff and do other things, and not just play WoW.
Interviewer: Your parents then, do they play computer games?
Student 1 + 2: No. They have almost no skills
Interviewer: Do you sometimes speak at home about playing WoW?
Student 1: No.
Student 2: Mom and Dad are a little worried in regard to becoming addicted. They know nothing.

226 ❖ Digital Storytelling, Mediatized Stories

In this last sequence of the digital story the students play out different voices and agentic statements. By drawing on Bakhtin's (1981) notions of 'heteroglossia' and 'multivoicedness', it is possible to consider this sequence as consisting of at least two different voices, what we here will term a *'formal voice'* and an *'informal voice'*—which are 'juxtaposed to one another, mutually supplement one another, contradict one another and . . . interrelated dialogically' (Bakhtin, 1981, p. 292). These two voices do not stand alone but stand in a dialogical relationship to each other, the 'formal voice' being the morally challenged adult, slightly institutionalised, position in regard to young people's participation in gaming activity. The 'informal voice', then, is represented by these young boys' own personal perception of this activity.

Agency, then, relates to a division between how young people and adults perceive the use of such media. With an ironic stance, they take the position of responsible adults, stating the typical adult solution as starting with a hobby or sport. At the same time they, as seen earlier in this digital story, are very much engaged in this gaming culture, positioning their own stance on this. The digital story gives these young boys an opportunity to mediate between different voices; gives them an opportunity to stage a dialogue about a subject that is important to their identity and self-representation. By drawing on different voices, they have positioned themselves as epistemic agents.

We have, earlier in this chapter, defined agency as 'the capacity to make a difference'. As shown through our analysis, this becomes evident for the three young boys in this particular setting. They are engaged in learning activities at school in a much more personal way than they are used to, drawing on their authentic interests from outside the school setting. The activity of playing games is an important part of who these boys are, constituting their agentic self. Through working with digital storytelling in the classroom they get the opportunity to make their voice heard and to make a difference in the way they express their own story in a personal way, in a formal setting. This way they might challenge and change how practices in that formal setting are made.

These issues of agency point back to the two dimensions of relevance to the educational context mentioned before; 'citizenship-as-practice' and 'epistemic agency'. Digital storytelling has provided the young boys we have studied with several ways of expressing themselves that facilitate agency in the formal context. First, we have seen that digital storytelling has provided the opportunity to produce an expression of the activity that constitutes an important part of their identity, by using their own 'cultural codes'. Second, for these young boys digital storytelling seems to lower the threshold when it comes to projecting their voices. The students are troubled by performing (face-to-face) directly in front of the whole class but get an opportunity in digital storytelling to pres-

ent their voice more on their own terms. Third, in digital storytelling these students find a place to enter into a dialogue between an informal and a more formal understanding of young people's gaming activity.

These three aspects are closely connected to the concept of agency, both in the democratic sense of the term and the more epistemological. They have learned to use a form of expression where they actively have used different voices that both belong to the formal and the informal contexts. This situation of learning relates to a notion of citizenship as *Citizenship-as-practice*, where elements from the 'totality' of the young person's life are included in the process of becoming citizens. It also relates with the notion of epistemic agency where the students are active and more self-governed in the knowledge-building that takes place inside the classroom, in between different positions and values that further enrich the learning environments of these young students.

How digital storytelling might be said to challenge the educational context can be summarised in the following issues:

1. *The relationship between teacher and students.* Digital storytelling challenges the way we traditionally think about teacher and student roles: that is, the teacher as active deliverer of information and content and the students as passive reproducers of content. By its focus on the personal voice and agency, digital storytelling creates a situation where the students become more 'visible' and learners in a personal sense. The teacher we have studied can be said to succeed in her efforts to use digital storytelling in the classroom. This is mainly because she is aware of and attentive to the personal voice of the students, combined with a way of understanding the affordances of new technologies, using digital tools for storytelling to support the students in the way they express themselves and reflect on their own learning.

2. *The epistemic orientation in school-based learning.* Digital storytelling might be said to challenge the epistemic culture of our education system since knowledge is not defined as something given but something to explore and enquire in different ways. This relates to what Scardamalia & Bereiter (2006) describe as knowledge *of* in contrast to knowledge *about.*

3. *Engaging the students in a collective way.* Even though digital storytelling is directed towards the personal voice, it is at the same time part of collective processes. The students collaborate on making stories at school and present their stories to others. Digital storytelling shows how new technologies can support collective learning processes and collaboration in new ways.

4. *Multimodality.* In making digital stories the students create multimodal texts, combining images, written text, sound, music and oral communication modes in one expression. These are new ways of thinking about texts in schools and the way students work with making expressions and products.

5. *Making explicit the relationship between contexts of learning.* As mentioned above, one of the most important challenges represented by digital storytelling in schools is the way it connects the formal and the informal contexts for the students. They are encouraged to use their everyday experiences to make texts/stories by using their own 'cultural codes' and relate something in the school context that they experience as relevant and authentic, which then can have consequences for their learning process.

Our case shows that it is possible to raise issues about new ways of engaging students in learning in schools today. Digital storytelling has proved to be an important asset for the students and the teacher that we have focused on in this study. However, how do we look upon these challenges when we study the education system and formal learning practices in general? This brings us to our last point.

Potentials made real?

It is easy to see the attraction and potential of working with digital storytelling in school settings. However, to make this potential become real in a practical sense might often prove to be a challenge. Even though the implementation of information and communication technologies has been strong in latter years, research shows that many schools are not ready for realising the full potential of these new technologies for changing educational practices (Erstad et al., 2005).

Mark Smith (2006) has pointed out that 'it is easy in many education systems with their focus on the "delivery" of pre-packaged programs, testing, and the achievement of externally set targets and outcomes for educators to become technicians and to lose their sense of agency' (p. 17). The activity that takes place within the domain of the school will always to some extent suffer under the 'delivery of pre-packaged programs'. The fact that the educator weakens their sense of agency will have significance for the classroom environment and will consequently influence the students' chance of a sense of engagement in learning.

From our research, we see that digital storytelling is an interesting way to engage the students in a personal way. The concept of identity and self-representation then becomes important in the way we conceive learning. From our perspective, it is all about the possibilities students have for influencing their own activities in formal learning settings. In the system of education as we know it today, this is often a challenge. One issue is, for example, the emphasis on assessment. The digital stories we have studied are, for instance, to be graded in a formal context. They are given grades that are constructed on the basis of certain criteria defined inside the institutionalised framework of school. It is not difficult to imagine how this fact might have implications for the stories and the students' sense of agency.

Another challenge is that digital storytelling just becomes a playful activity and, from the teachers' point of view, an easy way to engage the students. Our point in this chapter is that the personal stories made by the students have to be taken seriously in the school context and a way found to combine the formal and the informal in the way in which such digital stories are created and made relevant. Mary comments on this when she mentions that she often finds it difficult to trace the personal in the students' digital stories even though she stresses this when working with the students. Many of the students produce just strictly professional stories and thereby weaken their own possibility of being agents. As Basil Bernstein (1974) has reminded us; young people are being socialised in a particular way in the educational arena. It is often difficult to break out of this formal discourse.

Digital storytelling, however, puts an emphasis on important issues in our education system today concerning the way we engage students in their own learning process by using the possibilities new technologies represent for expressing personal stories and facilitating agency. Our example in this chapter shows that digital storytelling has great potential as an innovative and progressive way of learning inside school which might give the students the opportunity to make self-representations in the school setting and foster agency in ways that challenge the traditional educational context.

Notes

1. As for example seen in workshops on digital storytelling organised for teachers in countries like UK, Sweden and Norway.
2. For examples on digital stories in this genre see: *http://www.storycenter.org/*, *http://www.bbc.co.uk/wales/capturewales/*, *http://www.coe.uh.edu/digital-storytelling/examples.htm*
3. See also the chapter by Erstad and Wertsch in this book (Chapter 2).
4. We do not take the naïve stance that claims that learning how to use digital tools in schools

necessarily *de facto* leads to increased democratic participation through use of technology in the society—a stance, one might argue, that is often taken by actors in this particular field of research (Selwyn, 2002) but rather try to construct an understanding of how digital storytelling might hold a democratic potential—keeping David Buckingham's (1999) encouragement in mind: 'In attempting to understand the development of political understanding, we need to adopt a broader definition of politics, which recognizes the potentially political dimensions of "personal" life and of everyday experience' (p. 178).

5. Which can be seen in relation to Arthur & Davidson's (2000) division between *passive* and *active citizenship*.

6. See Chapter 6 by Kaare and Lundby in this book.

References

Arnseth, H. C., Hatlevik, O., Kløvstad, V., Kristiansen, T., & Ottestad, G. (2007) *ITU monitor 2007*. Oslo: University Press.

Arthur, J., & Davidson, J. (2000). Social literacy and citizenship education in the school. *The Curriculum Journal, 11*(1), 9–23.

Bakhtin, M. (1981). *The dialogic imagination: Four essays*. Austin: University of Texas Press.

Bekerman, Z., Burbules, N. C., & Silberman-Keller, D. (Eds.). (2006). *Learning in places: The informal educational reader*. New York: Peter Lang.

Bereiter, C. (2002). *Education and mind in the knowledge age*. Mahwah, NJ: Lawrence Erlbaum.

Bernstein, B. (1974). *Class, codes and control. Vol 1. Theoretical studies towards a sociology of language*. London: Routledge & Kegan Paul.

Biesta, G. (2004). Against learning: Reclaiming a language of learning for education in an age of learning. *Nordisk Pedagogikk*, 24 (1), 70–82.

Biesta, G. (2006). *Beyond learning*. Boulder, CO: Paradigm.

Blizzard.com (2007). http://www.blizzard.com/press/070307.shtml (last visited 27.08.07).

Bransford, J. D., Brown, A. L., & Cocking, R. (2000). *How people learn. Brain, mind, experience and school*. National Research Council. Washington, D.C.: National Academic Press.

Buckingham, D. (1999). Young people, politics and news media: Beyond political socialisation. *Oxford Review of Education, 25*(1 & 2), 171–184.

Buckingham, D., & Harvey I. (2001). Imaging the audience: Language, creativity and communication in youth media production. *Journal of Educational Media, 26*(3), 173–184.

Castor, T., & Cooren, F. (2006). Organizations as hybrid forms of life: The implications of the selection of agency in problem formulation. *Management Communication Quarterly*, 19, 570–600.

Cooren, F. (2004). Textual agency: How texts do things in organizational settings. *Organization*, 11, 373–393.

Cope, B., & Kalantzis, M. (2000). *Multiliteracies: Literacy learning and the design of social futures*. London: Routledge.

Cuban, L. (2001). *Oversold and underused: Computers in the classroom*. Cambridge, MA: Harvard University Press.

Dewey, J. (1959). The school and society. In M. S. Dworkin (Ed.), *Dewey on education: Selections* 33–90. New York: Bureau of Publications, Teachers College, Columbia University.

———. (1916/1997). *Democracy and education*. New York: The Free Press.

Dysthe, O. (1995). *Det flerstemmige klasserommet.* [The multivoiced classroom.] Oslo: Ad Notam Gyldendal.

Erstad, O. (2005). Digital kompetanse i skolen [Digital competance in schools.] Oslo: University Press.

Erstad, O., Kløvstad, V., Kristiansen, T., & Søby, M. (2005). *ITU monitor 2005.* Oslo: University Press.

Erstad, O., Gilje, O., & de Lange, T. (2007). Re-mixing multimodal resources: multiliteracies and digital production in Norwegian media education. *Learning, Media and Technology, 32* (2), 183–198.

Gee, J. P. (2003). *What video games have to teach us about learning and literacy.* New York: Palgrave Macmillan.

Hardy, C. (2004). Scaling up and bearing down in discourse analysis: Questions regarding textual agencies and their context. *Organization*, 11, 415–425.

Hull, G. A., & Schultz, K. (2002). School's out! Bridging out-of-school literacies with classroom practice. New York: Teachers College Press, Columbia University.

Hull, G. A., & Katz, M-L. (2006). Crafting an agentive self: Case studies on digital storytelling. *Research in the Teaching of English, 41* (1), 43–81.

Hull, G. A., & Greeno, J. G. (2006). Identity and agency in nonschool and school worlds. In Z. Bekerman, N. C. Burbules, & D. Silberman-Keller (Eds.), *Learning in places: The informal educational reader (pp. 77–97).* New York: Peter Lang.

Jenkins, J. (2006): *Convergence culture: where old and new media collide.* New York: New York University Press.

Jonassen, D. H., & Land, S. M. (Eds.). (2000). *Theoretical foundations of learning environments.* Mahwah, NJ: Lawrence Erlbaum Associates.

Knorr-Cetina, K. (1999). *Epistemic cultures: how the sciences make knowledge.* Cambridge, MA: Harvard University Press.

Kozma, R. B. (Ed.). (2003). *Technology, innovation and educational change. A global perspective.* Eugene, OR: International Society for Technology in Education (ISTE).

Kress, G. (2003). *Literacy in the new media age.* London: Routledge.

Lambert, J. (2006). *Digital storytelling: Capturing lives, creating community* (2nd ed.). Berkeley, CA: Digital Diner Press.

Lankshear, C., & Knobel, M. (2006). *New literacies: Everyday practices & classroom learning.* Berkshire: Open University Press.

Lawy R., & Biesta, G. (2006). Citizenship-as-practice: The educational implications of an inclusive and relational understanding of citizenship. *British Journal of Educational Studies, 54*(1), 34–50.

Poster, M. (2001). *The information subject: Essays.* Amsterdam: G+B Arts International.

Rheingold, H. (2002). *Smart mobs: The next social revolution.* Cambridge, MA: Basic Books.

Sandholtz, H., Ringstaff, C., & Dwyer, D. C. (1997). *Teaching with technology: Creating student-centered classrooms.* New York: Teachers College Press.

Scardamalia, M. (2002). Collective cognitive responsibility for the advancement of knowledge. Retrieved 27 August 07 from http://ikit.org/fulltext/2002CollectiveCog.pdf

Scardamalia, M., & Bereiter, C. (2006). Knowledge building: Theory, pedagogy, and technology. In R. K. Sawyer (Ed.). *The Cambridge handbook of the learning sciences* (pp. 97–115). Cambridge, MA: Cambridge University Press.

Schugurensky, D. (2006). 'This is our school of citizenship': Informal learning in local democracy. In Z. Bekerman, N. C. Burbules, & D. Silberman-Keller (Eds.), *Learning in places: The*

informal educational reader (pp. 163–182). New York : Peter Lang.

Selwyn, N. (2002). *Literature review in citizenship, technology and learning*. Report 3. Retrieved 27 August 2007 from http://www.futurelab.org.uk/resources/documents/lit_reviews/Citizenship_Review.pdf

Smith, M. (2006). Beyond the curriculum: Fostering associational life in schools. In Z. Bekerman, N. C. Burbules, & D. Silberman-Keller (Eds.), *Learning in places: The informal educational reader* (pp. 9–33). New York : Peter Lang.

Tyner, K. (1998). *Literacy in a digital world. Teaching and learning in the age of information*. Mahwah, NJ: Lawrence Erlbaum Associates.

Wertsch, J. V. (1991). *Voices of the mind: A sociocultural approach to mediated action*. Cambridge, MA: Harvard University Press.

Wertsch, J., Tulviste, P., & Hagstrom, F. (1993). A sociocultural approach to agency. In E. A. Forman, N. Minick, & C. A. Stone (Eds.), *Contexts for learning. Sociocultural dynamics in children's development* (pp. 336–356). New York: Oxford University Press.

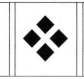

Fairytale parenting

Contextual factors influencing children's online self-representation

ELISABETH STAKSRUD

Introduction

Children's digital self-representation exists in a context. This chapter seeks to explore different factors influencing where and how Norwegian children between nine and sixteen years use the Internet for self-representation. A special interest is taken in the different parental strategies used to regulate children's online activities, and whether or not these strategies influence the children's actual use of those Internet services that can be used for self-representation.

Research on children and the Internet is growing considerably. By January 2007, the EU Kids Online project identified 235 separate research studies on children's use of online technologies in Europe[1] (Staksrud, Livingstone & Haddon, 2007). Analysis of the identified surveys showed that, while online usage, access, interest and activities were the most researched topics, there is less research on parental mediation and children's response to this. In addition, research on online social networking appears concentrated in mainly Scandinavia and the United Kingdom. Most studies are single-country studies, but the earliest multiple country-study in the field of children and the Internet

is SAFT (Safety Awareness Facts and Tools),[2] providing a basis for several other surveys of which the Eurobarometer is one of the largest (Staksrud et al., 2007). Lobe, Livingstone and Haddon (2007) argue that the SAFT surveys can be seen as an example of a *nation as context of study,* one of the four distinct approaches to cross-national comparison within social science (Kohn, 1989). The cross-European 2003 and 2006 SAFT children surveys reveal that informal structures, especially self-exploration and amongst peers, play a vital role for children's development of Internet competences. It is within this context they explore their self-representational skills.

This chapter seeks, using the SAFT survey results, to explore contextual factors influencing Norwegian children's digital self-representation. While operating on their own, what is the framework for their activities? What regulates their real-world behaviour when their self-representation is grounded in their own desire to communicate? Do they have sufficient access to digital tools and Internet services? Within what context do they have this access? Are they willing to reveal personal information about themselves to others? Who is the perceived authority of their activities—who influences their choices and usage? And finally, in what way and by whom is their usage limited, structured and controlled? The basis for the analysis is one of the largest surveys on children and youths' digital activities to date.

This chapter is based on statistics from Norway specifically and the northern part of Europe generally. For readers unfamiliar with these territories, a small roadmap of the demographics and *mode of being* is necessary.

Norwegian children are among the earliest adopters of computer and communications technology in the western hemisphere. While not as cutting-edge as in some Asian countries, children and youths in Norway and the rest of Scandinavia, on a general level, very quickly see the possibilities in new technologies and start using them as they become available. The reason for this is partly financial: Norway continuously ranks as one of the world's most financially stable and prosperous countries, for example, ranking number one in the UN's Human Development Report from 2001 to 2006 and number two in 2007 (*Human Development Report 2007/2008*, 2007), meaning that the base-cost of new technology is a not a deal-breaker in the purchase of it. Early adaptations of technology can also be explained by social factors. A key idea in the parent-child part of the construction of the Norwegian society is the recognition of the child as a separate, singular and autonomous entity, socially and legally. Any form of corporal punishment is illegal and has been since 1972 (Grande, Dørum, Ludvigsen & Skjelstad, 2007–2008). In addition, Norwegian children have their own ombudsman, whose sole purpose is to oversee the society's treatment of children. The UN's Children's Rights Charter, including its stipulation of the right to receive information, is enforced heavily. Children

are informed of their rights almost on a daily basis, in schools and, through public access television, in regular children's programming. Within this context, it is quite clear that parents in general do not see it as their role to deny *access* to communications technology, although they obviously enforce other types of control and/or regulatory schemes. As for the society as a whole, the right to high-speed Internet access is recognised as something close to a basic right and something that is to be prioritised as an area to be pushed by the government, making it an 'ambition that everyone shall have access to broadband [Internet]', budgeting up to NOK 30m (USD 6.7m) on the finalisation of the broadband project (Regjeringa Stoltenberg II, 2007). Many public services are, as of 2007, in practice only available on the Internet.

Digital competence is also prioritised. From the beginning of the school year in 2006, the Norwegian student, from primary level to high school, has been taught according to the Norwegian national learning reform *Kunnskapsløftet.*[3] This substantial reform defines the ability to use digital tools as one of the five basic skills needed to become an educated citizen, along with the ability to express oneself verbally, the ability to read, mathematical skills and the ability to write (Regjeringa Bondevik II, 2003–2004: 31). This means that the access to and use of digital tools are seen as something inherently positive, while still retaining some negative consequences. This is mirrored in official advice, and guidelines are given for the use of these tools, where personal integrity and responsibility is emphasised and technical control downplayed.

While fully adjusted to a global, commercial media reality, the Norwegian media landscape is rooted in the idea of public government service. Vertical integration of media companies is not allowed (Lov om eierskap i medier, 1997). The Media Authority oversees that both the ownership regulations and the media content standards are upheld. This should not be confused with some totalitarian states' censorship; on the contrary, the basis for this control is in the constitution (§100), which states that every citizen has the right to free expression. In addition, §1 of the Media Ownership Regulations Law states that 'The purpose of this law is to promote the freedom of speech, actual possibilities for expression and a wide range of media content'. The regulation of media ownership is there to ensure that different voices are heard. While by no means always effective, the very idea permeates the Norwegian society in its entirety.

The surveys

In order to map out Norwegian children's usage patterns online in general, their self-representational activities in particular, and the contextual factors

that influence this use, this chapter will analyse results from four representative surveys conducted among Norwegian children between the ages of nine and sixteen, and parents with children in that age group and with Internet connection in the household. The surveys were first conducted in 2003 and then replicated in 2006, and were part of the SAFT project. The SAFT project—Safety Awareness Facts and Tools—has, as part of its awareness-raising efforts, conducted two major, cross-European representative surveys on children's use of electronic communications media and their parents' perception of this. The first was done in 2003 and covered Norway, Sweden, Denmark, Iceland and Ireland, and it was followed up in 2006 with a comparable study in Norway (parents and children) and Ireland (children). All the surveys included offline electronic activities, but the main body of the data concerns online/Internet tools, services, behaviour and attitudes. Given the pervasive and omnipresent nature of the Internet within the target group, this is, though noted, not seen as a significant weakness of the surveys.

The two surveys of parents targeted those with children between the ages of 6–16 with an Internet connection in the household. For Norway in 2006 this constitutes 23 per cent of the total population. The size of the group of children within this parent group is approximately 500,000. The responses were collected via CATI telephone interviews for the 2006 survey: 802 interviews were conducted in the period from 28 November to 11 December, 2005. The results were weighted based on gender, age and geography. The population was collected from MMI Norwegian Media Index 2005.1. The target group for the two children's surveys, the main focus for this report, was between the ages of 9 and 16. Collection of the children's data was done by self-completion questionnaires filled out by the children themselves during class at school. In order to ensure that the questions were both understood and deemed appropriate for the target group, a pre-test was performed on pupils in two schools. In addition, national and international experts were consulted on the questions and their wordings. This chapter addresses the Norwegian findings.

During the 2003 data collection period (20 January to 14 February, 2003), 1004 interviews were filled out. During the 2006 data collection period (23 January to 8 February, 2006), 946 interviews were filled out in total, but because of missing gender and age information used for weighting the results, the reporting on the results is based on 888 interviews. No teacher or parent was present in the classroom, and the collection was supervised by a professional representative from the MMI Synovate team on behalf of the SAFT project. Schools were selected from all parts of the country and from both urban and rural areas. The results were weighted based on gender and age according to publicly available statistics.

Access and physical context

If given access to the Internet, some technical and/or production resources and competence, children can present themselves digitally and share their stories online. In order to investigate contextual factors that might influence these presentations, it is interesting to map out to what degree they have access to the Internet and where their activities take place. What is the physical setting, and how can this setting influence their use?

Norwegian children have one of the highest Internet penetration rates in the world. The analysis of the SAFT 2006 children survey results revealed that 94 per cent of all children from the age of nine have Internet access at home; 50 per cent claimed to have their own computer. Eleven per cent of the children said they access the Internet regularly from non-computer equipment like mobile phones, Xboxes or other electronic devices. The children surveyed pinpointed the home as the primary arena for Internet use; 70 per cent of the children reported to be using the Internet every/almost every day at home—a 33 per cent increase from 2003. The average introductory age for Norwegian children in 2006 is five years; hence most children will have started using the Internet before they start school (at age six in Norway). There is also a significantly higher number of children of parents with a university degree that have had an early introduction to the Internet (25 per cent vs 16 per cent by the age of 6 years), have their own computer with Internet access (53 per cent vs 45 per cent) and have access through equipment other than a computer/PC, such as an Xbox, mobile phone etc. (17 per cent vs 7 per cent).

According to the parents, three quarters of the sample either had ADSL or broadband. Home rather than school as the focal point for youngsters' Internet usage is a tendency that was identified in most European countries, with the exceptions of United Kingdom, Portugal and to a lesser extent Greece (*Special Eurobarometer 250 / Wave 64.4—TNS Opinion & Social*, 2006; Staksrud, 2006). Only 11 per cent of the children answered that they use the Internet every day/ almost every day at school, and 50 per cent of the children use the Internet in school less than twice a month. Usage outside of the home/school setting was rare. Thirty-six per cent of the children revealed a pattern of weekly usage of the Internet 'at a friend's house', but this can still be defined within the 'home' category in terms of context and attempted framing by parents. Other places mentioned for weekly usage among Norwegian children were rare: library (9 per cent) and Internet cafe (2 per cent) are the only two mentioned.[4]

Control and regulation of online activities

We have now established that for Norwegian children, their physical context in terms of Internet access exists primarily in the home. This is a setting where children are normally subjected to various degrees of control and/or attempts at regulation by a higher authority, in most cases their parents. In general, parents stated that they have a high level of supervision over their children when the children use electronic media. TV is the medium most parents supervise (90 per cent) followed by DVD/video (84 per cent) and the Internet (79 per cent). It is therefore interesting to understand what strategies and potential attempts to structure, control, limit, or regulate children's creative processes and output in terms of online self-representation the children are subjected to by their parents. The term 'parental supervision' is not self-evident and can include a wide range of possibilities and strategies. When analysing the strategies the parents in the SAFT 2003 and 2006 survey said they use to solve various dilemmas and challenges relating to their children's online use, four main regulatory strategies can be identified when it comes to structuring the children's online activities. These different strategies bear a strong resemblance to classic modes of parenting, popularly described in western fairytales, and are described below:[5]

1. 'Sleeping Beauty parenting'

Here the strategy is to remove the perceived dangerous item and just not talk about it or provide advice as the problem no longer exists. This parenting style is operationalised with denial of access or the use of strict content filtering tools. In the Norwegian cultural setting, the unwanted content was defined by all the parents selected, when asked what they would hypothetically like content filters to block, as being *pornography* (83 per cent), *violent or gory content* (71 per cent) and *child pornography* (42 per cent). In general, the use of filtering tools is not recommended as parental strategy by Norwegian authorities (Barne-og Familiedepartementet, 2001). Twenty-nine per cent of the parents said they use some sort of blocking software, filters or devices on their browser to limit access to certain sites by their child, an increase from 15 per cent in 2003. The effectiveness of this strategy was described as 'very effective' by 8 per cent of the parents and 'somewhat effective' by 51 per cent of the parents. However, it is uncertain how many of those who said that they use filtering tools had installed these themselves as a conscious parental strategy or were referring to the virus tools, family options or child pornography filter provided

as a standard by their service provider. Also gender plays a role in whether or not you have your own computer with Internet access. Of the total target group (9–16 years), 52 per cent of the boys had their own computer with Internet access, while only 37 per cent of the girls had the same tool. All in all, 'sleeping beauty parenting' is, at least in its extreme forms with denial of access, very rare. In general, parents believe that the benefits of the Internet are greater than the negative aspects, and 9 out of 10 parents strongly agreed or somewhat agreed with this statement. The older the children are, the more the parents agreed that the Internet has clear advantages. Clearly the largest benefit parents see for Internet use is that it can help the children with homework and finding useful information (49 per cent). However, it is important to note that the research results from the parent survey do not include parents who do not have Internet connection at home. In the children's survey 8 per cent said they do not have an Internet connection, while 3 per cent of the children said they have never used a PC/computer. According to the official numbers from Statistics Norway, 11 per cent of families with children (0–18 years) do not have domestic Internet access (Statistics Norway, 2007).

2. 'Rapunzel parenting'

Here the parents want to control and direct their children's interest and creativity, while monitoring their moves. Strong warnings against the outside world, and what are perceived as 'bad influences', are given, such as talking to 'strangers' or revealing personal information online, fear that they will 'run off' or, potentially, be abused by strangers 'riding by'. 'Rapunzel parents' are often fathers and self-proclaimed experts in Internet skills. Over half of the parents (56 per cent) stated that they check bookmarks/logs to see what the children have been visiting on the Internet; fathers check more than mothers (61 per cent vs 52 per cent). This checking increases as the child gets older. Parents who consider themselves beginners to some degree check less. Eleven per cent of the parents stated that they are familiar with the fact that their child has a website or blog, and in these cases, 84 per cent of the parents stated that they have logged on and looked at it themselves.

3. 'Little Red Riding Hood parenting'

Within this regime, parents try to establish rules on how to behave and who to communicate with, but the parents do not participate themselves, for example, by sitting with their child when they are online. If something bad happens,

parents rely on a more authoritative source for help and handling of the situation, preferably schools or the government. Parenting by rules is a common strategy in terms of media regulation in the Norwegian home. In 2006, only 12 per cent of the parents stated that they do not have any rules, a decrease from 25 per cent in 2003. Over half stated that they have rules for TV, computer DVD/video, games and/or mobile phones. Again, according to the parents, Internet usage is the most common area to have rules (70 per cent of the parents). Mapping out what type of rules exists, the main rule is how much time is spent (54 per cent), and the second most mentioned is 'not being allowed to visit certain sites' (25 per cent). Other rules included not giving out personal information/pictures (11 per cent), not visiting pornographic websites (10 per cent), and not occupying the phone lines at certain times of the day (7 per cent).[6] Five per cent had the rule 'not to talk to strangers in chat rooms'. Approximately 85 per cent of the children who use the Internet at home said they have one or more rules for its use. Girls claimed to have more rules than boys on average, and the younger children have more rules than the older ones. However, having rules does necessarily indicate effectiveness: approximately half of the children surveyed believed that they could use the Internet without their parents knowing about it, and 28 per cent said that they have used the Internet without permission. Sixty-four per cent of the children said that their parents never sit with them while they surf, and 56 per cent said that their parents never check in on them. In terms of seeking a 'higher authoritative source for help', 77 per cent of parents believed there should be 'someone' in charge of supervising content on the Internet: most of them believed this is a job for the government (41 per cent), followed by parents themselves (18 per cent) and Internet service providers (9 per cent).

4. 'Hansel and Gretel parenting'

This is a prevalent strategy amongst Norwegian parents: children are let loose without parental supervision in the digital forest and one can only hope they can cope and will help each other. If you are lucky they will come back wiser (and richer). Twelve per cent of Norwegian parents had set no rules, regardless of media, while 30 per cent had no rules or other regulatory strategies regarding use of the Internet. Turning to the children's survey, an analysis of brackets and polarity of the children by age shows that the 13–16 age group to a larger extent (63 per cent) than the 9–12 age group (31 per cent) claimed to have taught themselves Internet skills as opposed to being taught by parents or other adult authority figures such as teachers. The differences between the

age groups might be explained as a natural consequence of the rapid introduction of the Internet in Norwegian homes and society. When the older group of respondents were nine years old (between 1999 and 2002), schools had less Internet access and no digital learning 'curriculum'. The Internet penetration rate in Norwegian homes, especially in families with children, has been very high, and in 2003 (SAFT, 2003), 75 per cent of Norwegian children between 9 and 16 had an Internet connection at home. However, introducing the Internet in the home does not necessarily mean that their parents had self-competence or ability to teach children how to use it or other digital skills. In the 2003 SAFT parents' survey, 82 per cent of Norwegian parents defined themselves as a beginner or intermediate Internet user. In addition 64 per cent of the children in 2006 (63 per cent in 2003) said that their parents never sit with them while they are online. Forty per cent responded that they have never, or to only a small degree, talked with their parents about what they do online.

So far we have established that Norwegian children have access to the Internet, and that their activities are conducted and skills developed primarily in a home setting. We have also reviewed the different overall strategies that parents try to implement in order to regulate their children's usage of the Internet. Strategies to regulate children's use of the Internet are often a result of one's perceived knowledge of the child's use: what issues seem relevant relating to your child's age and the interest and the knowledge that you have about the child's actual use of online services. Strategies are then developed accordingly. One can therefore expect that parents, except for the 'Hansel and Gretel parents', will have a good knowledge of how their child uses the Internet, and that this use to a large degree coincides with the preferred types of usage as expressed by the parents. A comparison of what parents think their child is doing online with what the children say they do online can therefore serve as a test on how well the parental strategies work and say something further about the contextual factors influencing the children's usage.

Most parents believe they are either very or somewhat aware of what their children use the Internet for. Only 9 per cent admitted to not knowing much about it. Of the parents with small children (6–8 yrs), 84 per cent believe they are very aware. Playing games (53 per cent) and schoolwork (41 per cent) are the two activities at the top of the list when it comes to what parents believe the children spend time on while on the Internet. The games share has increased from 37 per cent in 2003. The combination of 'chatting' and IM (Instant Messaging), MSN (Microsoft Messenger) and 'blogging' also makes up a large share, with 44 per cent in total. Among boys' parents, games are among the most popular (66 per cent), while among girls' parents the results indicate

that schoolwork and chatting/IM top the list.

However, comparing the results between surveys of the children and the parents, it is clear that although there has been a development of parental awareness of children's actual use from the 2003 to the 2006 survey, the overall comparison shows that parents are generally little aware of the multitude and complexity of their children's online activities:

> Q19: (C) What kind of things do you do on the Internet? Prompted (Filter: Uses the Internet, 96 per cent)
>
> Q15: (P) As far as you know, what does your child use the Internet for? Unprompted (Filter: The child uses the Internet)

For instance, when the parents were asked about their children's online activity, only 23 per cent said that their children chat, compared to the 47 per cent of the children who claim that they do. Parental knowledge of face-to-face meetings as a result of online encounters was also low. Fourteen per cent of the total children population claimed to have met an online friend, while only 3 per cent of the parents had knowledge of such meetings taking place. One can assume that the information gap between parents and children also influences the regulatory regimes implemented in the home. Attempting to analyse the influence from the regulatory regimes, the results from the children's survey show that the rules about 'not talking to strangers' and 'not behaving badly/say bad things about others' have increased. Twenty-five per cent of the children said they have a home rule of 'not talking to strangers in a chat room', and 43 per cent had been told 'not to meet anyone in person that I first met online'. However, when comparing the results with the results from the equivalent question posed to the parents, 'What rules have you implemented for your child's use of the Internet', only 5 per cent had set the rule of 'not talk to strangers in a chat room', while none (!) of the parents had explicitly told their children not to meet online friends in real life.[7] Many children see the Internet and chat as generic communication, as opposed to 'a technology', hence naturally implement established parental rules from the 'offline' to the 'online' world, not making a distinct divide between the two communication spheres. The information gap also indicates that while children might possess strategies, knowledge and the perception of being subjected to rules and regulations regarding online communication, their online activities are likely to take place in an adult-free setting.

Authorities of Internet learning

The access patterns revealed in the SAFT surveys suggest that digital self-representation by Norwegian children happens within the context of home and/or school. In other words, Norwegian children have the access and opportunity to use digital tools and the Internet for self-representational purposes. However, having the technical means is not in itself sufficient to ensure output, and creative processes are influenced by how digital tools are used. At the same time it is clear that parents in general do not have knowledge of what their children actually do online. Therefore, in order to further explore the contextual factors influencing children's digital self-representation it is also relevant to review the underlying conditions and influences for the telling digital stories, by and through the Internet, to take place. Who and what has laid the foundation for children's understanding of the Internet? Who teaches the digital tools—and whether they are to be used formally or informally? Who has taught them the most about the Internet, and on what underlying premises do they base their online experience?

In order to measure the children's perception of the authorities of Internet learning, children were asked the question 'Where have you learned the most about the Internet?'[8] Of the total selection of children, 47 per cent of all children rated 'myself' and 47 per cent rated 'friends my own age' as most relevant for learning, defining the child and her peers as the self-assessed authority of teaching, through exploration and sharing. The authoritative child, self or peer, was followed by 'parents' (41 per cent) and 'older siblings' (23 per cent), making learning of ICT tools and use of the Internet as a process linked to close personal relations rather than more formalised education or societal structures. These personal learning processes primarily take place in the home, the principal arena for Internet use. Of the four most mentioned authorities of learning, the teacher—a traditional authority of learning—is absent. 'My teacher' rated at 16 per cent of the total population of the survey. As for the frequency of education, the 2006 survey revealed that only 1 in 10 said that they have had regular education in school regarding use of the Internet, a 4 per cent increase from 2003. Thirty per cent reported to have had education 'a few times', while 65 per cent had very little or no education at all, contributing to the explanation of why the teacher is not perceived as a central learning authority for Internet competences. Most children will seek some sort of adult input, preferably by parents when it is available. But the key source of learning will most likely be peers, in the form of on- or offline friends or siblings, in other words; 'peer-parenting' in an informal learning situation.

As described above, this form of parenting is especially prevalent among

the older brackets of children (13–16), under the 'Hansel and Gretel parenting' regime. However, exploring other socio-demographic factors[9] that might influence who the children have learned from, we find that this form of parenting is linked not only to age but also to gender: boys were more likely than girls to answer that they have mostly taught themselves (51 per cent vs 43 per cent for the girls). The gender patterns are linked with opportunity as a key factor: if you have a personal access, especially access combined with privacy, you are more likely to explore and learn on your own. However, lack of personal access and privacy does not ensure learning and influence by parents: Although girls were more likely than boys to have learned Internet skills from their parents (47 per cent vs 36 per cent for the boys), for many, solitary exploration has been substituted with learning from 'friends their own age' (52 per cent girls vs 42 per cent boys). Comparing parents' educational level reveals that children of parents without a university degree have had less parental influence than children whose parents do have a university degree. To a significant degree these children mentioned 'friends my own age' (48 per cent), 'older siblings' (27 per cent), and 'chat room/online friends' (11 per cent) as their authorities of Internet learning. Children seek help where it is available to them. If you do not have a personal computer or Internet access at home, you might use your school's computer, but the development of Internet skills will most likely come from your peers in the form of an online friend, not your teacher.

Norwegian children's self-representational activities

Most Norwegian children have access and the opportunity to use Internet services, and they have developed skills and user patterns to a large degree influenced by peers or by self-exploration. But, do they use the Internet for self-representation?

Digital storytelling and self-representation have originally been strictly defined as short personal stories told by still images and a narrative voice-over. In line with the technological and cultural development, the term has been widened to include user generated personal stories through social networking sites or personal websites or blogs. This means that the interaction between the storyteller and the story-reader can happen in real-time, via, for example, instant messaging, sms-chat, web-cams or online chat rooms, or asynchronous via, for example, e-mail, web-logs and social networking websites. The outwards representation can utilise some or all of the communicational channels

available, such as text, pictures, audio or video. Preferred networking websites, techniques, layout and style vary, but two concrete common denominators can be identified as vital for the digital storytelling regime, namely (1) you need to communicate with or to others and (2) you need to reveal some sort of personal information, real or fictional, in order for it to be self-representational.

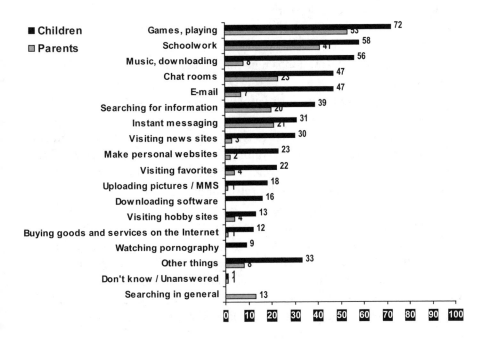

- ■ Children
- ☐ Parents

Activity	
Games, playing	53 / 72
Schoolwork	41 / 58
Music, downloading	8 / 56
Chat rooms	23 / 47
E-mail	7 / 47
Searching for information	20 / 39
Instant messaging	21 / 31
Visiting news sites	3 / 30
Make personal websites	2 / 23
Visiting favorites	4 / 22
Uploading pictures / MMS	1 / 18
Downloading software	16
Visiting hobby sites	4 / 13
Buying goods and services on the Internet	1 / 12
Watching pornography	9
Other things	8 / 33
Don't know / Unanswered	1
Searching in general	13

Figure 13.1, SAFT Children 2006 Q19 and Parents 2006 Q 15 in percentage.

The diversity of activities present in adolescent Internet usage described above illustrates how Internet usage has become an integral part of their everyday life, whether related to school, leisure activities or communication with peers. Looking at the actual usage pattern of the children (Figure 13.1), the main types of Internet usage that might be used for self-representation in terms of communicating with or to others and revealing information about themselves are: Playing games on the Internet[10] (72 per cent); chatting in chat rooms (47 per cent); making personal websites/blogging (23 per cent); and publishing pictures/MMS[11] (18 per cent). In addition, we can identify sending and receiving e-mails (47 per cent) and using Instant Messaging (IM) (31 per cent) as potentially being used for self-representational purposes. It should be

noted that the SAFT survey does not map out the details of each activity to such an extent that one can identify 'self-representation' in its strict sense. It is, however, quite clear which activities should be viewed as representational. What we can map, however, is willingness to share—at some level—some type of personal information, hence self-represent.

The target group for the survey, the nine to sixteen year olds, is accustomed to television shows like 'Big Brother' and numerous other reality and/or dating shows featuring 'ordinary' or non-celebrity people as an integrated part of the media picture. One might therefore expect that the willingness to self-disclose and reveal personal information is high and perceived as more 'natural' than for previous generations.

An interesting observation is that when comparing the 2003 survey to the 2006 one, there is generally a clear pattern of children moving towards a more restrictive behaviour with regards to sharing personal information online. At the same time the parents are becoming more liberal in allowing their children to submit personal information online in all categories. When it comes to children publishing pictures of themselves online, considered one of the most sensitive issues both regarding privacy issues in general and the grooming issue in particular, there is a 67 per cent increase from 2003 to 2006 in parents allowing their children to do this. Of those children who report using chat rooms, self-experimentation, for example, by pretending to have a different name, age, gender, or talents, is quite common. However, when comparing the results from the 2003 and 2006 surveys, we see a decrease in all the different 'pretending' categories, and a substantial increase in the number of children not wanting to pretend to be someone else online.

A willingness to publish personal information can on one hand be seen as an opportunity—a way to utilise the potential embedded in the new digital communication tools. Self-representation can be and is encouraged as a creative process. On the other hand, privacy, especially children's privacy and the publishing of personal information, is seen as one of the key risks of using new communication tools, especially the Internet. Numerous awareness campaigns, of which the SAFT project has been a vital part since 2002, have focused on the importance of not publishing personal information online, due to the risk of abuse by commercial companies, paedophiles and others. In addition, lack of knowledge about how published information can be used and interpreted in the future, and outside its original context, has led to advice from public authorities like the Norwegian Media Authority, the Norwegian Directorate for Education and Training, and the Data Inspectorate about being very restrictive. Public advice has been directed to the parents as well as the children. Yet there seems to be a shift towards a more restrictive attitude from the children

in terms of publishing personal information and a more liberal attitude from the parents. The difference might be explained by the different experiences encountered when online: children use different Internet services for communication and creative output and have sophisticated user patterns—an activity that may have also given them negative experiences as a result of publishing personal information. Parents, with their mail- and web-centric use, do not have the same hands-on experience with the wide range of online services available nor the knowledge of what children actually do online.

Conclusion

As described, the digital status in Norway is slightly atypical compared to most of the rest of the world. The official policy of the government is to provide broadband Internet access to the whole population, and digital competence is recognised as a central skill throughout the public schooling system. This makes the Norwegian situation an interesting looking-glass for studying the relationships between assumptions, facts, policies and realities.

The Norwegian economy has been remarkably stable for decades, in both the public and private sector. Norway was one of the very first countries outside the United States to become part of the Internet, and the personal computer has been a mainstay in private homes since the early 1980s. Today's parents have therefore been able to use the various Internet services for many years. Based on these experiences, the parents have chosen different strategies for parenting their children's digital behaviour. However, one of the most striking results of the surveys is that, regardless of the parental strategy chosen, having access to the Internet with parents that are users themselves has not led to parents being perceived as the prime authority of learning, especially among the older children. The digital divide is generally seen as a schism between the haves and the have-nots; the results from the SAFT study reveal that there also exists a generational divide. In an area with a high and demographically widespread technology penetration, the digital divide has shifted from access versus non-access to child versus parent, resulting in various forms of fairytale parenting.

Notes

1. The EU Kids online project addresses European empirical research and policy, prioritising the 18 countries represented in the project. Of the 235 research studies identified, surveys

from 12 other countries were also identified and included in the repository. For further and updated information on research identified see www.eukidsonline.net

2. SAFT—*Safety Awareness Facts and Tools*—is a project partially funded under the European Commission's Internet Action Plan and The Safer Internet Action Plan, aiming to increase awareness and empowerment on electronic media to children, teachers, parents and the general public. The project, originating in Norway, also has partners in Sweden, Denmark, Iceland and Ireland. For more information about the project and its partners see www.saftonline.org. The author was the initiator and coordinator of the SAFT project, and professionally responsible for the surveys conducted.

3. Knowledge Promotion ('Kunnskapsløftet') is the latest reform in primary and lower secondary education. It introduces certain changes in substance, structure and organisation from the first grade at basic school (primary and lower secondary school) to the final grade at upper secondary school—13 grades in all. The reform took effect in the autumn of 2006 for pupils in grades 1–9 at basic school and for pupils in the first year of upper secondary school (i.e., the 11th grade) (Norwegian Ministry of Education and Research. Kunnskapsløftet). http://odin.dep.no/kd/english/topics/knowledgepromotion/bn.html

4. The home also provides usage context for parents. Ninety-seven per cent of the parents in the sample use the Internet themselves. This means that when there is an Internet connection in the household, it is also very likely that the parents are users as well. Those who consider themselves beginners have ISDN to a higher degree, but even so, ADSL and broadband still have the greatest penetration even among beginners. Every day use among parents has increased considerably. In 2006, 72 per cent stated that they use the Internet every day, whereas it was 51 per cent in 2003.

5. Unless otherwise noted, all statistics refer to the 2006 surveys, thus reflecting the most recent results.

6. This rule pertains to those that do not have broadband or ADSL access to the Internet; one-fourth of the parents in the SAFT survey fall under this category. According to Statistics Norway, 2nd quarter 2007, 9 per cent of families with children access the Internet via a modem, and 8 per cent via an ISDN line. Thirty-one per cent use mobile phones with WAP or GPRS, alone or in combination with other access forms (Statistics Norway, 2007). This statistic includes families with children 0–18 years, while the corresponding SAFT figures include only those families with children between 9–16 years.

7. In order to measure conscious regulatory regimes in the home, the question 'What rules have you set regarding your child's usage of the Internet?' (Q22) was asked unprompted to the parents. In the study *UK Children Go Online* (Livingstone & Bober, 2004), similar questions as the SAFT survey were used. Findings from this survey suggest that UK parents had a substantially higher account of regulatory regimes and rules said to be implemented in the home. Sixty-two per cent of UK parents forbid their children to use chat rooms (and 40% of the children say this is the case). However, the question was prompted, pointing to methodological challenges when mapping out parental mediation regarding new media. The same pattern can also be found in the 2005 Eurobarometer survey (*Special Eurobarometer 250 / Wave 64.4—TNS Opinion & Social*, 2006).

8. In answering the question, 11 different options were given; My parents; My teachers; Friends my own age; Older siblings; Library; Magazines; Chat room/online friend; Websites; My self; Other places; Do not know. Multiple answers were possible.

9. Wanting to map out demographic and social factors that might influence or correlate to the findings, the children were asked questions on age, gender, country of birth of both

child and parent(s)/guardian(s), number of family members, if they had older or younger siblings, parents' education level, if their parents lived together, and if anyone was present in the house when they returned from school.
10. It is important to include electronic games in this. The reason is twofold: first because of their inherent representational qualities, in particular in multiplayer, online games, second because playing games is the number one online activity for most children.
11. This question was not asked in the 2003 survey.

References

Barne-og Familiedepartementet. (2001). *Tiltaksplan—Barn, unge og Internett*. Retrieved 11 February 2008 from http://www.regjeringen.no/upload/kilde/bfd/bro/2001/0014/ddd/pdfv/136845-internettvern.pdf

Grande, T. S., Dørum, O. E., Ludvigsen, G., & Skjelstad, A. N. (2007–2008). *Representantforslag nr. 31 (2007–2008), Dok.nr.8:31 (2007–2008)*. Retrieved 11 February 2008 from http://www.stortinget.no/dok8/2007/dok8-200708-031.html *Human Development Report 2007/2008*. (2007). New York: United Nations Development Programme.

Kohn, M. L. (1989). Introduction. In M. L. Kohn (Ed.), *Cross-national research in sociology*. Newbury Park, CA: Sage.

Livingstone, S., & Bober, M. (2004). *UK children go online: Surveying the experiences of young people and their parents*. London: The London School of Economics and Political Science.

Lobe, B., Livingstone, S., & Haddon, L. (2007). *Researching Children's Experiences Online across Countries: Issues and Problems in Methodology*. London: The London School of Economics and Political Science.

Lov om eierskap i medier, Lov 1997–0613–53 C.F.R. (1997).

Regjeringa Bondevik II. (2003–2004). *St. meld. nr. 30 Kultur for læring*. Retrieved 04 February 2008 from http://www.regjeringen.no/Rpub/STM/20032004/030/PDFS/STM-200320040030000DDDPDFS.pdf

Regjeringa Stoltenberg II. (2007). *Utgiftskapittel: 1–2, 1500–1582, 2445 og 2470*. Retrieved 2 January 2008 from http://www.regjeringen.no/nn/dep/fad/Dokument/Proposisjonar-og-meldingar/Stortingsproposisjonar/2007–2008/Stprp-nr-1–2007–2008-.html?id=483477

Special Eurobarometer 250 / Wave 64.4—TNS Opinion & Social. (2006). Luxembourg: TNS Opinion and Social.

Staksrud, E. (2006). *Eurobarometer 2006, Findings and comments*. Paper presented at the Safer Internet Forum. Retrieved 30 January 2007 from http://europa.eu.int/information_society/activities/sip/si_forum/forum_june_2006/agenda/index_en.htm

Staksrud, E., Livingstone, S., & Haddon, L. (2007). *What do we know about children's use of online technologies? A report on data availability and research gaps in Europe*. London: The London School of Economics and Political Science.

Statistics Norway. (2007). IKT i husholdningene Tabell 2 (pp. Andel med ulike typer Internett-abonnement, etter familietype, husholdningsinntekt, kjønn, alder, utdanning og arbeidssituasjon). Oslo: Statistisk sentralbyrå.

PART V

ON THE EDGE

FOURTEEN

Creative brainwork: Building metaphors of identity for social science research

DAVID GAUNTLETT

As a means of gathering information about people's lives, digital storytelling projects are obviously distinctive in that they invite participants to tell *stories* using words and *pictures*. Interviews or focus groups, by contrast, require people to generate spoken accounts in response to questions. Participants are unlikely to see each utterance as a fresh task in the art of storytelling and do not usually provide illustrated answers. Digital storytelling enables a different kind of account to emerge, through a process which is driven by visual elements and which—in its very name—highlights the task of *telling a story*. This is not co-incidental, of course. At the start of his *Digital Storytelling* book, Joe Lambert recalls how he was inspired as a child by folk singers who 'looked for ways to capture their own and others' sense of the extraordinary in the ordinary comings and goings of life' (2006, p. 2). This democratic and empowering impulse was built into the heart of digital storytelling—a conscious and deliberate process of composing song-sized celebrations of everyday lives.

This chapter is not about digital storytelling *per se*. My connection with the Mediatized Stories project is slightly tangential, as I do social research in which people are asked to make visual artefacts and then reflect upon them, telling

the 'story' associated with the thing that they have made—which is similar to, but different from, digital storytelling. Whilst digital storytelling projects typically value the sharing of stories for their own sake, my work is more connected with the growing fields of visual sociology and visual methodologies, using these techniques in order to gain a better understanding of people's lives—in other words, as tools of social research (Gauntlett & Holzwarth, 2006). Nevertheless, there are strong connections with the ideas which underpin digital storytelling: getting to the meaningful heart of people's social experiences by asking them to participate in a process of construction and reflection, which fosters creativity and gets the brain working in a different way.

This chapter will discuss this relatively new approach to exploring identities, in which researchers have asked people to *make* things—such as videos, drawings, collages, or other visual items—as part of a process of reflection upon identity. We will consider some of the advantages of this kind of research, before looking more closely at the results of my own recent study in which participants were asked to build metaphorical models of their identities using Lego, the colourful plastic construction toy.[1]

Why visual methods?

Visual methods are increasingly becoming recognised as valuable tools for social researchers, as they enable research participants to think about or communicate their experiences in a different way. Visual prompts and visual artefacts encourage people to reflect differently on social life and its organisation and provide researchers with something 'concrete' which they can probe and discuss in a dialogue with their subjects. Visual methods help in particular with complex and abstract concepts such as self-identity, which participants typically find difficult to discuss, unless it is reduced to more tangible subcategories such as 'key events' or 'likes and dislikes'.

Certain theoretical approaches can sometimes tend to make the process of thinking through self-identity seem more-or-less rational—as though developing and presenting an identity is the result of a deliberate set of actions, like putting together a photo album. Everyday experience, though, tells us that it's not like that, and researchers have certainly found that people don't have a simple 'identity printout' button which will somehow reveal their identity, on demand, as a simple linear explanation.

Because it is hard to interview people about their distinctive personal characteristics, some researchers have tried to devise processes for thinking about identities which employ more reflective and creative activities. Being asked to

make something requires participants to take a roundabout route into the research topic. The 'data' that comes from such studies usually includes not only the things that have been made but also observations and statements arising from the *process* of their production and the participants' own *reflections* on the things they have created.

In comparison to the standard qualitative research techniques—such as interviews and focus groups—I believe that this approach offers a number of advantages, whether the research question is about identities or any other aspect of attitudes or experiences. These benefits should become clearer during the course of the chapter but can be summarized as follows:

- Participants are given *time* to reflect on the research questions or issues and to thoughtfully create a response.
- Therefore participants are *not* required to produce instant descriptions of their views, opinions or responses, in language (which is not easy for everyone).
- The process operates on the visual plane, to a substantial degree—like many aspects of social experience.
- Creative visual tasks get the human brain working in a different way, and therefore may 'unlock' different kinds of responses.
- Participants are able to present something as a whole, rather than in the linear sequence which language forces us into.
- Participants using certain methods (such as digital storytelling, or the Lego technique outlined below) can use metaphors to express abstract thoughts and feelings in a concrete way.

Of course, one would not want to assert that these visual and creative methods will be 'better' than language-based methods, in all cases. Nevertheless, they are certainly a useful addition to the researcher's toolkit and have helped with our understanding of identities in particular, because identity is an abstract concept filled with abstract things (passions, experiences, memories, sensations, influences, repulsions and attractions) which may need to be mediated—given form—and expressed in ways that social scientists may not have traditionally accepted.

Video-making identities

Giving people the opportunity to make videos about their lives or identities can be a fruitful research process. With the rise of less expensive video cam-

eras, and popular video-sharing sites such as YouTube, video-making is not such an *unusual* activity these days, but still, *most* people don't actually spend time making videos about their lives. As I argued when I conducted a video-making project over 10 years ago (in which young people were asked to make videos about the environment), the task of making a video requires participants to make particular decisions about what to include, how to represent it, and what level of importance or priority to assign to different elements (Gauntlett, 1997). As mentioned above, the valuable data that a researcher gets from such a project is not just the finished set of videos but also the observations of the *process* through which they were made.

An interesting example is Ruth Holliday's project (1999, 2004) in which gay, lesbian or bisexual participants were given video cameras for up to three months and were asked to keep video diaries. The project aimed 'to examine the performative nature of queer identities' (2004, p. 49). Respondents were asked to consider different 'work, rest and play' aspects of their lives by dressing in the clothes which they would wear in different situations and to speak about their 'self-presentation strategies'. This brought the often-ignored visual dimension of social life into the heart of the study, and as Holliday notes, the video diaries 'capture visual performances of identities and the fascinating ways in which identities are mapped onto the surfaces of bodies, homes and workspaces' (p. 54).

The video diary approach was clearly an invitation for respondents to produce a *representation* of themselves, like in digital storytelling projects; they could 'stage', work on, re-record, or delete material before it was even seen by the researcher. Whilst some scholars might be concerned that this procedure would not produce sufficiently 'accurate' or 'authentic' results, Holliday argues that it is a positive feature, giving the participant 'greater "editorial control" over the material disclosed' (p. 51). Whilst 'staging' an identity for the camera might sound rather false, Holliday asserts that the video diary-making process is just an extension of the *reflections* of self which individuals necessarily already produce. Researchers obviously cannot actually 'capture' parts of a person's authentic self—whatever that would mean—so Holliday suggests that we should give participants visual tools and enable them to *share* instances of self-expression.

The process enabled Holliday to gain insights into 'the ways in which identities are performed in different times and spaces—which I call work, rest and play—and also how these performances become mediated by academic, political and "subcultural" discourses of sexuality' (1999, p. 475), and the idea of the body as a text which expresses identity. The performance of being out on

the 'scene' was contrasted with that of being at home, typically seen as a place of greater comfort and authenticity (although not necessarily better for being less playful).

Video-making methods have some limitations, of course. One is that they are a pretty obvious *intervention*, where participants are being asked to specifically *do something* for the sake of the research. In that sense they have a somewhat artificial connection with 'normal events'. However, this also applies to the contrived setting of, say, a focus group, and because video production takes time to do, the feelings reflected tend to become more 'authentic' as time passes.

A more serious problem for video and photography projects is that in order to make pictures, participants must necessarily point their camera at things. Therefore, things close at hand—which it is easiest to point the camera at—are most likely to be filmed, and the process is given a rather literal orientation: the visual material is perhaps more likely to be concerned with the physical world that we live in rather than with the subjective life of the mind. The *metaphorical* approach of the Lego study, discussed below, largely avoids this problem. (We should also note that the poetic, storytelling orientation of digital storytelling projects is also likely to encourage a more metaphorical use of imagery—unlike some other visual sociology projects which have given cameras to participants, where the intention is more bluntly about 'documenting' their lives.)

Building identities in Lego

There are a number of other interesting studies which have used visual methods to explore people's lives and experiences, which are discussed in a number of books (for example, Prosser, 1998; Knowles & Sweetman, 2004; Gauntlett, 2007). Here, though, we turn our attention to the Lego identity study, which I have mentioned a couple of times already.

This project grew out of a wish to explore identities in a new way, using visual methods. I had noticed that in the kinds of methods discussed above, participants are led to create images of *existing things*. Photography or video methods necessarily require people to produce pictures of things which the camera can be pointed at, as we noted above, whilst the use of drawings is often constrained by participants' concerns about their lack of 'ability'. Studies using collage could also be limited by the range of collage materials available. Therefore when I was contacted in 2004 by Per Kristiansen, who at that time was Director of Lego Serious Play, I saw an interesting opportunity.

Figure 14. 1: Participants building metaphorical models of their identities in the Lego identity study.

Lego Serious Play is a form of consultancy for businesses and organisations, used as a problem-solving and team-building tool, in which groups build *metaphorical* models of their experiences. It is run as a kind of franchise by the Lego company, which trains facilitators (typically people from business consultancy companies) in the Lego Serious Play processes, licenses them to be official Lego Serious Play practitioners, and supplies them with Lego bricks and pieces. The different applications of Lego Serious Play have been carefully worked out with expert psychologists and business innovators. (Their website is at www.seriousplay.com.)

Because I was already doing studies in which people were asked to *make* things as part of the process of thinking through an issue, Lego invited me to collaborate with them, and I developed a project which employed some of the Lego Serious Play techniques as a social research method for exploring identities. Because the process uses metaphors, participants can declare that any Lego shape, animal or construction represents whatever they like, and therefore this approach avoids the problem of having to point a camera at things,

be good at drawing, or have access to particular collage images. (For full details and a much more comprehensive discussion, see Gauntlett, 2007.)

In my study, ten groups of individuals took part in workshop sessions, each of which lasted for at least four hours. Groups were typically of seven or eight people; 79 people took part in total. Obviously, if a researcher was to begin a session by saying to participants, 'I want you to build a metaphorical model of your identity in Lego', this would probably be rather baffling and would lead to some limited or confused responses. This is why the sessions were necessarily lengthy, as the participants were taken through exercises in which they became familiar with Lego building, then got used to metaphors and building them in Lego, and then, eventually, built metaphorical models of their own identity, and influences upon that identity. Participants were from diverse backgrounds: three groups were unemployed or low-paid part-time workers; other groups included social workers, architects and charity managers. (Because it would be difficult to persuade most people to participate in such a time-consuming session, most participants were paid or rewarded for their time, showing recognition and respect for the time that they had given up to take part.)

The use of metaphors meant that participants were able to build a representation of their identity and its elements—aspirations, influences, and desires—which otherwise would be difficult to picture. Metaphors are also powerful because they suggest additional fruitful meanings—which is why we employ them so often in everyday speech (often without really thinking about it). Instead of saying, for example, 'I was really pleased', which is straightforward but bland, I might say 'I was over the moon', which conveys the idea that I was delighted whilst adding additional imagery: a kind of vertiginous leap for the stars, the unusualness of space travel, and the pleasing feeling of being 'up, up and away'. All metaphors offer images which communicate ideas more powerfully than their more literal, non-metaphorical counterparts. (To remind you of a few common examples: 'She devoured the book'; 'There was electricity between them'; 'He is a snake'; 'She lives in an ivory tower'.)

To give an impression of the kinds of things built by participants, here are just a few examples of metaphors from the many hundreds which went into the 79 participants' models. Some were quite straightforward:

- A dinner table, representing family.
- A dish with bright shiny coins, representing friendship.
- A sequence of hurdles presided over by a 'witch figure', representing work.
- A man paddling along in a kayak, representing meditation.
- A bird on the ground, representing responsibilities ('because I feel like

a bird that wants to fly away, but can't').

Others were more complex:

- People under a transparent plastic container, representing people from past, who continue to have an influence but who cannot be accessed directly.
- Nine bodies with tubes going up into one big head, representing different sides of the personality.
- A tiger underneath the main representation of personality, representing an underlying pride and defensiveness.
- A see-saw with a crowned king figure opposite an 'evil' person, representing yin and yang, and the choices to be made in life between good and bad behaviours.
- A wobbly ambulance with only three wheels, representing health problems.

In addition to the individual metaphors that made up each model, we were also able to consider the metaphorical meaning of *the whole model*. Just as a poem may contain a number of different metaphorical phrases but also have an overall metaphorical meaning, the Lego identity models could be viewed both as a set of individual meaningful parts and also seen as a whole representation. Indeed, participants were typically struck by the way in which the thing they had made represented their identity *as a whole* even though, whilst building it, they had been focusing on it as a set of parts or areas. For example, one person's whole model might appear rather spacious and empty, suggesting loneliness, lack of fulfilment, or perhaps serenity; conversely, a model with many elements crammed into a limited space might suggest a sense of chaos, or a feeling of being 'swamped'.

In order to interpret the Lego identity model, its meanings and its metaphors, the project relied on the *participant's own* interpretations. This principle emerged partly from the history of the practice of art therapy: in the early to mid-twentieth century, it was believed that the professional 'expert' should interpret the client's work, in some cases drawing on a standardised manual that would list likely interpretations of particular bits of imagery. More recently this approach has generally been replaced by the view that the interpretation should come from the client themselves, in a dialogue with the art therapist. (For more details see Gauntlett, 2005, pp. 162–163.) As art therapist Cathy Malchiodi writes (1998, p. 36),

In my own work with children's drawings from a phenomenological approach, the first step involves taking a stance of 'not knowing'. This is similar to the philosophy described by social constructivist theorists who see the therapist's role in work with people as one of co-creator, rather than expert advisor. By seeing the client as the expert on his or her own experiences, an openness to new information and discoveries naturally evolves for the therapist. Although art expressions may share some commonalities in form, content, and style, taking a stance of not knowing allows the child's experiences of creating and making art expressions to be respected as individual and to have a variety of meanings.

In terms of social research, it similarly seems appropriate to value the knowledge and experience of participants and to build explanations which begin with their own interpretations. I do not believe that there is a justifiable rationale for why the researchers should impose their own 'expert' interpretation, replacing that of the person whose identity is represented.

Of course, the act of explanation or interpretation brings the material back into the world of *language*. The study doesn't, therefore, remain 'purely visual'— whatever that would mean. This is not surprising: talking or writing about things in order to deal with them, especially in an academic study, is almost inevitable. But what is important in these studies is the *visual* and *creative* process, which takes *time*, and which involves thinking and making with the *hands*, all of which importantly *precedes* the part where the meanings are considered in language.

Findings from the Lego identity study

The study led to a set of 11 findings: three on methodology, four on social experience and identities, and four on media audience studies. (These are summarised from Gauntlett, 2007, pp. 182–195.)

Three findings about method

Finding 1: Creative and visual research methods give people the opportunity to communicate different kinds of information
> Whilst language leads people to give linear accounts (one thing after another thing, with ones mentioned earlier seeming to be more important than ones mentioned later), visual methods enable people to present information as a *whole*, as a landscape of interrelated parts. A creative task gives people *time* to think through and develop a meaningful response, and the process of making with the hands prompts the

brain to respond differently and fully to the challenge.

Finding 2: Metaphors can be powerful in social research
As already mentioned, metaphors enable people to communicate about intangible concepts, experiences and feelings, and to encapsulate them in a meaningful image, which may suggest additional meaningful ideas. Building a whole metaphorical thing (such as a Lego identity model) means that both the *parts* and the *whole* can be seen as meaningful.

Finding 3: Research participants need reflective time to construct knowledge
Giving people *time* to make something and generate a response to the research question, as mentioned in Finding 1, allows people to assemble meaningful responses (rather than instant 'gut reactions') and can enable ideas to 'bubble up' from the subconscious and find expression within the creative activity.

Four findings about understanding social experience and identities

Finding 4: Recognition of 'identity'
The notion of 'identity' is taken for granted, as a meaningful term, by researchers in this area, but it seems possible that a sample of 'ordinary people' would actually find this confusing and not know what they were being asked to represent. But, no: the notion that 'I' have 'an identity', which could be represented in some way (such as in Lego), was already accepted by all participants. Indeed, the task of representing identity through visual items (which could often be seen, in some way, as metaphors) is often familiar to people who have put up posters and photos on their bedroom walls, or decorated their fridge with postcards, stickers, magnets and mementoes.

Finding 5: Identity theories are common currency
Social theorists may like to think of their models of self and identity as specialist, privileged information, but the Lego study showed that certain notions about self-identity in everyday life are already known and understood, at some level, by most people already. Of course this takes the form of working knowledge, rather than academic discourse. For instance, the essence of Erving Goffman's classic sociological argument (1959) that people have to routinely generate a kind of social performance for different audiences, in order to appear competent and coherent in everyday life, was taken for granted by most participants.

It was assumed to be unsurprising that their identity models would include, for example, 'back stage' areas where the more private aspects of identity were to be found and a more 'public face' which looked out to and interacted with the external world. Similarly, Anthony Giddens's (1991, 1992) argument that individuals in contemporary western societies have to construct and maintain a personal biographical narrative of the self, in order to enjoy a coherent and stable existence, was recognised by the Lego study participants, who all took to the task of putting together their identity 'story' in a particular way, whilst acknowledging that there could be other ways of telling it.

Finding 6: Identities are typically unified, not fragmented
Although postmodernists have propagated the idea that modern identities are 'fragmented', the Lego study found no evidence of this. On the contrary, every one of the participants built their identity as *one thing*—even though it would have been perfectly possible to present identity as a shower of separate pieces or as a set of different fragments arranged together. The identity models were often *complex*, but nevertheless the participants in this study consistently presented themselves as distinctive individuals, but *whole* identities, making their way on the journey of life. This may be a 'discourse' they have bought into, or a popular metaphor for experience which they have applied to themselves, but nevertheless we saw none of the painful 'fragmentation' or 'schizophrenia' which is supposed to be eating at (post)modern subjects—and which they are meant to be conscious of—in works such as Baudrillard (1988, 1994), or Jameson (1991). There certainly was some uncertainty, but this was actively fought against by what we might call 'the will to coherence'—the desire to have solid stories about the self.

Finding 7: Relationship between the individual and society
Almost everyone likes to think that they are somewhat different to the general mass, and yet almost nobody wants to think that they have nothing in common with anyone else. This was the most common theme found across all of the identity models in the study: a tension between the desire to be a distinctive individual and the need to be part of a broader social community. This reflects the 'double relationship' identified by the early German sociologist Georg Simmel (1893), which acts as a driving force in both individual and social development: 'On the one hand the individual belongs to a whole and is a part of it, while on the other hand s/he is independent and stands opposed

to it' (translated in Scaff, 2000, p. 255). See Simmel (1971, 2004) and Frisby (2002).

Four findings about media audience studies

Finding 8: Media studies is often too much about the media
All forms of media, from mainstream TV shows and movies to niche websites and fanzines, find their meaning within a social context, as people consume, discuss and interact with them, and embed them in their lives. Media studies, however, has a tendency to discuss 'the media' as an independently fascinating set of texts and technologies. We have to deal with the media as it occurs in the world, and in terms of the ways in which it finds a place in people's lifeworlds and identities. Therefore we cannot presume to know the meanings of media texts unless we have studied what people do with them in the real world.

Finding 9: Audiences are people, and people are complex
Participants built a wide range of aspects of identity (even with my best efforts to group similar items together, there were 128 different themes represented), and influences upon their identity (again, even when grouped together, there were 100 different kinds of influences). Media audience studies tend to acknowledge at the beginning that they are dealing with a complex subject-matter—that audiences are varied and cross-pollinated and diverse—but then proceed anyway, as if talking about 'audiences' is fine as long as you mention this first. In fact, of course, it is the case that audiences are not only a diverse set of individuals, but that each individual is complex, internally diverse and often somewhat contradictory in their attitudes, tastes and pleasures. Researchers need to accept this and incorporate a recognition of it into their studies, rather than trying to ignore it.

Finding 10: People generally do not think the media influences their identity much
This study asked participants to consider influences upon their identity but did not *ask* them to consider media influences in particular. Research projects which prompt people to talk about 'media influences' are usually able to elicit views on that topic, but, interestingly, when participants were given the chance to consider all influences in general, aspects of the media appeared very little. Of course, individuals are not necessarily aware of everything that influences them, and we like to think of ourselves as independent thinkers, so there is a kind of taboo

against claiming to be heavily influenced by the media, of all things. It seems highly likely that the media must influence, *in some way*, how we see relationships, the purpose of life and how to spend one's time on the earth. We consume so many stories about these things that it doesn't seem far-fetched to suggest that they must have some impact on our consciousness. But this finding is that, in general, when asked to consider influences upon their identities, the participants in this study did not usually think of media products or technologies.

Finding 11: A role for media in thinking about identity

Does this mean, then, that the media has nothing to do with the formation of identities? No, the Lego study did point strongly towards a way in which the media *do* influence our thinking about self-identity: by providing stories and narrative frames through which we understand our lives. Philosopher Paul Ricoeur argued that all the narratives in the world—of which thousands are circulated every day in the media—offer 'a vast laboratory for thought experiments' (1992, p. 148). We inevitably think through the implications of these stories and connect these with our own lives. We also draw upon particular frames and metaphors from these stories to help us understand our experiences. In *Creative Explorations* I argue that since participants themselves recognised that they were assembling identity in the style of a narrative (Finding 5) and sought unifying themes (Finding 6), their identity-storytelling is bound to have been influenced in some ways by the media stories which are so prevalent in their social and cultural worlds and which are the mainstream place (along with published novels and biographies) where 'the story of a life' is commonly presented.

Those were the eleven findings of the Lego study, derived from an analysis of the Lego models, the process of making them, and what their creators said when explaining and reflecting about them. A different way of looking at what participants did in this study comes from looking at how they told their stories.

Seven ways of telling identity stories

If we look for what we might call the 'primary story emphasis' in each of the 79 identity models, we find three general types of narrative, which can be further

divided into a total of seven different kinds of central story about identity. One-third of the models showed the individual's identity primarily as a *traveller* (33 per cent), whilst just over half showed it as an *object* (54 per cent)—which does not necessarily mean the identity was seen as fixed or unchanging, merely that the snapshot of 'my identity now' did not primarily emphasise movement. However, the theme of the journey was still often found somewhere in these models. Between these two was a further type—*object seeking travel* (13 per cent)—as they built a home-rooted identity (like the object) which was still seeking dreams (like the traveller).

The notion of life as a journey does not appear out of the blue, of course. George Lakoff and Mark Johnson, in *Metaphors We Live By* (1980, new edition 2003), identified certain basic conceptual metaphors which underpin a wide range of metaphorical phrases or ideas, which we use every day. The basic conceptual metaphor 'life is a journey' is one of the most popular, being at the root of expressions such as 'We're at a crossroads', 'He took the higher path', 'I don't want to get in your way', 'I don't know where I'm going', 'She's really going places', and many more. It is one of the primary models that human beings use to order and organise experience, as can be seen in numerous songs, stories, and the phrases used in everyday life (see also Lakoff & Turner, 1989).

Having employed a process which reveals complex reflections on identity, I did not want to crudely simplify the participants into certain 'personality types'. This part of the analysis is only meant to show the primary (inevitably simplified) ways in which the identity stories were told. The types which were identified are as follows:

Traveller models (33 per cent):

1. *Dream-seeker* (16 per cent): These models emphasised movement towards goals and dreams (although the route might be uncertain). The models included metaphorical items such as a winged horse, a drifting boat, chasing rainbows and towers reaching towards aspirations.
2. *Traveller* (11 per cent): These models represented travelling through life—not necessarily geographical travel, although that was also popular amongst this group. These journeys were not so much about chasing dreams but rather just the desire to move on and to experience new things. The models included metaphors such as the whole identity being built on a tractor or a boat moving contentedly forward, a journey towards God, and, in one case, handles on the base (to pick up the whole model and put it down somewhere else).
3. *Lonely traveller* (5 per cent): These models were typically spacious, and

other people were not central to their story. The story about the model emphasised an independent and isolated journey. Metaphors included skeletons queuing up to enter the world with 'misplaced optimism', an empty ocean, and the individual as a rare plant in a dry and barren land.

Object models (54 per cent):

4. *Unified independent* (28 per cent): These models were often based around a solid structure or web of connections and represented a unified and independent sense of self, which would be self-contained (rather than being associated with home or family), although relationships with others were often an important aspect of the model. Some of the unified independent models showed not only the unified self, but also the now-completed journey which brought the individual to that point.

5. *Home-rooted* (24 per cent): In these models the story was primarily about the home and family and was also often based around a solid structure or web of connections. The home itself, or family members, were typically represented at or near the heart of the model and were the hub of identity for these individuals.

6. *Chaotic independent* (3 per cent): In these cases (just two models), the emphasis was on chaos. Some sense of order was still visible though the parts would be diverse, but interconnected, and so the models were not completely 'random'. Ironically perhaps, the makers of 'chaotic' models also commented that the Lego-building process helped them to see their situation with more clarity.

Object seeking travel models (13 per cent):

7. *Home-rooted dream-seeker* (13 per cent): These models combined the 'home-rooted' and 'dream-seeker' themes, being based in the home but also looking towards dreams and the future. The metaphorical representations would therefore typically include aspects of home and family but also towers, radars, or a staircase reaching towards aspirations, or an imagined (happy) future for the family.

As noted above, these are rather crude simplifications, based on reducing each model to 'one central story', when in fact each model tended to have a number

of parallel, interconnected stories. However, they highlight the importance of unity, sociability, and a journey in how individuals think about identities.

Conclusion

Participants in exploratory, creative visual projects—whether digital storytelling, video-making, or the Lego study discussed here—frequently report that the experience has been one of discovery and revelation, enabling them to communicate aspects of themselves to others, but also—more importantly—finding out or making explicit aspects of their self-identity for *themselves*. The process of reflective creation, using the hands and taking time, enables the brain to work differently and produce new understandings. Participants in the Lego study often commented that their identity model revealed aspects of their character which would not usually be seen by others, and which in each case was a unique mapping out of identity elements within an overall journey or story. The building process involved a sense of discovery and revelation, in several cases, which can be linked with Paul Ricoeur's argument that the reflective process of configuring an identity narrative would lead to new understandings, as participants marked out their position in relation to personal ethics, aspirations and entanglements with others. These creative methods, *making* things to tell a story about the self, are not simply a novel or alternative way of finding out information, then, but offer an unusual opportunity to explore the ways in which people live and think about their lives.

Note

1. These approaches and ideas in general, and the Lego identity study in particular, are discussed in much more depth and detail in the book *Creative Explorations* (Gauntlett, 2007), and more briefly—but with some gender analysis—in *Media, Gender and Identity*, Second Edition (Gauntlett, 2008). The chapter you see here partly, but inevitably, restates some pieces of that material.

References

Baudrillard, J. (1988). *America*. London: Verso.
———. (1994). *Simulacra and simulation*. Ann Arbor: University of Michigan Press.
Frisby, D. (2002). *Georg Simmel: Revised edition*. London: Routledge.
Gauntlett, D. (1997). *Video critical: Children, the environment and media power*. London: John

Libbey. (Online version available at www.artlab.org.uk/videocritical).

———. (2005). *Moving experiences: Media effects and beyond* (2nd ed.). London: John Libbey.

———. (2007). *Creative explorations: New approaches to identities and audiences.* London: Routledge.

———. (2008). *Media, gender and identity: An introduction* (2nd ed.). London: Routledge.

———., & Holzwarth, P. (2006). Creative and visual methods for exploring identities. *Visual Studies, 21*(1), 82–91.

Giddens, A. (1991). *Modernity and self-identity: Self and society in the late Modern Age.* Cambridge: Polity.

———. (1992). *The transformation of intimacy.* Cambridge: Polity.

Goffman, E. (1959). *The presentation of self in everyday life.* London: Penguin.

Holliday, R. (1999). The comfort of identity. *Sexualities, 2*(4), 475–491.

———. (2004). Reflecting the self. In C. Knowles & P. Sweetman (Eds.), *Picturing the social landscape: Visual methods and the sociological imagination.* London: Routledge.

Jameson, F. (1991). *Postmodernism, or the cultural logic of late capitalism.* London: Verso.

Knowles, C., & Sweetman, P. (Eds.). (2004). *Picturing the social landscape: Visual methods and the sociological imagination.* London: Routledge.

Lakoff, G., & Johnson, M. (2003). *Metaphors we live by* (Rev. ed.). Chicago: University of Chicago Press.

Lakoff, G., & Turner, M. (1989). *More than cool reason: A field guide to poetic metaphor.* Chicago: University of Chicago Press.

Lambert, J. (2006). *Digital storytelling: Capturing lives, creating community.* Berkeley: Digital Diner. Second edition.

Malchiodi, C. (1998). *Understanding children's drawings.* London: Jessica Kingsley.

Prosser, J. (Ed.). (1998). *Image-based research: A sourcebook for qualitative researchers.* London: RoutledgeFalmer.

Ricoeur, P. (1992). *Oneself as another* (Kathleen Blamey, Trans.). Chicago: University of Chicago Press.

Scaff, L. A. (2000). Georg Simmel. In G. Ritzer (Ed.), *The Blackwell companion to major social theorists.* Oxford: Blackwell.

Simmel, G. (1971). *On individuality and social forms.* Chicago: University of Chicago Press.

———. (2004). *The philosophy of money* (3rd enlarged ed.). (D. Frisby, Ed., T. Bottomore & D. Frisby, Trans.). London: Routledge.

Does it matter that it is digital?

TONE BRATTETEIG

Introduction

At the turn of the nineteenth century, folklore researchers went hunting for folk music in Norway, looking for people who knew how to play the traditional fiddle or sing traditional songs (Sinding-Larsen, 1987, 1988; 1991). They used musical scores to represent the music they collected but had a hard time trying to represent the 'troll keys' used in traditional songs and the Hardanger fiddle. When tape recorders became available, the folklore music researchers were happy to return to the field, hunting for people who knew how to sing and play the 'troll keys' they had not been able to represent in musical scores. Some old people remembered and could sing (and play) the songs and, even with a bad recording, the new technology gave a better representation of the 'troll keys'—the quarter-tone intervals—in the Norwegian folk songs than the musical scores would allow.

This story demonstrates that technology is important for how people express themselves and how technological properties sometimes interact with the expressions in ways that fundamentally change them. Changes in tech-

nologies may offer limitations or new opportunities for expression. The folk music regained its 'troll keys' with the tape recorder. Musical scores are excellent for representing classical music for classical instruments but problems occur when the predefined scale intervals do not fit the instrument or the song; then representational categories are used to sort out parts of the reality that do not fit—like the 'troll keys'. More serious examples of this can be found in, for instance medicine, where your illness is supposed to fit an accepted diagnosis, or in social life, where race, religion, class are used as sorting categories (see Bowker & Star, 1999).

Categorisation and representation are basic properties of all digital electronic systems, in addition to their capabilities of automating processes and distributing and sharing the information instantaneously through endless copies. These properties tend to influence what we use digital electronic systems for and influence what we see as opportunities and limitations.

Information and communication technologies (ICTs) are deeply embedded in contemporary society as structures and infrastructures, as tools and procedures, as objects and artefacts, and as communication media. The introduction of ICTs to media has made the distinction between mass communication (TV, radio, newspapers, etc.) and personal communication (telephone, etc.) blurred and near to disappearing.

The digitization of media has changed the media. Four characteristics of digital media are seen as particularly important (Maartmann-Moe, 1991): (1) the media can include all data types, (2) there are no deadlines, (3) all media are dialogical or two-way, and (4) everybody can participate in the public debate. The first point is a basic characteristic of all digitization; hence it is a basis for the others. The last three points have to do with changes in the distribution of mass media, and together they have changed them fundamentally. The fact that everybody can participate in public debate is a change for democracy.

This chapter discusses the technology aspects of digital media and applies them to digital storytelling, aiming to understand more of how the digital is part of the media and of the storytelling. My ambition is to go deeper into the properties of the digital technologies and how they interplay with digital stories and digital media. The discussion is structured with reference to the points above. The first section discusses digitization and the fact that digitized media include all data types. The next section discusses the consequences of this fact as concerned with digitized distribution and the dialogic and instantaneous characteristics of digital media. Based on this discussion I revisit digital storytelling and, finally, I summarize the discussion about whether it matters that the media are digital.

Digitization of all types of data

Digitization has led to digital systems being able to handle all types of data represented in digital form—be it numbers or text, images, sounds or film—and to the digitization of the machinery we use to see and listen to the data. The camera and music playing equipment are digital, and today they represent images and sounds just as well as the best analogue equipment (or not: Fujimoto, Nakagawa, & Tonoike, 2005; see discussion in Holm, 2007). The development of the power-size-price relation in digital technology has made even small digital equipment very powerful.

The term 'digit' means number and originates from the word for 'finger' and counting on the fingers (see Bratteteig, forthcoming 2008). 'Digital' refers to something being represented by digit(s), using calculation by numerical numbers and the numbers 1–9 or any other discrete units. 'Digital' also usually denotes being represented in a digital electronic system, a computer. At the core of digitization are differences in voltages in electric current represented binarily as zeroes and ones. The binary representation is an abstraction from the fact that current is continuous. The computer is built up by digital logic, by combinations of zeroes and ones into logical gates, further combined into larger logical units at increasingly complex abstraction levels. The digital electronic system is abstractions all the way from the voltages to the surfaces that meet the user. The printer icon that we click on our computer screen is translated into a large number of operations, at many abstraction levels, in order to connect to the physical device and make it print stuff (see Dourish, 1997, 2001; Hailperin, Kaiser & Knight, 1999).

Anything represented in a digital electronic system is converted to binary form but can be (re-)presented to the user as symbols like numbers, letters, signs, icons. An analogue system, however, has a continuous spectrum of values. A traditional temperature measure illustrates the difference between analogue and digital by having a scale beside the mercury column so that the widening or shrinking of the mercury can be easily 'translated' to a number on the temperature scale, be it Celsius (centigrade) or Fahrenheit. The world is analogue but can be represented by numbers or other discrete and unambiguously defined categories.

The digital representation is a particular kind of simplification of the analogue referent. Instead of continuous analogue flows we get discrete digital steps. The digital thus implies introducing lines where there is continuity and dichotomies where there are relation and introduces a need for labelling and categorising. Phenomena that are not categorised or explicitly described cannot be represented in the computer.

The data stored, processed and presented in a digital electronic system normally represent and stand in for something else, which is not necessarily digitized (Bratteteig, 2004). The clock represents time; the bank's computer represents the amount of money I own; the hospital system represents me as a patient and by numbers referring to blood tests, heart beats, etc. The digital system represents analogue, mechanic and manual phenomena as digital. The representation is a translation of particular aspects of the phenomena—re-presentations in a medium that transcends time and space. The representation is made up but becomes itself a part of the world, with its own life cycle. The world is full of representations that 'stand in for' and refer to something else.

The simplifications made by the digital re-presentation are important characteristics of digital systems and artefacts. However, the enormous development in the power-size-price relations of digital equipment has virtually eliminated computing and storage capacity problems, and the crude simplifications of earlier times have been replaced with digital representations where the discrete steps are so small and so many that they can act as virtually analogue. Digital music recordings, photography and films are represented in such fine-grained ways that (almost) nobody can see or hear a difference. The quantity of pixels and sound elements constitute a qualitative change.

The difference between a mechanical and a digital photo lies in the possibility for manipulation of the photo after it is taken. The digital photo can be manipulated in a number of fundamental ways; the light can be set as daylight even if it was taken at night; the colours can be changed separately—substituted or just adjusted, and it is easy to adjust and manipulate the picture: stretch, cut, cover or include new elements. A photo does not necessarily picture reality anymore—it has become fiction.

Digital representations (bits) can take any form and be translated to any type of presentation for the user: a measured temperature can be presented as a number, a colour, a sound or whatever form that seems convenient in order to present this information to the user. Digital representations are translations of non-digital referents to digital forms and furthermore to presentational forms aimed at the user.

The fact that digitized data is processed and presented on digital equipment makes digital media different from analogue media. Digital equipment is a tool for processing and presenting the data and supports particular ways of processing the data and of presenting them. A basic characteristic of digital electronic systems is that they are program executions: they do things. A program execution performs a series of specified operations, processing input and transforming it to output. Digital electronic systems consist of programs that can perform predefined operations on the data and often force the human operating the system to perform in particular ways and in particular sequences.

The logic of the computer program is often not presented to the user in ways that make the user understand how the computer behaves or why it behaves the way it does (Norman, 1988). The limits and possibilities implemented through the programs are often deliberately hidden from the user in order for the system to appear simple to use. The design of the system rests on assumptions about user behaviour that may be wrong (Woolgar, 1991) and thus make the system appear illogical and incomprehensible (Suchman, 1987).

By the choice of programs in the digital tool, it allows for some ways to process data and limits other ways. In this way the tool contributes to the development of certain genres (see e.g., Orlikowski & Yates, 1994). Genres develop as we get used to particular forms of behaviour; adjusting to some limits and pushing others. Even a jazz improvisation concert does not last longer than two hours (Becker, 2000), and storytellers of all times have made use of clichés and genres to make their own story and storytelling style stand out (see e.g., Ong, 1982). Storytelling is a multimodal practice; even oral storytelling involves many modalities beside text (Kaare & Lundby, Chapter 6 of this book).

Digital storytelling is also influenced by the digital tools and media used when shaping and communicating the stories. The email message has developed as a distinct genre (Orlikowski & Yates, 1994); websites have gone through fashions and settled on a set of styles and standards—or genres (Nielsen, 1999). The genre(s) of the personal digital story borrows from other storytelling genres—including digitized ones. Blogs, for example, borrow from newspaper and diary forms and add photos and links. The story in digital storytelling is formed by other stories already seen and heard, by the storytelling project, by the tools available as well as the skills to use them. Digital storytelling skills are technical and communicational and concern the abilities to mediate a message and master the appropriate forms. Organised digital storytelling projects for youths often have the mastering of the forms as the main objective, like writing assignments in school. However, the ease of use of the digital tools makes it possible to work on developing a personal style and selecting appropriate content.

Digitized distribution: Instant access and two-way communication

Digital media are characterised by having no deadlines, being dialogical or two-way, and by the possibility for everybody to participate in the public de-

bate. The basis for this is that contemporary media can present all data types: text, numbers, images, sound and film. Newspapers appear on paper and on the Internet and include text and images and also—on the Internet—film and sound, as well as links to other media. You can watch television on the Internet—or read your newspaper there.

The blurring of media types in digital media means that, as a consequence, there are no deadlines anymore: being first is a constant demand. After being first, the news can be made 'thicker' with more material from which a subset can be picked for presentation in the various media types: images and film for TV, sound for radio, images and longer text for paper media (Hilstad, 2001). The Internet can easily act as an information storage since the information is not organised in a sequential way or in easily distinguishable versions. We meet this in every digital production process: as long as it is digital it is possible to continue manipulating and processing the data—it is not finished until it is materialised in a product. When the means for processing and manipulating the data are the same as the means for presenting the data, the data processing can still continue. The unlimited possibilities for reworking digital representations can be applied to all digital productions—texts like this, web pages, photography can all be endlessly modified, even after publication, if the publication media are digital.

As with any technology, digital media make the basis for developing styles and genres. Newspaper journalists write their text so that it can be cut down from the end if necessary, contrary to, for example, academic writing styles that present the basic arguments and conclusions towards the end. Web journalism relates to limits of the web as a production and presentation medium, for example, by presenting the story on one page (i.e., standard screen size) since the second page will very often not be read.

Pre-digital media had limited opportunities for the public to have their voice heard. The editor was responsible for everything published, including the controlling and selecting of public opinions to be published. In digital media, everyone can comment and have their voice heard with very limited editorial control—if any. Any news article can have associated commentaries from people who might know much about its topic—or just have an opinion about it. Digital media are dialogical, two-way media.

Adding to the dialogical nature of digital media is the fact that everybody (in principle) can get their voice heard on the Internet. The consumer also has the chance to be a producer and distributor of information as the digital equipment for consumption also allows for production and distribution.

The invention of the printing press made printed materials available to the public and made it possible for everyone to learn to read and have access

to books. As the public have learnt to read and write, more people can also be authors of books—although actually publishing a book requires work and funding from institutions built up around book production. Publishing on the Internet does not require the same apparatus: the Internet is even available on your mobile phone and literally enables everybody to voice their concerns.

I would like to stay with the printing press for a moment in order to look for parallels to the democratisation process started by Gutenberg in the 1400s. The printing press made reading (and writing) available for all and not an exclusive right. Reading became important, and the written word gained status and made learning from books important. School teaches us to master many forms of reading and writing and presents us with information that transcends time and space. Literacy is deeply integrated in the workings of contemporary societies and cultures though in her Nobel Literature Prize speech in 2007, Doris Lessing reminds us that not all people have access to books or reading skills even today.

What about digital media? Obviously 'reading' and 'writing' the digital is important and is being taught in school. Some skills developed from the printing press era are still valid for the digital media, but some may not be, even if they look as if they are. Searching for facts on the Internet requires different reading skills than searching for facts in the encyclopaedia: evaluating the quality of facts is more difficult when there is no authoritative quality check—or when there are several claims of authority. Paradoxically, you actually need to know something before you can learn about it. Or you need to develop skills for learning to check the quality yourself. Buckingham (2006) suggests that digital literacy includes literacy skills that address the representation, the language, the production and the audience of the digital media.

Digital literacy looks a lot like literacy from the printing press era but is more complex. Above, I mentioned the problem of evaluating content quality when using skills developed for the printing press: nicely produced text looks finished and right, even if the author sees it as a draft in a text production process. The appearance of contradicting facts makes greater demands on the individual to make their own evaluations of the facts—or treat facts as beliefs.

A second and more demanding aspect of digital literacy is the mastery of the digital forms as they are given by the digital equipment. The mastery of digital tools also includes the ability to 'read and write' the limits and possibilities embedded in the tool. This requires knowledge about technical issues that often are deliberately hidden from the user interface. If you want to 'read' your search results you need to take into consideration how the search program works and the criteria it uses to make the result list sequence—and how you yourself can design your web page so that it will appear first on that list.

The complexity of this type of literacy is a consequence of the fact that digital systems are designed to hide the parts of the complex machinery that we do not need or want to know about—but in that hiding there also may be hidden information that would help us 'read' the presented information better. Not hiding technical issues is also a designed feature. The impossibility of practising Internet censorship illustrates this point: technical limits to accessing parts of the Internet can be worked around utilising technical possibilities like access via proxy servers. Technical competence is required for making this work, as well as knowledge about the things that are censored: you need to know what you are not allowed to see in order to find it—or even look for it.

To the user, the fact that the production tool is also a distribution tool is potentially confusing. The operation of saving a text file on my personal PC desktop looks the same as when I save a text on the Internet—that is: when publishing my text for the world to see (Hillestad, 2003). The operation can be made to look exactly the same in order to make it easier for the user to publish things on the Internet by being able to use existing skills. In this case the difference between filing and publishing is hidden. However, even when I know that I publish my text on the Internet, it is difficult for me as a non-journalist to imagine the potential number of readers that will have access to my text the minute I publish it. The text is still a text on my PC—the blurring of consumption, production and distribution tools into one tool (or tool box) makes it conceptually difficult to maintain these distinctions. Through experience (or trial-and-error) people learn to distinguish between their activities with the digital tool so that things that are better suited for the personal diary are not published for the whole world (Hillestad, 2003). Design of role identities and role-playing happens on Facebook just as much as in World of Warcraft (Erstad & Silseth, Chapter 12 of this book).

Digital storytelling in society

Digital communication tools and digital data change the ways that stories are produced, consumed and distributed: the digital matters in the practices of digital storytelling and digital media. At the societal level, the changes in media practices add up to larger changes. The fact that everybody can participate in public debate suggests a fundamental change in how we understand media and media politics.

Digital storytelling started out as a way to engage local communities in local political action (Lambert, 2006). The stories concerned the local culture: history that was in danger of disappearing or stories that captured the identity

of a place or a local culture. The storytelling was a method for local action as well as a means for preservation of local culture. Many later storytelling projects maintain the spirit of Lambert's original storytelling activities and use the storytelling mainly as a vehicle for local action (cf. the discussions of The DUSTY project (Hull & Nelson, 2005; Hull & James, 2007) and the BBC Capture Wales project (Thumim, Chapter 5 of this book)).

The emphasis on initiating local action with local inhabitants resembles an approach for development of information systems called 'participatory design'. Participatory design has its origin in Norway in the 1960s, when the Labour Union and the Employers' Federation collaborated on improving work life democracy and (through this) improving production (see, e.g., Nygaard, 1996). The first projects resulted in 'data agreements' with local unions and businesses and influenced legislation regulating worker participation in development of system changes in the Scandinavian countries. Later projects explored and developed alternative technological solutions in collaboration between researchers and workers, aiming at developing good working tools for workers and methods for user participation in systems design (Bjerknes, Ehn & Kyng, 1987; Greenbaum & Kyng, 1991; Clement & Van den Besselar, 1993; Kyng & Mathiassen, 1997; Bratteteig, 2004). At the core of participatory design is the aim to develop working tools that support the autonomy of their users.

The aim for autonomy of the users makes the participatory design approach interesting in a digital storytelling context. The Scandinavian participatory design projects are characterised by being grounded in work life institutions like labour unions and connected to societal institutions like legislation. In North America the participatory design approach is not connected to societal institutions (like unions) but instead builds on the American tradition of grassroot movement and volunteer local action grounded in American history (see, e.g., Greenbaum, 1993).

Digital storytelling can easily be placed in the American participatory design tradition, where local action improves the local community and through this makes a difference. Democracy is built by many individuals participating in shaping their living conditions. In Scandinavia, the trust in societal institutions has encouraged a multi-levelled approach that emphasises the combination of local action and global strategy for change—as in the first participatory design project with the Norwegian Iron & Metal Worker Union in the early 1970s (see Bjerknes & Bratteteig, 1995). In this tradition, the local action gains its meaning as an example of a global strategy (see Kraft & Bansler, 1994).

What difference can a voice make? Local action makes a difference only locally if it stays in the local context. The promise of digital media is, however, that it reaches beyond the local community to a world of potential listeners and

viewers. Even for locally framed participatory projects, the potential for global distribution and consumption of that which is produced bears the promise of bringing more than the single voice to public debate. The challenge is for media to support such actions and strengthen the voices through societal and technical mechanisms.

Concepts like 'mediation' and 'mediatization' aim to capture the important aspects of the relations between societal institutions and media that explain how institutional and media practices are intertwined (see, e.g., Hjarvard, 2007; Couldry, Chapter 3 of this book). Lundby (Chapter 1 of this book) points out that the discussions related to the concept of mediatization are not new and refers us to Hernes' (1977) analysis of the commercialisation of TV. These discussions do, however, concentrate on societal issues and miss out technical issues that can add to our understanding of the limits and possibilities for changes in media and media use: the digital is missing.

Bolter & Grusin (1999) suggest that what characterises 'new media'— digital media—is that they represent other media: 'we call the representation of one medium in another *remediation*, and we will argue that remediation is a defining characteristic of the new digital media' (p. 45). I agree, however, with Manovich (2007) that

> The computer does not 'remediate' particular media. Instead, *it simulates all media*. And what it simulates is not surface appearances of different media but all the techniques used for their production and all the methods of viewing and interaction with the works in these media. (p. 70)

The point here is that digital media are computers that execute programs and can represent data in any form. In order to be 'read' their presentation forms build on well-known 'languages', but adding computing properties like interactivity and program executions make them fundamentally different from the media they borrow their language(s) from. However, the old media also borrow from the digital: when film is digitized the leap to computer-generated animation is not so great, and films that mix film footage with human actors and computer-generated animations are becoming more common.

The digital matters

The aim of this discussion has been to argue that the digital matters when we try to understand human practices that include digital equipment. Even the expressions 'mediatized stories' and 'digital storytelling' suggest that the digital

is an integrated part—or even a property—of such stories and storytelling. But in what way does it matter that they are digital? In this chapter I have tried to argue how the digital matters to the individual user: the media consumer who also can be a media producer and distributor. The fact that the media are digital profoundly influences media practices—at individual as well as societal levels.

A good digital story utilises the possibilities of the digital medium to tell its tale. The mediatized story is characterised by the digital: it makes use of many data types presented digitally using the computer's ability to present digitized data of all types in a sequence of programmed operations 'playing' the digital story. The consumption medium is (similar to) the production and distribution media, and the same set of skills is involved.

Digital storytellers learn to master digital equipment and they also produce stories. Digital stories are instantaneously shared with others, creating a sense of community even with listeners and viewers far away. Mastery of digital storytelling tools is digital literacy and involves the abilities to 'read' and 'write' digital media. Most often, however, the digital literacy does not reach beyond the surface of the equipment. The design of digital tools should take the challenge of enabling a deeper understanding of the hidden digital structures that limit and provide possibilities for digital media practices. The story about the representations of the troll keys that started this chapter also illustrates the level of detail necessary to explore how the digital influences the representation and how the consequences can reach far beyond the concrete representation. like, for example, the possibility of losing the troll keys.

The discussion in this chapter is a first attempt to address digital limits and opportunities for digital storytelling and digital stories. I conclude with suggesting more research on ways to conceptualise how the digital matters in digital storytelling and mediatized stories. Both the process of storytelling and the resulting stories embed properties of digital electronic systems and are influenced by them.

References

Becker, H. (2000). The etiquette of improvisation, *Mind, Culture, and Activity*, 7, 171–176 and 197–200.

Bjerknes, G., & Bratteteig, T. (1995). User participation and democracy. A discussion of Scandinavian Research on System Development. *Scandinavian Journal of Information Systems*, 7(1), 73–98.

Bjerknes, G., Ehn, P., & Kyng, M. (Eds.). (1987). *Computers and democracy*. Avebury: Aldershot.

Bolter, J. D., & Grusin, R. (1999). *Remediation: Understanding new media*. Cambridge, MA:

MIT Press.

Bowker, G., & Star, S. L. (1999). *Sorting things out: Classification and its consequences.* Cambridge, MA: MIT Press.

Bratteteig, T. (2004). *Making change. Dealing with relations between design and use.* Dr.Philos dissertation, Department of Informatics, University of Oslo.

———. (forthcoming 2008). A matter of digital materiality. In I. Wagner, T. Bratteteig, & D. Stuedahl (Eds.). *Exploring digital design.* Berlin: Springer Verlag, CSCW series.

Buckingham, D. (2006). Defining digital literacy. *Digital kompetanse. Nordic Journal of Digital Literacy,1 (4).* 78–91/263–276). Oslo: Universitetsforlaget.

Clement, A., & Van den Besselar, P. (1993). A retrospective look at PD projects. *Communications of the ACM, 36*(4), 29–37.

Dourish, P. (1997). Accounting for system behaviour: Representation, reflection and resourceful action. In M. Kyng & L. Mathiassen (Eds.). *Computers and design in context* (pp. 145–170). Cambridge, MA: MIT Press.

———. (2001). *Where the action is: The foundations of embodied interaction.* Cambridge, MA: MIT Press.

Fujimoto, K., Nakagawa, S., & Tonoike, M. (2005). Non-linear explanation for bone-conducted ultrasonic hearing. *Hearing Research,* 204, 210–215.

Greenbaum, J. (1993). A design of one's own: Towards participatory design in the United States. In D. Schuler & A. Namioka (Eds.). *Participatory design. Principles and practices* (pp. 27–37). Hillsdale, NJ: Lawrence Erlbaum.

Greenbaum, J., & Kyng, M. (Eds.). (1991). *Design at work: Cooperative design of computer systems.* Hillsdale, NJ: Lawrence Erlbaum.

Hailperin, M., Kaiser, B., & Knight, K. (1999). *Concrete abstractions.* Pacific Grove, CA: Brooks/Cole Publishing Co.

Hernes, G. (1977). Det medie-vridde samfunn. *Samtiden,* 86(1), 1–14.

Hillestad, A. (2003). Does the interface hamper the user's understanding? A discussion of the relation between the user interface and the user's understanding of the personal computer *(in Norwegian: Hindrer grensesnittet brukerens forståelse? En diskusjon av forholdet mellom brukergrensesnittet og brukerens forståelse av den personlige datamaskinen).* Masters thesis, Department for Educational Research, University of Oslo.

Hilstad, S.E. (2001). Multimedia news production in NRK: How technology interplays with work practices *(in Norwegian: Flermedial nyhetspublisering i NRK: Hvordan teknologi samspiller med arbeidspraksis).* MAThesis, Department of Informatics, University of Oslo.

Hjarvard, S. (2007). *Changing media—Changing language: The mediatization of society and the spread of English and medialects.* Paper presented to ICA annual conference, San Francisco, 24–28 May.

Holm, S. (2007). Låter vinyl bedre enn CD *www.forskning.no,* (retrieved December 20. 2007).

Hull, G. A., & Nelson, M. E. (2005). Locating the semiotic power of multimodality. *Written Communication,* 22(2), 224–261.

Hull, G. A., & James, M.A. (2007). Geographies of hope: A study of urban landscapes, digital media, and children's representations of place. In P. O'Neill (Ed.), *Blurring boundaries* (pp. 255–289). Cresskill, NJ: Hampton Press.

Kraft, P., & Bansler, J. (1994). The collective resource approach: The Scandinavian experience. *Scandinavian Journal of Information Systems,* 6(1), 71–84.

Kyng, M., & Mathiassen, L. (Eds.). (1997). *Computers and design in context.* Cambridge, MA: MIT Press.

Lambert, J. (2006). *Digital storytelling: Capturing lives, creating community* (2nd ed.). Berkeley CA: Digital Diner Press.

Lessing, D. (2007). *Nobel Literature Prize speech.*

Maartmann-Moe, E. (1991). *Multimedia.* Oslo: Universitetsforlaget.

Manovich, L. (2007). After effects, or velvet revolution. *Artifact, 1*(2), 67–75.

Nielsen, J. (1999). *Designing web usability.* Berkeley, CA: Peachpit Press.

Norman, D. (1988). *The psychology of everyday things.* New York: Basic Books.

Nygaard, K. (1996). 'Those were the days'? Or 'Herioc times are here again?' IRIS Opening speech 10. August 1996. *Scandinavian Journal of Information Systems, 8*(2).

Ong, W. (1982). *Orality and literacy: The technologizing of the word.* New York: Routledge.

Orlikowski, W. J., & Yates, J. A. (1994). Genre repertoire: Examining the structuring of communicative practices in organizations. *Administrative Science Quarterly, 39*, 541–574.

Sinding-Larsen, H. (1987). Information technology and the management of knowledge. *AI & Society, 1*(2), 93–101.

———. (1988). Notation and music: The history of a tool of description and its domain to be described. In H. Sinding-Larsen (Ed.), *Artificial intelligence and language: Old questions in a new key.* Oslo: TANO Forlag.

———. (1991). Computers, musical notation and the externalisation of knowledge: Towards a comparative study in the history of information technology. In M. Negrotti (Ed.), *Understanding the artificial: On the future shape of artificial intelligence* (pp. 101–125). London: Springer-Verlag.

Suchman, L. A. (1987). *Plans and situated actions. The problem of human-machine communication.* New York: Cambridge University Press.

Woolgar, S. (1991). Configuring the user: The case of usability trials. In J. Law (Ed.), *A Sociology of monsters: Essays on power, technology and domination* (pp. 57–102). London: Routledge.

Shaping the 'me' in MySpace:

The framing of profiles on a social network site

DAVID BRAKE

Introduction

A number of influential sociologists (Giddens, 1991; Bauman, 2001; Beck & Beck-Gernsheim, 2001) have suggested that one of the key characteristics of late (or second) modernity is the requirement for individuals to define and re-fine their identities reflexively. The growth of academic interest in institutional digital storytelling projects—as evidenced by the theme of this volume—may be a reflection of this, as these projects often require or at least encourage their participants to actively reflect about their identities in order to create their sto-ries (Lambert, 2006). But alongside these professionally facilitated, organized storytelling projects we have seen the emergence of a number of internet-me-diated spaces in which, unprompted and unguided, a much larger cross-section of members of the public publish details of their lives—a practice which may be important in this process of reflexive self-definition.

The online publishing of self-related texts has taken a variety of forms in recent years and its incidence has grown as Internet access and use have risen and, importantly, as new online services have emerged with new affordances.

Personal websites have existed since the web was invented, and in the last five years we have seen the invention and popularisation of weblogs—a technology that is more rigidly structured but easier to update and use—alongside services that are primarily non-textual like photo and video sharing sites. In the United States according to a February 2006 survey, 23.6 per cent of Internet users had posted a photo online, 12 per cent had their own websites, and 7.4 per cent kept a personal blog—the latter figure rose to 21.1 per cent of under-18s (USC Annenberg School Center for the Digital Future, 2007), while UK figures suggest 9 per cent of online users (as of March 2007) had a blog they have used within the last year (Dutton & Helsper, 2007). Most recently, the use of online social network sites (SNSs) like MySpace and Facebook has exploded—again particularly among younger people, who have adopted them even more rapidly and extensively than they have adopted earlier web-based tools. More than half of online teens (12–17) in the United States (as of November 2006) had created profiles on one of these services (Lenhart & Madden, 2007), and in the United Kingdom (as of June 2006) 70 per cent of those 16–24 and online had used such service, compared with 41 per cent of online UK adults (Ofcom, 2006). MySpace—the SNS chosen to be the object of the research for this chapter— was at the time of research one of the world's leading SNSs and appeared to be the dominant SNS in the United Kingdom (Ofcom, 2006, p. 172).[1]

MySpace profiles (and other SNSs) are already being analysed as spaces for identity production:

> The dynamics of identity production play out visibly on MySpace. Profiles are digital bodies, public displays of identity where people can explore impression management. Because the digital world requires people to write themselves into being, profiles provide an opportunity to craft the intended expression through language, imagery and media. (d. boyd, 2006)

Creating a text like an SNS profile is necessarily a self-reflexive act to some degree since it involves the choice and assembly of self-related episodes and attributes, but the *kind* and *extent* of self-reflection expressed in self-related online writing clearly varies. Institutional projects like the Center for Digital Storytelling encourage participants to 'tell *meaningful* stories' (emphasis mine) to 'improve all our lives' (http://www.storycenter.org/). Some academics studying the personal home page have suggested these can 'give authors a better sense of self-understanding and personal efficacy' (Hevern, 2000) or 'transform the very way we think of ourselves and to change ourselves to who we really want to be' (Chandler, 1998). Can the practice of SNS profile making provide similar benefits for the creators of their digital self-related texts? The technological affordances are there, but the nature of these texts and the way in

which their creation is approached depends on the way in which the practice of creation is framed.

Other chapters in this volume analyse the circumstances shaping the production of such writings in institutional contexts. There, the 'rules' of what 'counts' as a digital story are often clearly defined, certain forms and content are clearly encouraged, and there is generally a status differential between the owners/facilitators and those whose stories are to be told. On social networking sites and most other online spaces for self-related texts, the constraints and influences tend to be less clear since the purposes of these online spaces are less rigidly articulated, and performance in these spaces does not take place in a face-to-face group context (though as will be noted later there is generally an imagined group that the texts are produced for). The providers of the online spaces where identity-related texts are produced often frame them as being spaces for untrammelled self-expression. The first page of Blogger's 'tour of features' from its home page says, 'Your blog is whatever you want it to be. There are millions of them, in all shapes and sizes, and there are no real rules'(Blogger, 2007). And of course the name MySpace emphasises the profile creator's individual autonomy and ownership. This chapter outlines some of the ways in which the practice of self-related writing is nonetheless framed by a number of specific structural elements, using one context as a case—that of MySpace profile creation and maintenance by teenagers in the United Kingdom.

Schmidt's article on "Blogging Practices: An Analytical Framework" (2007) provides a means to examine the differing ways in which blogging practices are framed and while SNS profiles are created in a different context the technological affordances offered by blogging are similar enough to profile creation and maintenance, and the framework is general enough that it has been adopted here to structure the examination of SNS practices.

Schmidt's article asserts blogging practices 'are framed (but not solely determined) by three structural elements: rules, relations and code' (2007, p. 1411). Rules, as defined by Reckwitz (1997) and used by Schmidt 'act as schemas for action, guiding situational performance by providing shared expectations' (Schmidt, 2007, p. 1411)[2] He sub-divides those relevant to blogging in several different ways—the most immediately relevant rules in this analysis are those that govern publication.[3] Relations are divided into those articulated using blogging technology itself (hyperlinks) and social ties which may be maintained both through blogging and a variety of mediated and non-mediated practices. Lastly, he identifies code (the specific technical implementation of the software that underlies a blogging service) as being of fundamental importance because it enables or restricts certain actions (2007, p. 1418).

To give some insight into the way rules and relations may structure MyS-

pace practices, ten semi-structured hour-long interviews were conducted with MySpace users—all young people between 16 and 19 years of age from two UK schools. They were also invited to fill in a short questionnaire online after the interviews to clarify issues that arose during the initial interviews. Because these were self-selected and because of the small overall number of interviews and the limited variety of the sample, it is not possible to generalise conclusions from the interviews to young MySpace users more broadly, but their experiences and accounts provide some possible explanations for SNS user behaviour.

In the remainder of this chapter, an overview is given of the nature of the profiles created by the interviewees. The process of profile creation and maintenance is then placed in the wider context of the uses of MySpace as described by those interviewed, and some of the influences which appear to have shaped what was produced are outlined. In the conclusion, the implications of the manner in which these practices are shaped for institutions involved in digital storytelling are explored.

MySpace profiles as texts

The profiles examined included a range of information about likes and dislikes—generally favourite music, movies and TV shows—either using the forms provided for this purpose by MySpace (see section on Code below) or using self-descriptive questionnaires provided by third party sites. Four of the interviewees wrote no more than this. The remaining six provided more free-form self-descriptions, but in most cases these were brief. Three of them were less than 100 words, two were around 300 words and one (by Charlie[4]) was 730 words long.

The interviewees' profile pages were varied in their visual style and 'media richness', very often containing galleries of pictures of the authors and their friends and frequently including video as well (though generally of favourite musicians or—in one case—of other young people performing stunts rather than of themselves). All but one offered a song that played automatically when you visited their page, and all had a custom background to their page.

These profiles contain much self-*related* material, however the bulk of what was disclosed did not appear to be more than minimally self-*reflexive*, nor was it generally organized or expressed in order to provide the reader much insight into the user's self-understanding beyond the taste choices catalogued. Even when deeper themes were touched on in the profiles, they were not further

articulated. For example, two of the profiles appeared to suggest the author's religion was important to them (Sandra had a bible quote near the top of the page, and John had a repeated Christian image as a background to his profile). In neither case, however, was the significance of that religious adherence further articulated anywhere else on their profile.

As Livingstone found in her own SNS research (Livingstone, 2008), for many of her interviewees 'it seemed that position in the peer network is more significant than the personal information provided, rendering the profile a place-marker more than a self portrait'. It is for this reason that this chapter has labelled these profiles as self-related texts rather than using more value-laden descriptors like 'identity statements'.

MySpace usage practices

It's more of a friends and music thing really. Good way to keep in contact.

Sophie

When interviewees were asked to talk in general terms about their use of MySpace and in particular when they were asked to describe what MySpace is 'for' to someone who did not know, three dominant uses emerged. In order of popularity, these were interpersonal communication,[5] keeping up with bands that used the site to promote themselves and promoting their own artistic projects. The creation and maintenance of their profiles or the examination of others' profiles appeared to be less important to them (except insofar as their own profiles were useful to advertise creative enterprises they were trying to promote or insofar as some conversations took place using comments publicly posted on their and other people's pages).

This balance of priorities appears to be borne out in their descriptions of the time they spent. When the interviewees refer to the frequency with which they visit MySpace they tend to suggest they do so daily or at least every few days—indeed, one of the interviewees (Darrell) mentioned that MySpace is his home page. This is consistent with the very high number of page views attributed to the MySpace site as a whole—twice as many as Google's according to one estimate (Garrett, 2006). However, it appears little of this time was spent by those interviewed creating or modifying their profile pages. Of the five people who responded to questions about this in a follow-up questionnaire online, three said they spent less than an hour producing their initial profile, one spent 3–4 hours and one spent a day. Most of them changed their

profile infrequently after that—one added new features monthly, one 'when I feel I need a change' and one suggested that he/she never did—the other three changed every two to four months. The changes themselves took them between five minutes and half an hour to do. Although they said that their profiles were accurate—as far as they went—interviewees tended to assert that their MySpace profiles did not contain sufficient depth to give readers a good idea of what they were like.

> People look at my layout, and they think, 'colorful, happy, Indie kid', and then they look at my music, and it's like, hmm, SlipKnot. It's hard to sum yourself up in one page. It tells you the bare facts, but then there's nothing to link them together. (Charlie)

> You would get a sense of what the person is about, their interests, especially if they've got one of those surveys on their page. . . . you'd get a sense of how they think and what they're into. But I don't think you really know them that well until you have actually met them. (Tim)

> I change it quite often, so . . . people might look at it, and think that I'm one way, and the next week they might see, like a different layout. A lot of my friends with MySpace, they reflect their personalities. But mine, I don't think it reflects my personality that well. (Claire)

In at least three cases—those of Claire, Sandra and John—changes to their profile appeared to be more influenced by a desire to entertain those who visited them or to relieve boredom than by a desire to reflect changes in the author's idea of their self.

> You always change your blogs [blog postings] because blogs are inviting people to comment on your page, I mean, comment on the issue, and the more new blogs you have, the more people comment on your blogs. So you can't have one blog all the time, because everyone already knows the question, and already answered it. (John)

> [you have to] update your profile so people will have a reason to keep coming back onto it. (Sandra)

> I'll just look at, and I'll get bored of the same profile, and then I'll just think, okay, I'll change it. (Claire)

What then (using Schmidt's terms) are some of the relations, rules and code that frame the profile creation and maintenance practices outlined here?

Influences on the self-reflexive use of MySpace profiles

Relations

Intended readers

> The people who look at your MySpace mainly are people who already know you, or know of you or know a bit about you, and then all it sort of really does is it says a little bit more.
>
> David

Social relations appear to be central to the use of MySpace—while the site is sufficiently customisable to allow for many different uses, its self-definition (on its home page) is as 'a place for friends', and as we have seen in the section on MySpace usage practices those interviewed most frequently framed MySpace as a tool to articulate and maintain inter-personal links. The centrality of relations to MySpace use may, however, direct the owner's attention away from the kind of self-reflexivity observed by academics studying other online self-related spaces and encouraged by institutional storytelling projects and towards a more or less strategic self-presentation.

As David remarks above—and as echoed in research on another SNS, Facebook (Ellison, Steinfield & Lampe, 2007)—for most of those interviewed the primary audience (both expected and desired) appeared to be those they felt they already knew.[6] Perhaps it therefore would not be necessary to further articulate their identities, as the most important potential readers would be expected already to have some idea of how they present themselves.

In addition, the fact that in MySpace the intended readership of 'friends' is explicitly defined and delineated by each user may increase the authors' awareness of the consequences of any self-disclosure that is unacceptable to their peers (though the interviews did not shed light on this potential influence). Research suggests that self-revelation is more likely to take place in a communicative situation of (relative) anonymity, where such revelations can take place without perceived cost (Spears & Lea, 1994; McKenna & Bargh, 2000; Joinson, 2001). Of course MySpace users are free to create 'dummy' anonymous profiles for identity experimentation but those interviewed had not done this.[7]

By contrast, many other online spaces where self-reflexive writing takes place have some degree of anonymity—just over half of US webloggers, for example, reported blogging under a pseudonym (Lenhart & Fox, 2006).[8]

Unintended readers

The interviewees did not express concern over the way friends or family might react to reading about personal issues they might air online, although this concern may have been present but not acknowledged explicitly since studies of personal blogging (Qian & Scott, 2007) and earlier studies of other forms of interpersonal communication (Rubin, 1975; Derlega & Chaikin, 1977) suggest self-disclosure is considered less risky with complete strangers. Instead they (particularly the six women interviewed) consistently maintained that personal details should not be shared on profiles because of the risk that unintended readers would see them. Several of the respondents said simply that strangers did not have the right to know about personal matters. As John says

> You have to write about yourself to a limit, or, if you want to get to know me more, contact me. If you become that close, I will talk to you in that way, but if you're just viewing my page, I don't even know you, and you're just looking at my personal life, as if you're my best friend or something.

Even when MySpace profiles are not seen as dangerously exposed to unwanted eyes, the profile is still seen as a less appropriate means of communication for personal issues than face-to-face or telephone conversation. This is partly because MySpace is an asynchronous medium—in Tim's words—'If you want to say something that's not that important, then you would message them over MySpace. It doesn't matter when they get it, as long as they get it eventually. But if you need to talk to someone quicker, then you'd phone them'. There is also the implication that even when MySpace readers are not strangers they may be merely acquaintances, and sharing personal issues in depth would therefore not be appropriate.

> The messages that you send on MySpace are usually things to do with MySpace, like um, somebody messaging about a song, somebody messaging you to put them in the top friends, somebody messaging you about your layout.... If it was someone that you speak to, that you needed to tell them about something more important, you would usually have them on your MSN [instant messenger] list, or you'd have their phone number to just phone them. (Tim)

> Yeah, because some friends on MySpace, they're not really your friends, they're just people that you might talk to every so often. (Claire)

Some of the caution about online strangers may also have been connected with the media and educator discourses in the UK about 'stranger danger' which recent research shows have been widely promulgated (Livingstone & Bober, 2004). Rebecca, for example, clearly perceives a tension between these discourses and MySpace use:

> Not even a year ago, it would be that the internet is full of bad people who want to get your address and get your number and find out where you live and come after you. And with sites like MySpace, they are now encouraging you not to talk to strangers, which, in all fairness is making it harder for creepy people to get to you. But at the same time, it's easy for them to find out all about you.

In response to concerns about personal online safety, MySpace users under 18 are presented with a warning on the page where they are first invited to upload a picture of themselves, and are also reminded to 'exercise caution when posting personally identifiable information' when entering their profile information. In this way MySpace through its framing code is both responding to and reinforcing these rules, although it is difficult to say how much this has had an impact, and none of the interviewees mentioned these warnings.

Code

By its nature, this form of framing may operate without the users' realising it. As a result, the way that code may frame the production of profiles was not extensively probed in the interviews—this portion of the analysis relies therefore on an examination of the relevant technical affordances and limitations of the profile portion of MySpace at the time of the research (mid-2007).

Schmidt tends to treat the influence of the code of blogging services (and by implication of SNSs) as binary—allowing certain practices and preventing others. The analysis in this chapter seeks to foreground the subtle ways in which the interface through which an SNS like MySpace presents its functions and frames user content can influence user behaviour as well, encouraging some uses and discouraging others. The literature on default settings (Kesan & Shah, 2006) provides a telling example of this kind of influence in action. In one online experiment (Bellman, Johnson & Lohse, 2001), the numbers opting to be notified of more health surveys doubled when the default setting was changed from a negative to a positive one, even though the users in both cases were free to choose whichever option they wished.

The default interface through which MySpace enables its users to create a profile provides a structure for what can be said about the self. The user is

prompted to provide information about their favourite music, films, television, books and their heroes. Fields are also provided for the users to describe themselves demographically—gender, age, religion, income, marital status, educational attainment and so on. The particular life interests which are considered relevant to a profile are also suggested, (though not determined) by the nature of the questions asked and the order they are asked in. MySpace users are asked what their religion is but not their political affiliation, for example. Half of the interviewees chose either to supplement or replace this set of questions with others, but even here the lists of questions were themselves taken from third parties and were designed to entertain rather than inform—for example, 'Have you ever wanted to drive a race car?'

Users are also provided with more 'free form' opportunities for self-description in the form of 'about me' and 'interests' boxes, but the space into which they are invited to type only displays around 130 words at a time,[9] and as noted earlier half of those who used those boxes at all wrote less than 100 words. Users are of course free to enter as much text into such fields as they wish (the browser would provide a scroll bar once they had filled the box), and none of the interviewees mentioned the size of the box as an influence on their profile writing. The size of the text box may nonetheless have an effect on the length of the text typed into it.

The depth and scale of the whole profile are tacitly limited as well. MySpace profiles largely consist of a single page (though there are optional subpages for pictures, video clips and other features). As a result the length of the self-presentation may be limited by the reader's willingness to scroll down the screen, and it is not straightforward to divide one's self-presentation thematically—all aspects of one's self-presentation generally have to be presented on the same page.

Rules

It appears that all the interviewees were acting within a set of rules guiding their notions of what kind of content was expected on their profiles and what the purposes of a profile were expected to be, though the perceived rules in question were not always the same. This is not surprising as in order to find existing and new friends and in order to find new music, MySpace users view many profiles, and the contents of such pages—particularly those produced by their peers—provide models for how their own profiles should work and what they should contain.

The profile as promotional space

MySpace has become well known in part as a place for bands to promote their work (d. m. boyd & Ellison, 2007, p. 217), and as we have seen learning about new music is one of the dominant reasons expressed for using the website. Three of those interviewed either were using or were planning to use MySpace to promote their own artistic activities—Sandra and John were going to produce videos (though none were yet visible on their MySpace pages), and Rachel had both a band profile for the (amateur) music she has produced and a separate personal MySpace profile.

Sandra and John were strongest in positioning MySpace as a space for artistic or professional promotion. In fact, Sandra went further to suggest other uses of MySpace were less legitimate:

> That's what I think MySpace is good for, if you're promoting something . . . but I don't like it when people make MySpace pages, and they're just trying to show off, like, this is me in my bikini, this is me in Spain, with tan. . . . Well, it's their business. . . . I don't mind when people have an online profile and things like that. I personally wouldn't do it, because it's just exposing yourself over the internet. But if you're promoting something through MySpace, I think that's really good.

Even those without a particular promotional aim for themselves recognised such promotion as an important and legitimate use for MySpace. Rebecca remarked, 'It's quite odd that other people can see your page and everything about you and pictures of you. . . . it's quite good because, just for the publicity, if you like, for people that are trying to get themselves out there,' and both she and Charlie then mentioned people they knew who were using the site to promote their band, their photography or t-shirts they had designed.

While this rule relates specifically to MySpace and its media framing as a means of artistic promotion, one can also link it to broader emerging social rules. Bauman, for example, sees SNSs as another example of the way consumer culture encourages a desire to 'commoditize' one's self (Bauman, 2007) and Rosen sees the revelation of aspects of what was once one's private life online as part of a wider trend towards 'personal branding' (Rosen, 2005, p. 182). These promotional profiles contain details that could be considered 'personal', but they are not being shared as a means to build intimacy or trust with peers or to develop a better self-understanding but as a way to add a 'personal touch' to the product that is being promoted.

The profile as entertainment space

> People's MySpace, like they decorate it, they have games on it, so there's lots of things to do . . . and it's a more fun way of communicating I think.
>
> John

Entertainment—of the author or of their audience—is the other principal use given for the MySpace profile. As noted in the section on MySpace usage practices, those who spoke of this use presented it as a momentary relief of boredom rather than anything more ambitious. Three of the ten interviewees supplemented the information about themselves in the standard MySpace template with a variety of self-descriptive questionnaires created by third parties. But these were not done in order to increase the depth of the profiles—rather they added inconsequential details. In the cases where answering might provide a meaningful insight into the profile-owner's self, questions were just dodged or skipped. For example, Tim's answer to 'Do you have any regrets in life?' is simply 'yes'. The space available on the forms used to generate these supplementary questionnaires tend to be even more limiting than the ones MySpace uses—the one used by Tim (http://www.123mycodes.com/myspace-surveys/9.php) allows just 30 characters for each response. Moreover, some of these profile additions only hint at the profile-owner's answers by aggregating them to indicate—for example—what kind of superhero the author would like to be. As Tim says, 'They don't ask questions that are really important. It's just, I think they're just comfortable questions.' To which Claire adds, 'You can be honest, but you don't want everyone knowing every detail of your life'.

The profile as a minimally self-reflexive space

> I don't really tend to say, 'today I think this and this'. Some people do it, but I think among certain peer groups it's frowned upon as if maybe you look just a bit sad, to tell you the truth. It's not actually that much of a common thing. I haven't noticed many of my friends having blogs either.
>
> Darrell

As Darrell suggests, self-examination in front of others is not just risky because of the particular aspects of the self which might emerge (see the section on Relations above)—it is also challenging if practised in depth and it is a practice which can be seen as intrinsically self-absorbed and therefore embarrassing.[10] As noted in the introduction, however, it is impossible to create a profile with-

out examining one's self. Could it therefore be that the aspects of MySpace's code that seem to limit the amount of self-reflection required for participation on MySpace are in fact an important factor contributing to its popularity?

MySpace and sites like it provide a means for individuals to have a 'presence' online under their control without having to invest a significant amount of time in creating or maintaining it. They do not have to decide where (on which server) to host their presence, what (if anything) they should pay (the service is free), how their site should be structured (in terms of pages and sub-pages). Thanks to the default questions offered by MySpace they do not even have to ask themselves what a profile should consist of. Although the interviewees did not themselves allude to this point, it is arguable that part of the appeal of services like MySpace is that users do not have to concern themselves overmuch with determining which aspects of themselves best reflect who they are. The questions deemed relevant—who their peers are, what bands they like and so on—have already been decided and are presented to the potential profile maker by the service. Indeed, one service—http://www.elfriendo.com—has already emerged claiming to further streamline the process of MySpace profile creation. The site's home page says, 'It's called MySpace, not EmptySpace. Since no one is waiting around for another blank profile, and you don't have the hours it takes to list your DVD collection, we'll do it for you.'

Conclusion

The preliminary research conducted for this chapter suggests that the creation of MySpace profiles is framed—though not determined—by factors that can be usefully grouped into the categories identified by Schmidt—rules, relations and code. These do not stand alone but inter-relate with each other. For example, rules governing how MySpace profiles are created and maintained are influenced both by the nature of the relations with those reading—both intended and unintended—and by the code of the site—both directly by the capabilities it does or doesn't provide and indirectly through the interface embedded in the code of the site.

Increasingly individuals and groups are turning to existing digitally mediated spaces in which they are constructing self-related texts without institutional support. As mentioned in the introduction, research on personal home pages and weblogs suggests that some individuals can find them useful tools for the kind of self-understanding digital storytelling projects also often seek to foster. We do not know, however, what proportion of webloggers or personal home page creators choose to use these tools in that manner, nor about the

particular combinations of structural elements that encourage it.

The creation and maintenance of SNS profiles are much more widespread than blogging or home page maintenance, so widespread adoption of SNSs may represent an important potential opportunity for users—and young users in particular—to reflect on their lives through writing about them. But the analysis in this chapter suggests that the practices enabled by these new technologies are not the simple product of a meeting between needs and technological affordances but the products of complex, situated interrelationships. More research is therefore needed to understand the contexts which frame and enable differing uses of online self-related spaces and to suggest ways in which these contexts might be changed to encourage richer uses.

This suggests in turn a new potential role for the organizations which run institutionalized storytelling projects. Their traditional approach has been to draw groups in and to create their own spaces in which highly structured forms of storytelling can take place, often using digital media. There may be an opportunity for storytelling organizations to reach out from their traditional project-based work and address the much larger number of potential digital storytellers who have been attracted to these new spaces. There they could apply the wealth of experience they have accumulated to encourage the users of sites like MySpace to adopt practices that maximise the creative and self-reflexive potential of these spaces.

Notes

Thanks are due to the Research Council of Norway for funding this work as part of the larger Mediatized Stories project. I also thank Nick Couldry, Lotte Nyboe, Shani Orgad, Sonia Livingstone and Robin Mansell.

1. Nielsen Netratings 'Netview' data for September 2007 suggests that Facebook overtook MySpace in the United Kingdom for most age groups, and that SNS adoption—in the United Kingdom at least—has risen considerably since the figures given above. (Broughton, Pople & Human Capital, 2007)
2. To remain consistent with Schmidt's typology this chapter uses the term 'rule' to apply to the social norms and influences governing practices, though the word tends to imply a more rigid and determining power than most of these 'rules' have.
3. In addition to the informal, tacit norms described later in this chapter he includes formalized norms in his framework (p. 1414)—for example the terms of service of hosting services and laws about freedom of speech. These also bear on the interviewees as they would any MySpace users—interviewees would have been warned by the site owners not to post pornographic pictures during the process of signing up for the service, for example, and all members have to be willing to have advertising carried on their profiles over which they have no control. Those interviewed did not allude to these constraints in the interviews,

however, so this chapter will not analyse them further.

4. This is a pseudonym as are all other interviewees' names given.
5. In rough order of importance, MySpace 'messages'—a kind of proprietary service like email but in which only MySpace members could be contacted, 'commenting'—messages left publicly on another's profile page and 'bulletins'—a separate service which sends a message to all of those on a user's 'friends' list. There are other communication facilities like forums and groups, but they were not alluded to by interviewees.
6. Three of those interviewed had MySpace pages not principally aimed at friends but at potential customers for their creative works—this framing is dealt with in the section on Rules.
7. Charlie created a false profile but only as a prank—it was not based on himself in any way. Ann listed her age as 92 and Darrell gave a false income (250,000+) and profession, but these, too, were not meant to be read as anything but humorous experiments.
8. Although naturally not all pseudonyms are intended to protect the identity of the writer, and not all that are so intended are effective.
9. As with other measures this is an approximate figure based on default font sizes on a Windows PC running Internet Explorer—different browser/OS configurations could result in different outcomes.
10. It is this and not unhappiness that Darrell is suggesting with the word 'sad' in this context.

References

Bauman, Z. (2001). *The individualized society.* Cambridge, UK; Malden, MA: Polity Press.
———. (2007). *Consuming Life.* Cambridge: Polity Press.
Beck, U., & Beck-Gernsheim, E. (2001). *Individualization : Institutionalized individualism and its social and political consequences.* London: Sage.
Bellman, S., Johnson, E. J., & Lohse, G. L. (2001). To opt-in or opt-out? It depends on the question. *Communications of the ACM, 44*(2), 25–27.
Blogger. (2007, unknown). What is a Blog? Retrieved 23 April, 2007, from http://www2.blogger.com/tour_start.g
boyd, d. (2006). *Identity production in a networked culture: Why youth ♥ MySpace.* Paper presented at the American Association for the Advancement of Science. Retrieved from *http://www.danah.org/papers/AAAS2006.html.*
boyd, d., & Ellison, N. B. (2007). Social network sites: Definition, history, and scholarship. *Journal of Computer-Mediated Communication, 13*(1), 210–230.
Broughton, T., Pople, H., & Human Capital. (2007). *Facebook: An Empirical Analysis.* Paper presented at the Poke 1.0. workshop, London UK. Retrieved 12 February from *http://www.scribd.com/doc/513941/The-Facebook-Faceoff-An-Empirical-Analysis-by-Human-Capital.*
Chandler, D. (1998, 19 April 2000). Personal home pages and the construction of identities on the Web. Retrieved 22 August 2007, from *http://www.aber.ac.uk/media/Documents/short/webident.html*
Derlega, V. J., & Chaikin, A. L. (1977). Privacy and self-disclosure in social relationships. *Journal of Social Issues, 33*(3), 102–115.
Dutton, W. H., & Helsper, E. (2007). *The internet in Britain: 2007.* Oxford: Oxford Internet Institute, University of Oxford.

Ellison, N., Steinfield, C., & Lampe, C. (2007). The benefits of Facebook 'friends': Social capital and college students' use of online social network sites. *Journal of Computer-Mediated Communication, 12*(4), 1143–1168.

Garrett, J. J. (2006, 3 January 2006). MySpace: Design anarchy that works. *BusinessWeek.*

Giddens, A. (1991). *Modernity and self identity : self and society in the late modern age.* Cambridge: Polity Press in association with Basil Blackwell.

Hevern, V. (2000). *Alterity and self-presentation via the Web: Dialogical and narrative aspects of identity construction.* Paper presented at the First International Conference on the Dialogical Self, Katholieke Universiteit Nijmegen, The Netherlands.

Joinson, A. N. (2001). Self-disclosure in computer-mediated communication: The role of self-awareness and visual anonymity. *European Journal of Social Psychology, 31*(2), 177–192.

Kesan, J. P., & Shah, R. C. (2006). *Establishing software defaults: Perspectives from law, computer science and behavioral economics.* Urbana-Champaign: University of Illinois.

Lambert, J. (2006). *Digital storytelling : capturing lives, creating community* (2nd ed.). Berkeley, CA: Digital Diner Press.

Lenhart, A., & Fox, S. (2006). *Bloggers: A portrait of the Internet's new storytellers*: Pew Internet & American Life Project.

Lenhart, A., & Madden, M. (2007). *Teens, privacy & online social networks: How teens manage their online identities and personal information in the age of MySpace*: Pew Internet & American Life Project.

Livingstone, S. (2008). Taking risky opportunities in youthful content creation: teenagers' use of social networking sites for intimacy, privacy and self-expression. *New Media & Society, 10*(3), 459–477.

Livingstone, S., & Bober, M. (2004). *UK children go online: Surveying the experiences of young people and their parents.* London: ESRC.

McKenna, K. Y. A., & Bargh, J. A. (2000). Plan 9 from cyberspace: The implications of the Internet for personality and social psychology. *Personality and Social Psychology Review, 4*, 57–75.

Ofcom. (2006). *The communications market 2006.* London: Ofcom.

Qian, H., & Scott, C. R. (2007). Anonymity and self-disclosure on Weblogs. *Journal of Computer-Mediated Communication, 12*(4), 1428–1451.

Reckwitz, A. (1997). *Struktur. Zur sozialwissenschaftlichen Analyse von Regeln und Regelmäßigkeiten.*[Structure. Towards a Sociological Analysis of Rules and Regularities] Opladen: Westdeutscher Verlag.

Rosen, J. (2005). *The naked crowd: Reclaiming security and freedom in an anxious age* (1st ed.). New York, NY: Random House.

Rubin, Z. (1975). Disclosing oneself to a stranger: Reciprocity and its limits. *Journal of Experimental Social Psychology, 11*(3), 233–260.

Schmidt, J. (2007). Blogging practices: An analytical framework. *Journal of Computer-Mediated Communication, 12*(4), 1409–1427.

Spears, R., & Lea, M. (1994). Panacea or panopticon? The hidden power in computer mediated communication. *Communication Research, 21*(4), 427–459.

USC Annenberg School Center for the Digital Future. (2007). *The 2007 digital future report.* Los Angeles: USC Annenberg School Center for the Digital Future.

Contributors

David Brake

Ph.D. student at the London School of Economics and Political Science, University of London, UK, working on a thesis about personal webloggers. He wrote a chapter in *Personlige medier* (Lüders et al., 2007) and has contributed to *Harm and Offence in Media Content* (Livingstone & Hargrave, 2006). [http://davidbrake.org, email: davidbrake@gmail.com]

Tone Bratteteig

Associate Professor and Deputy Chair, Department of Informatics, University of Oslo, Norway. She holds a doctoral degree in interdisciplinary informatics, and her research concerns the interplay between technical artefacts and human activities, at various techno-socio-cultural levels. She is a co-editor of *Exploring Digital Design* (2008), a multidisciplinary approach to research on design of digital artefacts and systems. [email: tone@ifi.uio.no]

Nick Couldry

Professor of Media and Communications at Goldsmiths College, University of London, UK. He is the author or editor of 7 books, including most recently *Listening Beyond the Echoes: Media, Ethics and Agency in an Uncertain World* (2006) and (with Sonia Livingstone and Tim Markham) *Media Consumption and Public Engagement: Beyond the Presumption of Attention* (2007). [email: n.couldry@gold.ac.uk]

Kirsten Drotner

Professor of Media Studies, University of Southern Denmark, and founding director of DREAM (Danish Centre on Education and Advanced Media Materials). Recent co-authorship includes *Researching Audiences* (2003) and *The International Handbook on Children, Media and Culture* (2008). [email: drotner@dream.dk]

Ola Erstad

Professor and Head of Research at the Department for Educational Research, University of Oslo, Norway. He has been working within the fields of media and educational research. He has published on issues of technology and education, especially on 'media literacy' and 'digital competence'. Among recent publications is an article on "Trajectories of Remixing—Digital Literacies, Media Production and Schooling" in a book by C. Lankshear & M. Knobel (Peter Lang, 2008). [email: ola.erstad@ped.uio.no]

Larry Friedlander

Professor Emeritus of Literature and Theater at Stanford University, US. He was a pioneer in the application of computer technology to the arts and to education, co-founded the Stanford Learning Lab Lab and the Wallenberg Global Learning Network and has advised major museums, theatres, and universities all over the world. He has spent many years as an actor in leading roles in Shakespeare repertory companies and has published widely in Shakespeare and multimedia. [email: larryf@stanford.edu]

David Gauntlett

Professor of Media and Communications at University of Westminster, UK. He is the author and editor of several books on people's creative engagement with media, including *Creative Explorations: New Approaches to Identities and Audiences* (2007), *Media, Gender and Identity* (2002, 2008), and *Web Studies* (2000, 2004). He has created and maintains the websites Theory.org.uk and ArtLab.org.uk. [email: d.gauntlett@westminster.ac.uk]

John Hartley

Australian Research Council Federation Fellow, Research Director of the ARC Centre of Excellence for Creative Industries and Innovation, and Distinguished Professor at Queensland University of Technology. He was foundation dean of the Creative Industries Faculty (QUT). He is the author of 18 books, including *Television Truths* (2008), *Creative Industries* (2005) and *A Short History of Cultural Studies* (2003). He is the editor of the *International Journal of Cultural Studies* (Sage). [email: j.hartley@qut.edu.au]

Glynda A. Hull

Professor of Language, Literacy and Culture in the Graduate School of Education at the University of California, Berkeley, US. Her research examines digital technologies and new literacies; writing and students at-risk; and community/school/university partnerships. Her books include *School's Out! Bridging Out-of-School Literacies with Classroom Practice* (2002), and a recent monograph is entitled *Many Versions of Masculine: Explorations of Boys' Identity Formation through Multimodal Composing in an After-School Program* (2006).

Birgit Hertzberg Kaare

Professor of media studies at the Department of Media and Communication, University of Oslo, Norway. She holds a doctoral degree in religious folk culture. With a background in folklore, she researches popular culture, with a focus on humour, as well as the relationship between new media and youth culture. She has recently published on children and young people's use of new media from the project *Digital Childhood*. [email: b.h.kaare@media.uio.no]

Knut Lundby

Professor of media studies at the Department of Media and Communication, University of Oslo, Norway. He holds a doctoral degree in sociology of religion and researches the relationship between media, religion and culture. He was founding director of InterMedia, University of Oslo, researching design, communication and learning in digital environments. Lundby is the director of the international *Mediatized Stories* project. [email: knut.lundby@media.uio.no]

Kelly McWilliam

ARC Postdoctoral Research Fellow in the Creative Industries Faculty at Queensland University of Technology, Australia. She is the co-editor of *Story Circle: Digital Storytelling around the World* (forthcoming, with John Hartley) and the co-author of *Screen Media: Film and Television Analysis* (2008, with Jane Stadler). [email: k.mcwilliam@qut.edu.au]

Mark Evan Nelson

He recently received a Ph.D. in Language and Literacy Education from the University of California, Berkeley's Graduate School of Education, where he was a post-doctoral fellow. Since July 2008 he has been Assistant Professor of English Language and Literature in the National Institute of Education in Singapore. [email: mark.nelson@nie.edu.sg]

Lotte Nyboe

Assistant Professor of Media Studies, University of Southern Denmark. She has a Ph.D. in Media Studies and Cultural Studies from the University of Southern Denmark. Her research interests are children and young people's use of media and digital learning. [email: l.nyboe@litcul.sdu.dk]

Kenneth Silseth

Ph.D. Student at The Department for Educational Research, University of Oslo, Norway. In his doctoral thesis, Silseth addresses notions like learning, identity formations and intersubjectivity in relation to young people's use of

digital technology inside and outside of schools. [email: *kenneth.silseth@ped. uio.no*]

Elisabeth Staksrud

Ph.D. student/Research Fellow, Department of Media and Communication, University of Oslo, Norway. Initiator and director of SAFT (Safety Awareness Facts and Tools) 2002–2006, a cross-European awareness project funded by the European Commission conducting two of the largest representative international surveys on children, parents and new media to date. [email: *elisabeth. staksrud@media.uio.no*]

Nancy Thumim

LSE Fellow, Department of Media and Communications, London School of Economics and Political Science, University of London, UK. Author of "Tension in the Text: Exploring Self-Representations in *Capture Wales* and London's Voices," in Hartley & McWilliam (Eds.), *Story Circle: Digital Storytelling around the World* (forthcoming) and "Mediated Self-Representations: 'Ordinary People' in 'Communities'," in Herbrechter & Higgins (Eds.), *Returning (to) Community* (2006). [email: n.thumim@lse.ac.uk]

James V. Wertsch

Marshall S. Snow Professor of Arts and Sciences at Washington University in St. Louis, US, where he is a professor of anthropology as well as the director of the McDonnell International Scholars Academy. Among recent publications are *Voices of the Mind: A Sociocultural Approach to Mediated Action* (1991); *Voices of Collective Remembering* (2002); and *Enough! The Rose Revolution in the Republic of Georgia* (co-edited with Zurab Karumidze, 2005). [email: *jwertsch@ artsci.wustl.edu*]

All contributors except Hartley and McWilliam participate in the Mediatized Stories project.

Index

Digital Formations

General Editor: Steve Jones

Digital Formations is an essential source for critical, high-quality books on digital technologies and modern life. Volumes in the series break new ground by emphasizing multiple methodological and theoretical approaches to deeply probe the formation and reformation of lived experience as it is refracted through digital interaction. **Digital Formations** pushes forward our understanding of the intersections—and corresponding implications—between the digital technologies and everyday life. The series emphasizes critical studies in the context of emergent and existing digital technologies.

Other recent titles include:

Leslie Shade
 *Gender and Community in the Social
 Construction of the Internet*

John T. Waisanen
 Thinking Geometrically

Mia Consalvo & Susanna Paasonen
 Women and Everyday Uses of the Internet

Dennis Waskul
 Self-Games and Body-Play

David Myers
 The Nature of Computer Games

Robert Hassan
 The Chronoscopic Society

M. Johns, S. Chen, & G. Hall
 Online Social Research

C. Kaha Waite
 *Mediation and the Communication
 Matrix*

Jenny Sunden
 Material Virtualities

Helen Nissenbaum & Monroe Price
 Academy and the Internet

To order other books in this series please contact our Customer Service Department:
(800) 770-LANG (within the US)
(212) 647-7706 (outside the US)
(212) 647-7707 FAX
To find out more about the series or browse a full list of titles, please visit our website:
WWW.PETERLANG.COM